Vincent van Gogh

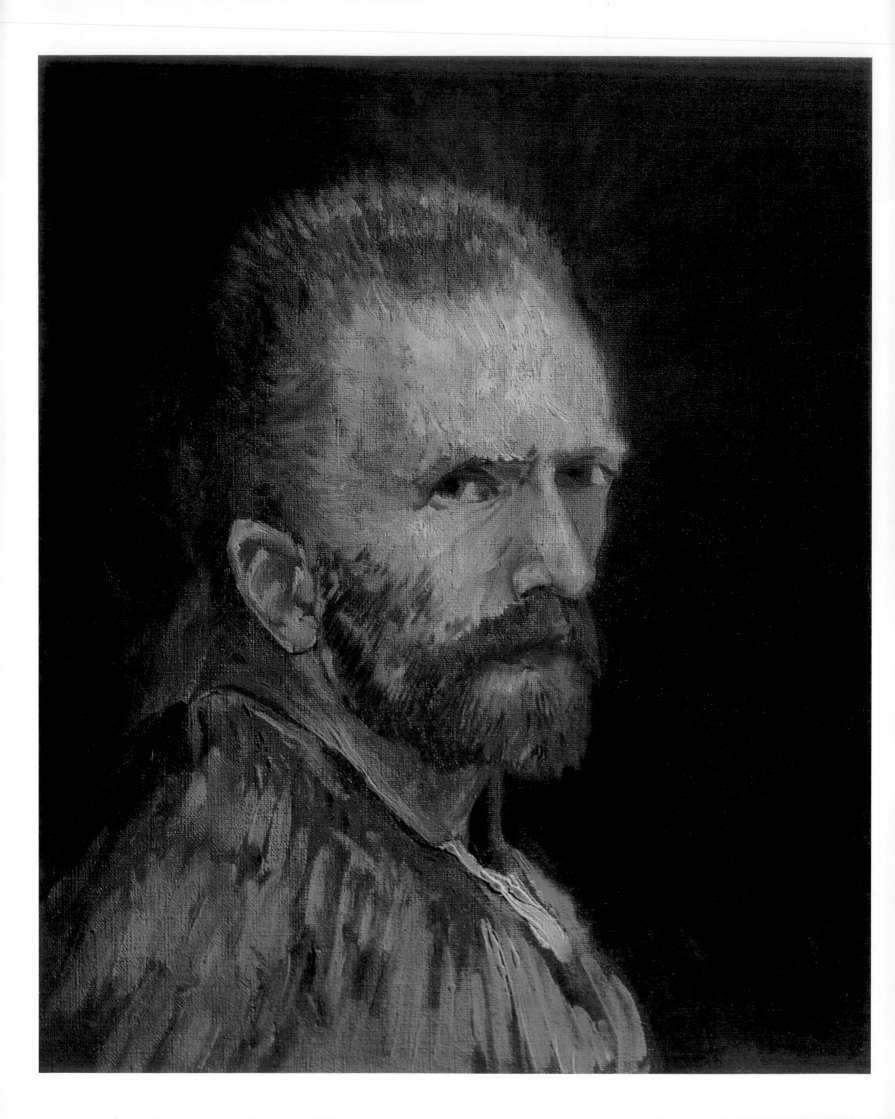

Rainer Metzger · Ingo F. Walther

VINCENT VAN GOGH

1853 – 1890

TASCHEN

KÖLN LONDON MADRID NEW YORK PARIS TOKYO

© 1998 Benedikt Taschen Verlag GmbH
Hohenzollernring 53, D–50672 Köln
www.taschen.com
English translation: Michael Hulse, Cologne
Edited and produced by Ingo F. Walther, Alling
Cover design: Angelika Taschen, Cologne

Printed in South Korea
ISBN 3–8228–7225–3

Contents

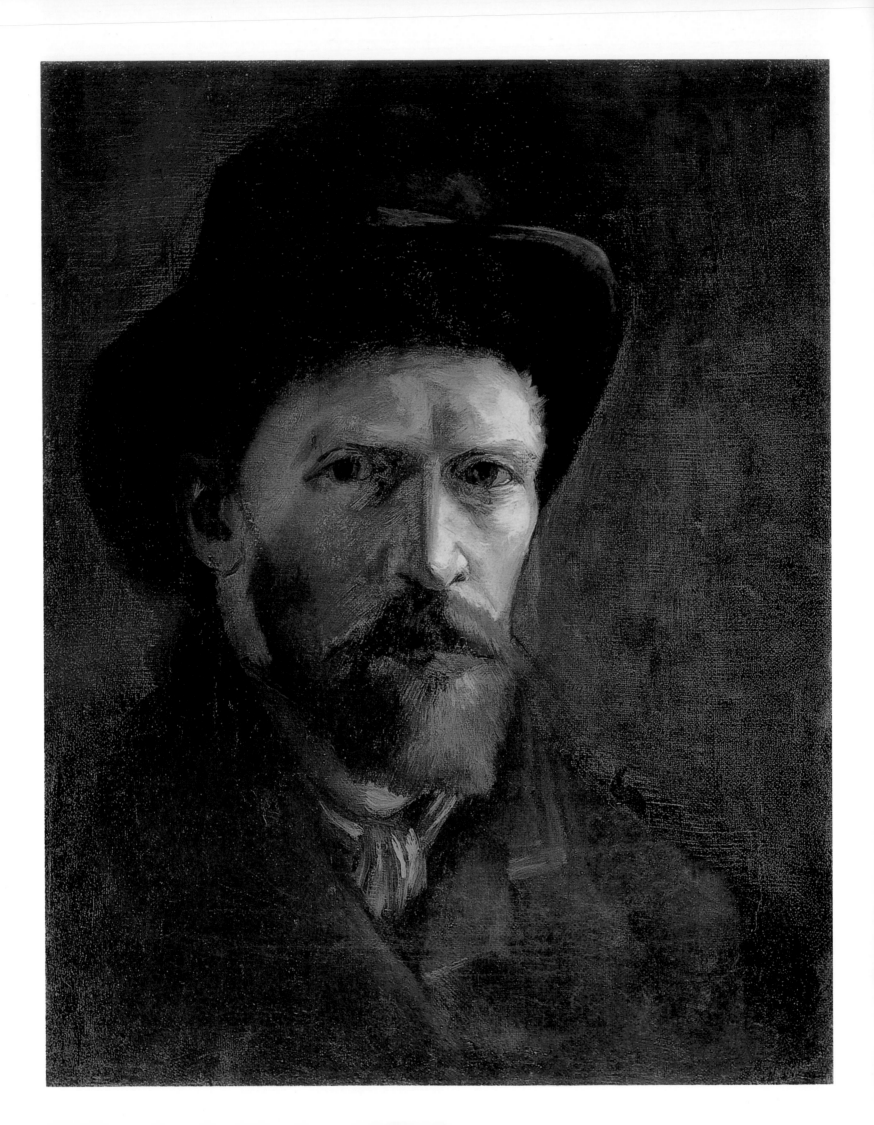

The Making of an Artist
1853–1883

The Family

Vincent van Gogh was the son of a Dutch pastor, Theodorus van Gogh, and his wife, Anna Cornelia. Their first son was still-born; a year later to the day, on 30 March 1853, another boy saw the light of day. This healthy son was given the names of the still-born first, Vincent Willem, after his two grandfathers.

His family lived a quiet life in the modest vicarage at Zundert near Breda, in Dutch Brabant. Theodorus's father had been a pastor too; indeed, so had generations of the van Goghs. They were not strict Calvinists in belief, but adherents of the Groninger party, a liberal branch of the Dutch Reformed Church. Vincent was profoundly influenced by the hard-working and pious atmosphere of his parental home.

Theodorus and Anna Cornelia van Gogh had six children. Vincent, the first-born, was followed by Anna Cornelia (born 1855), Theo (born 1857), Elisabetha Huberta (born 1859), Willemina Jacoba (born 1862) and finally Cornelis Vincent (born 1867). During his lifetime, Vincent was to keep up close relations with only two of his siblings: Willemina, and Theo, his financial supporter, father-confessor and viewer of his pictures. The childhood and youth of the siblings seem to have been much what we would expect in a *petit bourgeois* household.

Vincent's father had no fewer than ten brothers and sisters. Vincent's uncles, who lived in various parts of the Netherlands, emphasized their authority over their nephew. Four of them played an especially influential role. Hendrick Vincent van Gogh, "Uncle Hein", was an art dealer in Brussels; it was under him that Theo first ventured into the wider world. Johannes van Gogh, "Uncle Jan", had been made an admiral; Vincent was to live at his home in Amsterdam for the better part of a year. Cornelis Marinus van Gogh, "Uncle Cor", was also an art dealer, and thus active in the field that (along with the pulpit) was the other traditional profession of the van Goghs. Indeed, Vincent van Gogh, "Uncle Cent", was also an art dealer; he was the young Vincent's godfather. He had made the most impressive career for himself, working his way up in The Hague from the most modest of beginnings and ultimately incorporating his shop into the gallery chain of the Paris art publisher Goupil & Cie.

When Vincent joined the branch of Goupil & Cie in The Hague as an apprentice in 1869, at the age of sixteen, there seemed no obstacle to the kind of career the family council would have wished him. Goupil was one of the leading firms in Europe and had recently begun its conquest of America. The house specialized in the reproduction of printed graphics; from 1873, it was also Theo van Gogh's

Self-Portrait with Dark Felt Hat
Paris, Spring 1886
Oil on canvas, 41.5 x 32.5 cm
Amsterdam, Rijksmuseum Vincent van Gogh,
Vincent van Gogh Foundation

employer. Vincent was subsequently remembered as a friendly, dependable employee; the reference written in 1873 by Mr. Tersteg (manager of the branch in The Hague) was a paean of praise. When he was transferred to London in summer 1873, the move was doubtless meant as a reward.

"We must write each other plenty of letters," Vincent van Gogh baldly proposed to his brother Theo on 13 December 1872 (Letter 2). From this acorn, within two brief decades, there grew a mighty oak of correspondence. Over eight hundred of the letters have been preserved, thanks above all to Theo van Gogh's industrious collector instincts. The letters to Theo were by far the most important; it was to Theo that Vincent's first letter was written, and his last, too; indeed, over three quarters of the letters were addressed to Theo.

Van Gogh's correspondence is filled with his conviction that painting and writing are sister arts, and he is forever seeking to bridge the gap between Art and Reality through the sheer vividness of his words. "A female figure in a black woollen dress is lying before me; I am certain that if you had her for a day or so you would be reconciled to the technique." (Letter 195). Does not this comment on a drawing read as if he were writing of a real person close to him? "A flock of doves goes sailing by across the red tiled roofs, between the black smoking chimneys. Beyond is an infinity of soft, delicate green, mile upon mile of flat pasture land and a grey sky – as tranquil and peaceful as in Corot or van Goyen." (Letter 219).

When van Gogh looks at a real landscape, is it not as if he were considering a painted one? In his exploration of the nuances of natural and artificial description

Farmhouses in Loosduinen near The Hague at Twilight
The Hague, August 1883
Oil on canvas on panel, 33 x 50 cm
Utrecht, Centraal Museum (on loan from the van Baaren Museum Foundation, Utrecht)

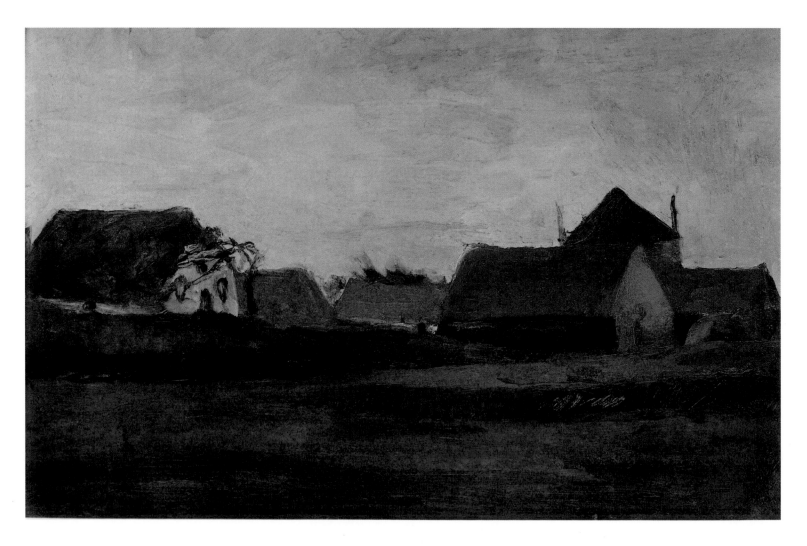

Still Life with Cabbage and Clogs
Etten, December 1881
Oil on paper on panel, 34.5 x 55 cm
Amsterdam, Rijksmuseum Vincent van Gogh,
Vincent van Gogh Foundation

Still Life with Beer Mug and Fruit
Etten, December 1881
Oil on canvas, 44.5 x 57.5 cm
Wuppertal, Von der Heydt-Museum

we can clearly detect his aim to give the language of his letters a flexibility and immediacy beyond statements of personal involvement, to take his bearings from the eloquence of writers such as Zola. It is that eloquence that gives van Gogh's letters the literary value widely ascribed to them.

And then, of course, van Gogh's letters provide a running commentary on his paintings. Almost every one of his works is referred to in some way, be it the subject, the choice of colours, or the circumstances that led to its being painted. His writings were confined almost entirely to correspondence, surely because of his fixation on his brother. This fixation had the effect of focussing Vincent's attention on one person at the expense of others, thoughout his life. It was to Theo that he wrote most of his letters, including those in which he criticizes himself most severely and opens himself up most profoundly. And it was also to Theo that Vincent's pictures were addressed: Theo was his artistic brother's

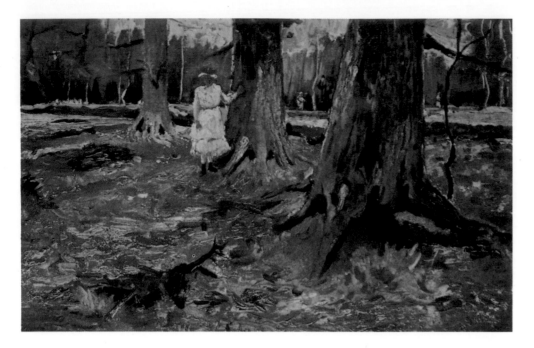

public. It was in his parallel activities of writing and painting, both of them addressed to a single person, Theo, that Vincent van Gogh saw significance in his own existence. Only there did he see himself as active, useful, and productive of things of value. And this is why his confessions (it is the aptest word for his paintings and letters alike) are so highly charged with emotion.

Van Gogh signed his works with a simple Christian name: Vincent. One reason why he did so was that he was seeking to put distance between himself and his origins in a family of careerists and *petit bourgeois* piety: "I ask you quite openly", he wrote to Theo (Letter 345a) at a time when he was living at home, chafing at his parents' cast-iron moral attitudes, "how do we relate to each other – are you a 'van Gogh' too? For me you have always been 'Theo'. I myself am different in character from the other members of the family, and really I am not a 'van Gogh' at all." What mattered was not one's descent, not the loudly proclaimed membership in some family of high social standing, but the individual pure and simple. And for the individual, the Christian name did good service. Vincent

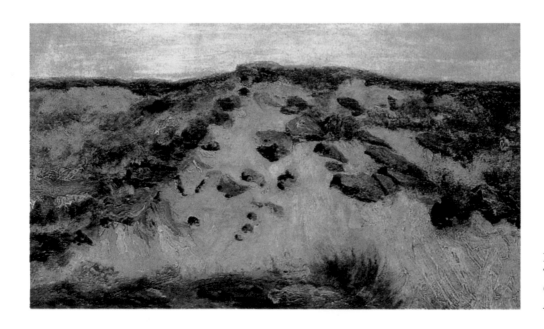

signed his paintings as he signed his letters. It was his way of declaring them the work of a man revealing his inmost self.

We sometimes have the impression that van Gogh's entire will to live is being focussed on his addressee; at the same time, it is his need to express himself to that person which establishes his will to live in the first place. The addressee is the point to which all his melancholy, but also all his confessional courage, tends. It is a precarious balancing act, since the writer becomes existentially dependent on his sense of the reader's interest; and out of that balance arises the desire for the two to become one. "Now I feel that my pictures are not yet good enough to compensate for the advantages I have enjoyed through you," he wrote to Theo (Letter 538). "But believe me, if one day they should be good enough, you will have been as much their creator as I, because the two of us are making them together."

The Religious Maniac

"Who sees that once our first life, the life of youth and young manhood, the life of worldly pleasure and vanity, has withered away, as wither away it must – and it will do so, just as the blossoms fall from the trees – who sees that then a new life is ours, in all its strength, a life filled with love of Christ and with a sadness

Beach at Scheveningen in Stormy Weather
The Hague, August 1882
Oil on canvas on cardboard, 34.5 x 51 cm
Amsterdam, Rijksmuseum Vincent van Gogh,
Gift of E. Ribbius-Peletier

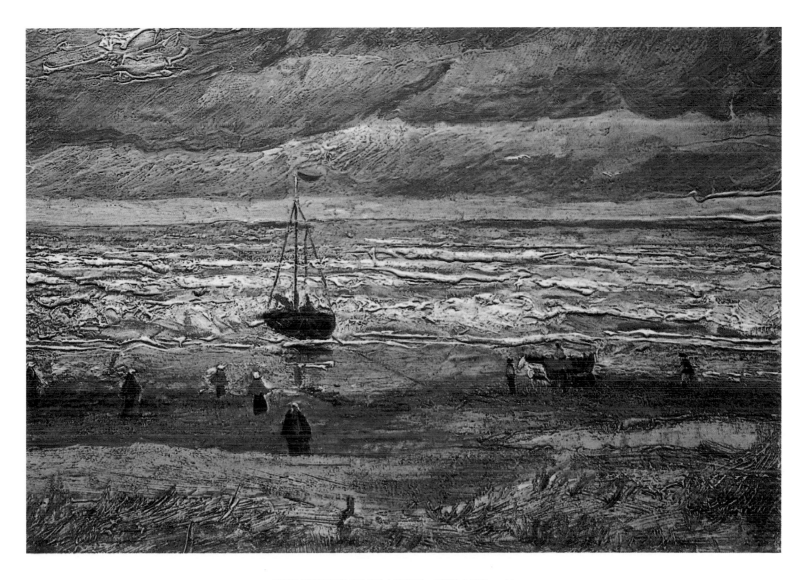

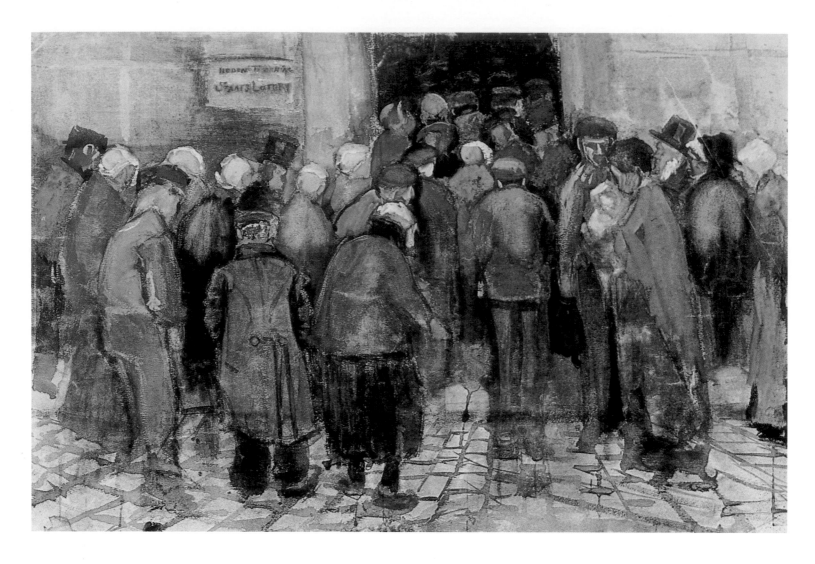

The State Lottery Office
The Hague, September 1882
Watercolour, 38 x 57 cm
Amsterdam, Rijksmuseum Vincent van Gogh,
Vincent van Gogh Foundation

that causes sorrow to no one, a divine sadness?" Most of the products of van Gogh's pen up to 1880 read like this passage from Letter 82a, dating from November 1876. He had developed what can only be described as a religious mania, and it involved excessive mortification of the flesh: van Gogh cudgelled his back, wore only a shirt in winter, and slept on the stone floor beside his bed. It was as if he wanted to catch up on his forefathers' piety – and was doing it at double the normal pace.

Vincent lacked experience with women, and one unfortunate love seems to have given him a considerable jolt. Hitherto an open, entertaining and liberal-minded man, he became an eccentric, taciturn loner who substituted late-night Bible reading for contact with his fellow-beings. It was of no avail when Uncle Cent arranged for his nephew to be transferred to Goupil's Paris headquarters: by spring 1876, Vincent van Gogh's career as an art dealer was at an end. Fractious advice to purchasers, suggesting they buy cheaper art, doubtless did credit to his love of truth but scarcely helped the company's turnover. After he had been dismissed, Vincent returned to England, to Ramsgate and Isleworth (near London), where he worked as an assistant teacher, for a pittance, and gave full rein to his missionary tendencies. Gradually, he came to feel he had a vocation to be a clergyman like his forefathers; at this period in his life, he saw his father, Theodorus van Gogh, as an important role model.

In spring 1877, Vincent went to stay with his Uncle Jan in Amsterdam, where he prepared for theology studies by tackling Latin and Greek, taking maths lessons, and generally trying to fill the gaps he felt his apprenticeship period had

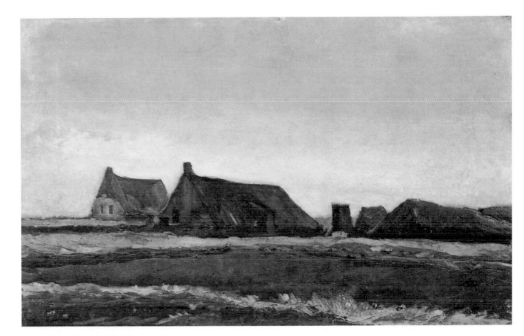

Farmhouses
The Hague, September 1883
Oil on canvas, 35 x 55.5 cm
Amsterdam, Rijksmuseum Vincent van Gogh,
Vincent van Gogh Foundation

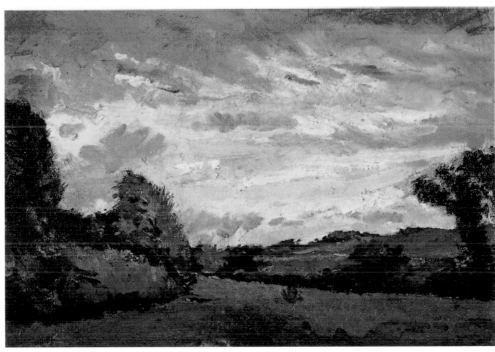

Landscape with Dunes
The Hague, August 1883
Oil on panel, 33.5 x 48.5 cm
Private collection

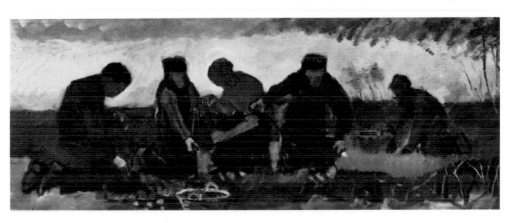

Potato Digging (Five Figures)
The Hague, August 1883
Oil on canvas, 39.5 x 94.5 cm
New York, Private collection

punched in his education. In the event, Vincent's plans to study came to nothing, however, and he broke off his preparations before risking failure in the entrance examinations. His heady piety was based on the imitation of Christ. With a humility that was veritably Franciscan, he neglected his appearance in the attempt

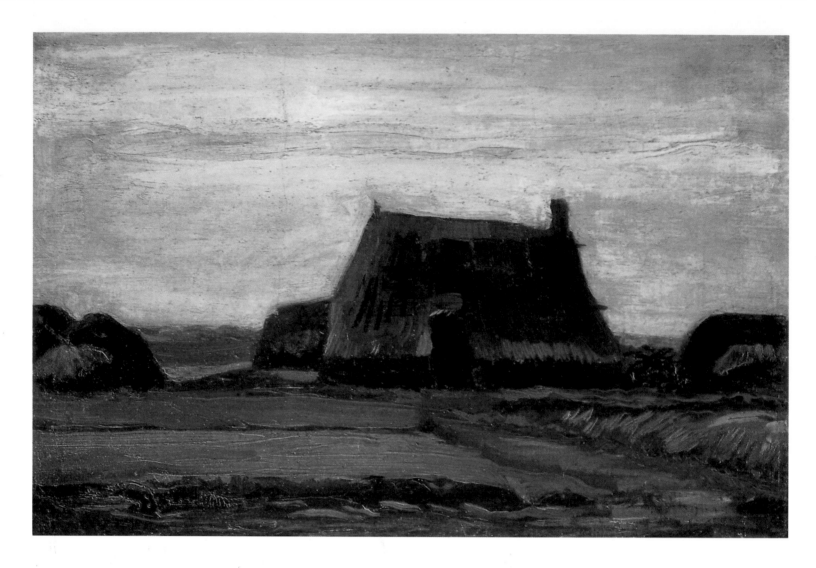

Farmhouse with Peat Stacks
Drente, October–November 1883
Oil on canvas, 37.5 x 55.5 cm
Amsterdam, Rijksmuseum Vincent van Gogh,
Vincent van Gogh Foundation

to discover those inner values which alone constitute true holiness. He took Thomas a Kempis's devotional work *The Imitation of Christ* as his text, and identified with St. Paul. He adapted his motto at this time from St. Paul's Second Epistle to the Corinthians: "in sorrow yet ever joyful." Repeatedly he glossed the words in letters written during this period.

"There will only be a little rest ahead once one has done a couple of years' worth of work and senses that one is on the right track," Vincent wrote to Theo from Amsterdam (Letter 97). In point of fact, his own restlessness – both in terms of geographic location and within himself – was worse than ever. At last the family council agreed that Vincent should try his hand as a lay preacher (since this required active humanity rather than theological expertise). And Vincent's Samaritan instincts were presently to come into their own in the Borinage, an impoverished Belgian mining district.

In the Borinage, his self-sacrificing spirit had a field day; the Evangelical Committee opted not to renew Vincent's contract, claiming that he had rather overdone his zeal. He had given his clothing to the needy like St. Martin, had lived in a tumbledown hut like St. Francis, and had existed on a diet of bread and water, as demanded by the strictest of spiritual exercises. In the Borinage, Vincent touched rock bottom. And he found that the life of a preacher really suited him no better than that of an art dealer; now he was living without any income among the poorest of the poor, a standing reproach to the middle classes. Even Theo was daunted. From October 1879 to July 1880 their correspondence was interrupted, and it was not till Vincent finally accepted one of his brother's postal

money orders that the silence was broken. In his reply, Vincent van Gogh proved to be a changed man, stripped of illusions, his head cleared, and with a new vocation – Art.

His brief apprenticeship in the world of art dealing had given him an early familiarity with paintings. But if we did not bear in mind the crucial part played by the years of religious mania in his subsequent development as an artist, our grasp of his work would remain superficial – indeed, it would be impossible to interpret it. His faith, his personal religion, acted as the catalyst of his creative impulses, and supplied a source of symbols, motifs and meanings that he was to draw on time and again. His pictures were a means of illustrating and backing up his view of the world. When van Gogh considered the works of art he saw, he was not applying technical or compositional standards, or assessing colour values; his criteria were not aesthetic. Instead, he was after expression of his own ideas. His approach to art was distinctly literary in character: he expected pictures to tell stories that he could identify with.

At the end of October 1876, van Gogh preached for the first time, at Isleworth. This sermon (included as number 79a in the Letters) is of particular interest because many of the subjects that loom large in his paintings are referred to in it: "I once saw a beautiful picture: it was a landscape, in the evening. Far in the distance, on the right, hills, blue in the evening mist. Above the hills, a glorious

Two Peasant Women in the Peat Field
Drente, October 1883
Oil on canvas, 27.5 x 36.5 cm
Amsterdam, Rijksmuseum Vincent van Gogh,
Vincent van Gogh Foundation

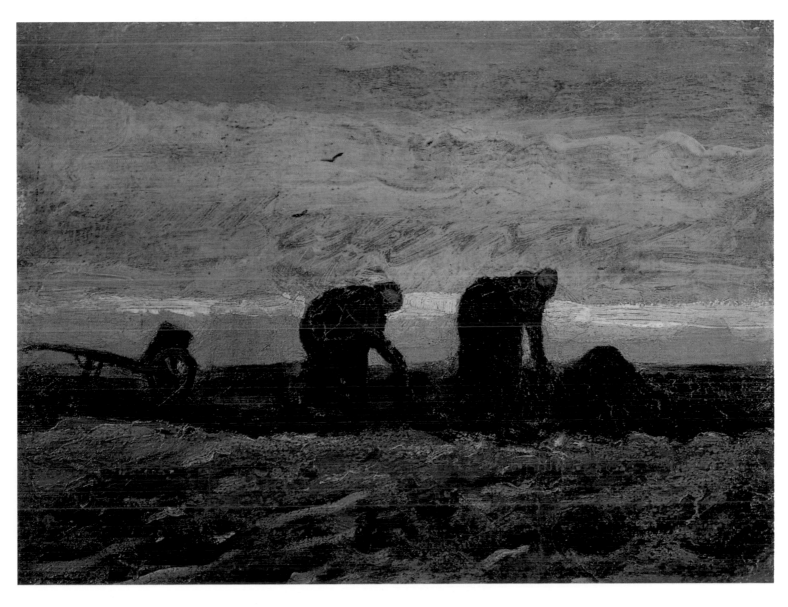

Man Digging
The Hague, August 1882
Oil on paper on panel, 30 x 29 cm
Private collection

sunset, with the grey clouds edged with silver and gold and purple. The landscape is flatland or heath, covered with grass; the grass-stalks are yellow because it was autumn. A road crosses the landscape, leading to a high mountain far, far away; on the summit of the mountain, a city, lit by the glow of the setting sun. Along the road goes a pilgrim, his staff in his hand. He has been on his way for a very long time and is very tired. And then he encounters a woman, or a figure in black, reminiscent of St. Paul's phrase: 'in sorrow, yet ever joyful'. This angel of God has been stationed there to keep up the spirits of pilgrims and answer their questions. And the pilgrim asks: 'Does the road wind uphill all the way?' To which

comes the reply: 'Yes, to the very end.' And he asks another question: 'Will the day's journey take the whole long day?' And the reply is: 'From morn to night, my friend.' And the pilgrim goes on, in sorrow, yet ever joyful." The landscape with a setting sun, the flatland stretching away to the mountains, the track crossing the landscape, the solitary wanderer, and the black figure were to be seen again, time after time, when van Gogh put up his easel in various places.

"Only he can be an artist who has a religion of his own, an original way of viewing the infinite." Thus Friedrich Schlegel, requiring a religious dimension in an artist. In purely biographical terms, van Gogh lived up to this requirement more completely than most artists. His art's ability to touch the hem of the Eternal derived from a profound and genuine longing for the sheltered security of religious faith. Deeply religious, van Gogh believed that security lay in God.

"And now, when each one of us returns to everyday life, to everyday duties, let us not forget that things are not what they seem to be, that God is using the things of everyday life to instruct us in higher things, that our life is a pilgrimage and we are strangers on this earth, but also that we have a God, a Father, who offers shelter and protection to strangers." The conclusion of van Gogh's Isleworth sermon was hardly unusual for its kind, yet it is interesting if we take his subsequent career as a painter into account. These words might almost serve as an illustration to paintings such as those of van Gogh's boots (pp. 74–75) or the chairs in his house at Arles (pp. 140–141). These things are not only what they seem; vivid and real, they yet direct our attention to something profounder, something all-comprehending, which lies beyond. In such works, van Gogh is close to allegory, which was adopted for specifically Christian purposes in order to relate all real phenomena to God. "Other speech" (the etymological meaning of Greek "allegory") was necessary if the distinction between the worldly and

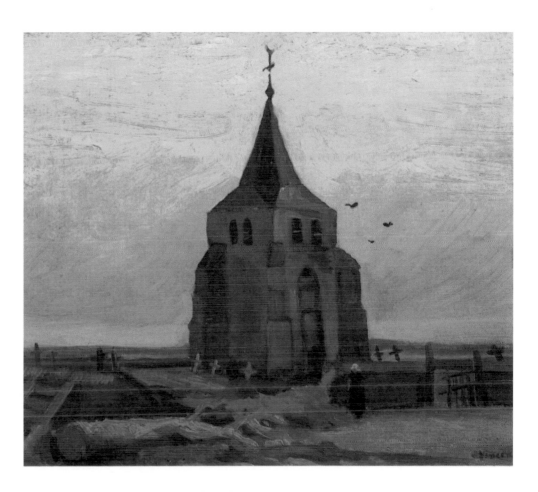

The Old Church Tower at Nuenen
Nuenen, May 1884
Oil on canvas on panel, 47.5 x 55 cm
Zurich, Stiftung Sammlung E. G. Bührle

the heavenly realm was to be preserved and revealed. Suffering and redemption, death and salvation, frailty and exaltation are indivisibly conjoined in allegory and can be associated with realities of different kinds at one and the same moment.

There is allegorical thought in van Gogh's Isleworth sermon, in the image of the stranger. This was borrowed from *The Imitation of Christ* by Thomas a Kempis. The greater the torment and the more inescapable the loneliness, the more Man is prepared to open himself to God and sue for redemption. Again and again – and with greater urgency towards the end of his life – van Gogh was to quote this image of the stranger. The metaphor embraced his own misfortunes – his persistent lack of success, his inability to relate to people, his sickness – and offered the consolation of a better world. That hope for consolation was in fact the true mainspring of his art.

First Steps as an Artist

After months of silence, van Gogh wrote to his brother from the Borinage (the Belgian coal-mining district) in July 1880; this letter (133) was the first in a series of level-headed and searching self-scrutinies. Before he could make these dispassionate assessments of his ill-organized life, though, he had to put self-sacrificing toil on behalf of others behind him to an increasing extent: his early religious spirit, involving an evangelical imitation of Christ that was expressed in caring for his neighbours, was of no help in overcoming his unceasing discontent with himself and his life in general. Once he started to view the tenets of faith in a more abstract sense, as a way of seeing the world, a new approach to Art became possible. Hitherto he had actively practised his faith and had seen pictures as a support for it, narrating the process of redemption; but now the pattern was reversed, and the working artist set out to create pictures representing the certainty of redemption. In this process, religion served as a kind of pledge that he empowered himself to redeem at any time.

"Once I was in another environment", van Gogh told his brother in that letter, "an environment of pictures and works of art, [...] an intense, passionate feeling for that environment overcame me, a feeling that came close to rapture. Nor do I regret it. And now, far from home, I am often homesick for that homeland of pictures [...] Instead of yielding to my homesickness I told myself that home, the fatherland, is everywhere. Instead of succumbing to despair I decided on active melancholy, insofar as being active was in my power; or, to put it differently, I put a melancholy that hopes and strives and seeks before a despairing melancholy of gloomy inaction." This passage provides us with a key phrase in his view of himself as an artist: "active melancholy". In the times to come it was to keep van Gogh going, ceaselessly, confronting his *Weltschmerz* with the utopian notion of alleviating action.

It was because of the element of abstraction in his thinking that van Gogh devoted himself to painting. It was widely agreed that Art enjoyed universal validity; and van Gogh not only wanted to do something for mankind, he also wanted recognition for what he was doing. Hitherto he had been "an idler in spite of myself; sometimes people in this position do not know themselves what they might be capable of, yet they feel instinctively: I *am* capable of something, my existence *does* mean something!" We should view van Gogh's new activity as

Avenue of Poplars in Autumn
Nuenen, October 1884
Oil on canvas on panel, 98.5 x 66 cm
Amsterdam, Rijksmuseum Vincent van Gogh,
Vincent van Gogh Foundation

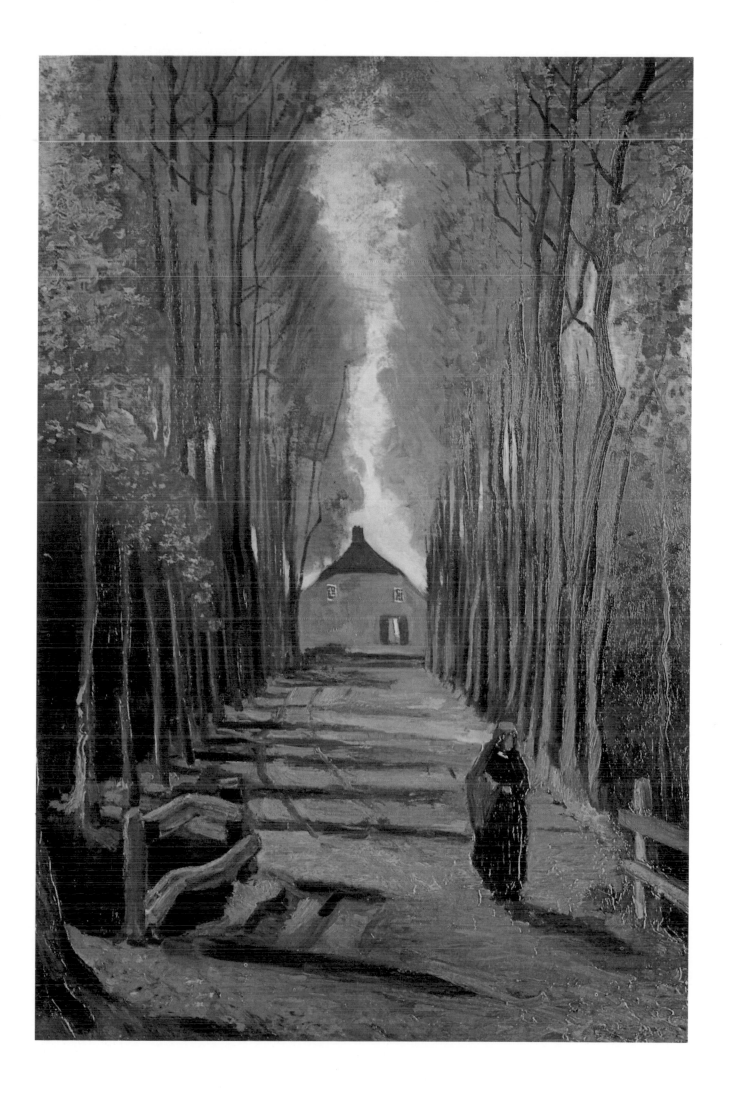

an artist as an offer he was making to his family, in particular to Theo, to re-establish trust in each other after the months of indifference. And it implies no disparagement of van Gogh's artistic work if we point out that there were also material considerations that impelled him to take his decision for Art. From this time on, Theo was punctual in sending off his postal money orders; and Vincent depended on the clout of the art dealers in the family.

In October 1880 van Gogh went to Brussels, to start on his training in Art. He matriculated at the Academy: "Once I have mastered drawing or watercolours or etching, I can return to mining and weaving country and shall be better at working from Nature than I am now. But first I have to acquire an amount of skill" (Letter 137). A model student, he copied pictures and practised drawing exercises. He suppressed the irresistible urge to go out into Nature. And he even sent his first works home, "to Pa, so that he can see I'm doing something" (Letter 138). Anton Mauve, his mother's brother-in-law and one of the best-known Dutch painters of the day, helped Vincent, introducing him to ways of handling paint and giving him essential advice. Van Gogh believed he had now discovered his true vocation, a path which might in due course earn him honour and financial rewards, and his family and relatives, tradition-minded as they were, approved. In April 1881 Vincent even went to Etten, to his parents' home,

The Parsonage at Nuenen
Nuenen, October 1885
Oil on canvas, 33 x 43 cm
Amsterdam, Rijksmuseum Vincent van Gogh,
Vincent van Gogh Foundation

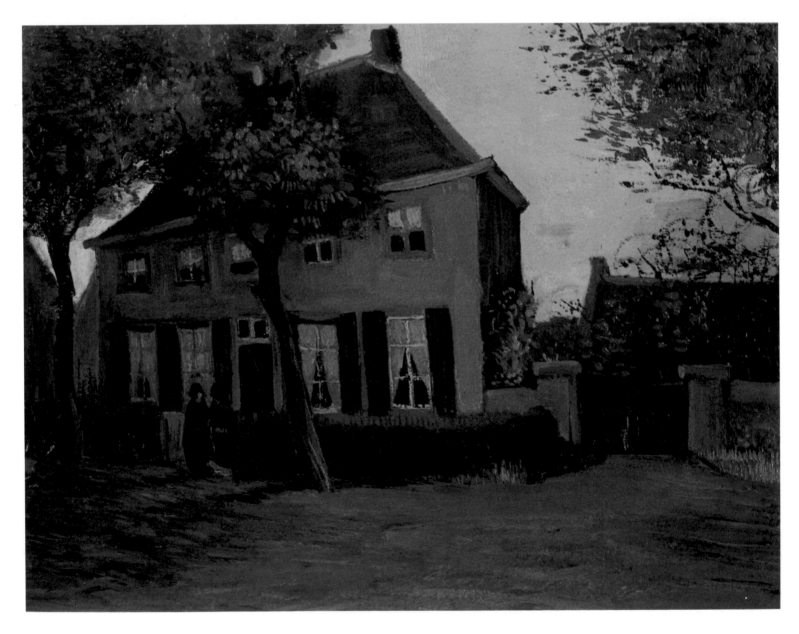

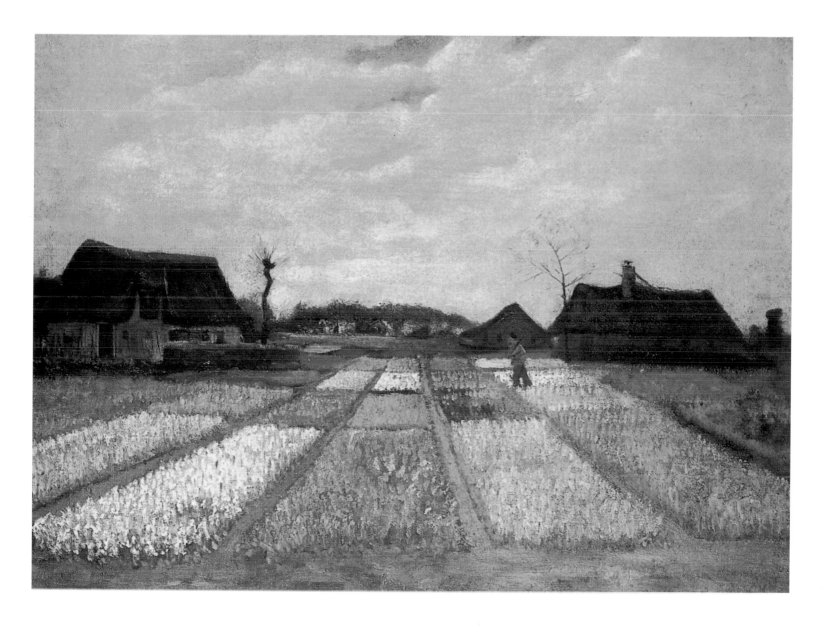

Bulb Fields
The Hague, April 1883
Oil on canvas on panel, 48 x 65 cm
Washington, National Gallery of Art,
Mr. and Mrs. Paul Mellon Collection

where Theodorus van Gogh was now the incumbent of the parish; and now that everything seemed to be working out he was welcomed with open arms.

Some six months later, however, Vincent was thrown out of the house, and the Rev. van Gogh seemingly even decided to disown his son. Vincent was in love. The lady in question was no other than his cousin Kee, recently widowed. She had a young son, and Vincent, with his weakness for children, soon acquired a passion for the boy's mother, too. The entire family were embarrassed by his advances, and found his protestations of love indecent, impious and lacking in sensitivity towards a woman in mourning. Vincent freely expressed his emotions to Theo (Letter 157): "Fall in love, and there you are, to your amazement you notice that there is another force that impels us to action: feeling." And he felt that his new devotion had a positive influence on his art: "To my chagrin, there always remains an element of hardness and severity in my drawings, and I believe that she (that is to say, her influence) is needed if they are to become softer." Kee's influence would supposedly purify his art and endow it with the flexibility it needed for the vital confrontation with Nature.

Van Gogh had a twofold vision of his cousin – as a prim and proper clergyman's daughter rejecting his advances because the family elders expected her to do so, and as a woman he loved and intended to fight for. He projected everything he hated and loved into her. Kee became a personification of conventions

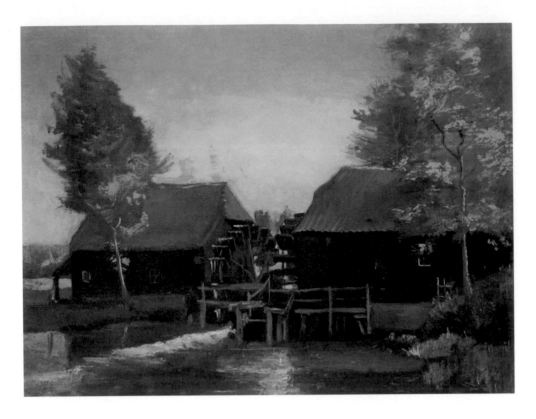

Water Mill at Kollen near Nuenen
Nuenen, May 1884
Oil on canvas on cardboard, 57.5 x 78 cm
United States, Private collection

and freedom alike, of the academic form of Establishment Art and of the openness of Nature, of the moral double standards of the middle class and of the immediacy of emotional life. It was in this connection that van Gogh first mentioned the concept that all his artistic efforts were to be devoted to and which art historians still identify him with: "May your profession be a modern one", he urged Theo (in Letter 160), "and may you help your wife to attain a modern soul, free her of the awful prejudices that shackle her." Modernity and emancipation were already inseparable in van Gogh's mind; and his emphatic calls for freedom were to be matched by the dazzling evolution of his art.

But he still had a long way to go. Van Gogh's first two paintings were completed at the end of 1881, under Mauve's guidance: *Still Life with Cabbage and Clogs* (p. 9) and *Still Life with Beer Mug and Fruit* (p. 9). Vincent's first steps as a painter were hesitant, tentative; he chose inanimate subjects, as he had been taught at the Academy, and tried to establish three-dimensionality and effects of light in a casual arrangement of the objects he had picked. The background remained a non-spatial brown; this approach was not a particularly good idea, since it afforded the individual items no optical purchase. But van Gogh had made a start. And in the rustic simplicity with which he took so obdurate a subject as clogs for granted we sense a foretaste of the scenes of peasant life that van Gogh was to paint in the years ahead.

Van Gogh's Early Models

In a distinctly new way, Vincent van Gogh's art was a product of the industrial era. The 19th century had embraced the ideal of industrial progress with enthusiasm. The multiplication of things was seen as the foundation of a better world. And works of the visual arts became subject to the process of reproduction too. Art was stored in museums, accessible to the public, and private homes

The Parsonage Garden at Nuenen
Nuenen, May 1884
Oil on paper on panel, 25 x 57 cm
Groningen, Groninger Museum voor Stad en
Lande (on loan)

had prints and books so that quiet hours of leisure could also be spent in the pursuit of Art. To a greater extent than any painter before him, van Gogh underwent his training as an artist by looking at reproductions. It was as if the autodidact needed to school his eye on the smooth impersonality of mass-produced printwork if his vision was to discover the living and universal qualities in Man and Nature. Goupil, van Gogh's early employer, was the leading name in art reproduction. Definite as van Gogh was about severing ties with his past, he continued to take pleasure in the reproductions Goupil published. Confident of his ability to acquire artistic skill from prints and drawing schools, he soon quit the Brussels Academy, although it was free (which had been his only reason for matriculating there in the first place). In his view it was enough if he diligently copied reproductions and then let the fruits of his labour ripen in the warm glow of Nature. Van Gogh's tutor was Charles Bargue. Bargue's *Cours de dessin* and *Exercices au fusain* (two volumes of drawing exercises for study at home, published by Goupil) took the place of the Academy in van Gogh's training. Van Gogh tackled both sections repeatedly; indeed, he had amused himself in this way every day during his Borinage sojourn.

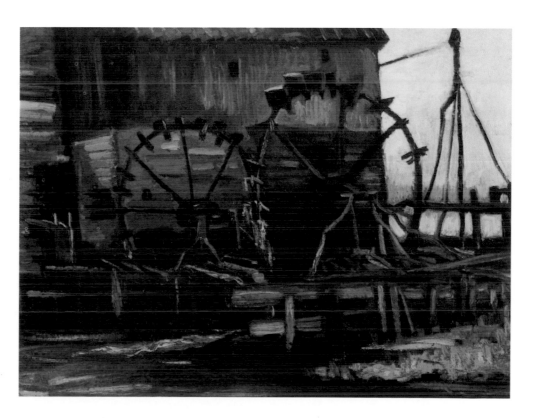

Water Mill at Gennep
Nuenen, November 1884
Oil on canvas, 60 x 78.5 cm
The Hague, Rijksbureau voor Beeldende
Kunst, Gift of E. Ribbius-Peletier

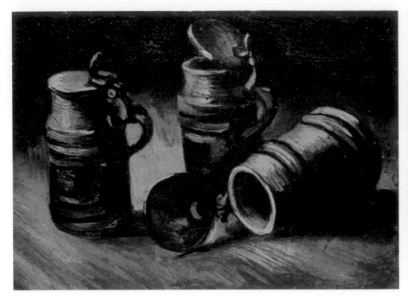
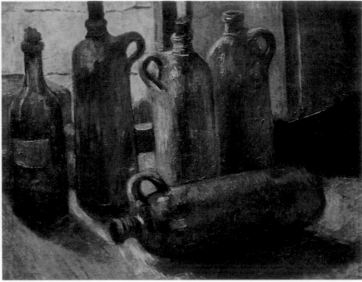

The engravings of contemporary works of art (which van Gogh also copied) made a lasting impression. His liking for the social romanticism of a Jean-François Millet or Jules Breton matched the fashionable taste of the day; they were paintings that gave a true-to-life account of the hard facts of everyday farming or factory life while at the same time misting them over in idyllic light (sunsets, and so forth). Millet's *Angélus* (Paris, Musée d'Orsay) was the perfect example of this kind of work. It showed a farmer and his wife, forgetful of their poverty, hearing the bells of the angelus ringing from a distant belfry and pausing for silent prayer. Paintings such as this must have met van Gogh's need for an art that included religious devotion.

Along with Bargues's exercises and the reproductions of Millet and Breton, a third body of graphic work influenced van Gogh's early drawings. It was an age of reproductions, and since mid-century (particularly in England) there had been a number of publications, most of them illustrated periodicals, that ran pictures showing scenes of everyday life, often with a socio-critical slant. Van Gogh had a

Left:
Still Life with Three Beer Mugs
Nuenen, November 1884
Oil on canvas, 32 x 43 cm
Amsterdam, Rijksmuseum Vincent van Gogh,
Vincent van Gogh Foundation

Right:
Still Life with Five Bottles
Nuenen, November 1884
Oil on canvas, 46.5 x 56 cm
Vienna, Österreichische Galerie in der
Stallburg

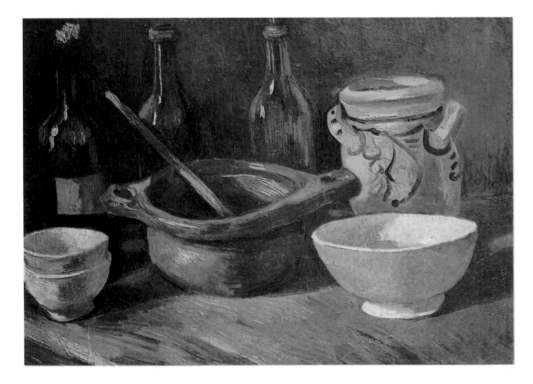

Still Life with Three Bottles and Earthenware Vessel
Nuenen, Winter 1884/85
Oil on canvas, 39.5 x 56 cm
Amsterdam, Rijksmuseum Vincent van Gogh,
Vincent van Gogh Foundation

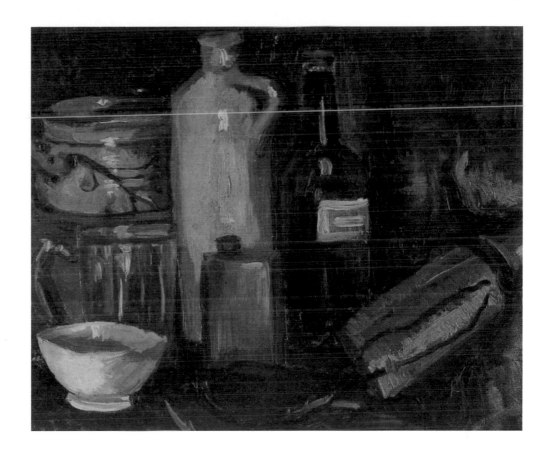

Still Life with Pots, Jar and Bottles
Nuenen, November 1884
Oil on canvas, 29.5 x 39.5 cm
The Hague, Haags Gemeentemuseum

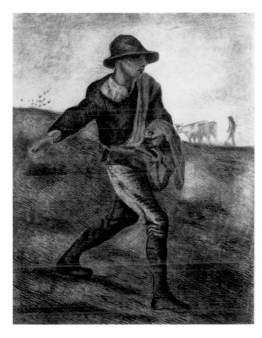

The Sower
The Hague, December 1882
Pencil, brush, Indian ink, 61 x 40 cm
Amsterdam, P. and N. de Boer Foundation

subscription to the best-known of these periodicals, *The Graphic*. The illustrations included a large number of human figures; and many of the unadorned, realistic reports made their mark on his own art. Fildes's drawing of Charles Dickens's empty chair is the most familiar example. An illustration by Helen Paterson was to prompt a painting now in The Hague, *Girl in White in the Woods* (p. 10). And the paintings of peasants done in Nuenen were closely related to William Small's portraits of working people. Only one copy dating from van Gogh's early years (and documented by references in the letters) survives: a drawing done of etcher Paul-Edmé Le Rat's reproduction of Millet's *The Sower* (p. 25). Van Gogh clearly took meticulous pains to mimic the etching's style and flow – his own lines follow the lines of the needle. But in Etten, van Gogh was already to put this faithful imitation, this impersonal devotion to a model, behind him.

"The first thing I have to do is find a room that's big enough, so that I can get the necessary distance. The moment he looked at my studies, Mauve told me: 'You're too close to the model.'" What van Gogh described (in Letter 164) as a problem of restricted space was to be a typical feature of his work in general: closeness to his subject. This closeness is a quite literal question of physical proximity; but it is also an emotional closeness that results from an immediacy of identification with all things. Van Gogh acquired his draughtsmanship skills by schooling himself on the stereotyped objectiveness of illustrations, and in consequence his early drawings were on the dull side in terms of line and flow; but nevertheless, from the very beginning those early works emanate the pleasure van Gogh must have taken in dealing with his subjects. However poor the quality of the drawings, they always have an intense note of solidarity which derives not so much from the handling of the pencil as from the perspective of van Gogh's approach. The rough love of detail, which is incapable of reproducing tactile, material, three-dimensional effects, is balanced from the very start by a quality that could be termed conceptual. Before committing his vision to

paper, van Gogh would always evolve a sense of his subject that had a great deal of longing, sympathy and trust in it. In Letter 195 he himself left an account of this: "I have tried to endow the landscape with the same feeling as the figure. Taking firm root in the earth, frantically and passionately, as it were, and still being half torn away by the storms. In both the white figure of the woman and the black, gnarled roots I wanted to express some of the struggle of life. Or, to be more exact: because I was trying to be faithful to the natural world before me, without philosophizing, in both cases, almost in spite of everything, something of that great struggle entered in."

In the process of copying, van Gogh appropriated all his subjects complete with contexts. He found them in total, finished units which had to be grasped overall if he was to give deeper attention to the details. He was plainly unskilled, and this absence of skill made it impossible for him to take a descriptive approach to things; but this absence was compensated by an expressive vigour that enhanced all his shapes and forms and made sheer energy into an aesthetic quality. In every new work, van Gogh laid bare the roots of his creativity.

The Hague and Drente

The first two still lifes van Gogh painted (p. 9) were done in Mauve's studio in The Hague. The old city became Vincent's base when he travelled to Amsterdam to make a last attempt with Kee. When Kee rejected him, he turned to any other woman who would have him – and found one. Clasina Maria Hoornik, known as Sien, was a prostitute; older than Vincent (like Kee), she had a daughter and was expecting a second child. "It is not the first time that I've been unable to resist the feeling of attraction and love towards those women in particular whom the pastors damn so vehemently, condemning and despising them from on high in their pulpits." (Letter 164). Vincent himself brought all his powers of sympathy to bear on Sien. Solidarity with this ill-treated woman meant more to him than observing conventions that forbade contact with fallen women.

Farmers Planting Potatoes
Nuenen, August–September 1884
Oil on canvas, 66 x 149 cm
Otterlo, Rijksmuseum Kröller-Müller

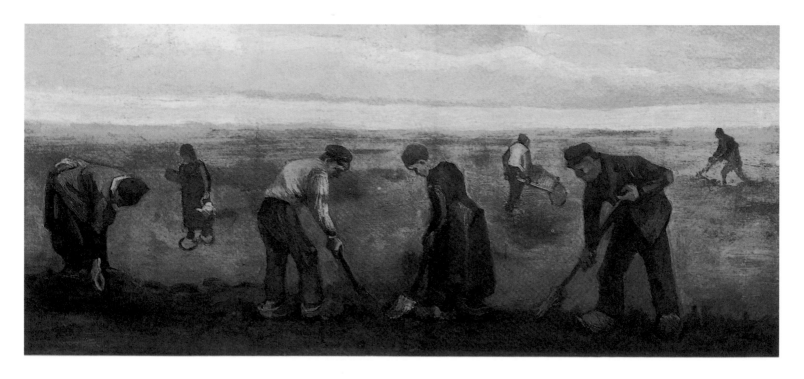

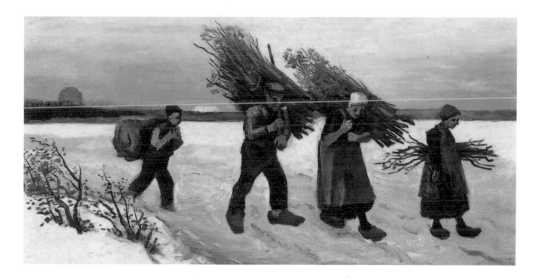

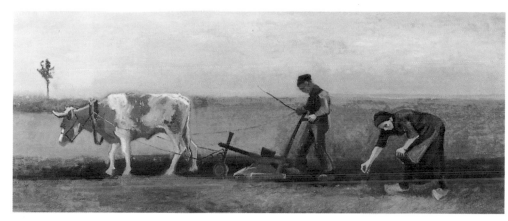

Wood Gatherers in the Snow
Nuenen, September 1884
Oil on canvas on panel, 67 x 126 cm
Private collection

Potato Planting
Nuenen, September 1884
Oil on canvas, 70.5 x 170 cm
Wuppertal, Von der Heydt-Museum

The woman he loved was seen with an artist's eye, too: "Never before have I had so good a helper," he wrote to Rappard (Letter R8), "as this ugly??? faded woman. To me, she is beautiful, and I find in her the very things I need; life has passed her by, and she has been marked by suffering and misfortune. If the earth has not been ploughed, one cannot grow anything in it. She has been ploughed – and for that reason I find more in her than in a whole heap of the unploughed." Sien's pockmarked, careworn face reminded him of a tilled field. Without a trace of irony, van Gogh adapted her face to the Biblical metaphor of sowing and reaping, the same metaphor as he used to describe his own painting. Sien became his muse. She had no mythological beauty to offer him; but her incorruptible vitality was more than sufficient compensation for any lack of literary or historical status.

Anton Mauve was a member of the 1880 Movement, a Dutch school of *plein air* painters centred in The Hague, a school that were trying to reconcile the approach of the Barbizon painters with the landscape tradition of the baroque Golden Age. Théodore Rousseau had founded an artists' colony around the middle of the century in the woods at Fontainebleau. Tired of the hectic bustle of daily life which they faced in Paris, these artists were out to reform the genre of landscape painting; a genre which was in an ailing condition, crushed by the dogmas of the academies. Mauve's group in The Hague practised a Barbizon escapism on Dutch soil, but in addition they were drawing upon a second tradition, a line that had achieved the sheer élan of liberation even in times of prescriptive rules laid down by the pontificating Guardians of Art: this was the line of 17th century Dutch landscape art. In the works of Jacob van Ruisdael or

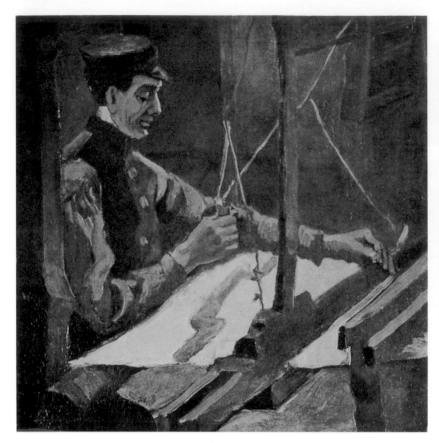

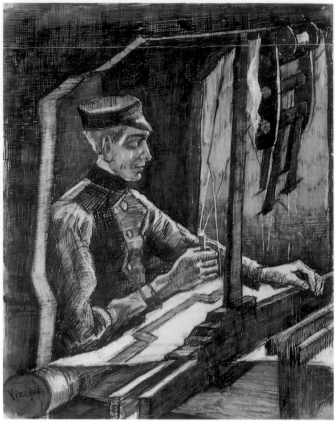

Left:
Weaver Facing Right (Half-Figure)
Nuenen, January 1884
Oil on canvas, 48 x 46 cm
Berne, Collection H. R. Hahnloser

Right:
Weaver Facing Right (Half-Figure)
Nuenen, January–February 1884
Pen, washed with bistre, heightened with
white, 26 x 21 cm
Amsterdam, Rijksmuseum Vincent van Gogh,
Vincent van Gogh Foundation

Meindert Hobbema, communion with Nature had always been valued above all things.

Van Gogh closely resembled them in his choice of subjects. He too was attracted to the outskirts of The Hague, a transitional area that was neither city nor countryside, where the light was dimmer, the air freer, the motifs lighter of heart, and the mood unclouded by the full melancholy of rural areas. In the main, he painted sea scenes: views of the beach at Scheveningen and of the subjects that presented themselves there, such as dunes, fishermen, boats, and crashing waves. But this coincidence of subject matter represents the only common ground between van Gogh and the 1880 Movement.

In the dunes he used as subjects, as in all things, van Gogh was seeking consolation, an opening for communication, an option on some kind of identification. To a far greater extent than the enlightened artists of his time he withdrew into Nature, searching for its anthropomorphic side, the image of himself and of the gloomy frame of mind he was in. That is why his dunes look so monumentally close (p. 10). "Theo, I am definitely not a landscape painter; if I paint landscapes, there will always be something figural in them" (Letter 182). Landscape was a model for van Gogh. He tried to talk to it, as if it were there in a studio and he could provoke a response. In this, van Gogh was far closer to a Ruisdael, with his religiously motivated approach to Nature, than to the disillusioned snapshot scenes of a Mauve.

"I have been in Scheveningen frequently and have brought two small seascapes home with me. There is a great deal of sand in the first – but when it came to the second, with a storm blowing and the sea coming right up to the dunes, I had to scrape it totally clear twice because it was completely caked in sand. The storm was so rough that I could hardly stand, and could see next to nothing because of the blowing sand." Here (in Letter 226) van Gogh is describing the creation of seashore scenes (p. 11) in the teeth of the raging elements. The

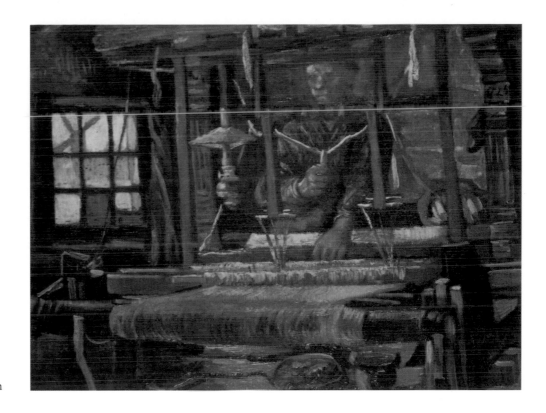

Weaver, Seen from the Front
Nuenen, July 1884
Oil on canvas on panel, 47 x 61.3 cm
Rotterdam, Museum Boymans-van Beuningen

reckless streaks of thick paint and the impetuous lacerations of the surface convey a well-nigh palpable sense of the beach and the dunes. The painter's material (paint and canvas) and Nature's material (fine sand) are mixed, and the artist is plainly conniving in the process in the interests of authenticity.

By now van Gogh had four mouths to feed. With customary missionary zeal he had succeeded in dissuading Sien from continuing her life as a prostitute; but this moral success had a financial side effect, since she no longer earned any money. Theo's monthly allowance hardly sufficed now, and Vincent's appeals for extra funds became ever more urgent. The family was literally going hungry. The spartan fare had its effect on the quality of van Gogh's work, and his hope of

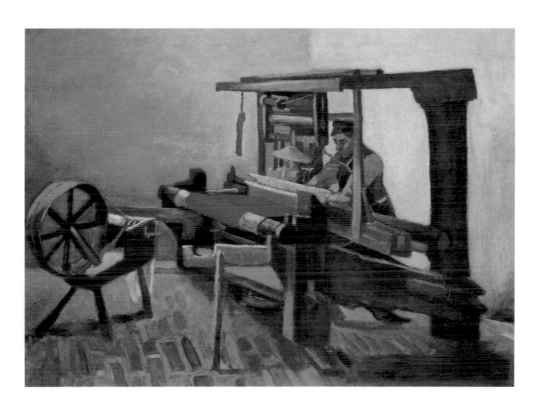

Weaver Facing Left, with Spinning Wheel
Nuenen, March 1884
Oil on canvas, 61 x 85 cm
Boston (MA), Museum of Fine Arts

ever making money as an artist began to recede. It was a vicious circle of poverty, with lethargy and resignation waiting at the centre.

After his brief excursion into painting (lasting a bare month), van Gogh returned to drawings and watercolours. He took his subjects as he found them in the streets, made hasty sketches, and then assembled the details in larger compositions. The group portraits he was now doing were broad in perspective, showed various kinds of people, and had a quality of narrative, journalistic accuracy: they are unique in van Gogh's œuvre. He did not see them as works in their own right but as studies, steps along the way to the artistic perfection he was aiming at. Watercolours such as *The State Lottery Office* (p. 12), done in autumn 1882, are struggling with multiple problems: the difficulty of making a whole out of the individual figures, of making the figures relate to each other without simply bunching them up, and of presenting the people as an anonymous mass yet simultaneously as individuals whose situation is understood.

Van Gogh was soon to flee the problem, without managing to solve it. He made a hurried return to his close-ups of individual people; and subsequent scenes, including several figures, were quite frankly indebted to those pictures of individuals in which he invested so much empathy. His figures are seen on a narrow foreground strip against a broad horizon, with only the land and the sky between them, each one isolated in silhouette, likelier to be absorbed in some silent task than interacting with the other people in the scene. In this respect, *Potato Digging*

Weaver near an Open Window
Nuenen, July 1884
Oil on canvas, 67.7 x 93.2 cm
Munich, Bayerische Staatsgemälde-
sammlungen, Neue Pinakothek

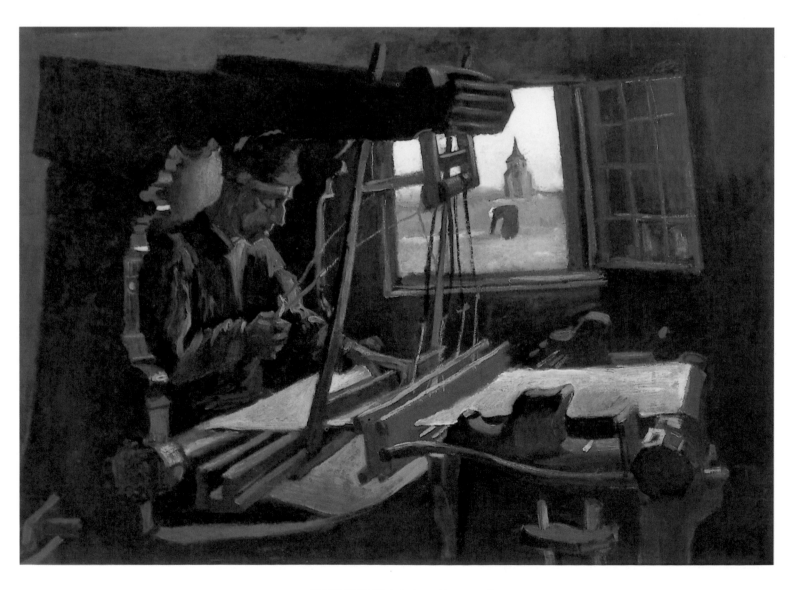

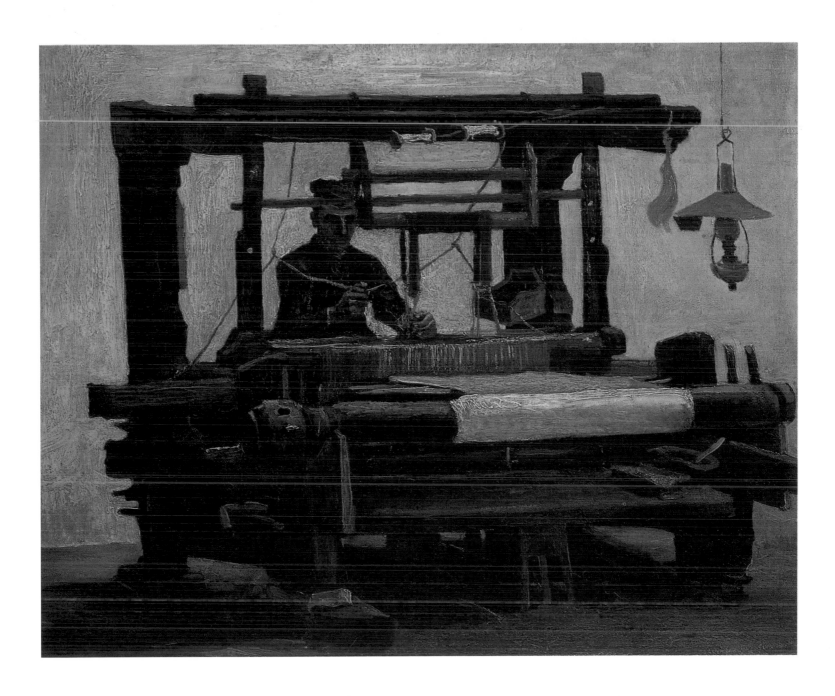

(p. 13) recapitulates van Gogh's art of his Hague phase. The crudely sketched rustic figures hardly overlap at all; their gestures, the devotion to their work, silently absorbed in digging, are conceived in a spirit of the individual, not the group. Their different movements represent the sequence of separate actions in potato digging rather than an actual scene in the field. Van Gogh was to use this kind of multi-figural picture again; this digging scene, done in late summer 1883, was the first in a series of similar works he produced in Holland.

Van Gogh's group portraits, such as the potato diggers, resulted from a new approach to the subject. Instead of drawing laborious sketches and then transferring them to canvas, in oil, van Gogh was now doing his initial sketches in oil straight off. The details were now turning out more vivid, direct, and were above all permanent. And this more intense kind of figure study also resulted in a more additive style of composition (compared with the watercolours); the sketch could be directly incorporated into the final work, and the painter scarcely needed to rework it any more.

For a whole year, financial worries had kept van Gogh from painting. In summer 1883 he ventured to paint again, and in addition to *Potato Digging*

Weaver, Seen from the Front
Nuenen, May 1884
Oil on canvas, 70 x 85 cm
Otterlo, Rijksmuseum Kröller-Müller

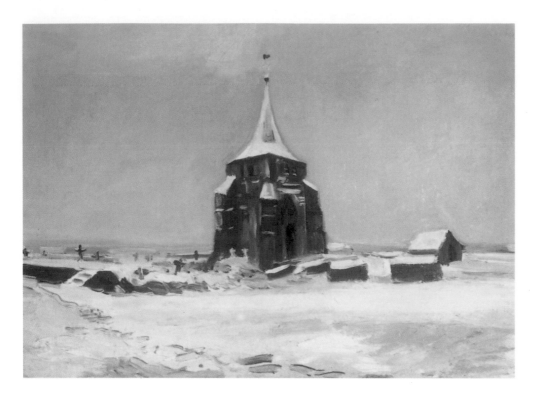

The Old Cemetery Tower at Nuenen in the Snow
Nuenen, January 1885
Oil on canvas on cardboard, 30 x 41.5 cm
Collection Stavros S. Niarchos

produced landscapes in the main. The remoteness of the viewpoint in these landscapes was likewise a product of his close study of detached illustration styles in the magazines. Van Gogh also used an invention of his own, a perspective frame of the kind often devised during the Renaissance. "It consists of two long bars," wrote van Gogh (Letter 223), "to which the frame is attached by means of wooden pegs, either in a vertical or horizontal format. This provides a view of a beach or meadow or field as through a window. The verticals and horizontals of the frame, plus the diagonals and the cross-over, or a subdivision into square sectors, afford a number of fixed points that make it possible to do an exact drawing with lines and proportions."

Driven into the ground, this frame henceforth provided van Gogh with that grid of lines which we can increasingly discern in his landscapes from this time onwards. If we compare the *Landscape with Dunes* (p. 13), painted in September 1883, with the close view done a year earlier (p. 10), the change in van Gogh's

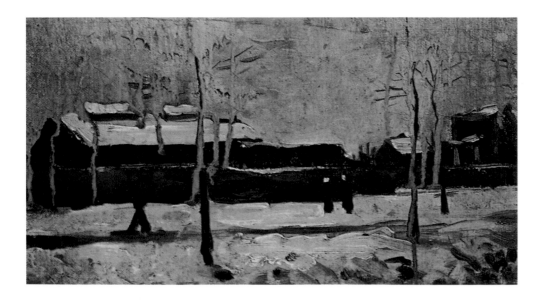

The Old Station at Eindhoven
Nuenen, January 1885
Oil on canvas, 13.5 x 24 cm
Otterlo, Rijksmuseum Kröller-Müller
(on loan)

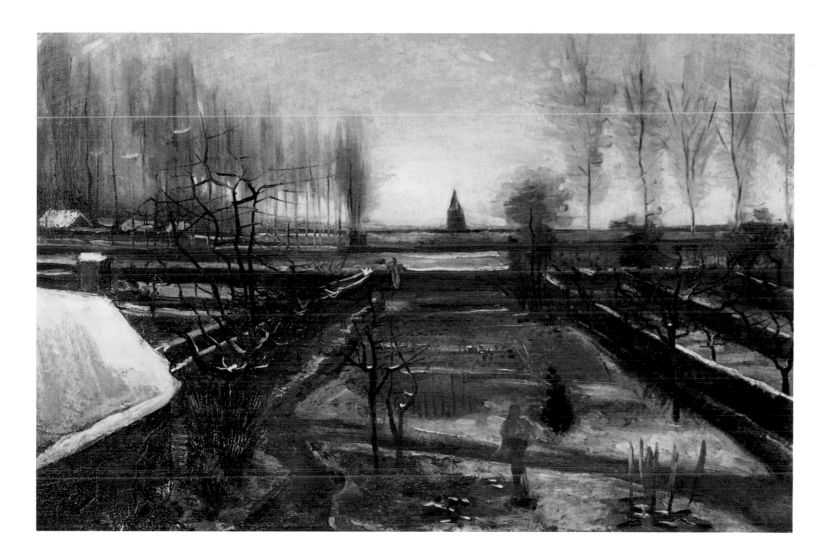

view of the subject is immediately apparent. In the later picture, a horizon divides the work into two sections, the lower of which is further subdivided by diagonals. Van Gogh's artistic resources had been increased. His dialogue with Nature could now be expressed as effectively in a broad landscape panorama as in a monumental close-up of a single motif. He was now better able to achieve nuanced articulation of feelings of exposure and loneliness, and feelings of harmony and sympathy: the period at The Hague provided van Gogh not only with the ability to handle a number of figures but also with a grip on perspective.

While his art was developing promisingly, his private life boded ill for the future. The financial problems remained undiminished, and Vincent, growing ever more confident of his artistic vocation, made no attempt to curb his expenses for the sake of Sien and the children. Faced with sheer necessity, Sien returned to her old work. Van Gogh, needless to say, was appalled that she had gone back to prostitution. A big-hearted man, he felt responsible for his loved ones. But their lives, however much he might long for security and trust, were too different. The painter and the head of the family were at war within him. Van Gogh was going to have to do without the woman he loved – and living with the consequences of this decision was not easy in the years ahead. From now on, all of van Gogh's intensity was focussed on a single object: his paintings. In them, he seized the world all the more firmly, the more mercilessly it evaded him. Suffering pathos in person, henceforth he was an artist pure and simple. In September he moved to Drente, a region of Holland that had preserved a plain and melancholy mood since time immemorial.

The Parsonage Garden at Nuenen in the Snow
Nuenen, January 1885
Oil on canvas on panel, 53 x 78 cm
Los Angeles, The Armand Hammer Museum of Art

Art and Responsibility: Commitments for the Future

The twenty months van Gogh had spent with a woman were not without consequences. With his plans for family life in ruins and his future (he believed) gloomy, he felt he was in a corner; but the fact of it was that his oppressive sense of responsibility for every living creature under the sun underwent a change during his time with Sien. It was as if van Gogh had needed the family experience as a focus for his devotional impulses – and now he was better able to master his overgenerous tendencies. Now he directed them towards his art, and concentrated in his paintings the energy he had hitherto been scattering. The way he saw himself as an artist became clearer too: poverty prompted him to develop a concept of art for the underprivileged. His daily toil at his art brought home to him the toughness but also the dignity of the craftsman's life. Under constant pressure to earn money, his life came to resemble that of a pieceworker. And van Gogh now felt that his life as an artist would be lived in a spirit of solidarity with the working classes, with the craftsman's ethic and with speed of production an end in itself.

In The Hague van Gogh left an aesthetic credo on record, in Letter 309. There, with the prospect of seeing his plans to start a family crumble, he put his thoughts on the art he wanted to produce into clear form. As always, he had his theory ready far before he created the work to match. The thoughts expressed in Letter 309 may well be the profoundest anywhere in his correspondence. They deal with the artist's responsibility to work with the future in mind (though van

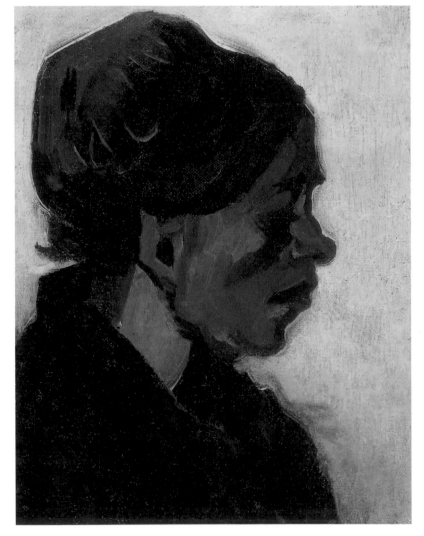
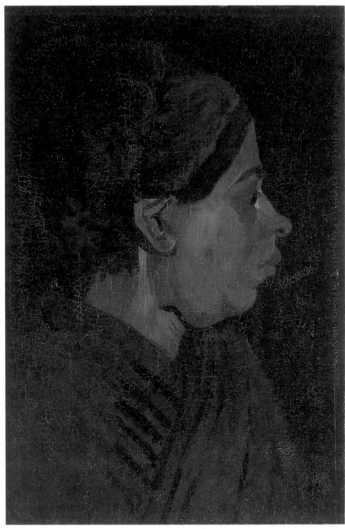

Left:
Head of a Brabant Peasant Woman with Dark Cap
Nuenen, January 1885
Oil on canvas on panel, 26 x 20 cm
Otterlo, Rijksmuseum Kröller-Müller

Right:
Head of a Peasant Woman with Dark Cap
Nuenen, January 1885
Oil on canvas on panel, 37.5 x 24.5 cm
Cincinnati (OH), The Cincinnati Art Museum

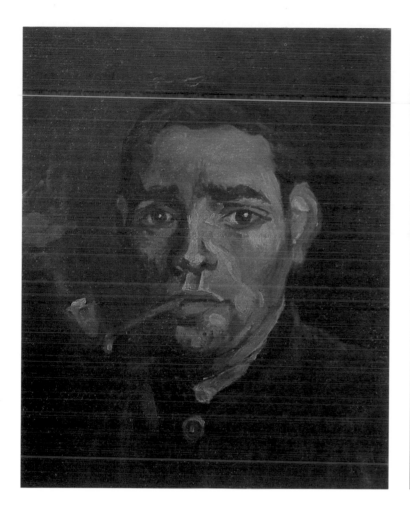

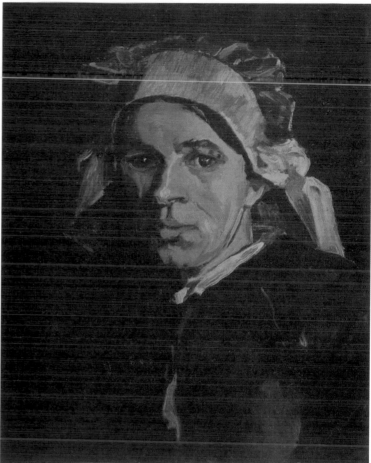

Gogh cannot say precisely where his commitments lie). If we bear the events of the preceding months in mind, the task van Gogh was setting himself becomes a little clearer: his hopes of private happiness and family contentment had come to nothing, and if his scope and range in life had become somewhat unclear, equally he was now intent on extending them. He was not out to love his neighbour, whether in a religious or paternalistic way; but he definitely planned the tireless production of paintings.

This extract from Letter 309 (written in summer 1883) reads prophetically in view of the stubborn consistency with which van Gogh made his expectations of life dependent on what he would create as an artist: "I not only began drawing relatively late, but in addition I may well not have so very many years of life ahead of me [...] As far as the time that remains for my work is concerned, I believe that without being premature I can assume that this body of mine will still keep going, despite everything, for a certain number of years yet – say, between six and ten. I feel all the more able to assume this since at present there is not yet a proper 'despite everything' in my life [...] I do not intend to spare myself or pay much heed to moods or problems – it is a matter of some indifference to me whether I have a longer or a shorter life, and in any case physical mollycoddling such as a doctor can accomplish up to a point is not to my taste.

So I am continuing in my life of ignorance, though there is one thing I do know: within a few years I must accomplish work of a certain order; I do not need to be in too much of a hurry, because no good comes of that but I must go on working calmly and quietly, with as great a regularity and composure as possible, and as much to the point as possible; the world is my concern only insofar as I have a certain debt and obligation, so to speak – because I have been

Left:
Head of a Young Peasant with Pipe
Nuenen, Winter 1884/85
Oil on canvas, 38 x 30 cm
Amsterdam, Rijksmuseum Vincent van Gogh,
Vincent van Gogh Foundation

Right:
Head of a Peasant Woman with White Cap
Nuenen, December 1884
Oil on canvas on panel, 42 x 34 cm
Amsterdam, Rijksmuseum Vincent van Gogh,
Vincent van Gogh Foundation

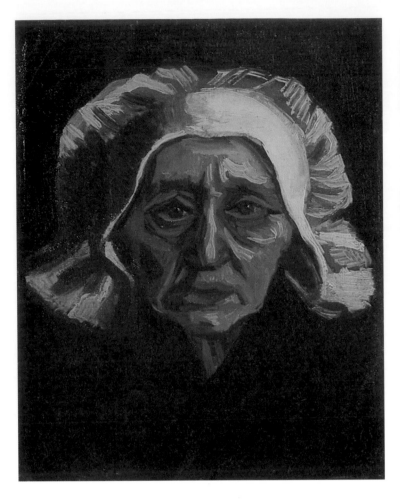 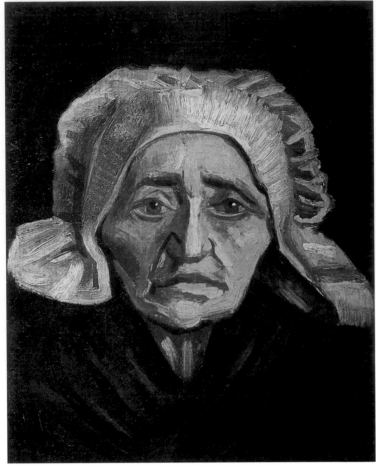

Left:
Head of an Old Peasant Woman with White Cap
Nuenen, December 1884
Oil on canvas, 36.5 x 29.5 cm
Wuppertal, Von der Heydt-Museum

Right:
Head of an Old Peasant Woman with White Cap
Nuenen, December 1884
Oil on canvas on cardboard, 33 x 26 cm
Private collection

wandering about this world these thirty years – to leave a certain something in memory of me behind, drawings or paintings, out of gratitude – not made in order to gratify some fashion or other but to express an honest human feeling. That work, then, is my objective [...]"

In autumn 1883 in Drente, van Gogh painted practically nothing but peasants' cottages (pp. 8 and 14). Like these squat, windswept cottages with slant roofs, scattered about the vast flatlands, van Gogh felt small; the cottages offered him a metaphor of his own need for an anonymity and concealment in which he could evade responsibilities. His flight into solitude left its mark, though, and van Gogh became more melancholy than ever.

"Theo, whenever I am out on the heath and I come across a poor woman with a child in her arms or at her breast, the tears come to my eyes. It is her that I see; their weakness and sluttishness seem only to heighten the resemblance," he wrote in the very first letter from his new solitude (Letter 324). He had wanted to escape from his responsibilities; but flight had only left his conscience uneasier than ever. He saw himself as a traitor towards both Sien and the children and his own ideals. In Drente, van Gogh was trying out escapism, and testing his ability to enter Nature in quest of oblivion. The watchwords he insisted on when writing to Theo were "simplicity and truth", and he tried to project these values onto the countryside, in the hope that ideas he had evolved in The Hague, in the urban bustle, would be upheld in the rural remoteness of Drente.

Still, those few pictures of people lifting potatoes or digging peat focus on his own gloomy frame of mind rather than on the country folk. Unlike *Potato Digging* (p. 13), which he did back in The Hague, *Two Peasant Women in the*

Peat Field (p. 15) scarcely attempts any solidarity with the farming people's arduous labours. The massive blocks of colour that serve as the women's silhouettes have a self-referential function in the more or less decorative way that the two figures appear in sequential rapport. They are aesthetic means of linking the ground to the streaky, cloudy sky, and as they bend beneath the burden of Life they seem to wish to become invisible, much as the painter did at the time.

Melancholy gained the upper hand and submerged the works in the unfocussed atmospherics of a wholly personal mood. The subjects van Gogh tackled had no autonomy; quite the contrary – this sadness had an unworldly quality. Vincent was doing his best to be a Romantic, but in reality he was not a mood painter; and whenever his pictures struck intense emotional notes it was only because the emotion was vitally present in the subjects. In Drente, however, the intensity of purely subjective sadness was his sole subject.

The time of year when he tended to take decisions, the period before Christmas, again saw van Gogh driven to act; and in December 1883 the prodigal son returned home – this time to Nuenen in Brabant, where his father had a new living. Vincent's apprenticeship lay behind him now. He had shed his religious mania and selfless love of his neighbour, and had turned his back on the dream of family life and infatuation with isolation alike; in the process he had acquired a robust sense of autonomy that was to be the seedbed of an art independent of the facts of everyday life. Shortly, in Nuenen, he was to plan the first of his masterpieces. The first of the classic 'van Goghs'.

Left:
Head of a Peasant Woman with Dark Cap
Nuenen, January 1885
Oil on canvas, 40.6 x 31.7 cm
Private collection

Right:
Head of an Old Peasant Woman with Dark Cap
Nuenen, January 1885
Oil on canvas on panel, 36 x 25.5 cm
Otterlo, Rijksmuseum Kröller-Müller

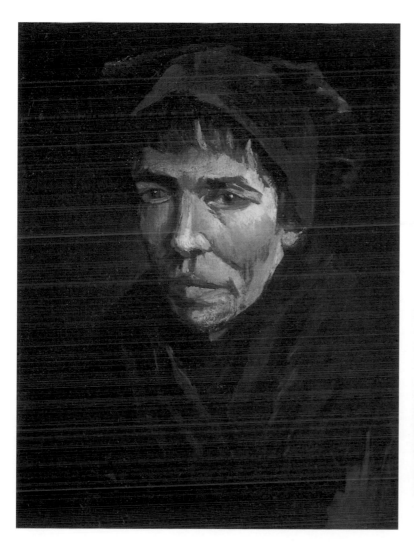

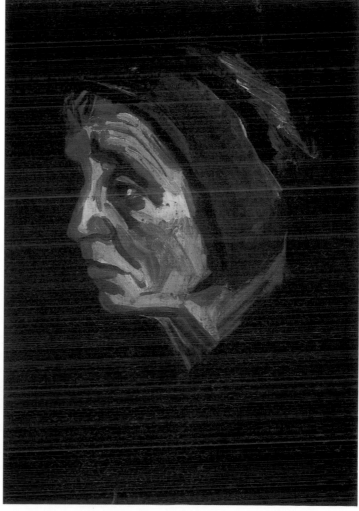

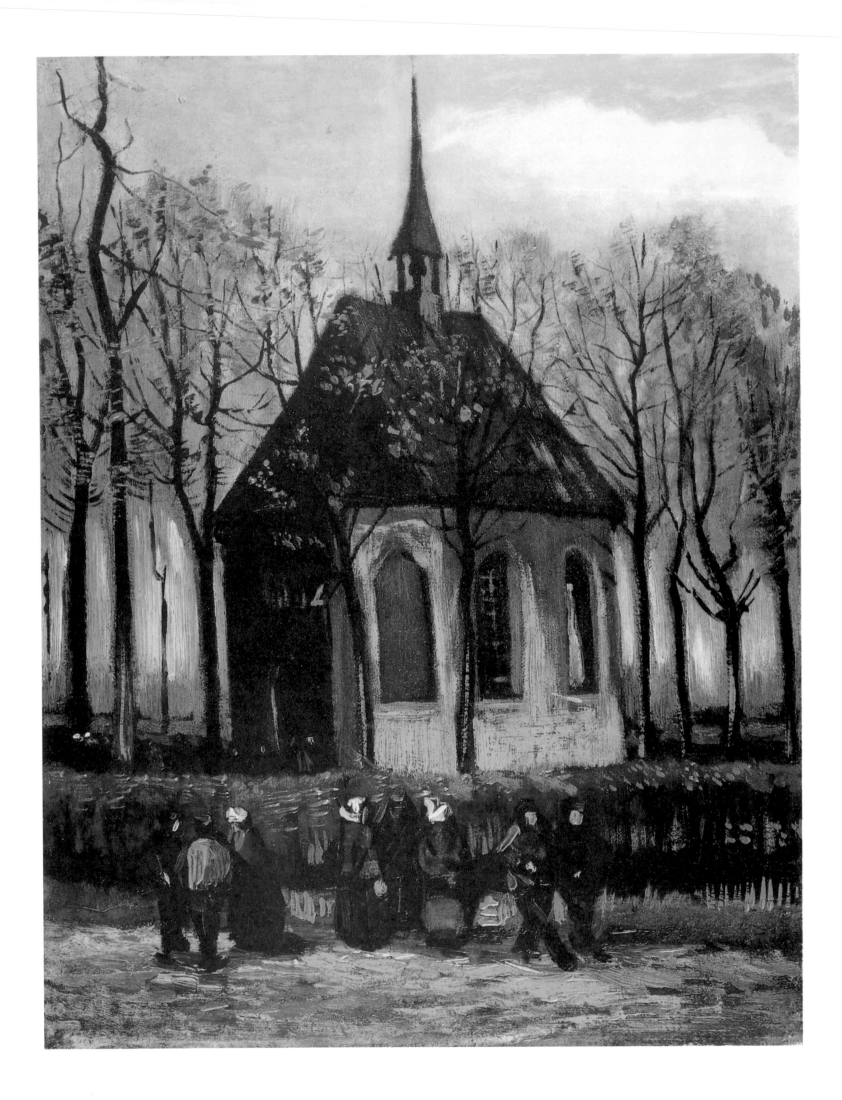

The Years in Nuenen
1883–1885

An Artist Pure and Simple

Van Gogh stayed at the Nuenen vicarage longer than at any other single place in his entire life as an artist. He was constantly at loggerheads with his father, and even vented his unrelenting mockery of society on his long-suffering brother Theo. But van Gogh could now devote himself entirely to painting, using oil on canvas, which he had previously been mostly unable to afford. He tried to perfect his command of the three types of picture he had hitherto been concentrating on: still lifes, landscapes and genre paintings. Working on various series at the same time, he used up all the suitable subjects he could find around the village where his parents were living.

One of the first scenes van Gogh painted in Nuenen, *Chapel at Nuenen with Churchgoers* (p. 38), introduces us to the milieu he was now living in. He painted this detached view of the village church for his parents, and he chose Sunday church-going as his subject, adopting an angle reminiscent of the figural compositions he had painted in The Hague. The simple chapel is seen close; yet the artist himself is far enough from the scene to avoid any kind of identification. His approach can be seen as a reaction to his parents' wish that he accompany them to church. In painting, he was serving "what some people call God, others the Supreme Being, and still others Nature" (Letter 133) in his own way.

Van Gogh moved closer to his subject when he painted the water mills along the Brabant canal-banks. *Water Mill at Kollen near Nuenen* (p. 22), painted in May 1884, was the first in a series of mill scenes which he continued that autumn with four more paintings. Throughout the series he was essaying picturesque showpieces; his rendering of a seasonal atmosphere, with the light reflected in the flowing water, was more ambitious than anything he had previously attempted. He was also interested in the way the solid contours of the barn-like buildings related to the lines of the millwheels themselves. The impact of these paintings draws equally upon draughtsman skills (symmetry in the composition, use of silhouettes, the contrast of light open spaces and the dark huddled clusters of mill buildings) and painterly creation of mood and atmospherics. At times, van Gogh's ambitions do not quite come off. In *Water Mill at Gennep* (p. 23), for instance, a doughy mass of hatching obliterates any contrasts that might have brought the scene effectively to life.

Doubtless, van Gogh chose the mills for iconographic reasons, too. The Christian metaphor of the mills of God that grind slowly was probably in his mind; and van Gogh had always been interested in sowing and reaping – a process that

Chapel at Nuenen with Churchgoers
Nuenen, October 1884
Oil on canvas, 41.5 x 32 cm
Amsterdam, Rijksmuseum Vincent van Gogh,
Vincent van Gogh Foundation

ends in the miller's labours. Still, the views have a posed, detached, even uninterested flavour; the mills are clearly being foregrounded as simple objects. The landscapes featuring the old tower on the outskirts of the village, on the other hand, seem far more loaded with meaning. The striking tower was all that was left of a Gothic church; the graveyard clustered about it. The metaphoric investigation of death is obvious. In the background of *The Parsonage Garden at Nuenen* (p. 23) the tower rises impressively on the horizon, commanding that we meditate upon last things even when we see spring burgeoning in the flower beds.

Nuenen was extremely provincial, in every respect, and this son of the parson, who had appeared from nowhere, struck the local people as a little odd. Yet at this period, van Gogh even had pupils, of sorts – amateur painters who were gratified if he took a look at their work in progress. In nearby Eindhoven, the only town that had any kind of claims to urbanity, he got to know a tanner by the name of Anton Kerssemakers and soon van Gogh was teaching the tanner and his acquaintances, in particular Charles Hermans, what he himself knew about art. Hermans was a man of means. Van Gogh started to call on him with some frequency, to use the utensils the goldsmith had in his home.

It is plain that in the preceding years van Gogh had been acquiring an eye for the arresting impact the organic unity of a composition could make. Admittedly, he could still be somewhat clumsy in arranging the objects in still lifes: merely toppling a bottle on its side was no way to redeem the monotony of a row of stoneware bottles (p. 24), nor could detailed close-up rendering of ornamental faience save unimaginative positioning of vessels beside or even *in* each other. Later, van Gogh was to re-use some of these canvases to paint self-portraits on their reverse sides, and he well knew that the loss was not great. After the progress he was to make in Paris, he found that these still lifes lacked that sufficient measure of autonomy that would justify preserving them. *Still Life with Pots, Jar and Bottles* (p. 25).

That said, though, there are occasional gems as well. Arguably the finest example of his successful still-life work at this time is *Still Life with Three Bottles and Earthenware Vessel* (p. 24), traditional in spirit though it is. In it, van Gogh succeeds in establishing spatial values with only a few objects. The things in the still life do not conflict with the format; rather, there is a natural air to the way they are grouped about the round bowl in the middle. The different kinds of material and different sizes of object have their own kinds of lighting; one bowl gives a mellow gleam, another is almost dazzling.

It was also Hermans the jeweller who gave van Gogh the only commission of his artistic career – or rather, to be exact, allowed himself to be persuaded to place the job in van Gogh's hands. A typical *nouveau riche*, Hermans was out to copy aristocratic ways, and wanted his dining room decorated by an artist. The two men agreed that Vincent was to supply sketches, like a painter at court, and Hermans the dilettante would then transfer the scenes to the panelling on the walls himself. As van Gogh told Rappart (Letter R48), the following scenes were to be included: "potato planting, ploughing with oxen, the harvest, the sower, the shepherd in a storm, people gathering firewood in the snow." The paintings would not only show the kind of work that was done in the country but would also communicate the ways people thought – in terms of the weather and of the natural rhythm of the solar year, which dictated that certain work be done at certain times.

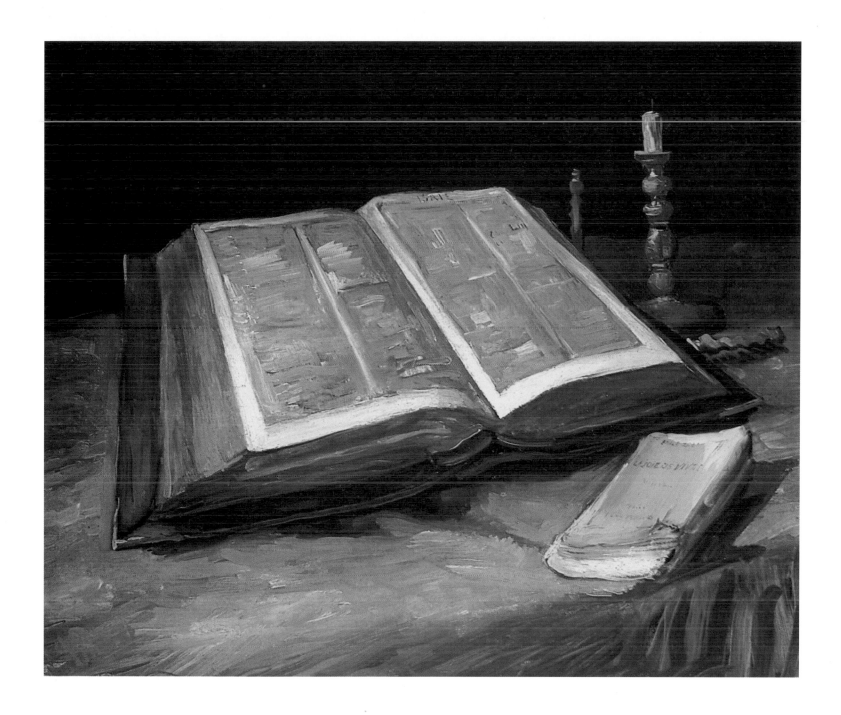

Van Gogh made paintings of these scenes himself, and four have survived: *Farmers Planting Potatoes* (p. 26), *Potato Planting* (p. 27), *Wood Gatherers in the Snow* (p. 27) and *Shepherd with Flock of Sheep*, all of them done in late summer 1884. Treating the canvas as a stage, van Gogh presents the action unimaginatively. The landscape is flat and dreary and recedes to the horizon bereft of any relief; and against this background the figures are presented as monumental in their dignity.

In van Gogh's sketches the silhouettes of a village, church tower or line of trees still marked the horizon, but now our attention is fixed completely on the people at their work. They bow their heads, they stoop, they walk bent beneath their loads and beneath the line of the horizon, and only occasionally does a head stand out against the light of the sky. In foregrounding his figures, van Gogh has also emphasized their rootedness in the soil that affords them a livelihood. It almost looks as if the ground were dropping away at their feet and they were falling into the depths of a grave.

Still Life with Bible
Nuenen, April 1885
Oil on canvas, 65 x 78 cm
Amsterdam, Rijksmuseum Vincent van Gogh,
Vincent van Gogh Foundation

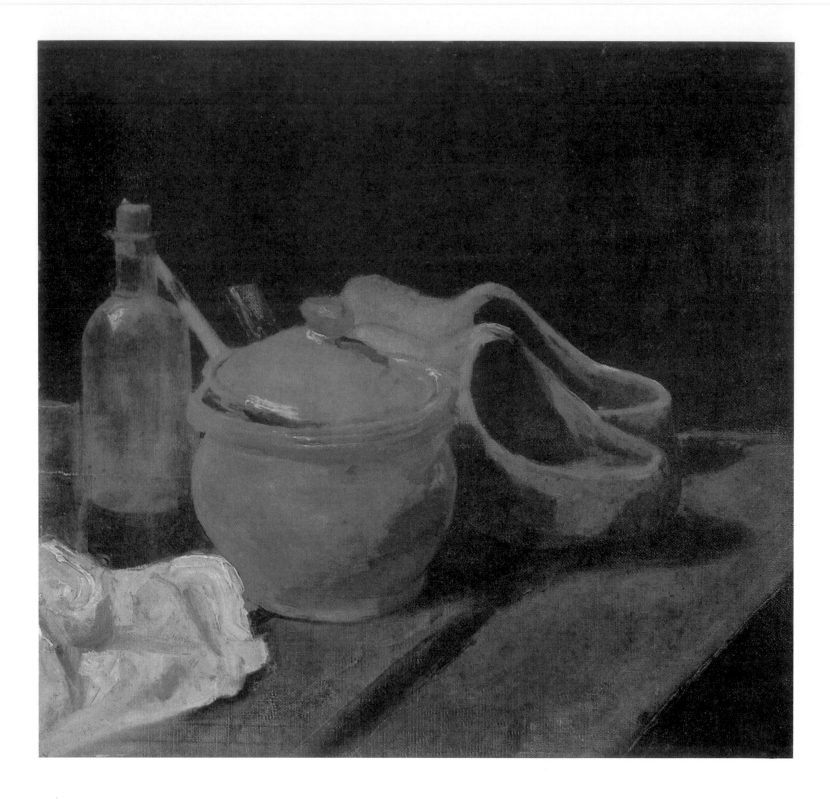

Still Life with Earthenware, Bottle and Clogs
Nuenen, September 1885
Oil on canvas on panel, 39 x 41.5 cm
Otterlo, Rijksmuseum Kröller-Müller

This cycle of the seasons constituted the only paintings that van Gogh did not place at his brother's disposal. In February 1884 Vincent had agreed to repay Theo's postal money orders with paintings. So now his works were regularly being sent to Paris; indeed, everything van Gogh produced from this time forth, till the day he died, went to Theo. Vincent considered his brother the owner of his paintings, while Theo, for his part, saw himself as a trustee – though both of them sensibly refrained from dwelling upon the exact details of ownership. The arrangement itself (which they both observed to the letter, without discussing it at any length in their correspondence) was the result of profound differences between the two brothers.

Vincent had lost sight of the *alter ego* he had always assumed Theo to be. He blamed his brother for his own alienation from their parental home, and saw him

as the personification of that code of respectability that constantly brought home his own inadequacy to him. The break peaked in a superb passage in Letter 379, in which Vincent discussed Eugène Delacroix's famous painting of the 1830 revolution, *Liberty on the Barricades* (in the Louvre in Paris), showing Liberty leading the people onward. Vincent imagined himself in the days of revolutionary fighting in 1830 or 1848, and went on to picture himself meeting his brother on the other side: "If we had both remained true to ourselves, we might – with a sorrow of kinds – have found ourselves enemies, confronting each other, at a barricade like that for instance, you as a government soldier and I behind it, a rebel. Now, in 1884 (by coincidence the numbers are the same, just the other way round) we confront each other once more; there are no barricades, it is true, but our minds cannot agree."

The Weavers

Van Gogh, relieved of concerns for his daily bread, now had 150 francs a month; Theo's support meant that he had about three times what a weaver family (each generation of the family living together under the same roof) had by way of income. Though van Gogh doubtless felt a sense of solidarity with the weavers, his visits cannot be accounted for on those grounds alone. We should also remember that in the cold winter months it was much better to paint indoors. And above all, he had the money to pay the weavers (who tended to have large families) for posing at their picturesque looms.

Van Gogh ascribed a certain depth to these milieu scenes, feeling they provided insight into his own work too; and indeed it is that depth which lends the series its special quality, even if the identification of artist with weaver, and vice versa, amounts to precious little in practice. In the weaver's work he had again located a metaphor for his own everyday labours; linen (or canvas), the final product of one man's work, was the starting point of the other's. Once he was on the spot, though, van Gogh had problems finding his pet idyll of the craftsman's life. The series of pictures he presently painted eloquently attest to van Gogh's gradual relinquishment of his preconceived notions and his acceptance of the careworn reality of everyday life as a weaver. For the first time in van Gogh's œuvre we can witness the artist engaging in the process of questioning his own subjective attitudes and starting a dialogue with his subjects.

Presumably it was their unanticipated obduracy that led van Gogh to take the weavers as his subject. The series was a kind of pilot project for him. Henceforth his work would typically be conceived in series, and in this way his tireless urge to create (as an end in itself) harmonized with his systematic investigations of the unfamiliar. *Weaver Facing Right, Half-Figure* (p. 28) is the only close-up in the series. Van Gogh is trying to gaze into that tensed face, touch those lips tight with concentration, and observe the hand movements the weaver makes at his work. Van Gogh is trying to see himself in this figure, whose gestures and facial expression remind him of his own at the easel – which the loom even distantly resembles.

In *Weaver Facing Left, with Spinning Wheel* (p. 29) van Gogh has already retreated somewhat. Now he is attempting a kind of reportage, documenting the working atmosphere, trying a new approach to a recalcitrant subject. The light, bright and diffuse, fills a room which merely serves as a space in which to

Lane with Poplars
Nuenen, November 1885
Oil on canvas, 78 x 98 cm
Rotterdam, Museum Boymans-van Beuningen

present a highly detailed rendering of the weaver's instruments. Van Gogh has added a reel, a commonplace attribute that confirms the everyday tone of this account of a weaver's existence. The addition shows the artist taking his bearings from the detached, anecdotal manner of the magazine illustrations he had so often admired. He was playing the part of an expert with vast, impartial knowledge of the working world.

Weaver, Seen from the Front (p. 31) places the "black monster" of the loom (van Gogh's phrase) dauntingly in the foreground. The weaver is scarcely individuated, a mere part of the complex mechanism, a figure in a geometrical construct of bars and shuttles, occupying a place in the incessant bustle of the loom. No light illuminates his face. No colour highlights him amidst the brown monotony of the wood. Man and machine operate in tandem, not because the man (like the machine) lacks a soul but because the artist's eye has discovered life in both. It is hardly possible to overestimate the importance of this loom for van Gogh's subsequent art: for the very first time a thing or object transcends the status of a mere prop in a still life. The eloquence of his chairs (pp. 140–141) or shoes (pp. 74–75) is anticipated here.

After six months of intense work, van Gogh found the solution he needed –

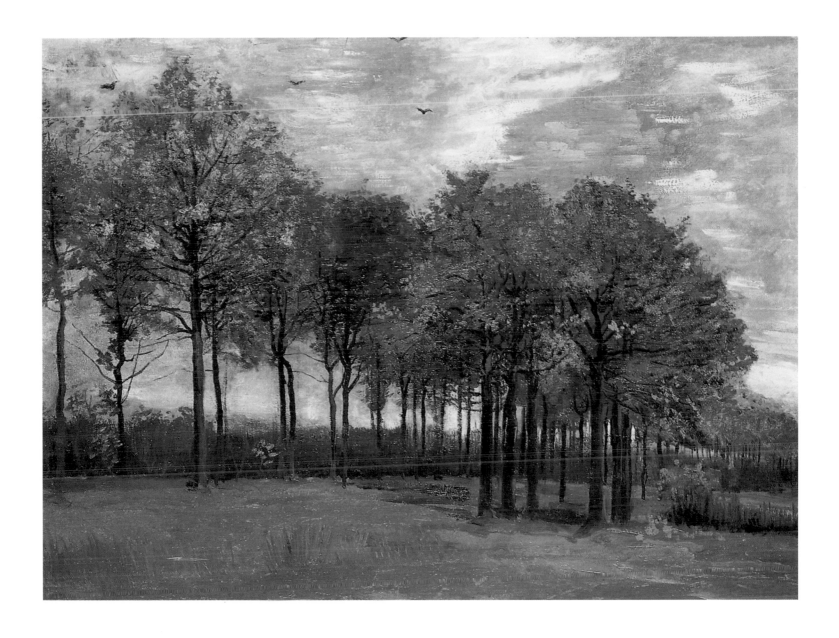

to be exact, two solutions, marking the peak and also the finale of the weavers series: *Weaver near an Open Window* (p. 30) and *Weaver, Seen from the Front* (p. 29). In these paintings, van Gogh locates two alternative ways of expressing distance and proximity, identification and remoteness, simultaneously. The window and the views it affords offer the artist's own commentary, while the weaver's person and machine confront him in a manner that seems antithetical, no longer personal.

The composition of these last two paintings in the weavers series neatly illustrates how van Gogh, at one point in his creative life, would acquire a hold on subjects that were trying to evade his grip: by juxtaposing his personal experience with what remained so implacably alien. It may seem a crude and antithetical method; basically, though, it was to be applied unaltered throughout van Gogh's career. In due course van Gogh was to find solutions that made a more sensuous appeal, were more natural, and enabled him to establish a greater unity of impact. He took the lesson he had learnt from the weavers and applied it to his subjects, approaching them with all his love of paradox, coaxing conflict and inconsistency out of the tiniest details. Ambiguity, which had hitherto been primarily a feature of his reception, now became a hallmark of his creative work.

Autumn Landscape
Nuenen, October 1885
Oil on canvas on panel, 64.8 x 86.4 cm
Cambridge (England), Fitzwilliam Museum

Painting as Manifesto

Hardly any artist's œuvre harmonizes so thoroughly with the cycle of the seasons as van Gogh's. He rarely leaves us in any doubt as to whether a work was created when the blossom of springtime was flowering, summer's harvest being made, the leaves of autumn falling, or winter's cold biting so harshly that the painter was driven indoors to his studio. He wanted to live and work like the farmers he lived amidst. His emotional sense of affinity with them was accompanied and indeed almost defined by geographical closeness (they were neighbours) and the closeness of fellow workers (whose labours were timed to suit the wind and rain). And as if the cold was part of some artistic programme, van Gogh set his easel up in the snow. Painting the picture of wood gatherers in the snow for the Hermans cycle, Vincent had done the winter landscape from memory, but now he was out for complete unity of subject and work. *The Old Cemetery Tower at Nuenen in the Snow* (p. 32), *The Old Station at Eindhoven* (p. 32) or *The Parsonage Garden at Nuenen in the Snow* (p. 33) all have a genuine wintry chill about them.

The snow scenes are only an intermezzo, though, in the major series of that six-month period, at the end of which van Gogh painted his first true masterpiece. *The Potato Eaters* (p. 47) was a synthesis of countless studies of peasants' heads, of people absorbed in work and handicrafts, which van Gogh painted that winter in the cottages of poor people in the village. As with the weavers, he had to paint a whole series in order to achieve any real closeness with these intractable people. This time, the series approach resulted in a final triumph.

Van Gogh adhered to a rigorous work schedule through to April of the following year, and over forty paintings of peasants' heads plus two dozen close-up studies of various kinds of cottage work have survived from this time. First, he would restrict himself to bust portraits. He had a preference for placing figures in profile, their silhouettes (in dark colours) set off against the monochrome gloom of the background; and he would dwell on the material of caps and kerchiefs, the folds and crinkles in the linen (cf. pp. 34–35). In the portraits where the sitters are seen full-face, van Gogh strikingly avoids meeting their careworn gaze and simply records that the villagers look full of mistrust; they remain in some unfathomable depths of their own, not communicating with their vis-à-vis, gazing straight past at some imaginary world (p. 36).

As time went by, van Gogh ventured to look his modest subjects in the eye. We can distinguish a second group of portraits in which the sitter meets our gaze; they are *en face* portraits or three-quarter profiles. Their rustic spirits become more open and mischievous, and the painter's growing intimacy with them is reflected in their facial expressions, which are expectant or possibly show a need for help but at any rate are less stubborn and timorous (p. 37). Van Gogh even painted sub-series within his series. The same person would be examined five or six times so that every detail of the face could be recorded as it became readier, more accessible.

The third stage in van Gogh's work on this series involved the change from portraits to interiors. He observed his subjects about their domestic chores, peeling potatoes, spinning, weaving baskets. The figures and their settings now received equal attention. The light, from a single source, is now diffuse, now contrastive, and creates an atmosphere of tranquil permanence in which the figures and objects appear interdependent. Van Gogh drew upon tradition, on

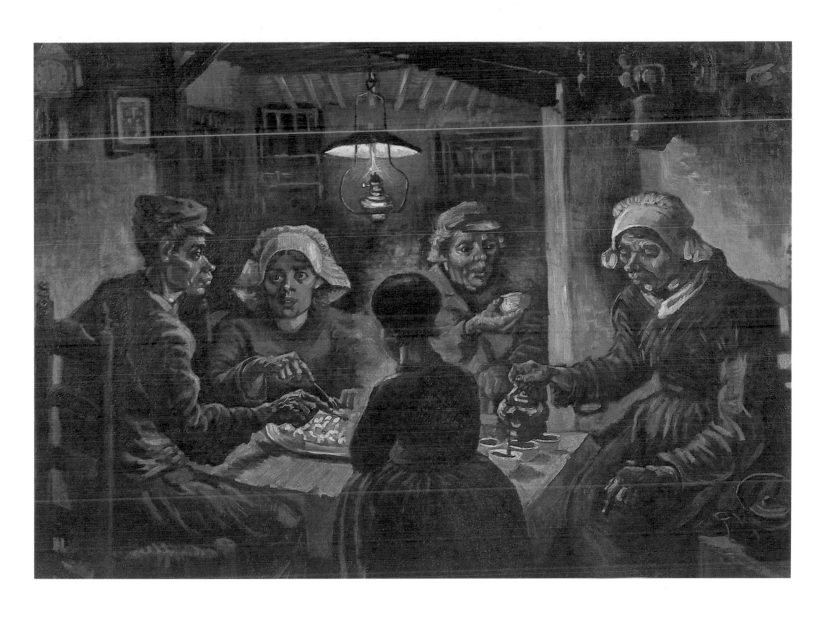

The Potato Eaters
Nuenen, April 1885
Oil on canvas, 81.5 x 114.5 cm
Amsterdam, Rijksmuseum Vincent van Gogh,
Vincent van Gogh Foundation

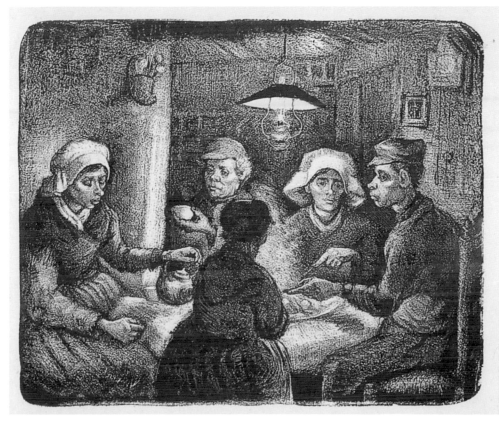

The Potato Eaters
Nuenen, April 1885
Lithograph, 26.5 x 30.5 cm

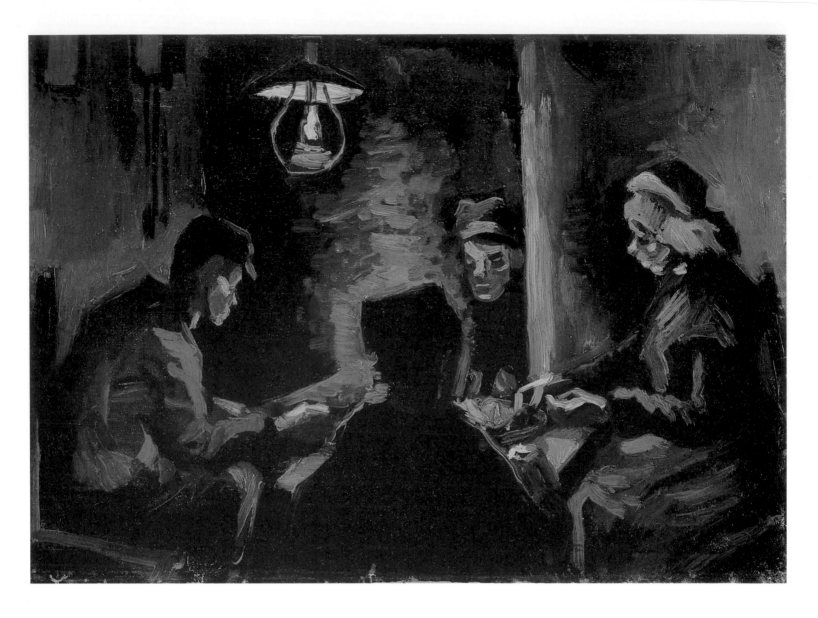

Four Peasants at a Meal (First Study for
The Potato Eaters)
Nuenen, February–March 1885
Oil on canvas, 33 x 41 cm
Amsterdam, Rijksmuseum Vincent van Gogh,
Vincent van Gogh Foundation

the genre scenes of the Dutch baroque, from Jan Steen or Gerard Terborch, in order to lend timeless meaning and relevance to specific views of everyday life.

The painting of *The Potato Eaters* in April, 1885 marked a turning-point in van Gogh's artistic life; his private life also underwent a turning-point at the same time. On 26 March, Pastor Theodorus van Gogh died suddenly, aged sixty-three, of a stroke. It may be no exaggeration to blame his son Vincent, at least in part. The vicar had been grieving ever since his artist son had come to live at home. Their characters were too different for any harmony to be possible and the discord made a bitter man of van Gogh *père*. Following his death, the family were able to stay on at the vicarage for the time being, but Vincent's standing in the eyes of the villagers deteriorated rapidly.

Naturally he commented on his changed circumstances in his art. *Still Life with Bible* (p. 41) is an examination of his relations with his father, whose correct reserve had always troubled Vincent. In the painting, objects express his feelings. The painting is dominated by the Bible, a fine and huge edition, sober, melancholy, leather-bound, emotive. Beside it is an extinguished candle, a traditional prop in any *memento mori* picture; this symbol of transience and death is sufficient to link the picture to the death of van Gogh's father. And in the foreground, modest yet insistent too, is a well-thumbed yellow copy of Emile Zola's novel *La joie de vivre*. The metaphoric polarity implied by the juxtaposition of this book

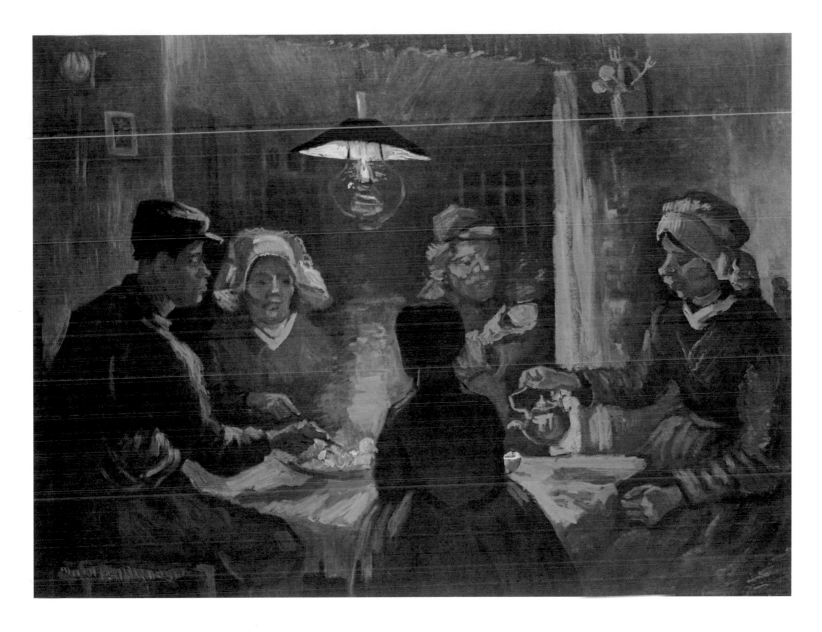

The Potato Eaters
Nuenen, April 1885
Oil on canvas on panel, 72 x 93 cm
Otterlo, Rijksmuseum Kröller-Müller

with the Bible is plain: the Bible was the father's source of authority in all his well-meant preaching and lecturing, while the novel represented a belief that there are other things in modern life besides wisdom that has been handed down through thousands of years.

"I think that the picture of the peasants eating potatoes that I painted in Nuenen is the best of all my work." Writing to his sister two years later from Paris (Letter W1), van Gogh still considered *The Potato Eaters* his most successful painting. Basically it was the only one of his paintings that he considered worth showing in public. A substantial number of letters deal exclusively with this painting. Every step the work involved is documented, with notes that (in van Gogh's usual syncretist manner) unambiguously forge a unity out of his attitudes to life and his brushstrokes, his social criticism and his use of colour, his analysis of the times and his choice of subject. Away in his village, van Gogh underwent one of the core experiences of modern art: in formulating a manifesto he had to face the dilemma of potentially being accessible only to the initiated few who read the accompanying texts, and of needing to supply further texts for the sake of being understood.

The painting (p. 47) shows five people seated round a rough wooden table. The younger woman has a bowl of hot, steaming potatoes in front of her and –

an interrogative expression on her face – is serving up portions. The old woman opposite her is pouring barley-malt coffee into cups. The three generations of a peasant family living together under one roof are gathered for this frugal meal. An oil lamp sheds a dim light on the scene, showing its plain poverty yet also highlighting an atmosphere of silent thankfulness. This lamp, shedding its weak and flickering light on all of them equally, establishes unity in the appearance of these careworn figures. Daily toil is visible in their faces; but their eyes signal trust, harmony and contentment with their life together, articulating a love that is also apparent in their gestures. It is as if there were no outside world to disturb their tranquil gathering with noise and bustle.

Van Gogh's first attempt at painting a group of potato eaters (p. 48) was compositionally more interesting. It includes only four figures round the table, and the sense of their sitting in a circle is made plausible by the irregularity of the positions they are in. Nor does the lamp have to illuminate two symmetrical halves with analogous groups of people. The relaxed approach is emphasized by the sketchy brushwork; this picture is of course a preliminary study, but as such it has an unpretentious spontaneity that the final version lacks. The second attempt (p. 49) shows van Gogh already having difficulty preserving this relaxed mood. The figure seen from the rear is already in position and has even less significance here than in the final painting, merely looking geometrical and stiff compared with the other four characters in the scene. The sense of a brief mo-

Cottage and Woman with Goat
Nuenen, June–July 1885
Oil on canvas, 60 x 85 cm
Frankfurt am Main, Städelsches Kunstinstitut und Städtische Galerie

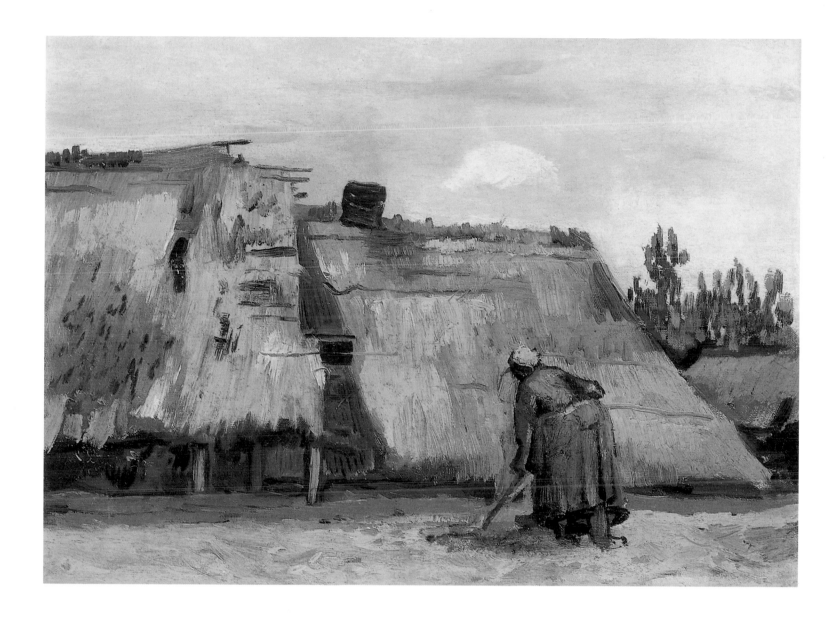

Cottage with Woman Digging
Nuenen, June 1885
Oil on canvas on cardboard, 31.3 x 42 cm
Chicago (IL), The Art Institute of Chicago,
Bequest of Dr. John J. Ireland

ment caught by chance in a cosy parlour and preserved as in a snapshot is still present, but a shift towards universal, emblematic significance is already visible. The final version now in Amsterdam, meticulously painted and then signed, has eliminated all trace of spontaneous reportage and substituted the forced authority of a historical scene.

Soon after completing *The Potato Eaters*, van Gogh added a written manifesto to the painted one: Letter 418, in which he reviews the thoughts that guided him while he was working on the picture. Paintings, he declared, needed to be created "with willpower, feeling, passion and love" and not with the hair-splitting subtleties "of these experts who are acting more important than ever nowadays, using that word 'technique' that is so often practically meaningless." Art could meet the world it served in sensitivity towards the simple and of course positive life of the underprivileged. The technology of the machine age and the technique of academic rules were both aimed at destroying that way of life. In these ideas, a belief in progress is paradoxically linked with hostility towards all things technical. The criticism is directed quite radically at the very roots of communal existence. If a new beginning was to be made at a profound level, the roots first had to be laid bare, cleared of the accretions of the status quo.

"Instead of saying: a man digging must have character," van Gogh went on in Letter 418, "I prefer to express it in a different way, saying: this peasant must

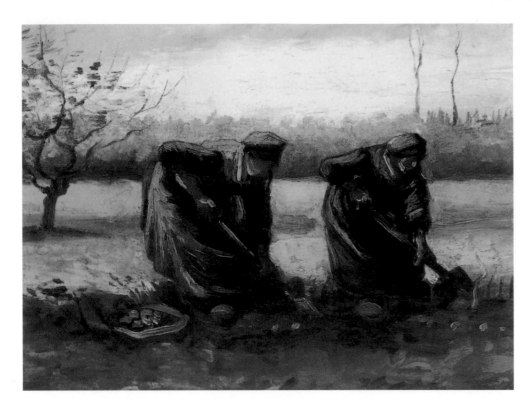

Two Peasant Women Digging Potatoes
Nuenen, August 1885
Oil on canvas on panel, 31.5 x 42.5 cm
Otterlo, Rijksmuseum Kröller-Müller

be a peasant, this man digging must be digging. Then there is something in it that is essentially modern." Everyday drudgery had left its mark on the faces of these people. Their backs were bent. Consistently enough, a painting conceived in the modern spirit had to highlight these facts if it was to give a characteristic account of the times. It had to be ugly, coarse, authentic [...] modern. Van Gogh authoritatively incorporated all these elements into *The Potato Eaters*. The peasant as hero of a better world, ugliness as proof of verisimilitude, of his reality, and a claim to truthfulness that demanded not only solidarity but a life literally lived side by side – all of this can be seen in the painting.

Understanding and Suspicion

"The party Vincent Willem van Gogh departed during the inventory proceedings without giving any reasons." Thus the bureaucratic version of van Gogh's sudden departure while Pastor Theodorus van Gogh's last will was being executed. In May 1885, apparently revolted by the bureaucratic arrangements that had accompanied the death of his father, and at odds with his mother and siblings, van Gogh left the vicarage. He rented a studio from the sexton of Nuenen's Catholic community – that is to say, again from a man of the church, as if he needed the daily confrontation with his own longing for spiritual well-being. Van Gogh's main subject in 1885 was perhaps the potato. He not only painted the eating of potatoes. He also did a number of still lifes of potatoes in baskets or crates. Furthermore, he followed the growth of potatoes, from the planting to the lifting, in a series showing people digging. *Peasant and Peasant Woman Planting Potatoes* (p. 53), for instance, was painted at about the same time as *The Potato Eaters*, in April 1885. The style and format suggest that this painting was only a preliminary study. In subject it returns to the thematic concerns of van Gogh's period in The Hague. "Peasants digging," he had written at that time (Letter 286), "are closer to my heart, and I have found things better

outside paradise, where the literal meaning of 'the sweat of his brow' becomes apparent." Rural folk toiling to live off the fruits of the land provided van Gogh with a metaphor for his own endeavours even at that date – and also with a metaphoric way of expressing his hope that one day he would be able to earn a modest living with his art.

Two Peasant Women Digging Potatoes (p. 52), a summer scene, shows the fruits of toil being gathered in, and is thus a companion piece to the April painting. One simple insight makes these pictures minor masterpieces of their kind: the realization that at the beginning and the end of the process the same torture is involved – back-breaking bending, calluses on the hands, hard and stony earth to struggle with. "The sweat of his brow" is a perpetual fact of life. In this work, van Gogh has also enriched his series principle by a further quality. The motif appears unchanged and we might conclude that van Gogh had made no progress as an artist, but we should not interpret the lack of change as a sign of incompetence; the series is unchanging because the reality it describes is also inexorably and unchangingly the same.

The instinct to tackle the cottages in the vicinity sprang from the same need to

Peasant and Peasant Woman Planting Potatoes
Nuenen, April 1885
Oil on canvas, 33 x 41 cm
Zurich, Kunsthaus Zürich

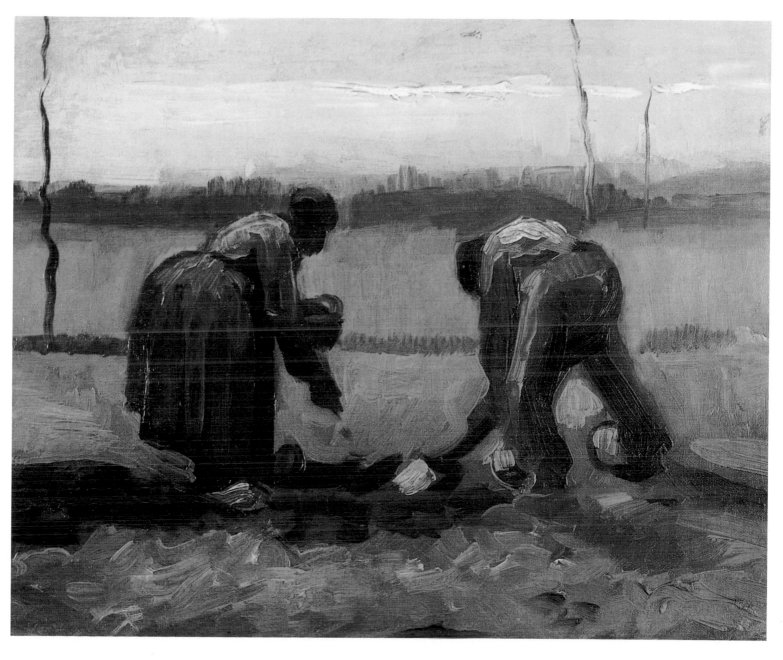

create a feeling of vitality. Unlike those in Drente, these homesteads have individual personalities, and are as straightforward and self-assured as those who dwell in them. Thatched, and surrounded by trees, they form an organic unity with their natural environment and, like the peasants' work in the fields, they record the presence of human activity. Like their owners they are rustic and natural; they are like open air summer portraits following upon the studio work of the winter. The cottages are van Gogh's protagonists, and the people seen near them are like their attributes. The woman, goat and hens in *Cottage and Woman with Goat* (p. 50) have no value in their own right; there is no distinction between them, and they merely serve to point up the farming milieu of the cottage. They supply the story, so to speak, and the modest building's personal background.

"The cottage with the mossy roof reminds me of a wren's nest," wrote van Gogh in Letter 411. It is no longer a very great step from this association to the series of still lifes with birds' nests that he painted the following autumn (pp. 54–55). They are indeed *nature morte*; van Gogh's respect for living things was too great for him to disturb a nest, and he did not find them locally himself. Instead he started a collection. Quite uncharacteristically, van Gogh approached these beautifully-worked objects in the same way as he was viewing fruit and potatoes in *Still Life with Basket of Apples* (p. 56) or *Still Life with a Basket of Potatoes* (p. 58) of the same period. He stacked them up against a dark, mono-

Still Life with Three Birds' Nests
Nuenen, September–October 1885
Oil on canvas, 33 x 42 cm
Otterlo, Rijksmuseum Kröller-Müller

Still Life with Five Birds' Nests
Nuenen, September–October 1885
Oil on canvas, 39.5 x 46 cm
Amsterdam, Rijksmuseum Vincent van Gogh,
Vincent van Gogh Foundation

chrome background, with only one or two scattered highlights to alleviate the gloom, in his quest for a way of balancing weighty solidity and lightness, amassed quantities and individual items, surface and detailed depth.

After his father's death, Vincent had realized how vital a part the pastor's protecting hand and natural authority had played in his life. He had hardly moved out of the vicarage before becoming a target of hostility that soon soured his life in Nuenen. The year before he had already occasioned a local scandal when an unmarried village woman who had fallen in love with him, and could not cope with the conflict between her feelings and the pressure her family brought to bear, tried to kill herself. She had swallowed poison and then collapsed while out walking with Vincent – unfortunate timing. Her life was saved, but the blame was heaped on the artist. When there was more bad news he was blamed again: a peasant girl who had posed for him got pregnant, and, since his name had already been ruined, it was easy to see him as the guilty party. At all events, the Catholic priest had a field day, forbidding his flock to associate with the painter.

Given the way his standing with the villagers had changed, departure was inevitable. In any case, van Gogh was also growing increasingly aware of a need to experience city life again. The pleasure he took in the simple life had obscured this need; but now he realized that his knowledge of the art world was all hearsay culled from Theo's Paris letters and the visits of friends. His information was all second-hand. He had never even set eyes on an Impressionist painting. And as a result his work tended to be overburdened with theory: he had to milk Nuenen's modest resources of all the subjects the village had to offer, and articulate everything he had resolved to say. We often find that there is a discrepancy between the sensuous visual impact of his pictures and that forced symbolism which his letters (rather than the works themselves) induce us to infer. The time had now come for van Gogh to enter the art world proper.

Evolving a Theory of Art

There was nothing provincial in van Gogh's main ideas on art. Though he lived away from the mainstream, he was thoroughly familiar with the aesthetic preoccupations of the day, as we see from his interest in two of the central concerns of contemporary artists: firstly, how does the motif in the picture relate to its original in Nature, and (following from this) when can a painting be considered "finished"? Secondly, what part does the use of colour play? In his sensitivity to these two problems, van Gogh showed a greater affinity to his age than he did in his works. Indeed, it was that great sensitivity that had really driven him out of his Nuenen retreat; books and magazines reached him in the country, but as long as he stayed there he could never look at new paintings.

"What has impressed me most on seeing paintings by the old Dutch masters again," he wrote in Letter 427, "is the fact that they were generally painted quickly. Not only that: if the effect was good, it stood. Above all, I admired hands painted by Rembrandt and Hals, hands that were alive though they were not finished in the sense that is being insisted on nowadays." Indeed, as van Gogh hazards in this letter, a Frans Hals would have found little favour with a Salon jury in the 1880s. But the painters of the 17th century had been incomparably successful at breathing life into their figures. Van Gogh had taken his bearings from them from the outset, and had gone on to an impulsive, crude art of vitality and energy that was so sketchy in character that there was surely a point in wondering whether his canvases were finished products. Van Gogh confronted this question, and the answers he came up with were to influence the whole of modern art.

It is not hard to see what van Gogh considered finished work. If he felt a painting was more than a study, he signed it. There are not a great many of them; in his Dutch period they amount to a scant five per cent. *Head of a Peasant Woman with White Cap* (p. 59, right), for instance, bears his "Vincent". But how

Still Life with Basket of Apples
Nuenen, September 1885
Oil on canvas, 45 x 60 cm
Amsterdam, Rijksmuseum Vincent van Gogh,
Vincent van Gogh Foundation

does that painting differ from the *Head of a Peasant Woman with White Cap* (p. 59, left), which he apparently felt to be only a character study? Both are thickly pastose, both are vehement, both were done at speed, and both evidence the affection with which the artist approached his subjects. Both were done in the same environment, for the same purpose, as part of the same work programme. It is difficult to see how van Gogh decided which work was superior. Yet he himself put a name to the essential quality: 'soul'. Only work that succeeds in capturing 'soul' can be considered 'finished'. In espousing this view, van Gogh assigned to his private inner self the role of ultimate arbiter in Art, and thus effectively removed his work from the public arena. This anticipated the purely subjective approach that is characteristic of modern art.

According to van Gogh, a painting with 'soul' is superior to natural Creation. From its higher vantage point, the work of art abstracts the essential in the world's phenomena in order to present a lasting impression. Though a painter may be far removed from Nature in the process, he also needs to remain close to Nature, because only Nature can correct the products of his scrutiny of the depths within. Dialogue between Nature and the work (with the painter eavesdropping, as it were) takes the place of dialogue between artist and critic.

This holds good for the second main point in van Gogh's theory of art, too:

Still Life with Basket of Apples
Nuenen, September 1885
Oil on canvas, 33 x 43.5 cm
Amsterdam, Rijksmuseum Vincent van Gogh,
Vincent van Gogh Foundation

his discussion of colour. "Studies after Nature, the tussle with Reality", he wrote in Letter 429, "I won't deny it, for years I approached the business well-nigh fruitlessly and with all manner of dismal results. I wouldn't want to have avoided the mistake... One starts with fruitless labours, trying to copy Nature, and nothing works out, and one ends up creating in peace and quiet using only the palette and Nature is in agreement and follows from it." In that letter, van Gogh established the basic principles of autonomous colour – colour that is used according to its visual impact in the picture rather than its fidelity to Nature; but it would be a while yet before he was able to paint as he thought.

By far the most important principle of van Gogh's palette, a principle that was later to become a dogma with him, was that of complementary colours. This too had been taken from Delacroix, during his second year in Nuenen. Complementary colours are colours that heighten their mutual effects most intensively if they are placed contrastively: blue and orange, red and green, yellow and violet. Initially van Gogh added a fourth contrast, white and black. He had found that the principle was at work in Nature, in the cycle of the seasons, so dear to him: "Spring is tender young shoots of wheat and pink apple blossom. Autumn is the contrast of yellow leaves with shades of violet. Winter is snow, with black silhouettes. If summer is taken to be a contrast of blues with the orange of golden, bronze grain, it is possible to paint a picture in complementary colours for every one of the contrasts." (Letter 372).

In spite of his sophisticated theory, van Gogh remained a realist in his use of colours. True, his ideas abstracted away from the immediate impression made by Nature; but in practice a look at the subject sufficed to guide his use of the palette. Van Gogh was alert to complementary colours, but was satisfied if he saw them in the contrast of yellow leaves with a violet sky or red flowers with a green field. His theory paved the way for autonomous colour, but in his practice he remained close to the old masters and his solitary hero, Millet. It would be another year before he shook off this fidelity.

Still Life with a Basket of Potatoes
Nuenen, September 1885
Oil on canvas, 44.5 x 60 cm
Amsterdam, Rijksmuseum Vincent van Gogh,
Vincent van Gogh Foundation

Head of a Peasant Woman with White Cap
Nuenen, March–April 1885
Oil on canvas, 44 x 36 cm
Otterlo, Rijksmuseum Kröller-Müller

Head of a Peasant Woman with White Cap
Nuenen, March 1885
Oil on canvas, 43 x 33.5 cm
Amsterdam, Rijksmuseum Vincent van Gogh,
Vincent van Gogh Foundation

City Life
Antwerp and Paris, 1885–1888

From Antwerp to Paris

"It is quite certain that I shall be without a place to work in Antwerp. But I have to choose between a place to work but no work here and work without a place to do it there. I have opted for the latter. And with such joy and delight," wrote van Gogh in Letter 435, "that it feels like returning from exile." He felt that, after the past few years, he urgently needed to return home – to rediscover that homeground that a city provides. His concept of artistic truth, borrowed from Millet and Breton, had led him to live in the same rustic, rural environment he liked to paint; but now he felt compelled to satisfy society's notions of the artistic life.

From the very start, van Gogh saw his time in Antwerp as an intermezzo before he moved on to the great metropolis, Paris. Theo, of course, first needed persuading to fetch his brother to Paris. Van Gogh tried to give his correspondent an honest account of his progress in questions of civilized conduct. He believed he might still need improvement in three respects: first, he simply wanted to dive into the sea of people and houses and forget the everyday feuding of the village; second, he felt he might profit from further instruction at the Academy, in order to have the technical means to tackle his new subjects; and third, he thought that after years of neglecting his outer appearance he might be in need of a little advice in that respect.

He spent three months in the Belgian port. Peter Paul Rubens was the presiding spirit in this period. Van Gogh, as a follower of Delacroix, was of course destined to discover the baroque painter. Having done so, he appropriated Rubens's subtlety and allusiveness with the same energetic thoroughness as he had borrowed Millet's simple devotion to Nature years before. In *Head of a Woman with her Hair Loose* (p. 62) van Gogh achieved a degree of artistic sensitivity that had hitherto been beyond him. The portrait is still vigorous, if not indeed violent, in its brushwork, but the colouring is exquisite. Sensitively patterned brushstrokes create a beautifully nuanced, detailed image in which the virtuoso technique has perhaps become more important than the subject. The woman is not rustic or picturesque like the Nuenen women in their caps. In fact, van Gogh has dispensed with everything that might tie the woman specifically to one walk of life.

"What colour is in a picture, enthusiasm is in life, in other words no mean thing if one is trying to keep a hold on it," he wrote in Letter 443, explaining his new interest in colour. Increasingly, the violent tonal clashes, streaks of

Skull with Burning Cigarette
Antwerp, Winter 1885/86
Oil on canvas, 32 x 24.5 cm
Amsterdam, Rijksmuseum Vincent van Gogh,
Vincent van Gogh Foundation

Left:
Head of a Woman with her Hair Loose
Antwerp, December 1885
Oil on canvas, 35 x 24 cm
Amsterdam, Rijksmuseum Vincent van Gogh,
Vincent van Gogh Foundation

Right:
Portrait of an Old Man with Beard
Antwerp, December 1885
Oil on canvas, 44.5 x 33.5 cm
Amsterdam, Rijksmuseum Vincent van Gogh,
Vincent van Gogh Foundation

colour, and patches of paint applied directly from the tube took over the function that his motifs had previously had: to reconcile the painter's subjective view of the world with the objective state of phenomena. Previously, van Gogh had been offering the better life – better because lived in harmony with Nature. Now he withdrew somewhat from natural plurality, as it were, and tried to present a synthesis, his own interpretation, on canvas. The world in his pictures became more artificial because it was more consciously filtered by the perceptions and mind of an artist.

Skull with Burning Cigarette (p. 60) is in many ways the key Antwerp picture. Van Gogh was mocking the procedure in drawing classes (he tried in vain to be admitted to the higher levels); there, a skeleton invariably served as the basis of anatomical studies. The lifelessness of the skeleton represented the very opposite of what van Gogh wanted a picture to express. With the burning cigarette jammed in its teeth, the skeleton, though still nothing but dead bones, has acquired a grotesquely funny hint of life.

The painting is less amusing if we bear in mind van Gogh's feeling that he needed to make his outer appearance more attractive. He had just had major dental treatment. If he was now coming to see himself as a man about town, he would have developed the self-confidence needed to think he merited a self-portrait (and first some improvement of his facial appearance, which was sunken and weary). In this sense, the skull can be seen as van Gogh's first self-portrait – a cynical, merciless comment on an unkempt and unattractive appearance that had

been a sign of solidarity with the peasants back in Nuenen but was now an embarrassment and a problem in the city.

For exactly two years, from February 1886 to 1888, Vincent went about the business of catching up on modern times. And there was only one location where the self-respecting artist could properly do that: Paris. He learnt the ways of the city as rapidly as the new aesthetics; his human qualities and cognitive powers were both considerable.

When he finally left, Theo wrote sadly to his sister: "When he arrived here two years ago I would never have thought that we could become so close. Now that I am on my own again I feel the emptiness in my home all the more. It is not easy to fill the place of a man like Vincent. His knowledge is vast and he has a very clear view of the world. I am convinced that if he has a few more years he will make a name for himself. Through him I got to know a number of painters who value him highly. He is one of the pioneers of the new ideas, or rather he is trying to revive ideas that have been falsified in routine everyday life and have lost their lustre. And he has such a good heart, too, and is forever trying to do

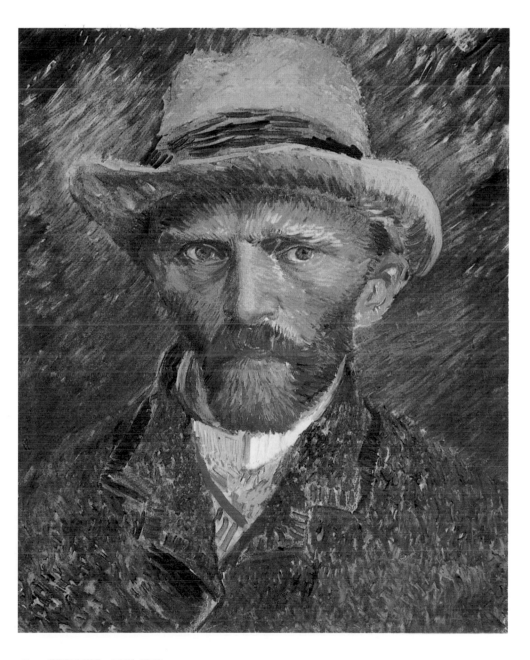

Self-Portrait with Grey Felt Hat
Paris, Winter 1886/87
Oil on cardboard, 41 x 32 cm
Amsterdam, Stedelijk Museum (on loan from the Rijksmuseum)

Montmartre: Quarry, the Mills
Paris, Autumn 1886
Oil on canvas, 32 x 41 cm
Amsterdam, Rijksmuseum Vincent van Gogh,
Vincent van Gogh Foundation

things for others. All the worse for those who do not want to know or understand him."

For years, Theo had felt a sense of family responsibility for Vincent; he had taken for granted that he should help his needy brother. It was only when he was carrying out this duty within the same four walls, with Vincent living at his home, that he truly began to see Vincent's personality. In the process a caring paternalism was replaced by closer personal relations; he discovered a man of integrity, and they became intimates. His brother's moods fascinated him, and he saw them as the mark of an artistic temperament.

Theo was the person to whom Vincent related most closely. Once he had Theo's approval, he felt strengthened and the pictures he painted were more cheerful and accessible. He was aware that he had quirky ways, but it now seemed that they were a kind of badge, and he fitted the societal stereotype of the difficult, temperamental artist perfectly. He also found support among the dreamers and reformers out to change the world, who were every bit as eccentric, enthusiastic and unknown as he was. He entered artistic circles, debating till the small hours, and proclaimed his opinions even if no one had asked them. Everyone who was still waiting for the breakthrough believed himself really one of the

elite; and in Paris van Gogh saw the necessity of the outsider's life if a man was to achieve greatness as an artist.

Initially, Paris was merely the sequel to Antwerp. Some time in 1886 (the exact date is disputed) he matriculated at a private art college run by Fernand-Anne Piestre, called Cormon. Cormon was a history painter whose archaeological detail could be seen as an evasion (by substituting scholarly precision) of the debate on the contemporaneity of Art.

Of greater importance for van Gogh, though, were the friendships he presently struck up with fellow-students who were admittedly a full ten years younger and lacked his experience of life but nevertheless were at a comparable level in their artistic training. Louis Anquetin, Emile Bernard and Henri de Toulouse-Lautrec were among them. They smoothed van Gogh's access to the art world, and soon he found theorizing more interesting than the dull routine of drawing plaster figures.

Cormon's art school was van Gogh's last chance to acquire a basic grounding in the academic mysteries; but he did not stay long. Van Gogh preferred to take his bearings from theory again. He was too much a part of the art scene for his ideas to be labelled those of an autodidact; rather, in acquiring a grip on modern

Montmartre: Quarry, the Mills
Paris, Autumn 1886
Oil on canvas, 56 x 62.5 cm
Amsterdam, Rijksmuseum Vincent van Gogh,
Vincent van Gogh Foundation

thought he was quite simply capable of assimilating more rapidly than others. And he wanted to paint in the way he knew how, the way he had learnt from all his discussions and all the exhibitions. As for his technical skills, his strength was not so much a steady hand as a forceful will and a clear eye. So all his works arc ad hoc creations, impetuously done, scarcely finished, and often bearing telltale signs of effort.

Theo's reputation as a specialist in the work of young artists, one of whom was his own brother, was growing. Vincent apparently helped; it was his job to make contacts. His success in this cannot be accounted for by the exotic appeal of his out-of-town appearance alone. Experienced fellow-artists found him likable, and he established friendships with Bernard and with Paul Signac that lasted beyond the Paris years; there must have been a deeper reason for this. Van Gogh had quite intuitively adopted a lifestyle that was then *de rigueur* for avant-garde artists. Naively (as it seemed) van Gogh had harmonized in his own behaviour traits that seemed forced or over the top when others tried them: he had reconciled artificiality and day-to-day ordinariness, the sense of vocation and life on the social periphery, conviction and playfulness, Art and Life.

Le Moulin de la Galette
Paris, Autumn 1886
Oil on canvas, 38.5 x 46 cm
Otterlo, Rijksmuseum Kröller-Müller

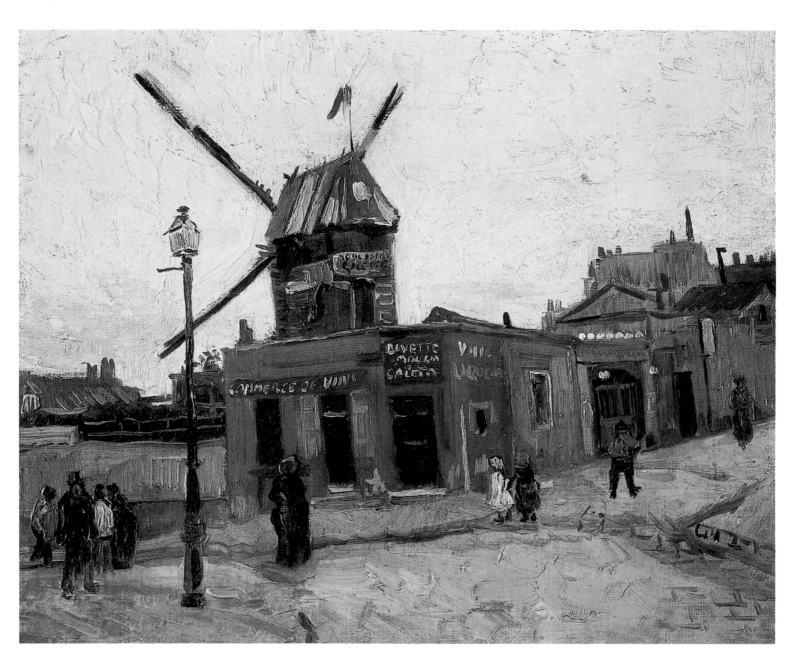

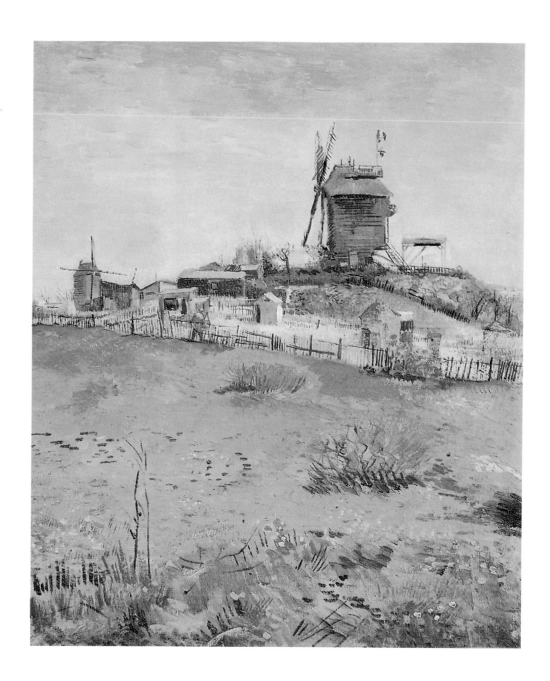

Le Moulin de la Galette
Paris, March 1887
Oil on canvas, 46 x 38 cm
Pittsburgh (PA), The Carnegie Museum
of Art

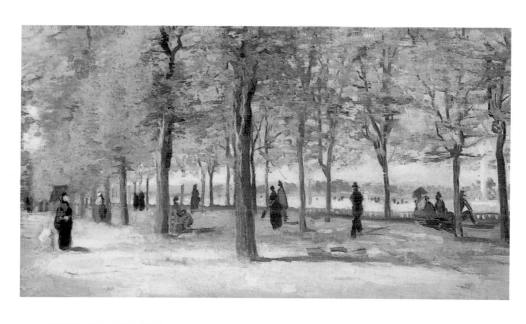

Lane at the Jardin du Luxembourg
Paris, June–July 1886
Oil on canvas, 27.5 x 46 cm
Williamstown (MA), Sterling and Francine
Clark Art Institute

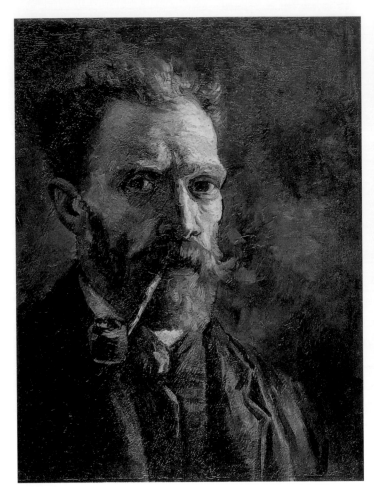 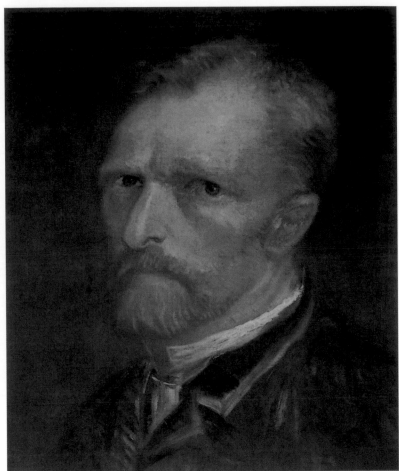

Left:
Self-Portrait with Pipe
Paris, Spring 1886
Oil on canvas, 46 x 38 cm
Amsterdam, Rijksmuseum Vincent van Gogh,
Vincent van Gogh Foundation

Right:
Self-Portrait
Paris, Autumn 1886
Oil on canvas, 39.5 x 29.5 cm
The Hague, Haags Gemeentemuseum

Page 69:
Self-Portrait with Straw Hat
Paris, Summer 1887
Oil on cardboard, 40.5 x 32.5 cm
Amsterdam, Rijksmuseum Vincent van Gogh,
Vincent van Gogh Foundation

Through the Window 1886

Van Gogh painted almost 230 paintings during his stay in Paris, more than in any other comparable period of his life. This work is more diverse in character, the frank record of two years of continual experiment. In Paris, van Gogh put the rootedness of his apprentice years behind him. In terms of energy, what he accomplished is amazing; though of course speed, and ingenious touches, could not be as important as steady work. The theories van Gogh had adumbrated in the last letters he wrote from Nuenen were still far from being visible in practice, and he was to spend the whole of 1886 putting the finishing touches to his early work. He was still travelling with a good deal of the baggage he had picked up as he started on the artist's life, and could not simply throw it away in his new milieu. The main features of his Dutch output remained. Those features might be characterized, in a word, as 'realistic'.

In *Lane at the Jardin du Luxembourg* (p. 67) we find the artist among people out for a stroll on a summer's day. The scene is a tranquil one, flooded with bright sunlight. The people are strolling along the shady lane or sitting on the park benches watching the world go by. The painter can feel quite at home in this environment; there is room for his easel and he can expect to remain undisturbed as he observes people at their Sunday pleasures. Trusting in what he saw with his own eyes, and believing that what he saw could be transferred with scarcely any reworking to the canvas, van Gogh created in this Jardin du Luxembourg scene one of his most attractive 'realistic' paintings. Van Gogh's symbolism, which could often seem forced, is certainly present in the picture, but it

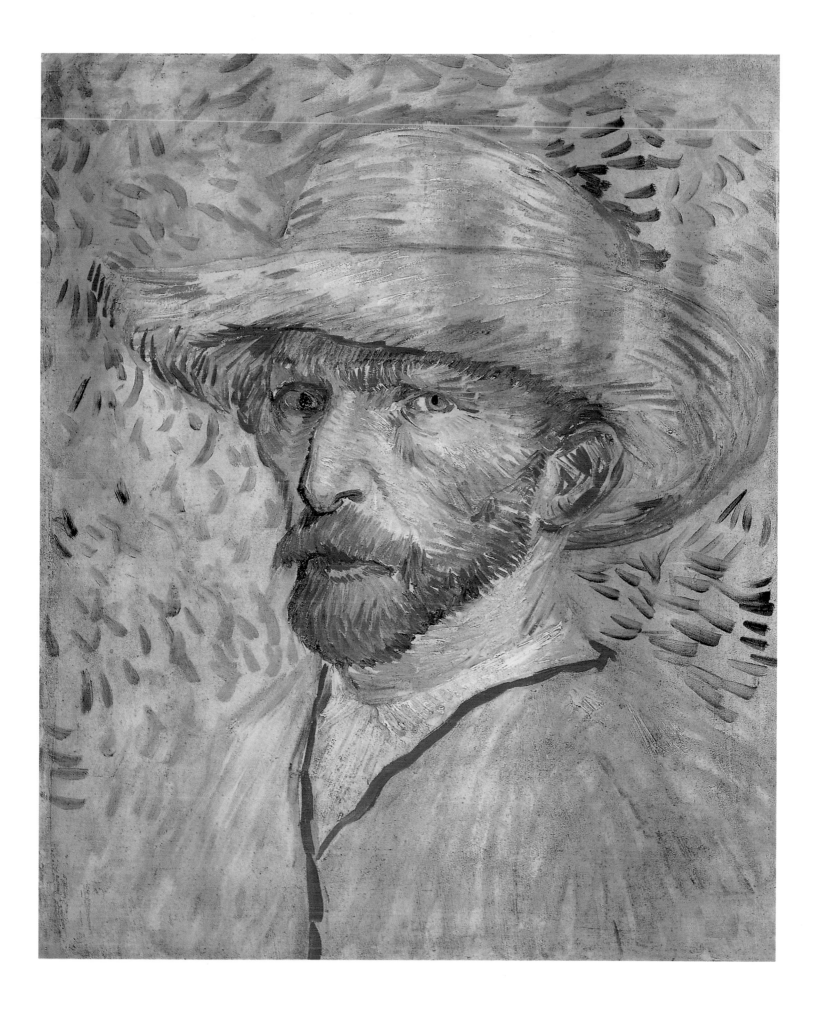

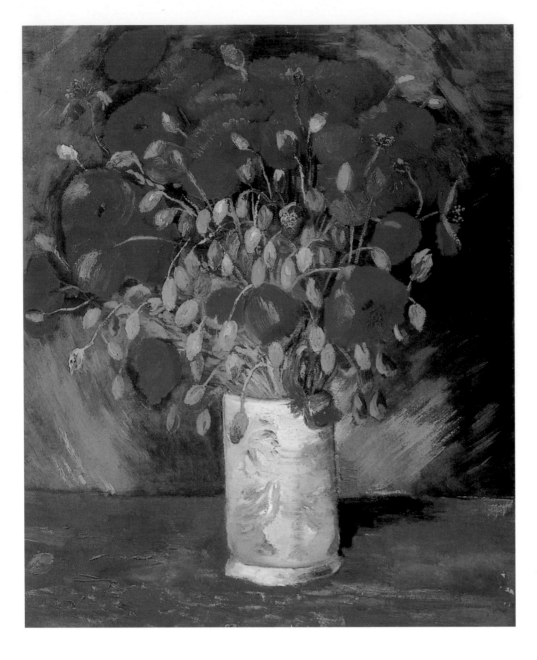

Vase with Red Poppies
Paris, Summer 1886
Oil on canvas, 56 x 46.5 cm
Hartford (CT), Wadsworth Atheneum

seems to have been quietly absorbed into it, without fuss, to create a new organic unity.

Van Gogh also found symbols in the evidence of his eyes when he saw the three mills on Montmartre. Anomalous relics of a rural age within the city limits, the mills had become a popular place to go on public holidays; but doubtless they also reminded van Gogh of his homeland. One was the Moulin de la Galette, the garden restaurant immortalized by Pierre-Auguste Renoir. Van Gogh's approach was altogether different. His attention was fixed not on the coffee-drinkers and dancers but on plain topography and architecture. In *Montmartre: Quarry, the Mills* (pp. 64 and 65) he offers a panoramic view of a moment of almost rural seclusion; his treatment emphasizes the mills' proud position atop the hill and directs our gaze away from the encroachments of the city. Van Gogh and his brother were living in a flat not far from the spot where Vincent made this attempt to see into the distance.

There are two scarcely noticeable figures deep in conversation in the second of these deserted landscapes – van Gogh's typically significant personae, dark and anonymous, lending a touch of the mysterious to familiar surroundings. Van

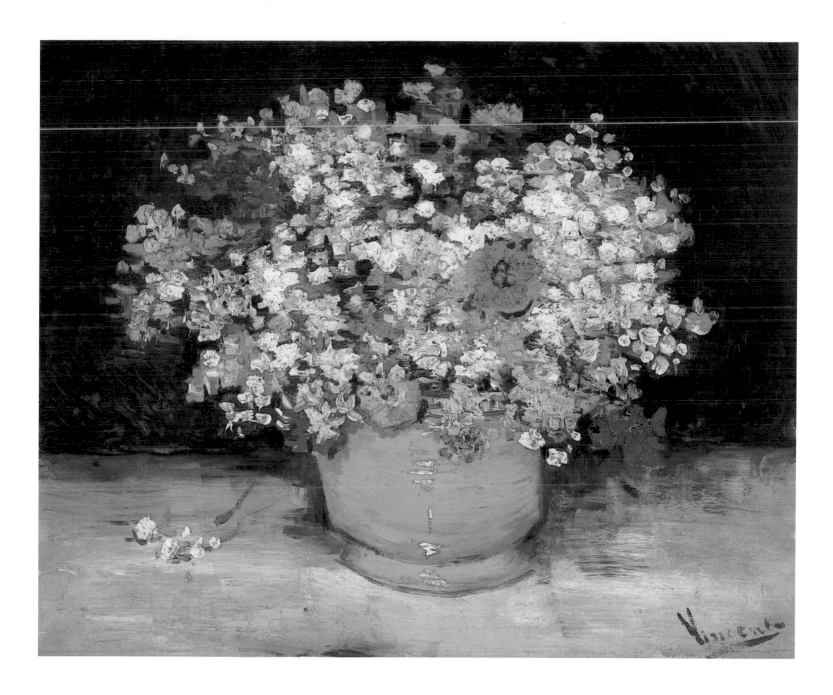

Gogh left his landscapes as the motif demanded they be painted. A *plein air* painter of a purist kind, he trusted in the fundamental effects of the light and air implicitly, and worked the atmospherics into the colours that filled his canvas. But there were times when the fascinating optical results he obtained did not satisfy him; his fondness for deep content would suspect that pleasures offered to the eye were merely superficial. And so he would place two black figures in the quarry, or position the forebodingly dark figure of a woman outside the Moulin de la Galette (p. 66). These iconographic afterthoughts were usually added in the studio.

Van Gogh's imagination was unable to kick free; instead, he shackled it with strictly mimetic rules. These rules applied principally to the brushwork and the use of colour. It was not until after 1886 that van Gogh shed his reticence about departing from a faithful, descriptive account of his subject. He made the greatest leap in his use of colour. In Nuenen he had written of "creating in peace and quiet using only the palette, and Nature is in agreement" (Letter 429). Yet in 1886 he did nothing of the kind. His colours remained far from the autonomy he had envisaged; indeed, van Gogh still abided faithfully to local colour, to the

Vase with Zinnias and Other Flowers
Paris, Summer 1886
Oil on canvas, 40.2 x 61 cm
Ottawa, National Gallery of Canada

Page 72:
Vase with Carnations and Other Flowers
Paris, Summer 1886
Oil on canvas, 61 x 38 cm
Washington, David Lloyd Kreeger Collection

Page 73:
Vase with Daisies and Anemones
Paris, Summer 1887
Oil on canvas, 61 x 38 cm
Otterlo, Rijksmuseum Kröller-Müller

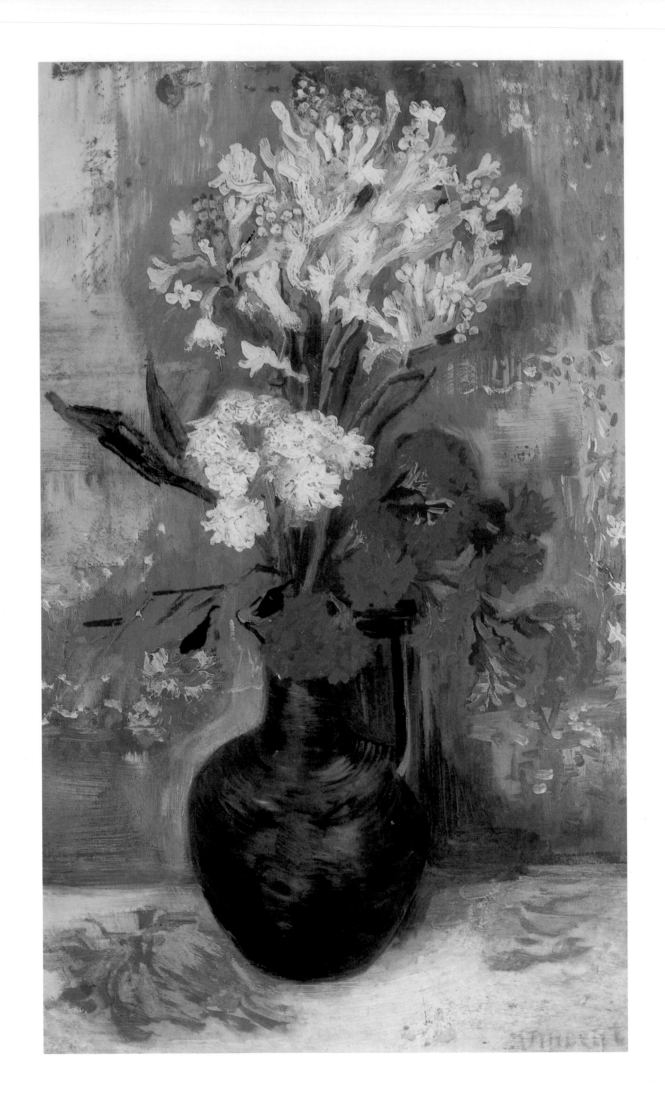

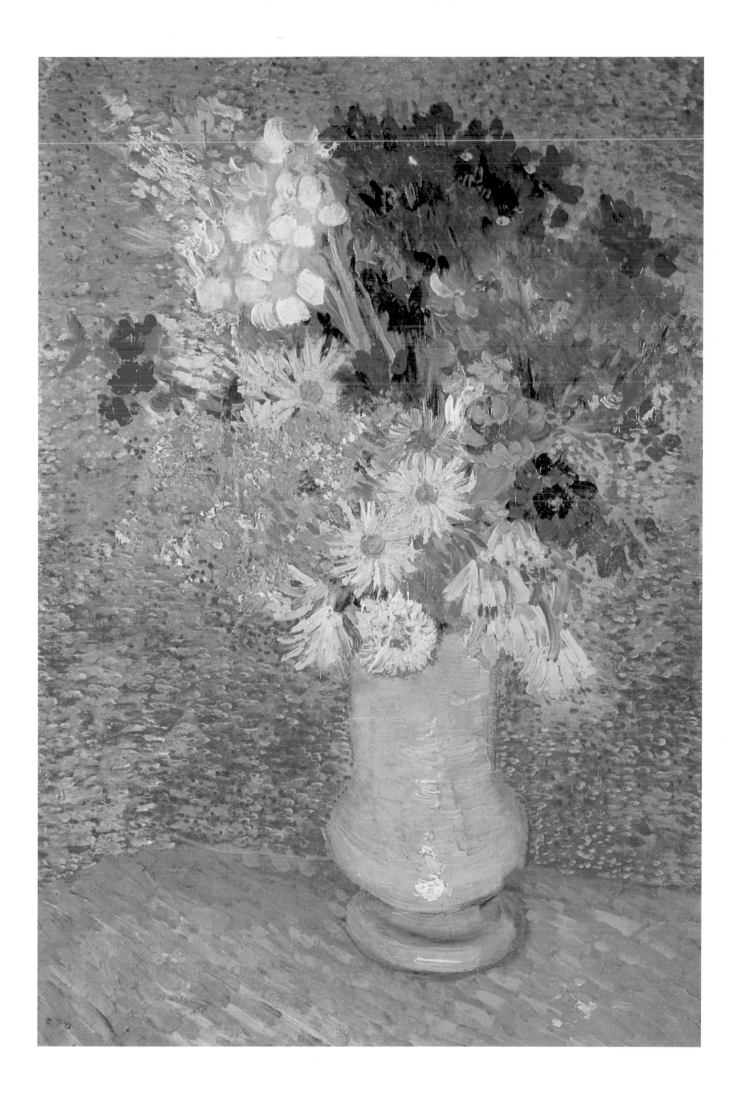

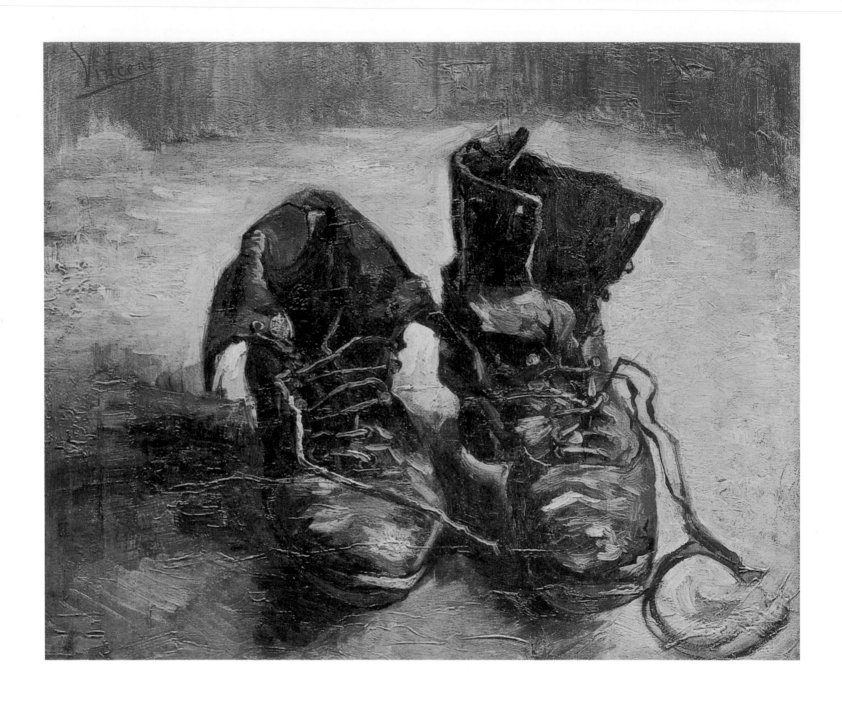

A Pair of Shoes
Paris, second half of 1886
Oil on canvas, 37.5 x 45 cm
Amsterdam, Rijksmuseum Vincent van Gogh,
Vincent van Gogh Foundation

appearance of his subject. His first self-portraits (pp. 6 and 68) indulged in browns reminiscent of the old masters, without a single highlight of pure, forth-right colour to enliven them. It was as if the fascination of his own face crowded out all possibility of experiment with colour.

Yet van Gogh's entire attention was on colour. He painted a series of flower still lifes (pp. 70–73), setting himself the task much as he had with the series of peasants' portraits. He produced over forty of them; they are not exactly among his greatest masterpieces, but they certainly prove his determination to master colour. The still lifes represented a transitional phase for van Gogh, at the end of which he was to be profoundly aware of the power of different tones. Afterwards he would indeed be able to create using only the palette – but for the present, Vincent was still painting what was out there. His fidelity to realism was as yet unwavering.

These still lifes nevertheless represent his furthest progress to date. Van Gogh might have started improvising freely from the palette, adding colour for its own sake, were it not for a figure of authority who confirmed him in his attachment

A Pair of Shoes
Paris, early 1887
Oil on canvas, 34 x 41.5 cm
Baltimore (MD), The Baltimore Museum
of Art, The Cone Collection

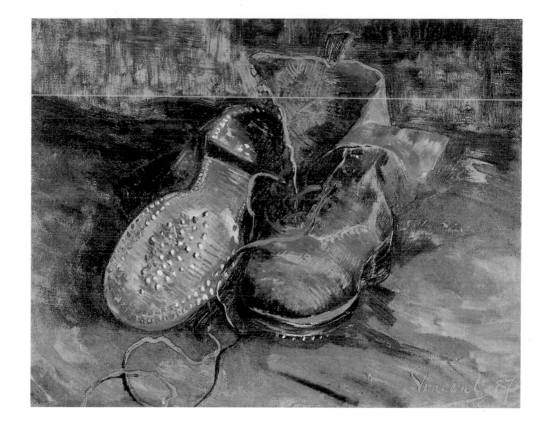

Three Pairs of Shoes
Paris, December 1886
Oil on canvas, 49 x 72 cm
Cambridge (MA), Fogg Art Museum,
Harvard University

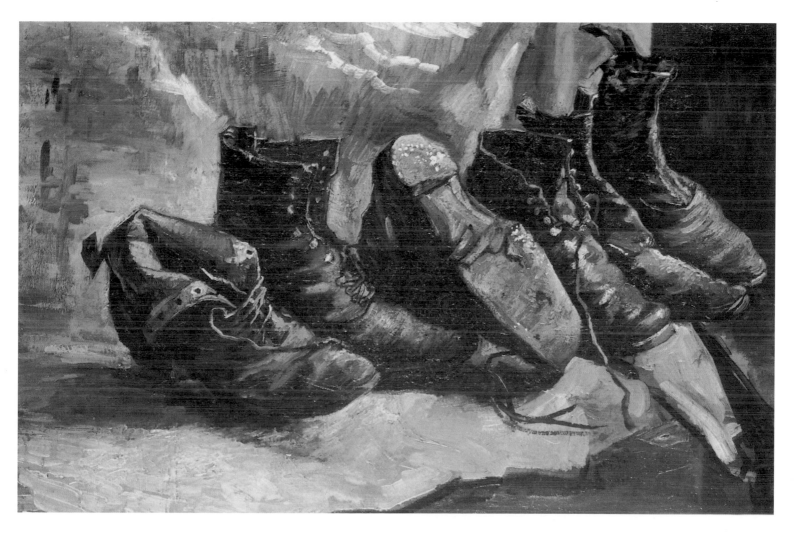

View of Paris from Vincent's Room in the Rue Lepic
Paris, Spring 1887
Oil on cardboard, 46 x 38.2 cm
Amsterdam Rijksmuseum Vincent van Gogh,
Vincent van Gogh Foundation

to the subject: Adolphe Monticelli. Monticelli was a French painter of Italian extraction. His pictures of flowers were extremely pastose. "I have been trying to convey intensity of colour," van Gogh wrote to Lievens (Letter 459a), referring to the flower still lifes. That was precisely it. The work he painted in 1886 was out to "convey"; it was still looking for (and in need of) the corrective reality would supply.

Isms, Isms, Isms

Hence the *Three Pairs of Shoes* (p. 75), well-worn footwear as the trademark of an artist who has travelled a long way. Van Gogh's attention is on the signs of heavy use. The worn leather, the ragged sole, the turned-back upper and the toe of the welt parting from the sole, are all emphatic indications of wear and tear. The shoes are seen without any illusions – a still life of fanatical mimetic fidelity. Similarly, the halfboots in *A Pair of Shoes* (p. 75, top) are by no means fashionable footwear. These, though, have a warmer orange tint and are seen contrasting

Self-Portrait
Paris, Spring 1887
Oil on cardboard, 42 x 33.7 cm
Chicago (Il.), The Art Institute of Chicago

against the blue of some indefinable background. White dots are used to convey the hobnails in the visible sole – though these dots also have a purely aesthetic function, as have the seemingly endless brushstrokes that do service as shoelaces. Vincent signed and (this is rare) dated the painting. He was making it quite clear that this picture was done in 1887, unlike another (p. 74) which probably dated from summer 1886. The artist's approach to colour and brushwork was now in the foreground. The earlier painting, with its love of detail, was losing the battle to a more individual approach that was unafraid of ornamental use of lines and loud colours. The two still lifes of shoes define the 1887 watershed: van Gogh was questioning his previous use of local colour and his purely descriptive style. He was quitting the analytic approach to his subjects which the 'realistic' method had impelled him to take.

The *Self-Portrait with Straw Hat* (p. 69), done in summer 1887, similarly departs from the approach of earlier work. Now it is colour analogy that engages the painter's main interest, and the picture contains a cheerful, summery abundance of yellows in the shirt, face, hat and even the background. Carefully deployed violet strokes add a subtle contrastive note. It is only in the ginger of the beard that

View of Paris from Montmartre
Paris, late Summer 1886
Oil on canvas, 38.5 x 61.5 cm
Basle, Öffentliche Kunstsammlung Basel,
Kunstmuseum

van Gogh still retains the principle of local colour; but even here the red is used too sporadically to rate as altogether descriptive. The artist's familiar face has become a terrain for visual experiment. The basic features of his face have naturally been retained, and van Gogh's quirky blend of shyness and severity is readily identifiable. But it is no longer a portrait done merely by looking in the mirror. It records an appearance in a form created for the sake of the painting's effect.

If we now turn to *Vegetable Gardens in Montmartre: La Butte Montmartre* (p. 81) we find the canvas covered in colourful brushstrokes: the fences and sheds are treated in the same way, so that they are stylistically integrated into the overall visual effect. The landscape itself has become an excuse for spectacular stylistic showmanship which tends to obscure the subject. The lines are like iron filings being drawn to a magnet: this chaotic approach has aptly been described as van Gogh's magnetic field method. As if on remote control, the brush flits about the canvas, adding here a stroke and there a stroke.

In 1887 van Gogh finally discovered that autonomous value of a painting which Cézanne referred to as a "harmony parallel to Nature." The change did not happen with explosive abruptness; rather, it happened without deliberate volition in the wake of Impressionism. Reality (the Impressionists believed) should enter by the eye, directly, without any interference from thought, and should leave a pure, visual impression in the resulting picture. The main thing was speed: only speed could prevent conceptual knowledge from hijacking the natural subject. To spend time and effort re-creating the colours of things on the palette, and to establish their contours on the canvas, would only have diminished the vitality of the work. The characteristic sketchy style of the Impres-

sionists was an inevitable consequence of this attitude. Ironically, though, the method evolved into its own opposite, using its engaging patterns of lines and colours to interpose a veil between the world and the picture far more than faithful realism ever did. The dabs and strokes and colourful dots highlighted the two-dimensionality of the canvas, which came to develop its own unsuspected qualities in a material sense. The painting no longer represented Nature, it simply presented itself: it became essential to bear this obvious fact in mind. In 1887 van Gogh, too, perceived it as a problem.

It was rarely, of course, that he painted a genuinely Impressionist painting. *Trees and Undergrowth* (p. 80), for instance, done in summer 1887, plainly picks up from work of Monet's such as the painting of an apple tree in blossom (Paris, Private collection). Like the French artist, whose 1874 *Impression, soleil levant* (Paris, Musée Marmottan) had given the movement its name, the Dutchman was in a sense trying to convey a feeling of Nature. This green infinity with dabs of bright yellows and whites is not a faithful copy of a wood. Yet the sense of growth fills the canvas all the more powerfully: there is vitality in this burgeoning green-

Fishing in the Spring, Pont de Clichy
Paris, Spring 1887
Oil on canvas, 49 x 58 cm
Chicago (IL), The Art Institute of Chicago

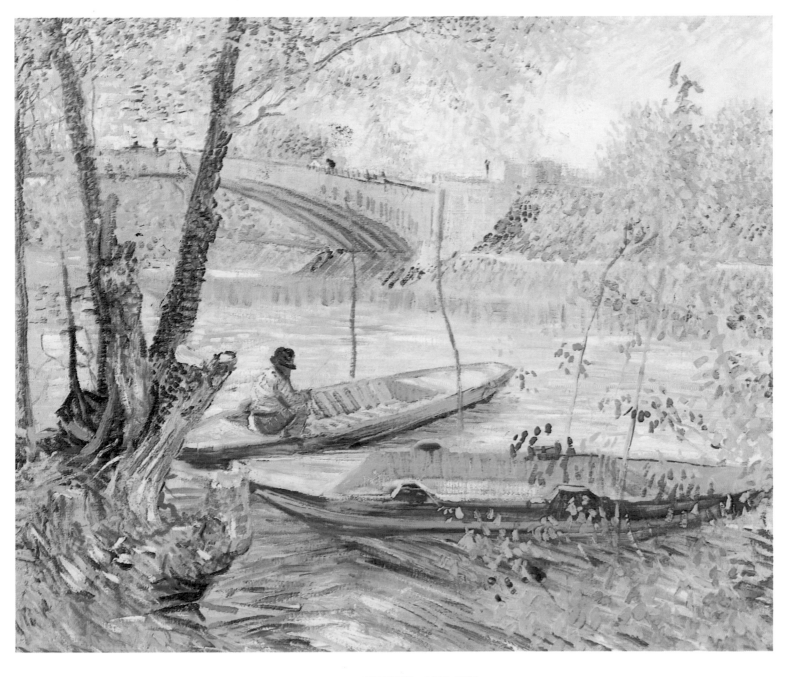

Trees and Undergrowth
Paris, Summer 1887
Oil on canvas, 46 x 36 cm
Amsterdam, Rijksmuseum Vincent van Gogh,
Vincent van Gogh Foundation

ery, and the work becomes a kind of Creation in its own right. The artist is the instrument of the creative energy demanded by Nature, and witnesses with astonishment the process he is himself caught up in. His work is Nature's.

The pleasure van Gogh was here taking in the plant world, the realm of vegetative growth, presently came under attack for neglecting immutable universals and objectivity. What Impressionism had plainly achieved was now expected to make way for Post-Impressionism's goal of harmonizing flux and stasis, change and constancy. In 1887 the Pointillists had occupied all the strategic positions, which meant that van Gogh was registering the sequential progress of two different movements at the same time. No doubt he was basically uninterested in the divergences of their programmes; but the Pointillists had a leading spokesman who also happened to have become a good friend of van Gogh's – Paul Signac, the right-hand-man of the movement's leader Georges Seurat and one of the few fellow-painters van Gogh was close to.

Self-Portrait (p. 77) was done early in 1887. The liveliness of the visual effect is not of a physical nature, as it was in the Impressionist view of trees and undergrowth; the basis is physiological. Charles Henry and Charles Blanc, the

Pointillists' foremost theorists, had found that juxtaposed dots of pure colour provoke a kind of visual panic: the eye compulsively tries to mix the distinct tones and see the staccato of dots as an even surface, as usual. The principle of optical mixing really does work – but it involves a constant sense of agitation. Now artists were trying to cool the overheated excitement of the dots by choosing static subjects: the timeless dignity of still lifes or portraits would help freeze matters. The plural meanings of the present moment (a truism in all modern world views) had been rendered by Impressionism in the polarity of the picture as window and the picture as surface. Pointillism expanded this polarity by adding the conflict of static and dynamic. In his self-portrait, van Gogh found a less radical way of expressing this conflict. Consistently enough, the lucid dabs of colour are used for the jacket cloth and the background but not for the living flesh of his face.

He borrowed another aspect of the Pointillist programme in *View from Vincent's Room in the Rue Lepic* (p.76). If dabs provide visual dynamics, a carefully calculated balance of verticals and horizontals can provide a static stability. We see this idea at work in van Gogh's panorama. A year before, in *View of Paris*

**Vegetable Gardens in Montmartre:
La Butte Montmartre**
Paris, June–July 1887
Oil on canvas, 96 x 120 cm
Amsterdam, Stedelijk Museum

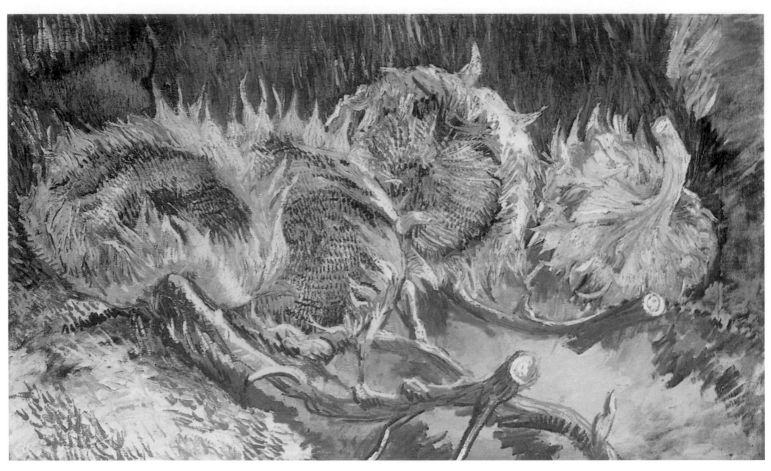

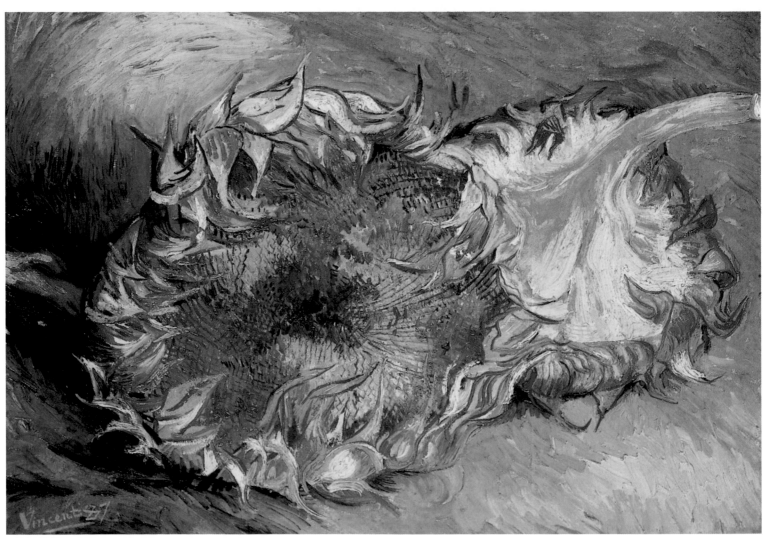

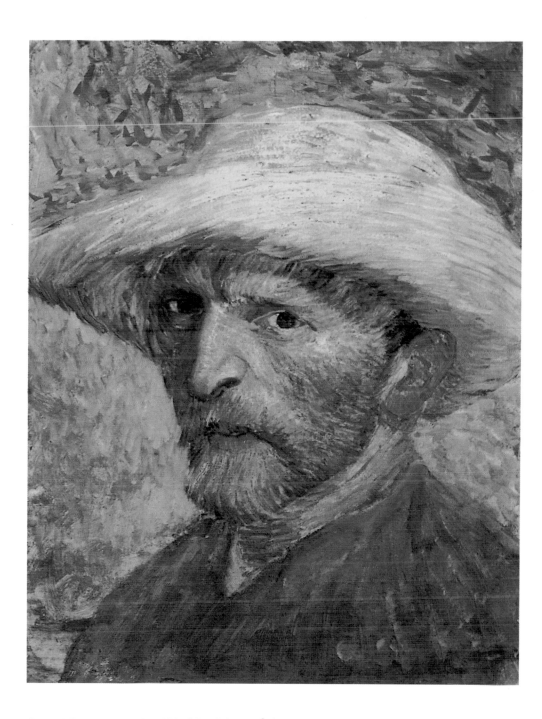

Self-Portrait with Straw Hat
Paris, Summer 1887
Oil on canvas on panel, 35.5 x 27 cm
Detroit (MI), The Detroit Institute of Arts

Page 82 top:
Four Cut Sunflowers
Paris, August–September 1887
Oil on canvas, 60 x 100 cm
Otterlo, Rijksmuseum Kröller-Müller

Page 82 bottom:
Two Cut Sunflowers
Paris, August–September 1887
Oil on canvas, 43.2 x 61 cm
New York, The Metropolitan Museum of Art

from Montmartre (p. 78), his vision of the city's houses had been of an infinite sea; but now the sea had been dammed by walls, roofs and the horizon. To find the distance, our gaze must first negotiate a set of geometrical obstacles. Beyond, of course, lies the promise of freedom, the richness of Life. And in that beyond van Gogh has again abandoned Pointillist technique.

Van Gogh was adrift in circles where everyone was hunting for the utterly new and convinced that he alone had found it. A standardized approach to Art had become as impossible as an unambiguous view of the world; so everyone was creating a language of his own, his own projects and manifestoes, and everyone subscribed to one style or another that he could believe to be universally valid. The metropolis was flooded with isms: Impressionism, Symbolism, Cloisonnism, Synthetism, Pointillism and more beside. This plurality signalled the revolutionary vitality of modern art, but also the marginal role it was increasingly having to accept.

Van Gogh himself never subscribed entirely to any one trend. He tried things out and borrowed whatever suited his artistic repertoire. He had gone

Nude Woman Reclining
Paris, early 1887
Oil on canvas, 24 x 41 cm
De Steeg (Netherlands), Private collection

to Paris to learn, and he knew there were many who had something to teach him. To the burgeoning art of Modernism, van Gogh applied an ism that had been characteristic of the entire 19th century: eclecticism. Unlike the academics who had not scrupled to rummage in the traditional box of tricks, though, he did not stop there. He stirred the Parisian brew and fished out what he found to his taste. The ism that made the strongest appeal to him was the Japonism.

Van Gogh also tried his hand at new subjects. For the first time he painted the sunflowers which were to become the symbol of his artistic self *par excellence*. He placed their fiery yellow against a familiar blue contrast (p. 82) and used short strokes and dabs for the seeds; but these borrowings from the isms leave no disagreeable aftertaste of imitativeness with us. Van Gogh's way of seeing – through his own tinted panes – was committed and caring. The ragged yellow petals, cut stems and robust close-up suggest metaphors in plenty: metaphors of menace but also of solidarity with a living thing about to wither and die. The casual atmospherics of Impressionism have been left behind, and authoritatively so.

Nude Woman Reclining, Seen from the Back
Paris, early 1887
Oil on canvas, 38 x 61 cm
Paris, Private collection

Page 85:
Agostina Segatori Sitting in the Café du Tambourin
Paris, February–March 1887
Oil on canvas, 55.5 x 46.5 cm
Amsterdam, Rijksmuseum Vincent van Gogh, Vincent van Gogh Foundation

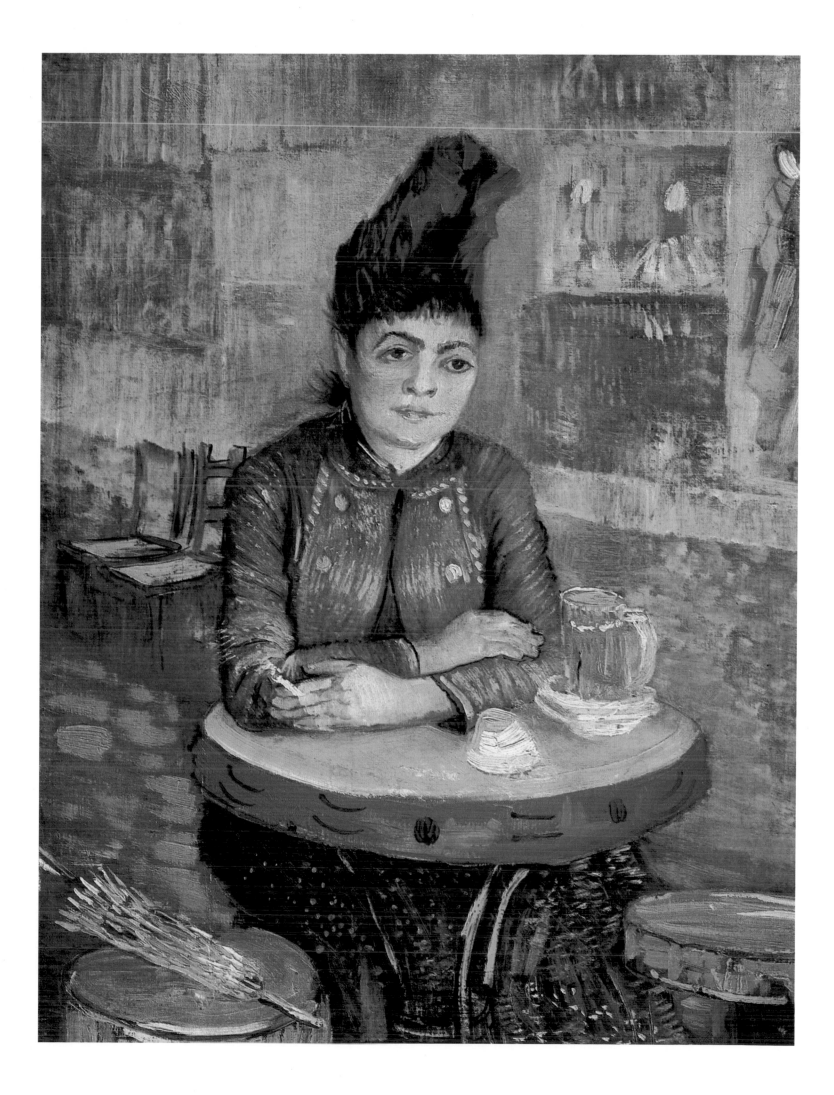

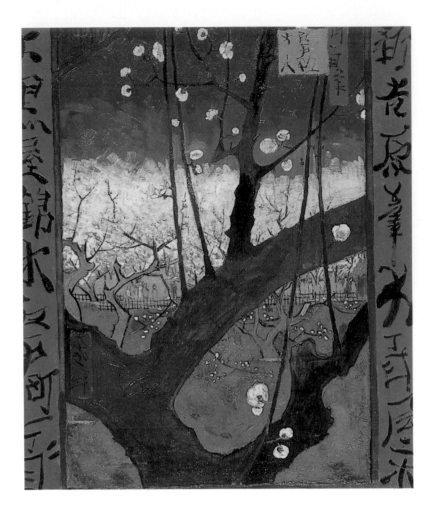
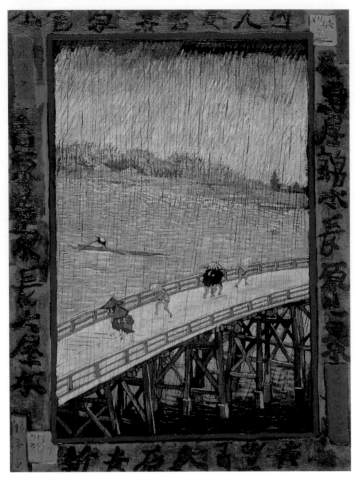

Left:
Japonaiserie: Flowering Plum Tree
(after Hiroshige)
Paris, September–October 1887
Oil on canvas, 55 x 46 cm
Amsterdam, Rijksmuseum Vincent van Gogh,
Vincent van Gogh Foundation

Right:
Japonaiserie: Bridge in the Rain
(after Hiroshige)
Paris, September–October 1887
Oil on canvas, 73 x 54 cm
Amsterdam, Rijksmuseum Vincent van Gogh,
Vincent van Gogh Foundation

Van Gogh and Japonisme

In 1891 the influential critic Roger Marx declared that Japan had been as important for modern art as classical antiquity had been for the Renaissance. Thirteen years earlier, Ernest Chesneau (in his article 'Japan in Paris') had already noted the wildfire that had been spreading throughout the studios, stores and cosmetic parlours of the city. Japan had made its impact on 19th century culture.

In the age of the shoguns, Japan had been isolated and xenophobic. But at the 1867 Paris World Fair, Japan burst upon the scene like a bombshell, so to speak. The Japanese made skilful use of western notions of oriental mystery – and Paris gladly took object lessons from the articles that were offered. Novelty always prompts a vogue; and Japan was fashionable. Society ladies wore kimonos, placed screens in their salons, and adored the tea ceremony. In the course of time the vogue evaporated and was replaced by a profounder understanding of Japan.

There were artists who were satisfied with the lure of the exotic and added conspicuous, kitschy props such as a low-level table or a woodcut to their pictures. Others stripped their scenes of genre ingredients in imitation of the purity of Japanese interiors which (in their view) were properly devoid of anything superfluous. Yet others, few in number, adopted a lifestyle modelled on that of Japan. Van Gogh was one of these few, though naturally he passed through the other stages in the reception first. In Paris he went through the first three stages; and his decision to go south signalled his wish to find a true Japan of his own.

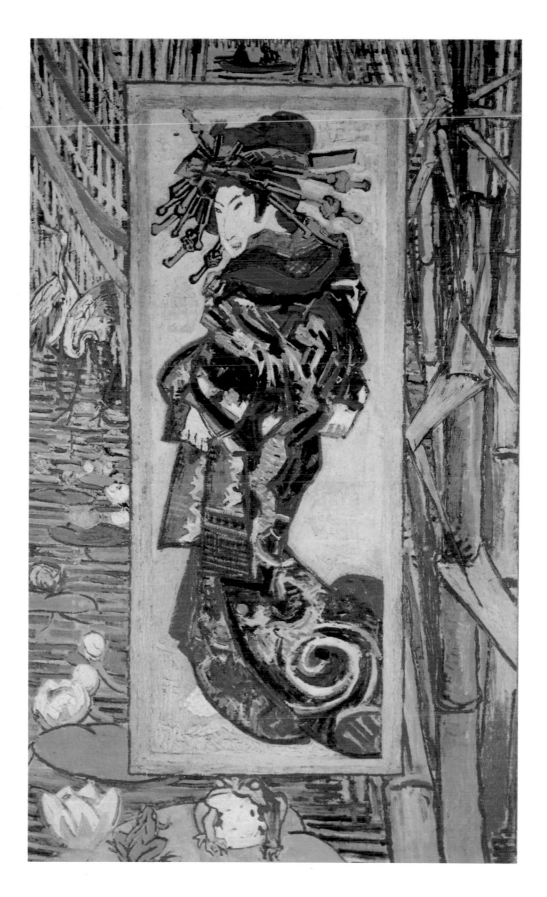

Japonaiserie: Oiran (after Kesaï Eisen)
Paris, September–October 1887
Oil on canvas, 105 x 60.5 cm
Amsterdam, Rijksmuseum Vincent van Gogh,
Vincent van Gogh Foundation

Back in Antwerp, van Gogh had already been decorating his walls with prints
of the Ukiyo-e (Popular) School. These scenes of everyday life were sold cheaply
in thousands by a growing number of western dealers in Japanese work. Van
Gogh practically spent his first Paris winter in Siegfried Bing's shop, a short walk
from his Montmartre flat. He was left to browse amongst the mysteries of orien-
tal art to his heart's content; and he started a collection of Japanese woodcuts

The Seine Bridge at Asnières
Paris, Summer 1887
Oil on canvas, 53 x 73 cm
Houston (TX), Collection Dominique de
Menil

for Theo and himself that ran into the hundreds. In spring 1887 he included
them in an exhibition he organized at the Café du Tambourin in Montmartre.

It was apparently then that van Gogh painted the portrait of the café's owner,
Agostina Segatori (p. 85). She had modelled for Camille Corot and for Jean Léon
Gérôme and now sat for van Gogh a few times too; the only nudes he ever
painted in oil were of her (p. 84). We see her sitting at a table in the Tambourin
that resembles the musical instrument that gave the café its name. Edgar Degas's
Absinthe (Paris, Musée d'Orsay) plainly inspired the setting. But in taking his
bearings from Degas, van Gogh was not so much out to record the hopeless
solitude of one woman seeking solace in alcohol and a cigarette as to practise an
Impressionist eye for a hazy, smoky atmosphere. Van Gogh has invested the full
resources of his modesty in painting an unprepossessing documentary picture:
merging unclearly with the greenish background are a number of Japanese
woodcuts on the wall panelling, doubtless from the collection of the brothers
van Gogh. They lack the laconic eloquence Edouard Manet found in them, in
his portrait of Zola (Paris, Musée d'Orsay). Van Gogh's prints look lost on the
wall; they seem to match the meditative, introspective, lost look of the woman
at the table. Like her hat, the prints are exotic accessories.

A resolve to appropriate Japan became apparent six months later when van
Gogh returned to a study method he had used in his early days as an artist:
copying. He tackled three Ukiyoye subjects, fitting them into his own repertoire
by imitating them – two Hiroshiges from his own collection, *Flowering Plum
Tree* (p. 86) and *Bridge in the Rain* (p. 86), and one by Kesaï Eisen, *Oiran*
(p. 87), which was on the cover of a Japanese number of *Paris illustré*, published
by Theo's company. Copies of this kind are known as japonaiseries. As far as we
know, van Gogh was the first to try his hand at them. And thus he embarked on
the second stage in his response to Japanese culture.

Van Gogh used these models primarily to perfect his grasp of colour. This was
the first time he had brought himself to use monumental areas of unmixed and
unbroken colour, undimmed by questions of light and dark, in their full, vivid,

On the Outskirts of Paris
Paris, Spring 1887
Oil on canvas, 38 x 46 cm
United States, Private collection

radiant power. He had always valued his fourth, wholly uncanonical contrast very highly too: that between black and white. The Impressionists had exiled black from their palette as a non-colour, but it was vital to the prints, and the Ukiyo-e School confirmed his love of the sensuousness and symbolic power of black.

Uninitiated into the greater mysteries of perspective, van Gogh had rigged up a rudimentary frame in the manner we have already described. The angles of vision that resulted from using this crude aid were not unlike those of the Japanese prints. The diagonals van Gogh's frame tended to insist on represent a distinct similarity. His *Seine Bridge* (p. 88) looks like an Impressionist version of Hiroshige's *Bridge in the Rain*; no doubt the resemblance was coincidental and not intended. At all events, van Gogh found his own spatial methods confirmed by the Ukiyo-e artists. And their decorative flatness, which counteracted the pull of depth, also impressed him. This afforded an option of staying on the flat surface of the canvas or entering the depths of the picture, as he preferred – and who could say what was incompetence and what an intentional aesthetic effect? One thing was sure: the woodcuts were there as a precedent.

The portraits of Père Tanguy (pp. 90 and 91) are particularly interesting. Julien Tanguy, from whom Vincent bought his paint, deserved his soubriquet. He had seen the glorious days of the Commune and, as a Communard, had been sent to prison. Now, his utopian vision of a better world distinctly faded, he himself was kindness in person, giving credit, presents and support to needy artists. The back rooms of his modest store were a gallery of sorts where their work could be viewed and bought. He saw the artistic idealists of the modern movement as fellow-travellers who had been ignored, misunderstood and despised as he himself had been. Tanguy's premises provided the first opportunity ever to see works by Seurat, Cézanne, Gauguin and van Gogh together in one place: the four precursors of the 20th century who at that time were of little or no interest to anyone. Vincent admired the old man's calm serenity.

Page 90:
Portrait of Père Tanguy
Paris, Winter 1887/88
Oil on canvas, 65 x 51 cm
Collection Stavros S. Niarchos

Page 91:
Portrait of Père Tanguy
Paris, Autumn 1887
Oil on canvas, 92 x 75 cm
Paris, Musée Rodin

His two portraits of Père Tanguy are very similar. The earlier (p. 91) is a shade more conventional, as we might logically expect. The background is covered with woodcuts in memory of the beginnings of van Gogh's Japonisme. Now they are so clear we could almost reach over and touch them. Most of them are identifiable as prints from the brothers' collection. What is far more arresting than these visual quotations, though, is the presence of the sitter himself, who has the dominant quality of a figure in an icon. There is not a hint of the spatial to distract his gaze. It is as if he and Japan were one, and the Ukiyo-e motifs (actor, courtesan, sacred Mount Fujiyama) were there for him alone. The portrait is not a hesitant approach; on the contrary, van Gogh boldly attempts no less than a synthesis of oriental and western art, and one that is far beyond the syncretism of his early period at that. But he still has to haul out a fine number of motifs in order to guarantee his point. He does not enact or re-create it; he tries to show it thematically.

Without a doubt, van Gogh's most daring venture is *Italian Woman* (p. 93). His model here may have been Agostina Segatori again, as in the Café du Tambourin portrait (p. 85) – the woman's full lips and broad nose (and the title) suggest as much. In this picture van Gogh's Japonisme draws upon resources that have little to do with qualities of the sitter. For instance, he imitates perfectly the crinkly surface effect of what was called Japanese paper, an approach that makes this painting a stylistic anticipation of a manner that later matured in Arles. We should also note two other things. One is the thrilling two-dimensionality of the painting, with its ornamental border at the top and right; this is quite simply the narrow side, the threads that attach to the frame. The other feature is the purely decorative quality of the colours, which do not so much describe the woman's skirt as offer a red and green contrast to balance the use of analogous yellow shades. Small wonder, perhaps, that van Gogh could write from Arles, in summer 1888 (Letter 510): "My whole work is founded on the Japanese, so to speak."

Italian Woman (Agostina Segatori?)
Paris, December 1887
Oil on canvas, 81 x 60 cm
Paris, Musée d'Orsay

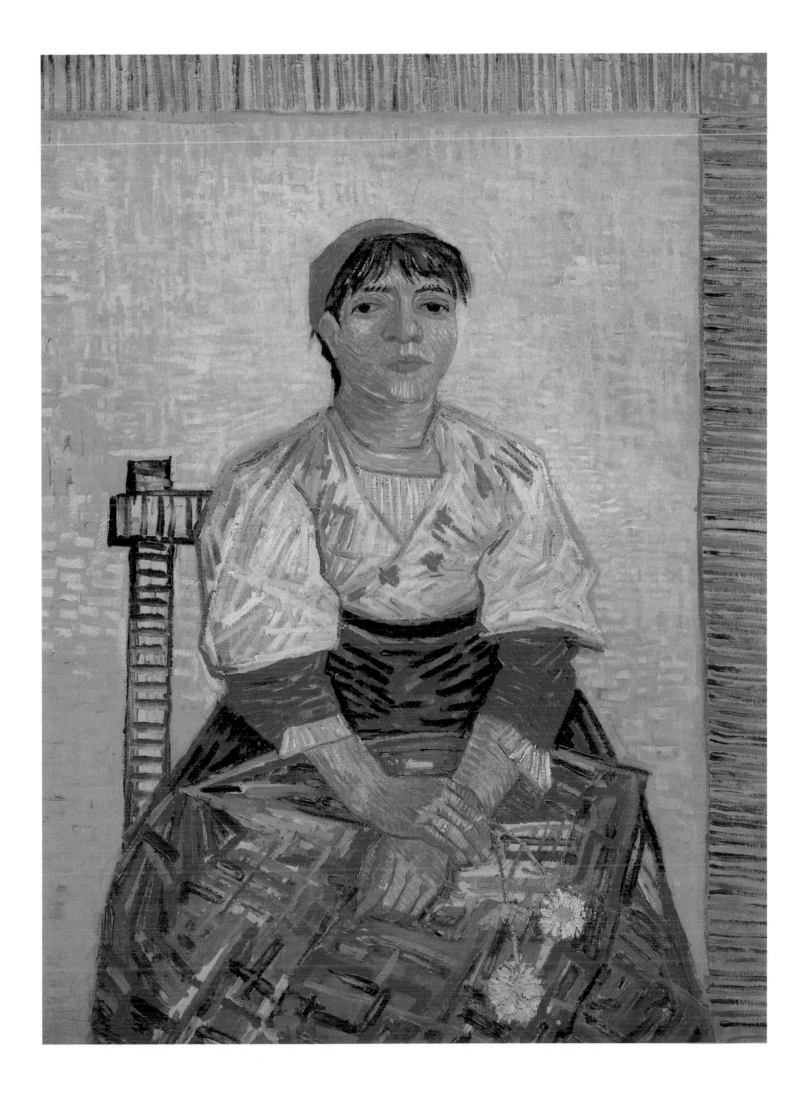

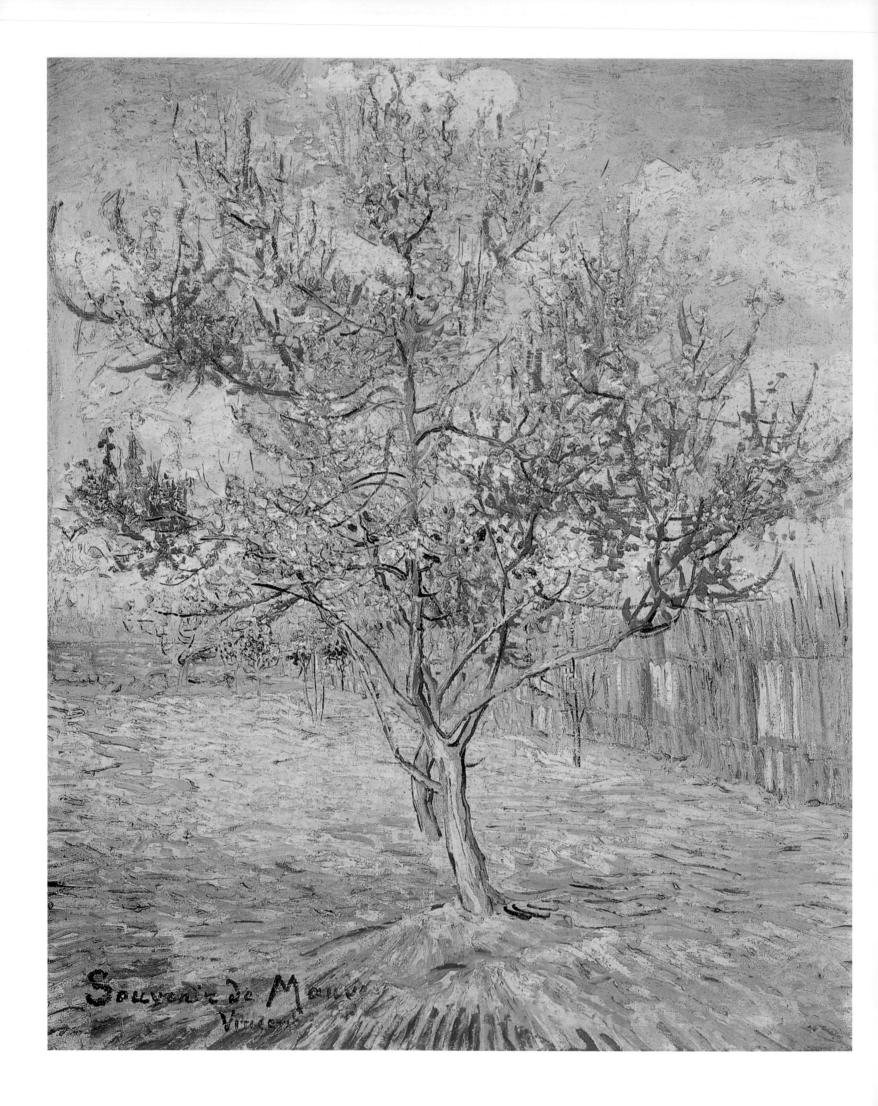

Painting and Utopia
Arles, February 1888 to May 1889

Arles – The Heart of Japan

"If one desires Truth, Life as it really is," van Gogh wrote to his sister (Letter W1), "the Goncourts' *La fille Elisa*, for instance, and Zola's *La joie de vivre*, and so many other masterpieces tell of life as we experience it ourselves, thereby satisfying our wish to be told the truth. Is the Bible enough? I believe that Jesus Himself would today tell those who sit about consumed by sadness: He is not here, He is risen again. Why do ye seek the living among the dead? It is precisely because I find the Old beautiful that I have all the more reason for finding the New beautiful. All the more reason, because in our own time we ourselves are able to act." Here, van Gogh again takes up the arguments that led to his *Still Life with Bible* (p. 41). Zola and the Concourts were providing him with the guidelines for a life in keeping with the times. The fact that they were engaged in literary work made no difference: van Gogh drew no distinction between Art and Life. He merely changed his models; the devotional, Christian pamphlets had been replaced by unremitting analytical writings of an altogether modern type.

The Bible was banished from all the still lifes van Gogh painted in Paris in 1887, but still he was forever including the books that now informed his way of thinking. *Still Life with Three Books* (p. 97) features *La fille Elisa* along with Zola's *Au bonheur des dames* and Jean Richepin's *Braves gens*. Doubtless, van Gogh was thinking in terms of colour compatibility, too, when he painted them. But his attention is so wholly on the three slim volumes that he has lost sight of the unity of the painting; so, in a sense, he has had to round off the centre and make do with an oval format. The grubby cheap editions of the novels, dog-eared and plainly well-read, are all the more striking as a result. Van Gogh has recorded the titles faithfully, though the words are there not so much to portray the lettering on the spines of the books as to inform us of certain names and thus admit us to the artist's literary predilections.

These books represent van Gogh himself – just as the chairs or shoes do. They are symbols, and operate as the traditional symbolic idiom of religion operates. Vam Gogh's symbols, though, no longer have any universal relevance. If we are to decode their meaning, we need to be familiar with the life of the artist and the significance he saw in them; for if we do not try to grasp this background, the books will simply be objects, of no greater interest or importance than any other objects. In van Gogh, then, we see a fundamental feature of Modernism becoming established: the phenomenon of individual symbolism. A Christian

Pink Peach Tree in Blossom
(Reminiscence of Mauve)
Arles, March 1888
Oil on canvas, 73 x 59.5 cm
Otterlo, Rijksmuseum Kröller-Müller

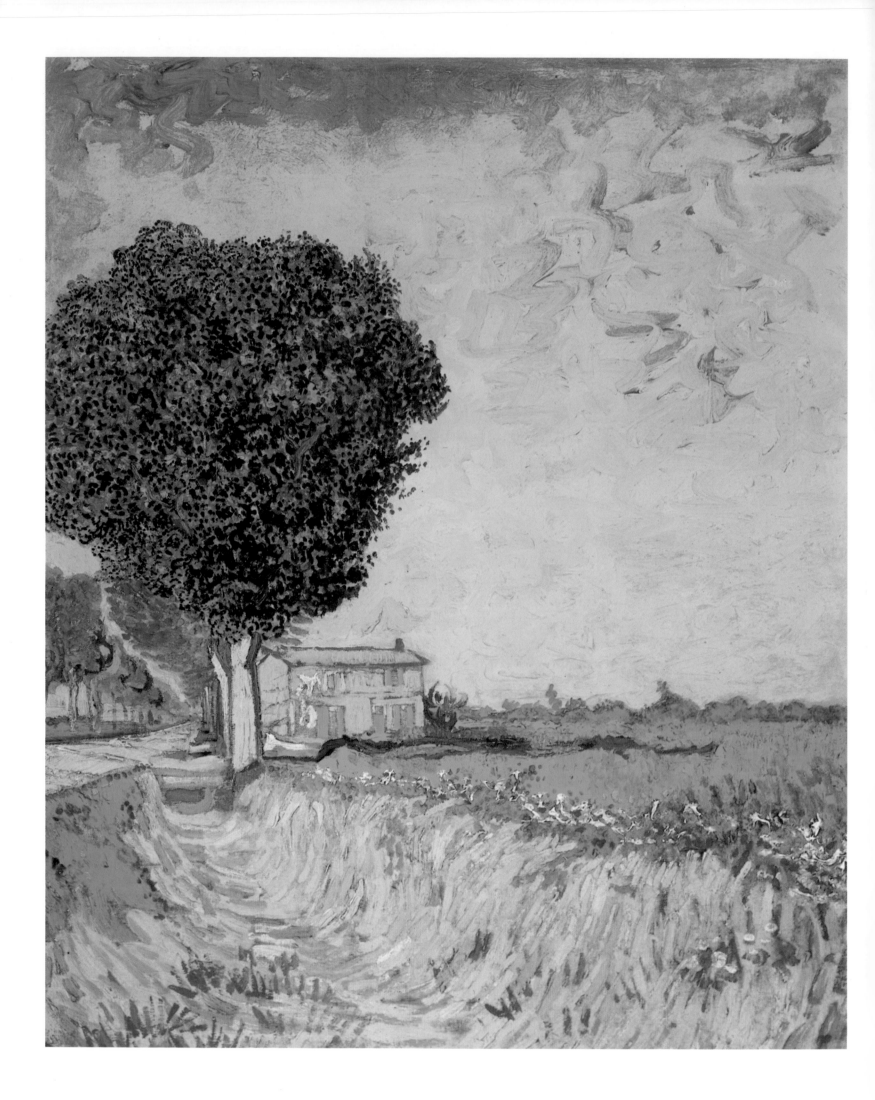

Still Life with Three Books
Paris, March–April 1887
Oil on panel (oval), 31 x 18.5 cm
Amsterdam, Rijksmuseum Vincent van Gogh,
Vincent van Gogh Foundation

upbringing, Romantic intensity, socialist hopes for the future and doubtless his deficient training as an artist all played their part in this

Art and Life constituted a single unity. Van Gogh himself was still far from making a programme of this unity. Indeed, in a manner of speaking he had got himself into this position against his own wishes. But Art was never to be the same again; and in van Gogh it had a figurehead who had taken this course in exemplary fashion, consistent and unwavering until his death. The unity of Art and Life, as practised by van Gogh, was founded on a deep feeling for the unfamiliar, the other. His own art was fundamentally alien to him,, something for which we can once again hold his poor training responsible. At the slightest technical problem he was cast upon his own devices, wondering about the point of doing something that was so obviously causing him difficulties. The vehemence with which he asserted his concept of art was simply an aggressive manifestation of a deep-rooted artistic insecurity. His very existence was alien to him. He felt he was out on the edge, with nothing to lose. If Life should fall, it would take Art with it. And if Art were to fail, Life too would be at an end.

"There is nothing but white in this area," Signac wrote in his diary in 1894, only a few years after van Gogh's death. "The unceasing reflections of light swallow up all the local colours and make the shadows appear grey. Van Gogh's Arles pictures are wonderfully impetuous and intense. But they do not in any way convey the southern light. People expect to see red, blue, green and yellow in the south. The north is however quite colourful (local colours), whereas the south is full of light." If van Gogh had gained control of colour, it was in spite of the fact that he was living in Provence, not because of it. The region he had gone to in February 1888 was less a supply of motifs than a utopia, a place that demanded a new principle of Life.

Van Gogh's existence depended on the motifs and atmosphere of a certain place; he needed to establish a symbiotic relation with his surroundings through his work. In the north, he had not painted darker merely because there was less brightness there; amidst the wretched, gloomy figures of the weavers and rural labourers, he had simply felt the place to be too confined for brightness and

A Lane near Arles
Arles, May 1888
Oil on canvas, 61 x 50 cm
Kiel, Pommern Foundation

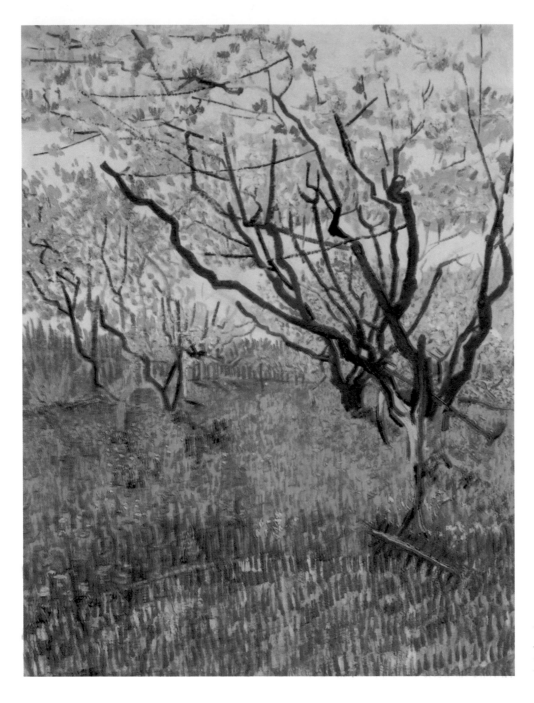

Orchard in Blossom
Arles, March–April 1888
Oil on canvas, 72.4 x 53.5 cm
New York, The Metropolitan Museum of Art

colourfulness. The colours and emotions were mutually dependent. And in the south, too, they afforded mutual support. Van Gogh's emotions were becoming more fictitious, as it were, more independent of the torments of actual reality – but this only in the degree to which he had adopted an autonomous use of colour that was answerable to him alone. Van Gogh was looking for Japan in the south. And he found it, too – abstracting ever more powerfully from the circumstances of his own existence and longing for that oriental paradise with the same fervour as he expressed in his colours. The months leading up to his breakdown were informed by the imagined conception of that better world promised by Japan. For three quarters of a year of happiness, the unity of Art and Life was a dynamic reality.

Any question as to why van Gogh chose Arles in particular is of secondary interest. It is certain that he wanted to go to Provence. Monticelli had ended his life there, in Marseille; Zola and Cézanne had spent their childhoods there, in Aix-en-Provence. Provence was simply the south; and it would afford a readier

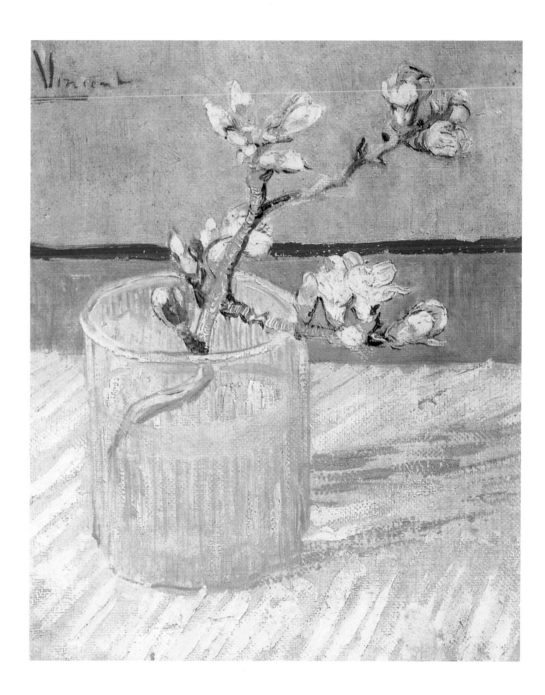

Blossoming Almond Branch in a Glass
Arles, early March 1888
Oil on canvas, 24 x 19 cm
Amsterdam, Rijksmuseum Vincent van Gogh,
Vincent van Gogh Foundation

means of formulating his critique of civilization. Initially, van Gogh planned to make only a short stop in Arles. Later he was to recall the childlike anticipation that had seized hold of him in rueful tones: "I can still remember vividly how excited I became that winter when travelling from Paris to Arles. How I was constantly on the lookout to see if we had reached Japan yet." (Letter B22). It seems that he simply stopped once he had found a place where he could abandon his lookout and enter into his Promised Land, his utopia, his Japan, which continued to hold him in thrall for the time being. Van Gogh seized hold of Japan with all his innate vitality. A comprehensive synthesis that linked the individual motif and an overall view of life now replaced the analytic approach characteristic of his initial Paris response to oriental culture.

Van Gogh had always prided himself on the speed with which he worked. Now his *premier coup* manner came into its own: "A Japanese draws rapidly, extremely rapidly, like lightning, because his nerves are finer and his feelings simpler." (Letter 500). Van Gogh could now place his own idiosyncratic style in the cen-

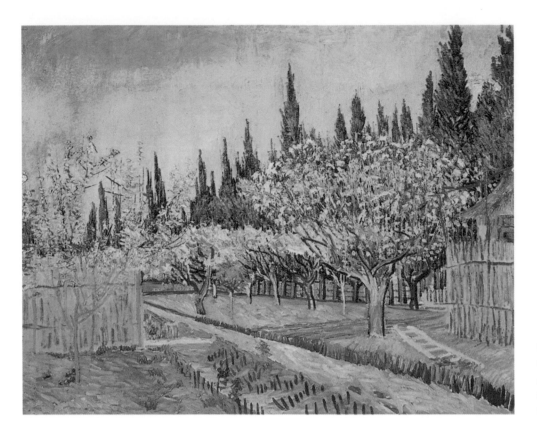

Orchard in Blossom, Bordered by Cypresses
Arles, April 1888
Oil on canvas, 65 x 81 cm
Otterlo, Rijksmuseum Kröller-Müller

turies-old tradition of an advanced civilization. The astonishing series of master-pieces he produced in 1888 can be accounted for if we see that what was new was not the speed at which he worked but his tremendous assurance, which blithely brushed aside whatever doubts he might have had concerning the meaning of what he was doing. With sovereign assurance, he used what he had learnt in Paris, moulded it, and gave it a quality of impressive monumentality. His assurance came from his conviction that he was establishing a connection

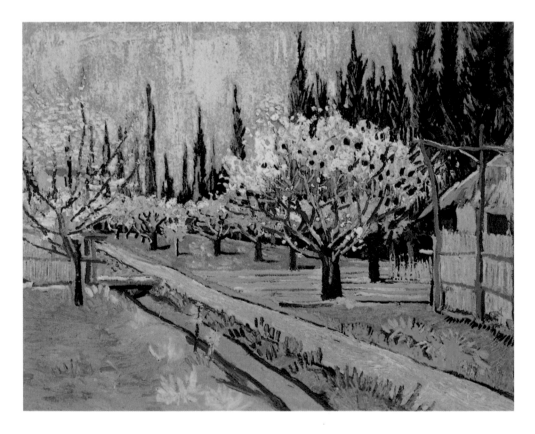

Orchard in Blossom, Bordered by Cypresses
Arles, April 1888
Oil on canvas, 32.5 x 40 cm
New York, Private collection

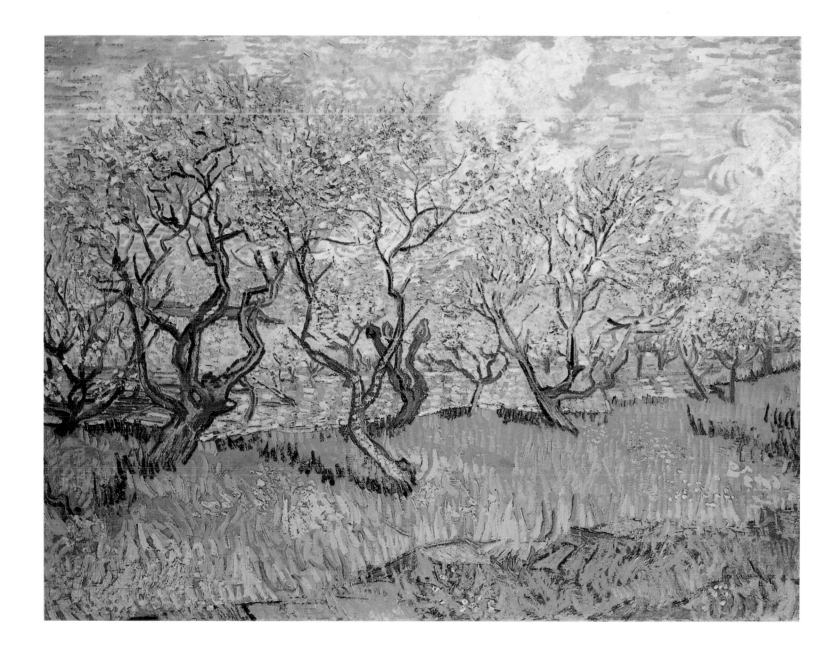

with the art he admired so much and with the exemplary lifestyle of the Orient. As if he was aware that this new harmony (which he maintained for nine months) was precarious, he tried painting anything and everything. Every day was a day full of work.

Orchard in Blossom
Arles, April 1888
Oil on canvas, 72.5 x 92 cm
Amsterdam, Rijksmuseum Vincent van Gogh,
Vincent van Gogh Foundation

Orchards in Blossom

Art was always to have its everyday use: thus the Japanese motto, in accordance with which pictures had a decorative function in interiors, a function they retain to this day. Hence irises bloom on painted screens, while outside the real thing is flowering in full splendour. Hence snowy landscapes adorn the walls, while the countryside is in the icy grip of winter. Hence, too, Hiroshige's blossoming twigs only grace houses when the real buds start shooting in spring. The rest of the time they are kept from view: "The drawings and curios are kept in safe places in drawers," declares van Gogh (Letter 509). Van Gogh thus found that his fondness for seasonal change had high-level support – from the Japanese. He had always revelled in the contrasts and changes afforded by Nature; in a

Orchard in Blossom (Plum Trees)
Arles, April 1888
Oil on canvas, 55 x 65 cm
Edinburgh, National Gallery of Scotland

sense, his artistic creativity represented a pursuit of Nature. Thus the views of orchards in blossom which he painted shortly after arriving in Arles have a cheerful, springtime atmosphere. But they are more than merely the product of a seasonal mood. As if he and the region had colluded, van Gogh found a world of motifs which could not have been more Japanese. He really did not need Japanese prints any more as he had done in Paris, when he had borrowed the little trees and budding blossoms from Hiroshige. The orchards were his utopia.

As a matter of fact, the south had welcomed him with snow. For the first few days, Japan had been a question of flower arranging. Unperturbed, van Gogh broke a budding twig off a tree and put it in a glass of water, waiting for the blossoms. *Blossoming Almond Branch in a Glass* (p. 99) might thus be described as a token of promise in more senses than one. The twig has been cut off, severed from the life-giving force of Nature, and will not be a thing of beauty for very long at all. Though the picture records van Gogh's happy anticipation, it also captures the sense of precarious tenure and danger that accompanied it.

If he needed to clutch at the splendour of the blossoms, wildly and feverishly, it was not only because the wind would, in the nature of things, soon be taking them from him, but also because he had to get to grips with his own vision,

Orchard with Blossoming Apricot Trees
Arles, March 1888
Oil on canvas, 64.5 x 80.5 cm
Amsterdam, Rijksmuseum Vincent van Gogh,
Vincent van Gogh Foundation

Orchard with Peach Trees in Blossom
Arles, April 1888
Oil on canvas, 65 x 81 cm
New York, Private collection

which (however great his imaginative powers) needed a correlative in reality. The
speed with which he went to work, which was indeed increased in Arles, opened
up a new visual world almost without his intending it. In the orchard series we
see an altogether personal, constantly varying version of Impressionism, an ap-
proach that bore all the signs of a wholly individual style. Van Gogh was trying
to see through the atmospheric veil of light and colour, to make lasting contact
with those points that could underwrite a sense of himself, a sense of security.

Van Gogh was rarely to find a subject that expressed the eternal in the fleeting and also pleased the eye as thoroughly as the trees in blossom did. They were timeless yet transient, fragile yet with the solid presence of icons. The paradoxical nature of these trees matched the paradoxes within van Gogh himself. His use of light made the major contribution in the presentation of this paradoxical quality, and in this respect (once we have recorded his obvious debt to Japan) we may be nearest the mark if we describe the orchard series as Impressionist. Impressionism itself had become a rather stale *plein air* routine by then; but van Gogh's paintings highlighted its strengths and made exciting use of them.

There is one case in which van Gogh revealed his procedure very openly. Two versions of the view of a garden with a stream in the foreground and cypresses at the back exist. One was plainly a preliminary study for the other. The earlier, small-format, less polished version (p. 100) gave its attention to recording the subject, setting out the topography, noting the two fenced-in huts at the sides. This version betrays the use of van Gogh's perspective frame in its emphasis on the left-hand vertical, the diagonals of stream and path, and the almost horizontal row of treetops receding into the background. The study is still more a drawing than a painting. It makes a distinctly unfinished impression, with the blobs of thick white squeezed from the tube looking rather out of place in the trees, compared with the delicate draughtsmanship that has gone into the scene as a whole.

Left:
Peach Tree in Blossom
Arles, April–May 1888
Oil on canvas, 80.5 x 59.5 cm
Amsterdam, Rijksmuseum Vincent van Gogh,
Vincent van Gogh Foundation

Right:
Blossoming Pear Tree
Arles, April 1888
Oil on canvas, 73 x 46 cm
Amsterdam, Rijksmuseum Vincent van Gogh,
Vincent van Gogh Foundation

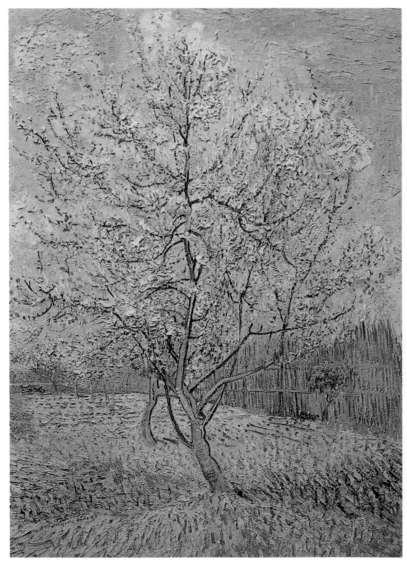
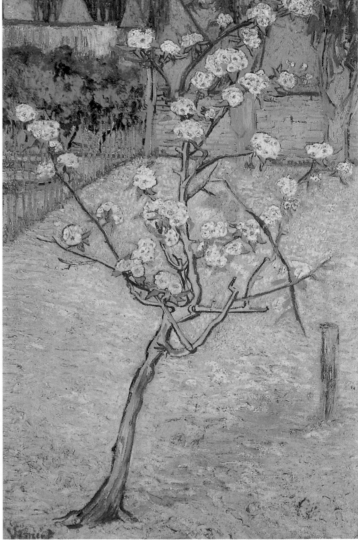

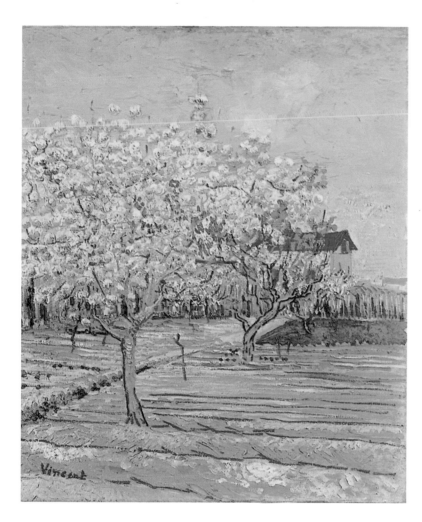

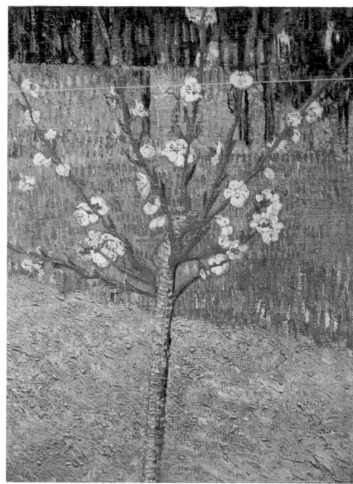

The later version (p. 100, top) resolves this uncertainty. The brushstrokes are now more even. The long contour lines have disappeared, as have the crude clusters of unmixed colours. The fixation on line survives only in the ladder lying on the ground, which places a barely detectable emphasis on spatial depth; the ladder is one of those props van Gogh often added later, props that tend to encumber his paintings somewhat. But at least the ladder is not foregrounded. And it does serve to show that this version was the later.

Both paintings are full of light and colour, showing them to have been inspired by Impressionism. But in the later version van Gogh is more radical in his approach. In an experimental mood, he has unobtrusively eliminated the shadows from the picture. Lack of shadows was a principle of Japanese woodcuts; the light, however, is genuinely European. Again it is the motif of a blossoming tree that prompts this juxtaposed presentation of approaches: the airy grace of sunlight is caught in the branches and endows Nature with a sacred dimension. It is all light. The very meaning of van Gogh's fruit trees is light. Even where shadows are suggested, the darker zones are like shadows cast by the blossoms themselves – as if the blossoms were a light bulb and the trunk and branches a lampstand. The two close-ups of a peach tree (pp. 94 and 104) demonstrate this in an exemplary manner: at ground level, shadows spread out on both sides. We might expect a second tree, casting its shadow in the bare garden; but van Gogh has left it out, and what remains is the impression of a candescent crown sending its rays skywards and laying down what is left of its earthbound nature as shade.

The two pictures of the peach tree are noteworthy in another respect. Van Gogh tackled them at different times, and both the date and the time of day

Left:
Orchard in Blossom
Arles, April 1888
Oil on canvas, 72 x 58 cm
Switzerland, Private collection

Right:
Almond Tree in Blossom
Arles, April 1888
Oil on canvas, 48.5 x 36 cm
Amsterdam, Rijksmuseum Vincent van Gogh,
Vincent van Gogh Foundation

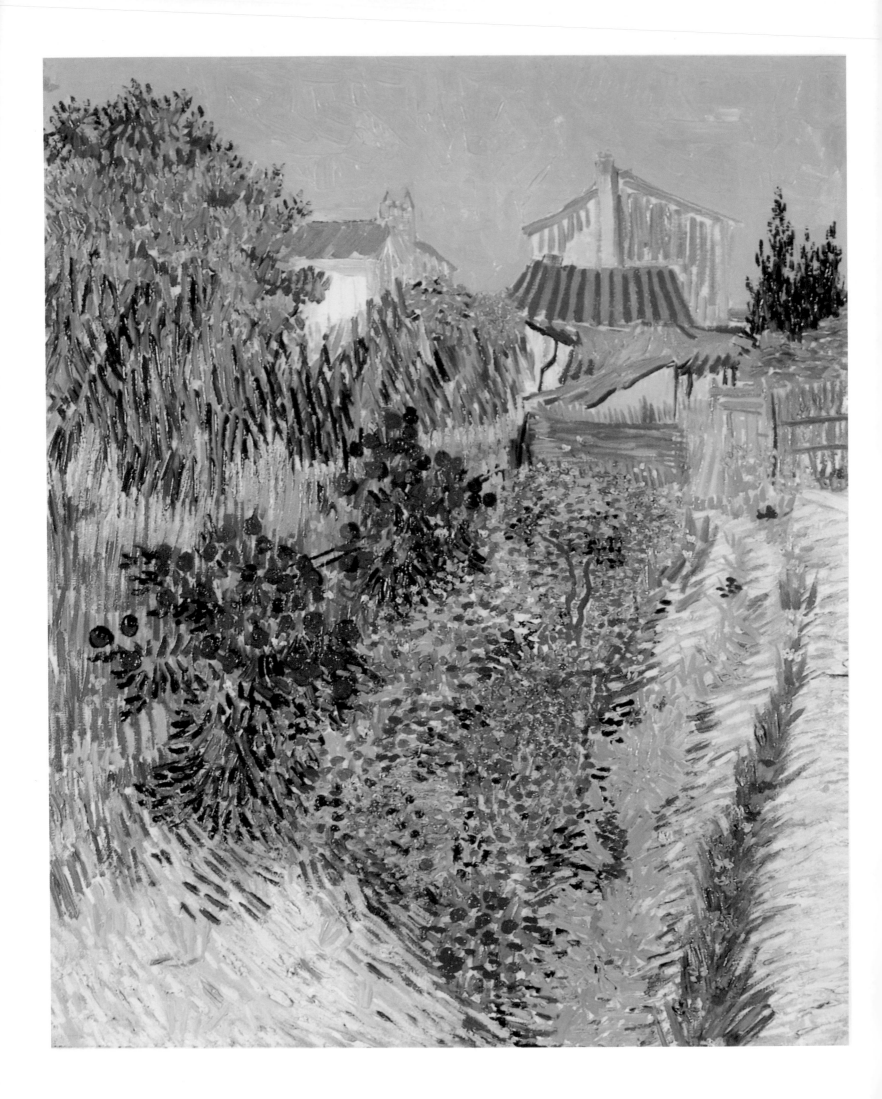

differ. The trees light up their surroundings as if they were suns, the earlier version (p. 94) being a diffuse whitish colour, the later (p. 104) gleaming in an intense, pinkish way. The thickness of the foliage and blossom apparently accounts for this intensity; at an earlier stage in the blossoming, the density of blossom and thus the intensity of colour are less, whereas both are greater at the later stage. Of course these differences could be explained by the position of the sun at the time in question. But what van Gogh produces quite distinctly manifests his interest in the independence and autonomy of the tree whose individuality is expressed in its luminous power.

Vincent's former mentor Mauve died in March 1888. In his memory, van Gogh wrote "Souvenir de Mauve" on the earlier picture (p. 94). At this time he attempted to clarify his relations with the master of The Hague School in a letter (W3) to his sister, in which he tried to assess his own use of colour: "You realise that Nature in the south cannot be properly reproduced by the palette of one such as Mauve – Mauve belonged in the north and remains the master of grey. But today's palette is thoroughly colourful: sky blue, orange, vermilion, bright yellow, wine red, violet. If one intensifies all the colours, one can achieve peace and harmony once again." Vincent was convinced that the south and colour were synonymous. Japan alone could not account for the intensity of his palette. The Japanese had thought the problem of light to be of fairly secondary importance, while the Impressionists subordinated everything to it. Van Gogh harmonized their concepts by distinguishing between light which came from outside and sources of light inherent in things. All his energy went into creative work that concentrated on the latter. Even the immense sun that was soon to rise in his work was depicted only in terms of its own luminous power. The blossoming fruit trees were the driving force in this development, which only took shape once van Gogh was in the south. Things were not themselves as glaringly bright as he had thought they would appear. So in order to show them in all the forceful colourfulness he had made himself master of in Paris, he had to suppress the effect of the natural light which damaged the intensity of colours and made shades of colour seem alike. The bright blossoms on the trees made an interim step possible. And the series of fifteen orchard paintings completed an important stage in his evolution: now, light was no longer a problem for him. He had equalled the Japanese.

Not everything he was then painting managed to handle the problem with this radical efficiency. In *Orchard in Blossom* (p. 102), for instance, the treetops dissolve into a nebulous grey; and in this picture van Gogh considered it necessary to add the factory with its tall chimney and farmer ploughing, scarcely visible on the horizon. The picture remains something of a snapshot, the more so as van Gogh fails to convey any luminous quality in the treetops. A successful companion piece is surely *Orchard with Blossoming Apricot Trees* (p. 103). The rows of trees, the point of view, and the copious blossom are similar, but the colour is more intense. It offers the contrast of red and green in the orchard grass, as if the blossoms had littered the ground with little balls of light.

Under a Southern Sun

The Painter on his Way to Work (p. 108): off the artist trudges, heavily-laden, through the deserted countryside. In straw hat and worker's outfit, clothing suitable for a *peintre ouvrier*, he carries his brushes and palette, canvas and easel

Garden Behind a House
Arles, August 1888
Oil on canvas, 63.5 x 52.5 cm
Zurich , Kunsthaus Zürich (on loan)

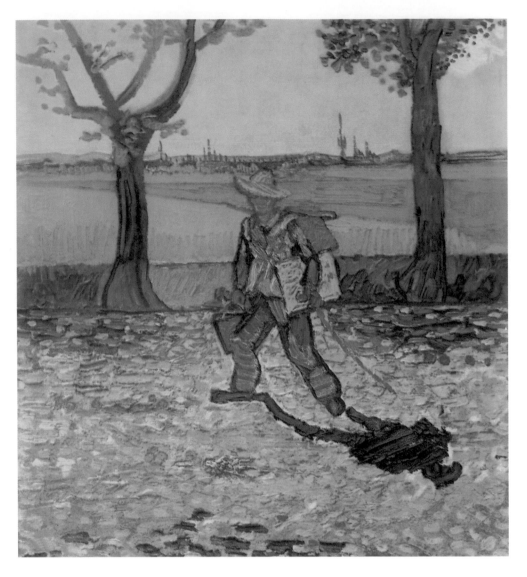

The Painter on his Way to Work
Arles, July 1888
Oil on canvas, 48 x 44 cm
Destroyed by fire in the Second World War;
formerly in the Kaiser-Friedrich-Museum,
Magdeburg

out of the town. He himself embodies the contrast that he has almost feverishly been demanding of his subjects: blue and yellow are the colours of the southern summer, and he is burning just as the landscape is burning under the baking sun. A shapeless shadow is dragging along behind him, a demon following in his footsteps, a portent that whispers warnings not to waste his time. The plane trees that line the roadway afford no shade. The horizon is marked by towering, threatening cypresses. And far and wide there is not a soul to be seen. It is a self-portrait of Loneliness.

Once again van Gogh had planned a workload for himself: in the near future he wanted to paint fifty pictures "good enough to exhibit". It was not that he intended to take part in an exhibition: he pressed on to confirm his own identity, his creative mission. And he wanted to prove himself worthy of Theo's unstinting support. His manic painting fever was meant as a way of eliminating fears that his lack of success as an artist might have something to do with laziness or lethargy. Every morning he would leave his lodgings, heavily laden, and roam the area in tireless quest of motifs to satisfy his creative urge. The artist set off to work day after day, into the blossoming hilly landscape of Provence – and produced one masterpiece after another. "It is the excitement, the honesty of a response to Nature, that guides our hand; and if this excitement is often so strong that one works without noticing that one is working, if brushstrokes sometimes come thick and fast like words in a conversation or letter, then one

Portrait of Patience Escalier
Arles, August 1888
Oil on canvas, 69 x 56 cm
Collection Stavros S. Niarchos

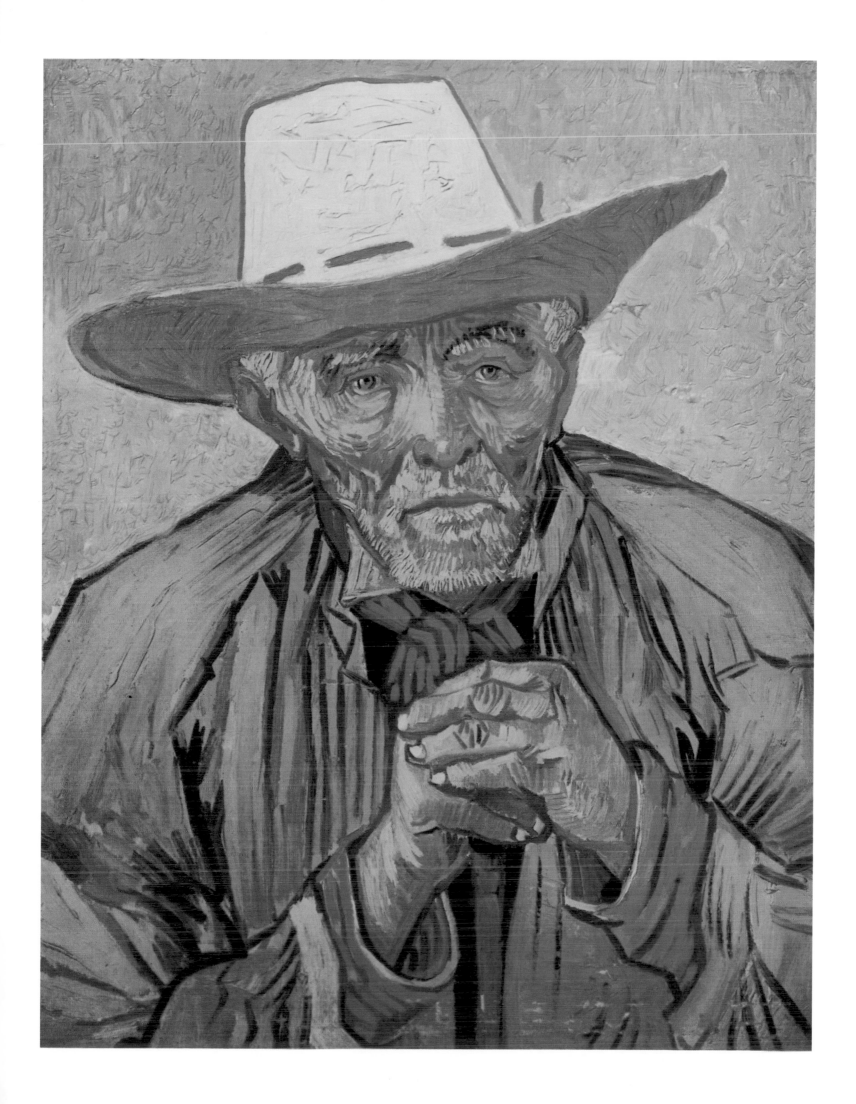

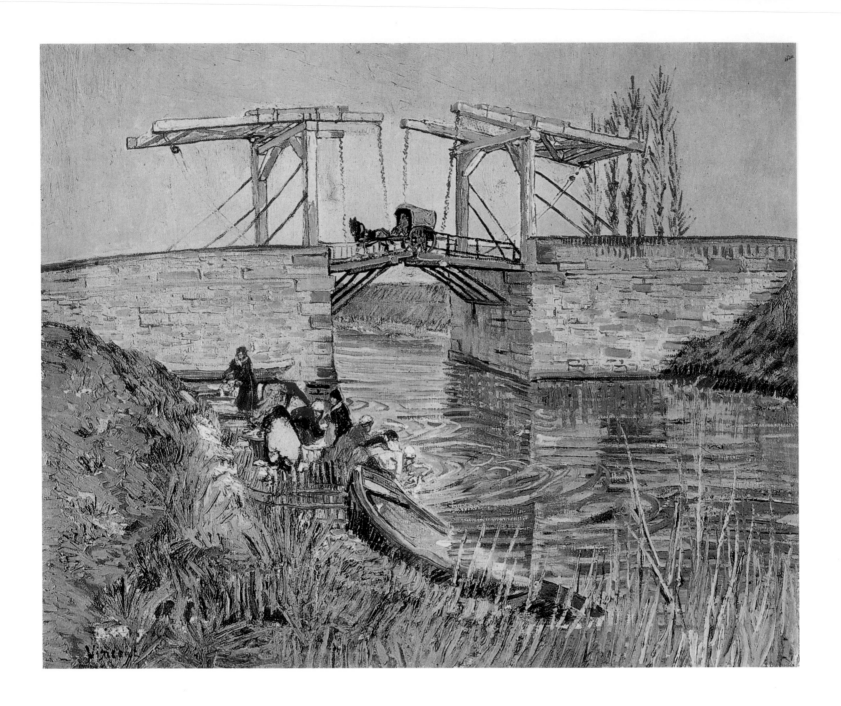

The Langlois Bridge at Arles with Women Washing
Arles, March 1888
Oil on canvas, 54 x 65 cm
Otterlo, Rijksmuseum Kröller-Müller

ought not to forget that it has not always been like that and that there will be many a depressing day barren of inspiration in the future." These words (from Letter 504) read prophetically in view of the breakdown van Gogh underwent before the year was out. But the tremendous vigour he now felt pointed to a better future. And the products of this creative burst may well strike us as thoroughly positive, with a *joie de vivre* that was not to be repeated in his work. The delightful surroundings he was living in, with its optimistic atmosphere, quite naturally stimulated van Gogh's "excitement".

The views of the Langlois bridge (pp. 110 and 111) offer a new interpretation of an old subject, one that is ablaze with colour. Back in Nuenen he had already tackled another specimen of this typically Dutch kind of construction, but at that time the suspension bridge had simply been part of a townscape. Now his interpretation of a bridge over the Rhône canal south of Arles took on the familiar idyllic quality of genre scenes. In one version (p. 110) van Gogh had climbed down the canal bank to watch the washerwomen at their work beside a wrecked barge. He saw their figures in the familiar stooped postures we remember from

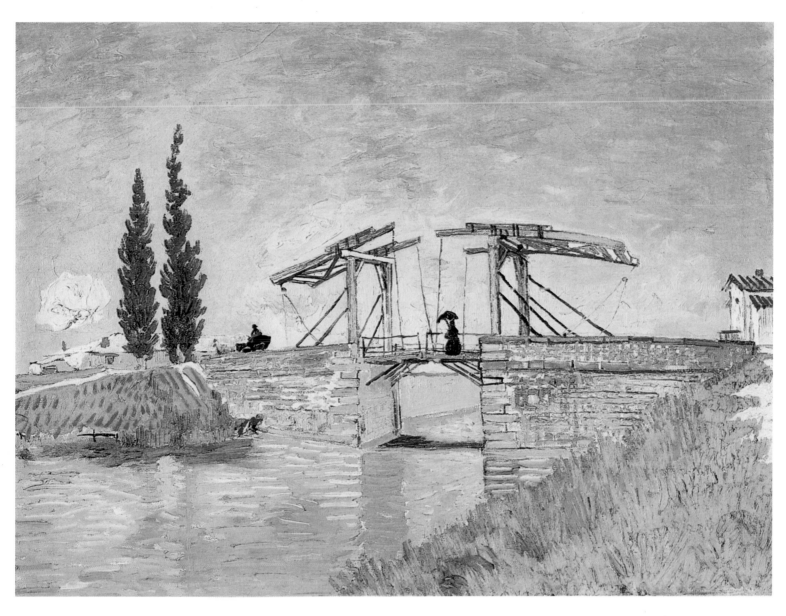

The Langlois Bridge at Arles
Arles, May 1888
Oil on canvas, 49.5 x 64 cm
Cologne, Wallraf-Richartz-Museum

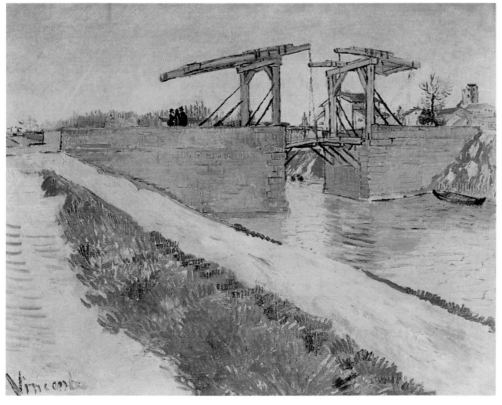

The Langlois Bridge at Arles with Road alongside the Canal
Arles, March 1888
Oil on canvas, 59.5 x 74 cm
Amsterdam, Rijksmuseum Vincent van Gogh,
Vincent van Gogh Foundation

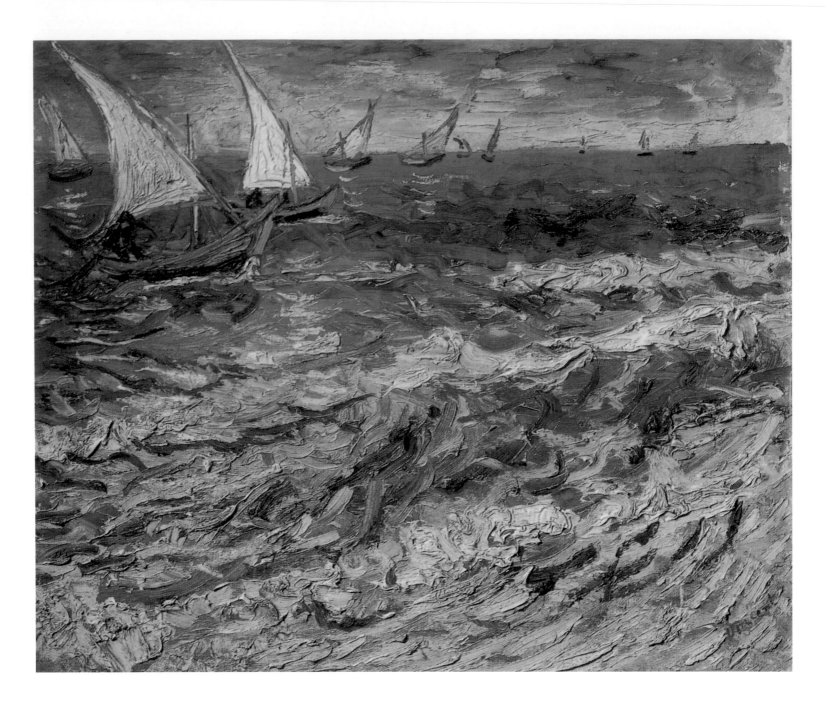

Seascape at Saintes-Maries
Arles, June 1888
Oil on canvas, 44 x 53 cm
Moscow, Pushkin Museum

his digging women in the Dutch paintings. In other words, it was not only the bridge that reminded him of home. If the colour were not so glowing and full, we might hardly suppose these two paintings showed southern scenes. We can grasp the foregrounded importance of the colour scheme if we pause to consider how van Gogh meticulously repeats every detail of the washerwomen, the outline of the bridge, and the touch of the pony and trap: the only significant differences between the two paintings are differences of colour. Colour, of course, is what makes the south different, as van Gogh repeatedly reminds us. The subjects might be anywhere. What counts is the intensity of feeling generated when the radiant power of the sun meets van Gogh's palette.

This does not mean that van Gogh no longer cared about the iconographic and symbolic subtleties that had hitherto always been the concern of his work. But their importance had been diminished. A somewhat later painting of the Langlois bridge (p. 111, top) makes the point nicely. Here, van Gogh has taken up his position on the opposite bank. Down by the water, not immediately apparent in front of the wall, is one solitary washerwoman; but now the track

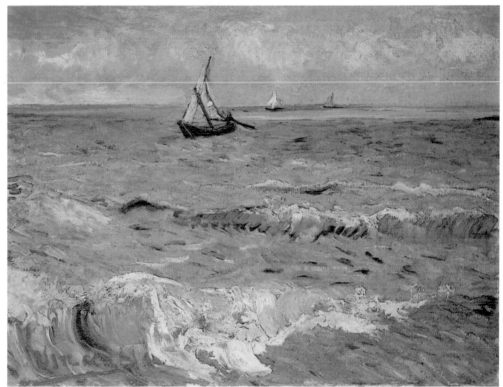

Seascape at Saintes-Maries
Arles, early June 1888
Oil on canvas, 51 x 64 cm
Amsterdam, Rijksmuseum Vincent van Gogh,
Vincent van Gogh Foundation

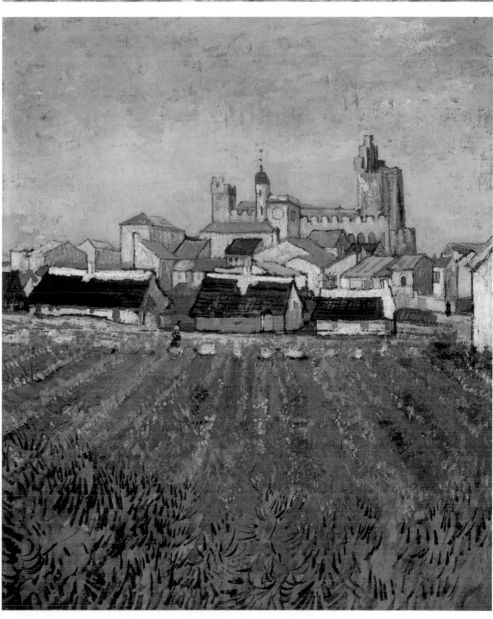

View of Saintes-Maries
Arles, June 1888
Oil on canvas, 64 x 53 cm
Otterlo, Rijksmuseum Kröller-Müller

Three White Cottages in Saintes-Maries
Arles, early June 1888
Oil on canvas, 33.5 x 41.5 cm
Zurich, Kunsthaus Zürich (on loan)

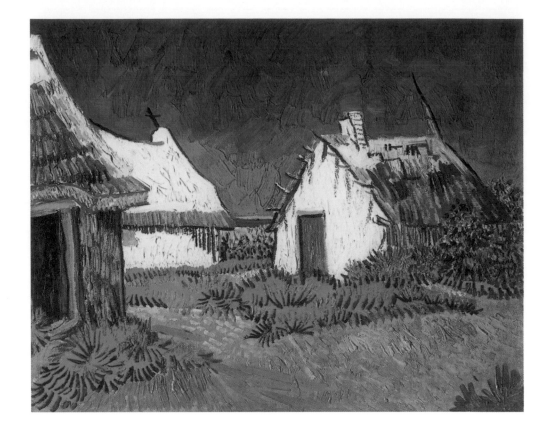

Street in Saintes-Maries
Arles, early June 1888
Reed pen, 30.5 x 47 cm
England, Private collection

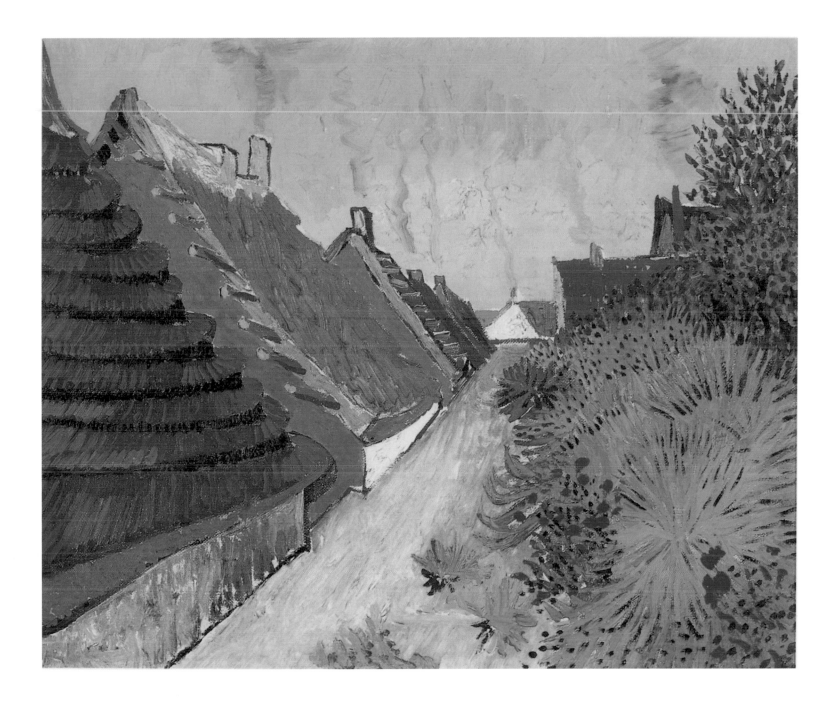

Street in Saintes-Maries
Arles, early June 1888
Oil on canvas, 38.3 x 46.1 cm
Private collection

that crosses the bridge is busier. With the light coming from beyond (so it appears, from the silhouette effects), we see a horse and cart heading off into the distance and a woman's figure with an umbrella crossing the bridge – both of them done in a rich black by van Gogh. But even here we cannot be sure of a source of light – in any case, the shadow cast on the surface of the water by the bridge implies a sun directly overhead. The black of the figures cannot be explained by saying that the picture was painted around midday. What we have here are once again autonomous images laden with meaning, of the kind that had peopled van Gogh's visual world from the very beginning: there is the woman in black, that relic from his religious times, posing on the bridge! She is small now, however, and merely a background figure, part of the scenery, to be taken for granted.

At the beginning of June, van Gogh tramped the long and tiring stretch through the Camargue to Saintes-Maries-de-la-Mer, a fishing village on the Mediterranean coast. The gypsies of Europe make an annual pilgrimage to the place in honour of their patron saint, St. Sara. Van Gogh decided to get to know

Fishing Boats on the Beach at Saintes-Maries
Arles, June 1888
Reed pen, 39.5 x 53.5 cm
Private collection

the place that was the cause of so much devotion; and again he discovered Holland, albeit with the intense colours of the south. He did three paintings on the spot (pp. 112–113), along with a number of drawings that he based paintings on once he was back in his studio.

Street in Saintes-Maries (p. 115) represents his greatest commitment (at that date) to the principle of autonomous colour. In it he lavishly indulges his fondness for contrasts, unusually using all three varieties in the picture. The contrast of red and green dominates the right of the painting; blue and orange, the left; and yellow and violet, the centre. Of the three contrasts, this last in particular derives its impact from the exciting monochrome of the sky, an unmixed, bright, pastose field of colour that flies full in the face of reality. Van Gogh based the painting on one of the sketches he had hastily made in Saintes-Maries, an affectionate drawing of snug cottages. The colours, detached from any real correlatives, were added subsequently in the studio. The fishermen's cottages show him using material that was thoroughly familiar to him and embellishing it with colours that expressed his new emotional intensity: the motif was what survived from his past, while he projected all his optimism and hopes for the future into the vitality of his colours.

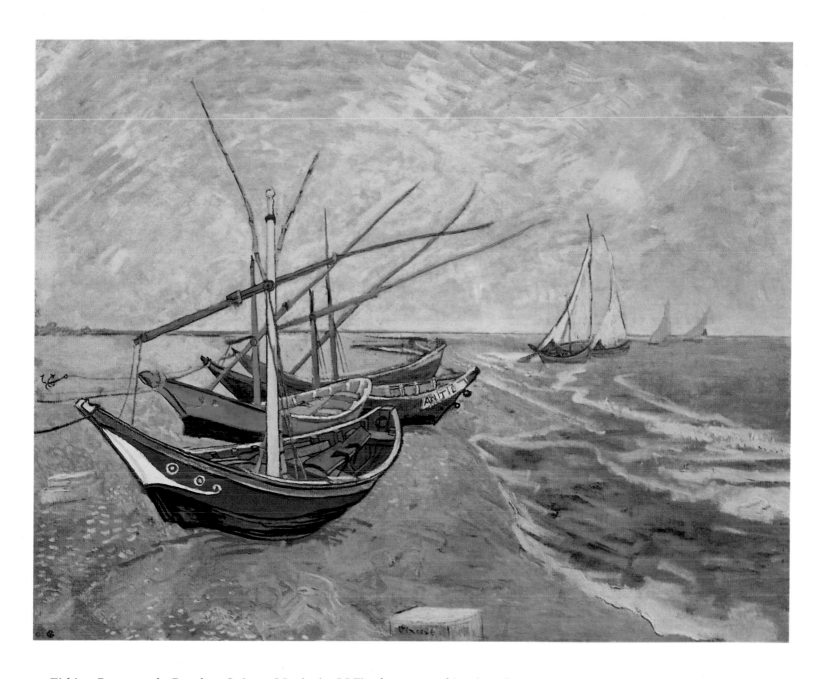

Fishing Boats on the Beach at Saintes-Maries (p. 117), also a reworking in paint of a sketch done on the spot (p. 116), is filled with a spirit of balance and harmony. Again his motifs recall his early works, and again it is only the use of colour that declares this a product of the southern ambience he had grown so fond of. The colours are kept in check by the drawn lines, and the result is a subtle study that preserves a fine balance between love of detail and abstraction. One of the boats is called 'Amitié' (friendship) – suggesting that even these objects are loaded with meaning. *Fishing Boats on the Beach at Saintes-Maries* is one of his most accomplished attempts to establish a harmony of motif and colour, pure description and meaning.

Van Gogh also went back to familiar material in his most extensive series of that summer. As in the past, he followed the harvest closely, recording the farmers' work and the state of the fields. To the southeast of Arles lay the plain of La Crau. It was as flat as van Gogh's native country, and surrounded on all sides by hills. These offered van Gogh an opportunity to escape the flatland. Much as he liked standing right in the centre of his landscape, he now also withdrew to a greater distance from where he commanded a panoramic view of the whole region. *Harvest at La Crau, with Montmajour in the Background* (p. 118) is a

Fishing Boats on the Beach at Saintes-Maries
Arles, late June 1888
Oil on canvas, 65 x 81.5 cm
Amsterdam, Rijksmuseum Vincent van Gogh,
Vincent van Gogh Foundation

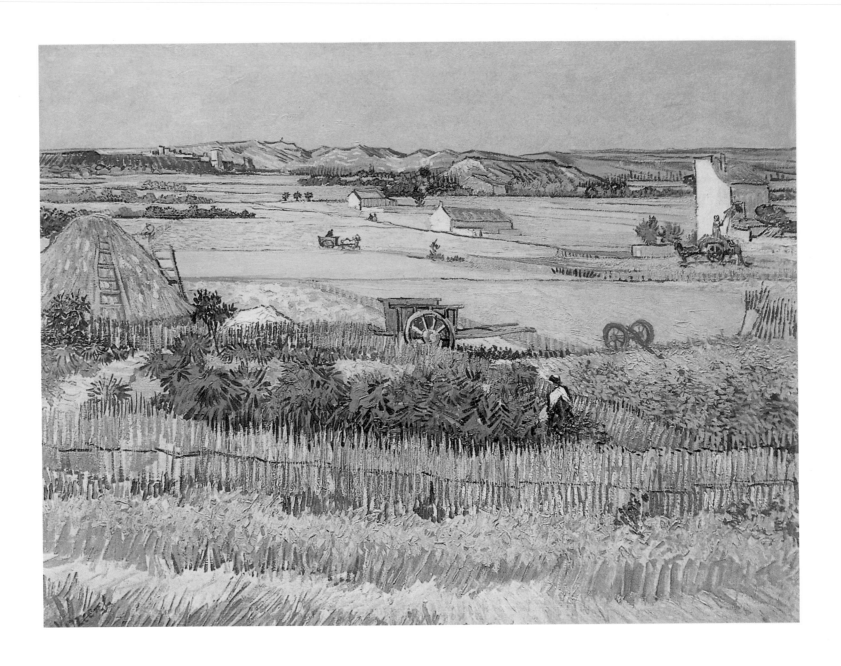

Harvest at La Crau, with Montmajour in the Background
Arles, June 1888
Oil on canvas, 73 x 92 cm
Amsterdam, Rijksmuseum Vincent van Gogh,
Vincent van Gogh Foundation

fine example of the work that resulted. This picture also established the size van Gogh preferred: with only a few exceptions in his very early and very late work, he used this 73 x 92 centimetre format (French canvas norm size 30). The painting includes just about everything we expect of a harvest scene: a haystack and farmhouse to frame the composition, people doing particular jobs (digging, raking, bringing in the harvest), and in the background a circle of hills surrounding the busy scene protectively. Van Gogh had not had such an extensive view in his Dutch period, if only for topographical reasons. But at that time he was probably not yet alert to its attractions: it was only the distanced view of Impressionism that had made this panoramic perspective accessible to him. Van Gogh brought his own perspective into line with the new panoramic view and added his own personal touches: the bright colours, the sense that light emanates from within his subjects, the total exclusion of shadows (which could only ruin the overall impression).

"I have just finished a week packed with hard work out in the fields under a blazing sun," Vincent reported (Letter 501). "What resulted were studies of cornfields, landscapes and – a sketch of a sower. On a ploughed field, a vast area of violet clods of earth reaching to the horizon – a sower in blue and white. A

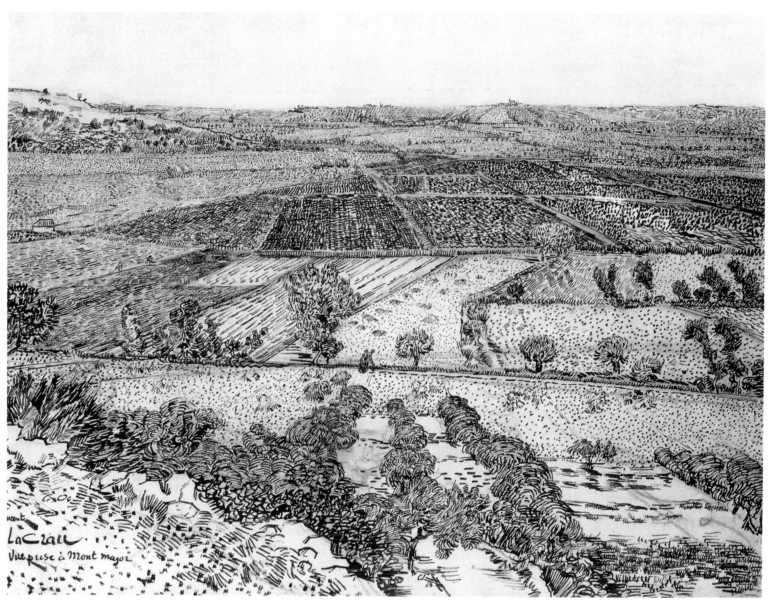

La Crau Seen from Montmajour
Arles, July 1888
Pencil, pen and ink, 48.6 x 60.4 cm
Amsterdam, Rijksmuseum Vincent van Gogh,
Vincent van Gogh Foundation

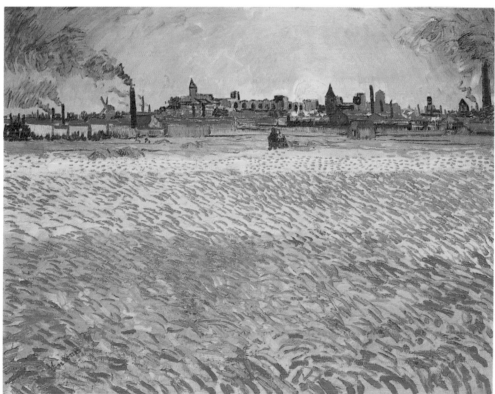

Sunset: Wheat Fields near Arles
Arles, June 1888
Oil on canvas, 73.5 x 92 cm
Winterthur, Kunstmuseum Winterthur

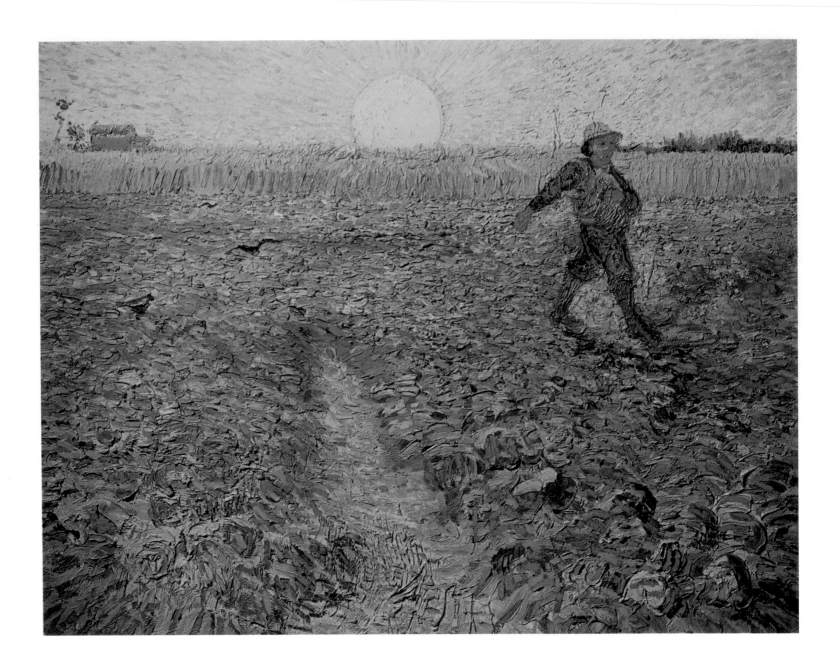

The Sower
Arles, June 1888
Oil on canvas, 64 x 80.5 cm
Otterlo, Rijksmuseum Kröller-Müller

low field of ripe corn on the horizon. Over it a yellow sky with a yellow sun. You will gather from my simple account of the colour values that colour plays a very important part in this composition." This sower (p. 120) appears at the end of the harvest series.

This picture focusses the entire significance of van Gogh's work during those first few months in the south. First, it includes his reconnaissances of the surrounding area, his affectionate interest in all that was characteristic of Provence: his sower, too, is on the broad plain of La Crau. Second, the painting offers memories of his homeland, memories that prompt the artist to choose motifs that are of a familiar nature.

The figure of the sower is even quoted from an early drawing (p. 25) in which he was copying Millet. Then there is van Gogh's quest for the light within things, and his tendency to banish light sources from his pictures. Even the giant sun rising over the horizon fails to spread its powerful yellow everywhere: neither the sower nor the farmstead in the background seems lit by it. And finally there is the colour autonomy, which he has now taken a striking step further: in the sower painting, the blue sky and earthy beige ploughed furrows have exchanged colours.

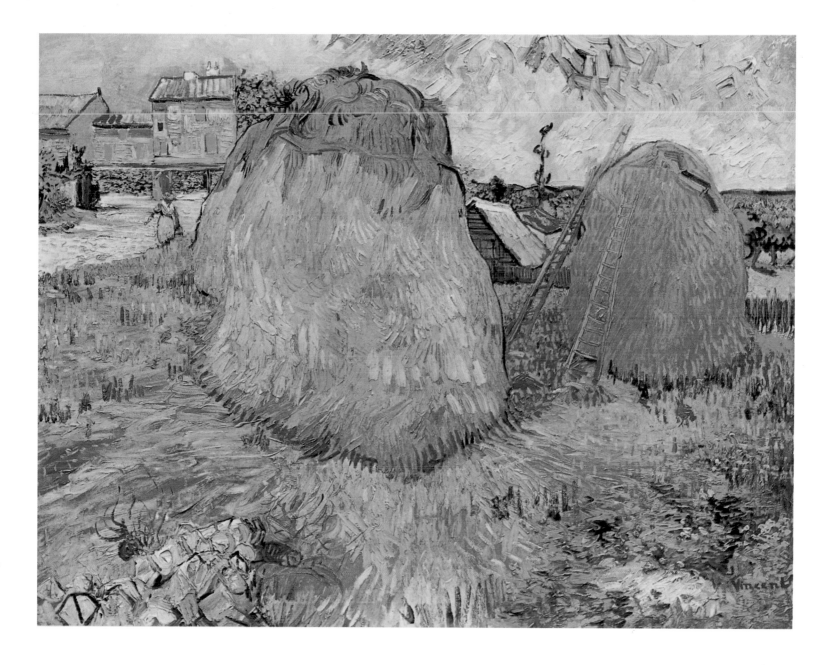

In fact, things have an aesthetic life of their own, a power that transcends mere representational recording of a subject. And van Gogh trusts his motif, tries to grasp it in a descriptive way, and sees a plurality of meaning in it that derives from his own life or from the universally valid iconography of Art. Increasingly, though, this traditional stock of experiences is accompanied or indeed obscured by the dearly-cherished wish to create a world of his own and take hold of it in his work.

Haystacks in Provence
Arles, June 1888
Oil on canvas, 73 x 92.5 cm
Otterlo, Rijksmuseum Kröller-Müller

Van Gogh's Drawings

Like most artists' work, van Gogh's lives from the mutual influence of painting and graphics. Line and colour are utterly inseparable. What was different about van Gogh was simply the way he devoted himself exclusively to drawings for weeks at a time. Drawings had been his way of embarking on the artistic life; and, just as his paintings had adapted the motifs of his native Netherlands to a southern ambience, he was now trying to apply the favourite medium of his early years to the new situation.

Street in Saintes-Maries
Arles, mid-July 1888
Reed pen, 24.5 x 31.8 cm
New York, The Museum of Modern Art

Flowering Garden
Arles, July 1888
Oil on canvas, 92 x 73 cm
New York, The Metropolitan Museum of Art
(on loan)

For all their sketchy quality, van Gogh's drawings are works of art in their own right. In the sketch of *Fishing Boats on the Beach at Saintes-Maries* (p. 116) he meticulously recorded the colours of the original subjects. Then in the actual picture (p. 117) he painted the hull of the boat red where he had marked his sketch *rouge*; the arabesque on the prow is white because he had marked it down as *blanc*; and equipment on board the boat, marked *bleu*, faithfully comes out blue. On paper, his motifs are more emphatically foregrounded, leaving correspondingly less space for atmospheric effects of sky and sea. It is only on the canvas that the subtle interplay of colours can appear to advantage – and so the boats recede somewhat in favour of broad expanses of hazy blue, bathing the landscape in a typically coastal light.

Sometimes the drawings were alternatives to paintings. The five works van Gogh did in July, from the ruined monastery at Montmajour, illustrate this perfectly. *La Crau Seen from Montmajour* (p. 119) can stand by itself. The artist has taken up a position he had not previously adopted, at the ruined monastery on the hills above La Crau; in the painting (p. 118) the ruins can be made out on the horizon. So van Gogh is now looking in the opposite direction. He has come a fair way from Arles – a distance he would have thought twice about walking laden with easel and frame, in fact. The sheet on which he did this drawing measures a full 49 x 61 centimetres. This format alone suggests another reason for seeing the drawing as a work in its own right. Van Gogh has made use of three different techniques to draw his subject: a rough pencil sketch outlines the position of the motifs; on this he overlays hatching in brown ink done with a reed pen; and this is then touched up in places with black ink. In other words, the master of the palette was also using three different colours in his graphic works. But his main concern was to find an equivalent for colour, and to vary the strokes so that the length, thickness or hatching of the carefully placed lines will not put us in mind of paintings. Both his paintings and his drawings were aiming at a conflation of oriental and occidental ways of seeing. If van Gogh were able to achieve a satisfactory result in both media, the unity of Art and Life would be palpably there – less a matter of technical sophistication than a proof of the power of the imagination.

Let us examine the selfsame garden of flowers, done both on canvas (p. 123) and on paper (p. 125). It is a chaotic confusion of shapes and colours, full of vitality – a luxuriant scene of growth, more a jungle than a garden. Van Gogh approaches Nature in flower with the eye of an Impressionist, an eye that he has trained in Paris and focussed on such subjects as undergrowth (p. 80). Reverent respect for Creation has him in thrall. There is a sheer and basic vitality in the growth in his garden; it seems unbounded, forceful, like van Gogh's own vigour. This may well be the very reason he chose to do it as a drawing. With the aid of his graphic work, van Gogh taught himself to work even more quickly than before.

"Do not suppose that I am artificially maintaining a fever pitch," he wrote in Letter 507. "You know, I am constantly making complicated calculations, which result in a rapid series of pictures that may have been painted fast but were in fact worked out far in advance. And so, if people say that it was done too hastily, you can reply that they looked at it too hastily." This wonderful observation once again adumbrates the conceptual nature of van Gogh's work. There was one respect in which van Gogh was an innovator here too, though. Drawing was not only to help when choosing subjects or viewpoints; it was to prompt a style, an

Flowering Garden with Path
Arles, July 1888
Oil on canvas, 72 x 91 cm
The Hague, Haags Gemeentemuseum
(on loan)

Page 125:
A Garden with Flowers
Arles, August 1888
Reed pen and ink, 61 x 49 cm
Private collection

approach, and thus mediate between the inventive thought process and the act
of painting.

Graphic work has a further function in van Gogh's œuvre, one that we can
infer by comparing two drawings of the row of cottages in Saintes-Maries. (We
have already discussed the painted version, p. 115.) The earlier drawing, done at
the beginning of June (p. 114), was the sketch for the painting. In the later, done
in mid-July (p. 122), the process is reversed, van Gogh taking his own canvas as
the model for a construct of lines and dots. This drawing was intended for Emile
Bernard, as were a whole series of works that Vincent had based on his own
paintings. The earlier sketch had conventionally established a framework of
motifs that could be painted in. But the later offers a wealth of draughtsmanly
sophistication, with its interplay of curves, dots and hatchings and its multiple
centres. Another new feature are the tightly-packed dots in the drawing intended
for Bernard – a genuinely Japanese technique which van Gogh had adopted in
the south. Indeed, the dot became the chief characteristic of his Arles drawings.
Used for the first time in *Fishing Boats on the Beach at Saintes-Maries* (p. 116), it
afforded one possible way of translating a colourful into a colourless scene, a
painted surface into a pen-and-ink version.

The Night Paintings

Unlike Paris, van Gogh hardly ever sought company in Arles. Only once did he overcome his shyness and set up his easel right in the centre of town, in the Place du Forum, not far from the famous amphitheatre and Saint-Trophime. There he painted *The Café Terrace on the Place du Forum, Arles, at Night* (p. 126). The motif he was after could only be seen there: the gaslight that shone in the darkness from the outside wall of the café out over the square.

The meeting of familiar yellows and blues in this painting has a vitality it has never previously achieved. The loud yellow and subdued blue represent areas of arresting brightness and delicate semi-darkness exactly as van Gogh must have seen them. Passers-by link the two zones. These figures are left in complete anonymity; the lighting conditions alone make identification impossible. And indeed, van Gogh's chief concern is with the way things are lit. There is only one source of light: the lamps. In the 1880s, gas had spread as far as the provinces. Gaslight was artifical and representative of the glaring directness of the new. Van Gogh was well aware of this, painting old and new meeting on the centre axis of the work. There is a kind of desolation in the way the uniform glare of the canopied area contests the glittering points of light in the darkness.

The theme of artifical lighting recurred in van Gogh's famous masterpiece *The Night Café in the Place Lamartine in Arles* (p. 128). The artist himself claimed the painting dealt with "terrible human passions" and called the bar "a place where one could ruin oneself, where one could go mad and commit crimes." And indeed, the figures huddled at the tables have a lost air, and empty glasses bear witness to the excesses of alcoholism. But by the rear wall sits a couple locked in an embrace; in fact, the background affords a fair amount of comfort, with a bunch of whitish flowers and a curtained doorway opening onto a bright, cheerful room. Still, van Gogh insists on seeing the composition in negative terms. It is the lamps alone that highlight the dismal, wretched hopelessness of the atmosphere. The steady, impersonal light renders everything pitilessly and coldly anonymous.

Typically, van Gogh could not let this pessimism stand unmitigated by redeeming optimism, and painted *Starry Night over the Rhône* (p. 131), a little-known but far more consistently conceived precursor of the more famous late masterpiece (cf. p. 188). Here, everything lies spread beneath the sparkling tranquillity of the natural lights in the heavens. Painting the stars out in the open – that was van Gogh's achievement in the night pictures. "I am tremendously gripped by the problem of painting night scenes or nighttime effects on the spot, actually at night," he wrote (Letter 537). The night style peaked in his portrait of the Belgian poet and painter Eugène Boch (p. 129). All van Gogh's ideas about night painting met in this picture. Taking a man of letters, a creative artist, van Gogh had located a way of projecting his idea of the stars as a utopian counterworld of the imagination where the artist might find a home. The better world which his entire creative energy sought at that time was up in the stars.

The Boch portrait has a companion piece, the self-portrait dedicated to Gauguin (p. 130) – like the two Paris paintings linking van Gogh with his friend Alexander Reid and like the two paintings of chairs he was to do later that year. The distinctly bony head, with its hair and beard fitting the skull shape perfectly

The Café Terrace on the Place du Forum, Arles, at Night
Arles, September 1888
Oil on canvas, 81 x 65.5 cm
Otterlo, Rijksmuseum Kröller-Müller

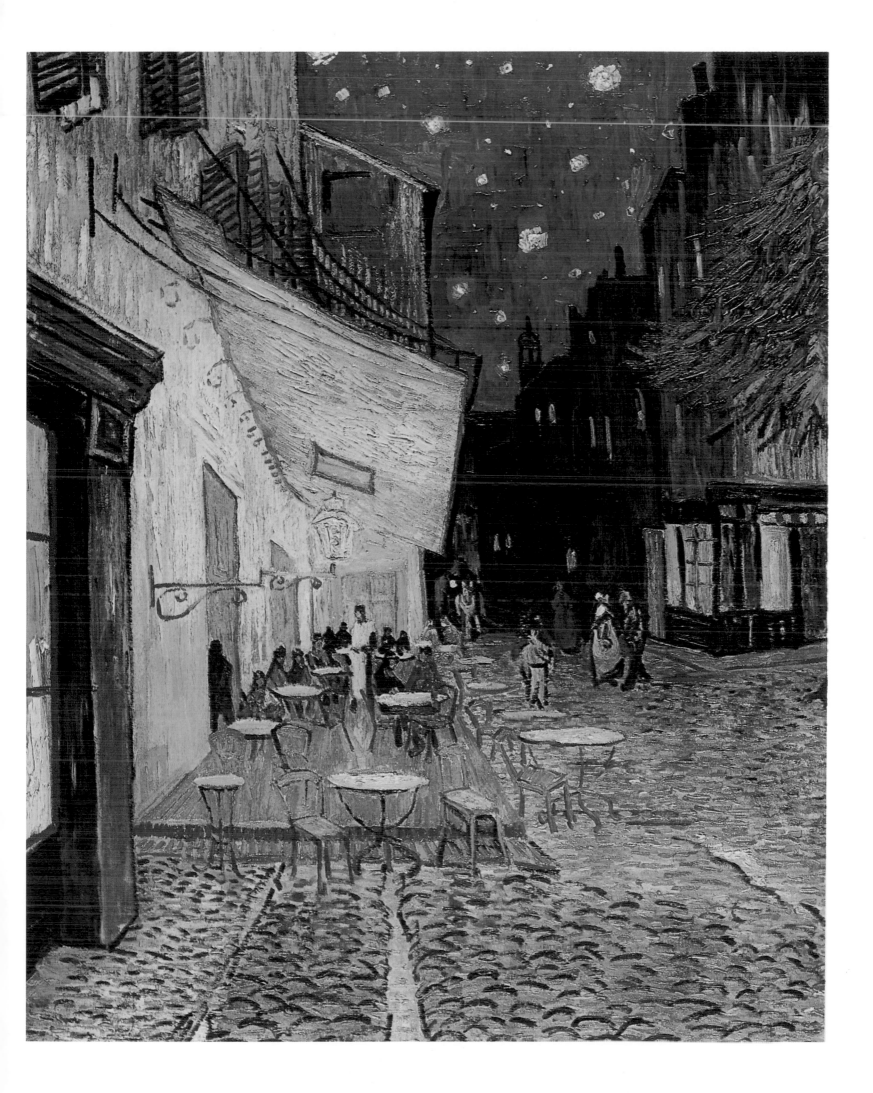

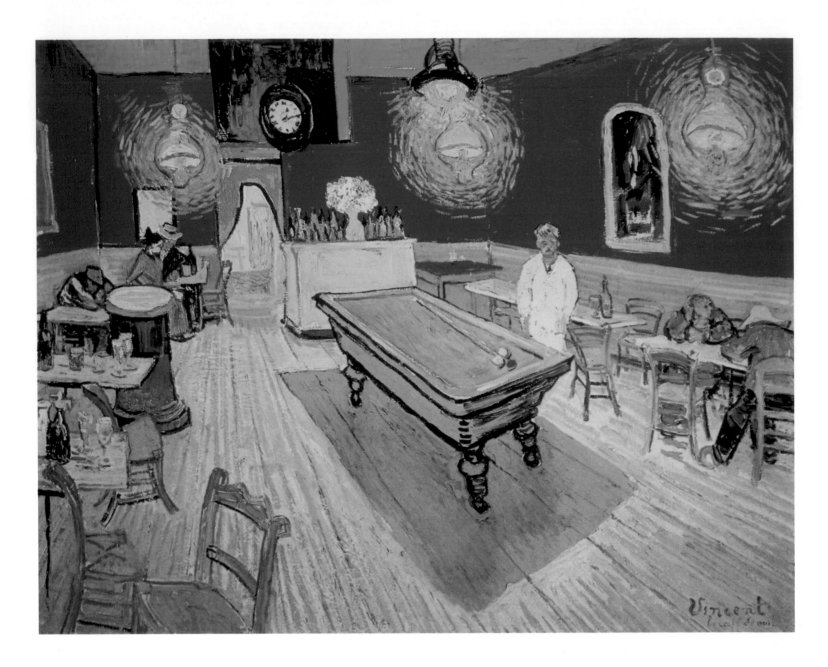

The Night Café in the Place Lamartine in Arles
Arles, September 1888
Oil on canvas, 70 x 89 cm
New Haven (CT), Yale University Art Gallery

Page 129:
Portrait of Eugène Boch
Arles, September 1888
Oil on canvas, 60 x 45 cm
Paris, Musée d'Orsay

and the contrast of red and green echoing that of yellow and blue, shows that van Gogh was trying (while preserving distinctions) to establish similarities in the two portraits. The painting of himself lacks the remote sublimity of a twinkling night sky; but the self-portrait anticipates, intuits and includes it. "I view this portrait as that of a Buddhist priest, a simple worshipper of the eternal Buddha." (Letter 545) Van Gogh was out to appear as oriental as possible: the better world on the other side of the earth and that amongst the stars were overlaid and became indistinguishable.

Any doubts about this interpretation can be allayed by a passage in one letter which, with its dark humour and the almost despairing nonchalance of tone, must surely be the most expressive he ever penned: "Death may possibly not be the hardest thing in the life of a painter. I must declare that I know nothing about them, but when I look at the stars I always start dreaming, as readily as when the black points that indicate towns and villages on a map always start me dreaming. Why, I wonder, should the shining points of the heavens be less accessible to us than the black dots on a map of France? Just as we take a train in order to travel to Tarascon or Rouen, we use death in order to reach a star. In one respect this thought is undoubtedly true: we can no more travel to a

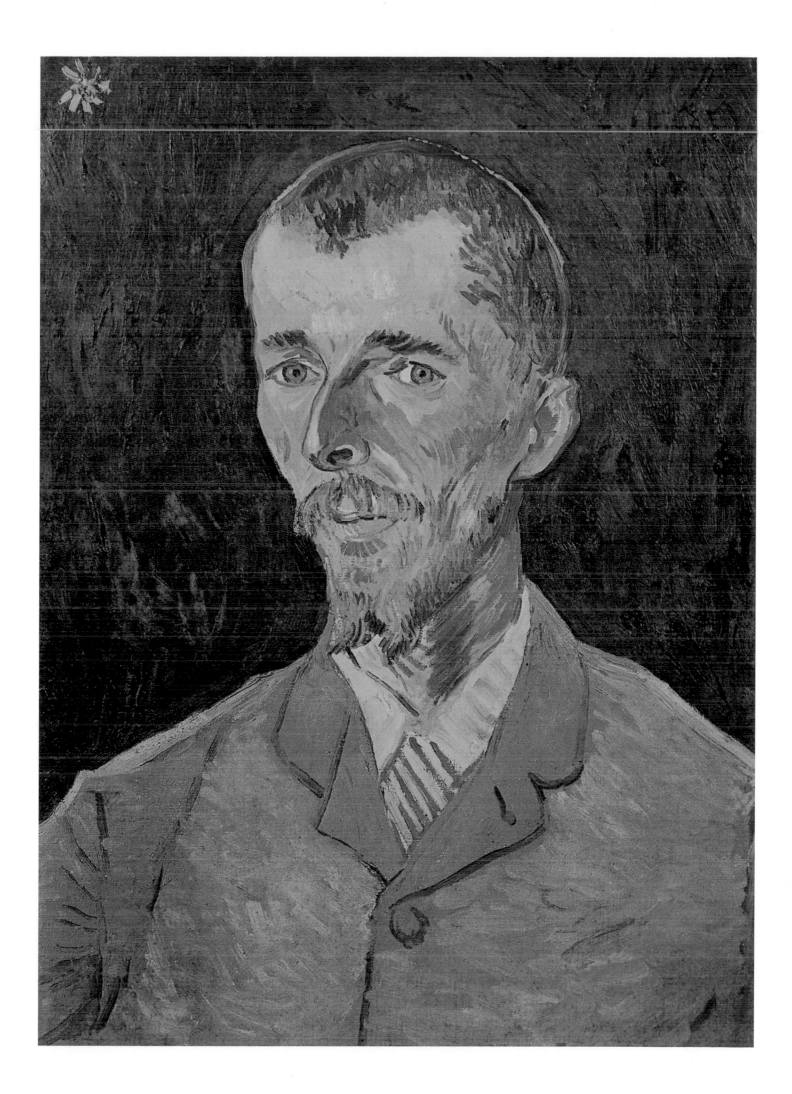

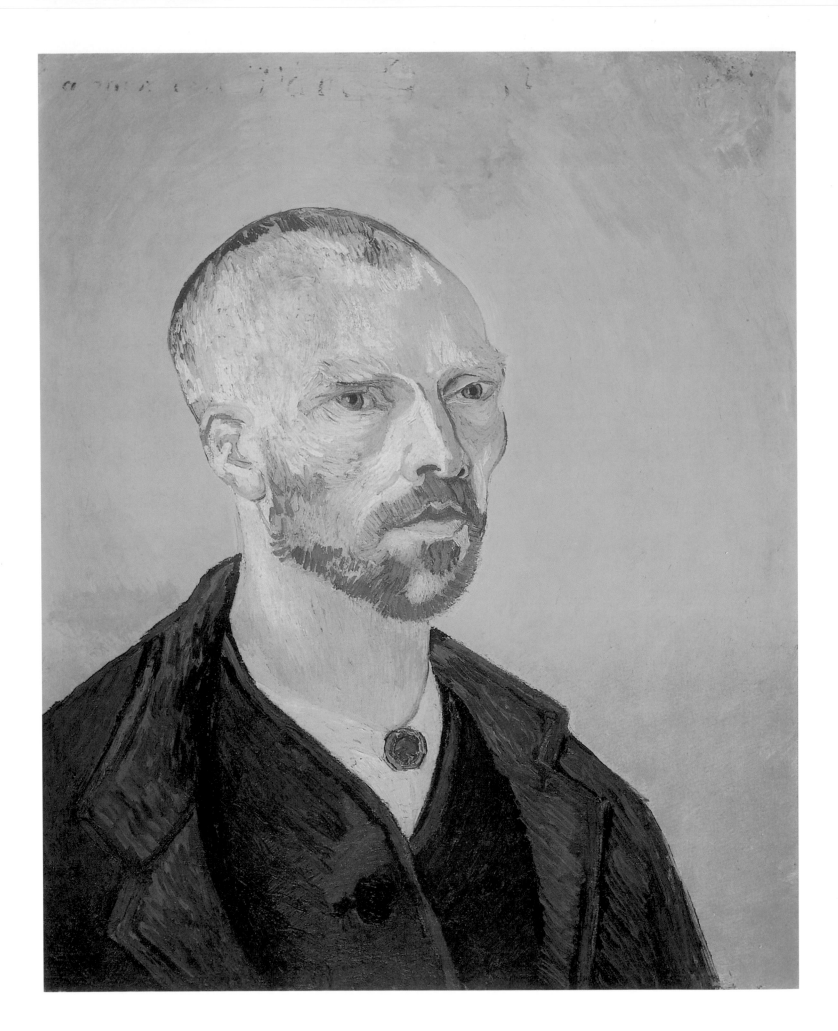

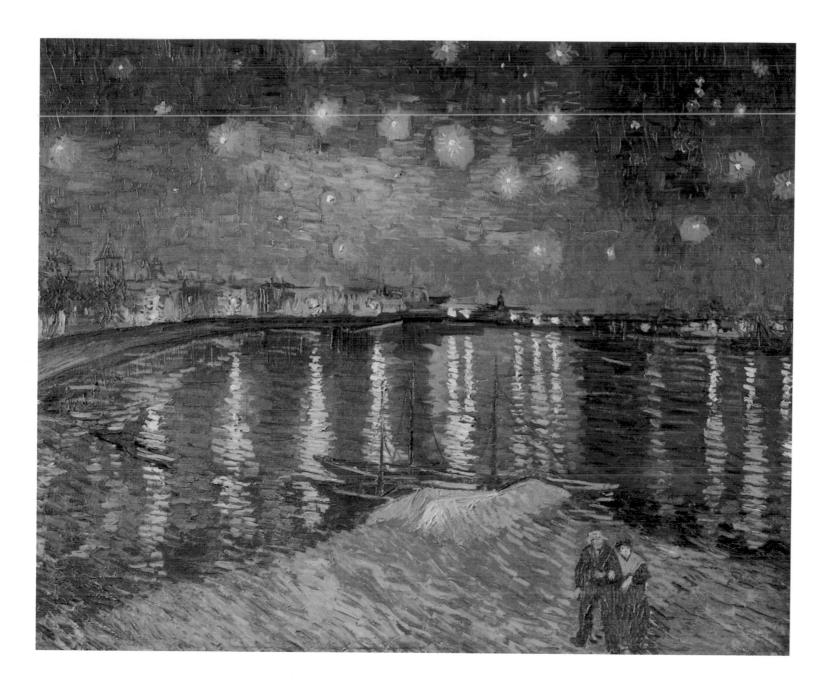

Starry Night over the Rhône
Arles, September 1888
Oil on canvas, 72.5 x 92 cm
Paris, Musée d'Orsay

Self-Portrait
(Dedicated to Paul Gauguin)
Arles, September 1888
Oil on canvas, 62 x 52 cm
Cambridge (MA), Fogg Art Museum,
Harvard University

star while we are alive than we can take a train once we are dead. At all events, it does not strike me as impossible that cholera, kidney stones, cancer and consumption should be means of celestial transport just as steamers and railways are earthly ones. To die peacefully of old age would be the equivalent of going on foot." This passage from Letter 506 is crucial to an understanding of the suicide that ended van Gogh's life but for the moment we can take it as defining two areas: a remote one (longed for and unattainable) out in the universe; and one in this world, quite concretely located in Arles, involving all the routine drudgery of everyday life.

Analogies aside, though, the Boch portrait and the self-portrait can each be assigned to a particular sphere. Van Gogh (not least through his use of almost exactly the same contrast of red and green as in the night café interior) sees himself as belonging in the same menacing world as that of *The Night Café in the Place Lamartine in Arles*. The two pictures work in the same way as the two chair still lifes: as a diptych invoking friendship and harmony. Seen in isolation from each other, they express the impossibility of being reconciled to Life: after all, they define the very polarity of day and night.

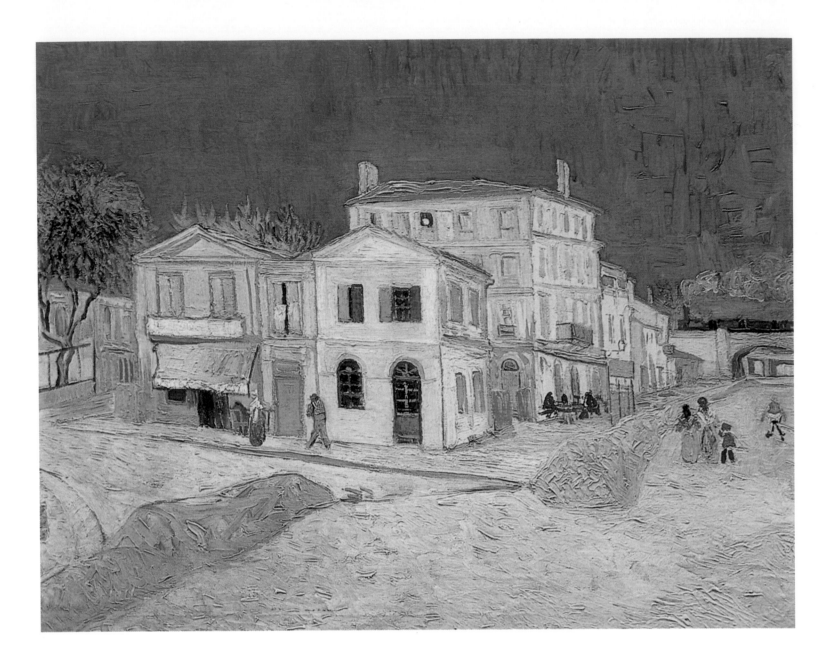

Vincent's House in Arles (The Yellow House)
Arles, September 1888
Oil on canvas, 72 x 91.5 cm
Amsterdam, Rijksmuseum Vincent van Gogh,
Vincent van Gogh Foundation

The Dream of an Artists' Community

At the end of July 1888, van Gogh's Uncle Cent, the wealthy art dealer, died. He left a large amount of money in his will, which enabled Vincent to fulfil a long-cherished wish: the rooms that had hitherto served as his studio and as a storeroom for his paintings could now be renovated, refurbished, and finally lived in. As of mid-September, a proud Vincent van Gogh was lord and master of his "yellow house".

Van Gogh immortalized it in a painting and a watercolour (pp. 132–133). It was an inconspicuous building on the corner of the Place Lamartine in the north of the town. It had a double frontage, with a small shop in the other half. An entry separated it from the much bigger building behind it. As if this view were too unimportant in itself to be recorded on canvas, van Gogh has added a train in the background. In the overall contrast of the various yellows of the houses with the vast blue of the sky there is, however, no overdone modesty at play. The yellow house we see on the canvas is a painting turned architecture, and the yellow colour operates programmatically: it is both housepaint and a message, a real coat on a real building and an aesthetic statement.

Vincent's House in Arles (The Yellow House)
Arles, September 1888
Pen and ink, 13 x 20.5 cm
Switzerland, Private collection

Yellow is the colour of the sun. And yellow was also the preferred colour of one of van Gogh's great exemplars: "Monticelli was a painter who painted the south all in yellow, orange and sulphur colours. Most painters do not see these colours because they are not really experts in colour" (Letter W8). Van Gogh could now set about fulfilling a dream that had always been in his mind as the goal of all his preparatory labours: he could create his *atelier du Midi*, with the yellow house at the very heart of a new artistic era. Everyone, sooner or later, would go there – all his acquaintances and fellow artists from the Paris art world. There they would establish a community; Theo would handle the financial arrangements and present the fruits of their happy toil to an astounded public back in the capital. Van Gogh conceived of this community as resembling a monastic

Vincent's House in Arles (The Yellow House)
Arles, September 1888
Water colour and reed pen, 25.5 x 31.5 cm
Amsterdam, Rijksmuseum Vincent van Gogh,
Vincent van Gogh Foundation

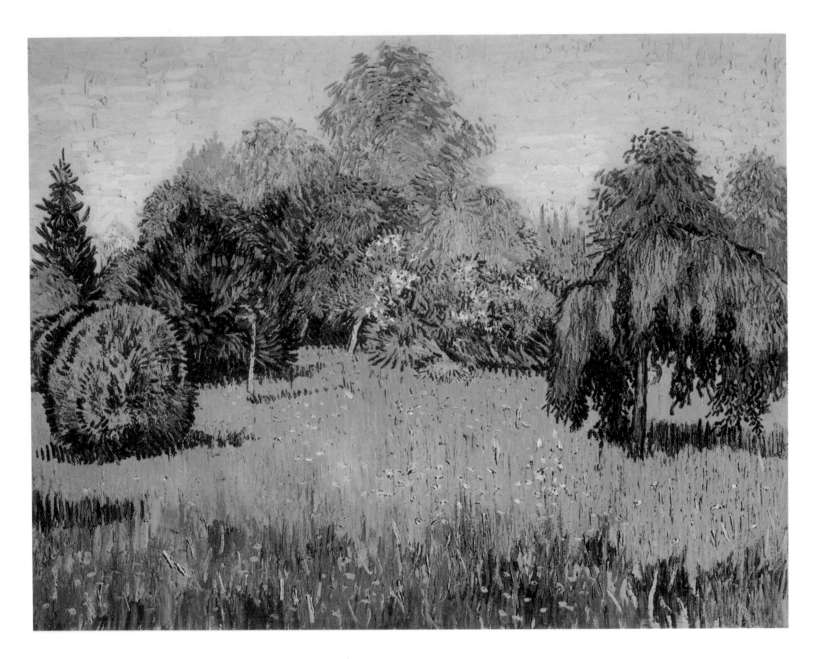

Public Park with Weeping Willow: The Poet's Garden I
Arles, September 1888
Oil on canvas, 73 x 92 cm
Chicago (IL), The Art Institute of Chicago

order, and for its "abbot" (van Gogh's word) he knew exactly whom he wanted: Paul Gauguin.

At this time he already knew that Gauguin would shortly be coming to Arles, though he did not know the exact date of his arrival. Gauguin, of course, was a staunch atheist, and one who liked the things of this world. He was not to be tempted by the prospect of monastic rules and observances. He did, however, see his own life as an artist as a mission, and himself as chosen. Indeed, he was a past master at this role. Van Gogh played along with this, partly out of shrewdness but partly because he identified with his friend. "You must live like a monk who goes to a brothel every other week," he wrote to Bernard, who was intimate with Gauguin (Letter B8). Bernard's obsession with brothels had also found an outlet in a series of drawings which (some time before Toulouse-Lautrec) gave an altogether clear-sighted account of the life of whores.

Even without a Gauguin, van Gogh was of course a deeply religious man, an ascetic who could literally live on bread alone. Furthermore, van Gogh had needed no Bernard to help him discover brothels. But whenever he detected traits of his own in friends, he exaggerated them; and then he threw himself heart and soul into the attempt to be what he felt was expected. He wanted to be the perfect

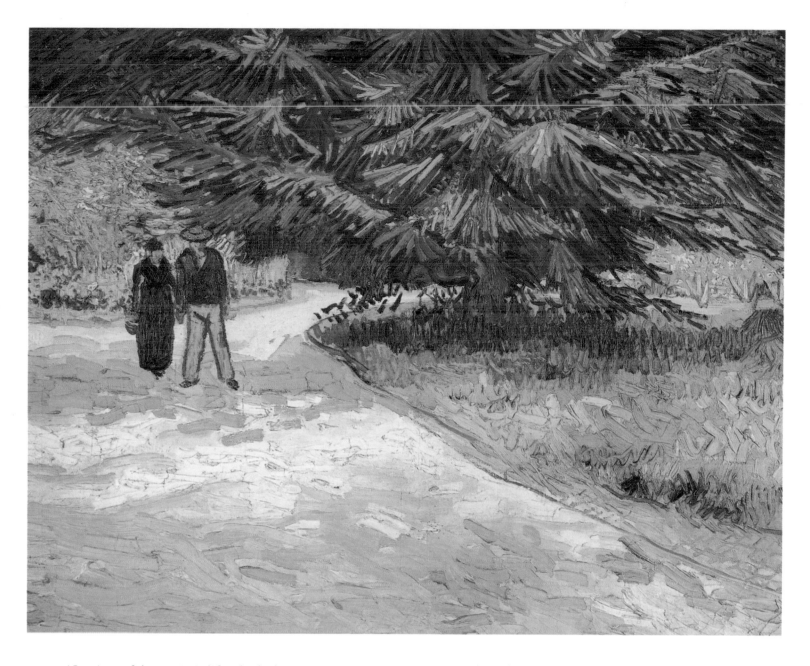

personification of that artistic life which they were pursuing. For Gauguin the cult of the artist had always been a game, a part to be played the more eagerly, the more it conferred an aura of genius – but van Gogh entered into it with his customary emotional commitment. Gauguin toyed with his moods; but for van Gogh it was all in deadly earnest. We must bear this in mind if we are to understand the breakdown that shortly followed. As yet, however, he was still merely trying to cut a favourable figure, and to find the common ground between his painting and his sense of identity in a way that would prompt discussion amongst his friends and indeed the artistic community at large. For the first time in a long while, since the work of his months in Nuenen (cf. p.27), van Gogh was able to ascribe a specific function to his pictures: he was painting to make an impression on Gauguin, to elicit reactions from him and to point up his own artistic capabilities. Two series were meant to initiate debate: the *Poet's Garden* pictures, and the sunflowers.

The poet's garden was across from van Gogh's house on the Place Lamartine, a municipal park complete with people out for a stroll and picturesquely clipped bushes and hedges. Van Gogh gave the title *The Poet's Garden* to four paintings (pp. 134–135), if we include one that is now missing and can only be imagined from a surviving sketch. They were intended to adorn Gauguin's room, to keep

Public Garden with Couple and Blue Fir Tree: The Poet's Garden III
Arles, October 1888
Oil on canvas, 73 x 92 cm
Private collection

his eyes (even in the small world of a framed canvas) firmly on the lyrical pleasures the south had to offer. Indeed, the four views possess a poetical charm that is rare in van Gogh's works. They seem particularly balanced, particularly inviting. They offer us a distinctive sense of harmony. The people in them are couples – that is to say, the subject is an open invitation to be lyrical. The garden itself is accessible, domestic, bespeaking the human touch in its trimmed shrubs, friendly paths, and lack of hostile and impenetrable undergrowth. Man and Nature are in harmony. The evocatively timeless realms of Gauguin's art doubtless prompted this serenity. It is a mood that we may perhaps explain by van Gogh's attempt to establish a common ground between his own work and Gauguin's.

This series of compliments he paid his fellow artist was matched by a second series of paintings focussed more on himself. At first, van Gogh also produced four versions of the sunflowers, (pp. 136–138); three more followed in 1889. He was to remember these paintings with a pang of longing after his breakdown (Letter 573): "You know Gauguin was especially taken with them. One of the things he said about them was: 'That... that is... the flower.' As you know, peonies are Jeannin's, hollyhocks are Quost's, and sunflowers, well, sunflowers

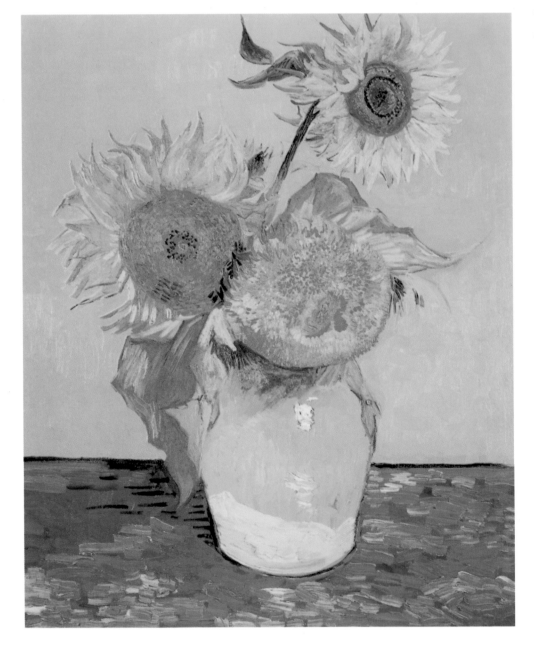

Three Sunflowers in a Vase
Arles, August 1888
Oil on canvas, 73 x 58 cm
United States, Private collection

Still Life: Vase with Twelve Sunflowers
Arles, August 1888
Oil on canvas, 91 x 72 cm
Munich, Bayerische Staatsgemälde-
sammlungen, Neue Pinakothek

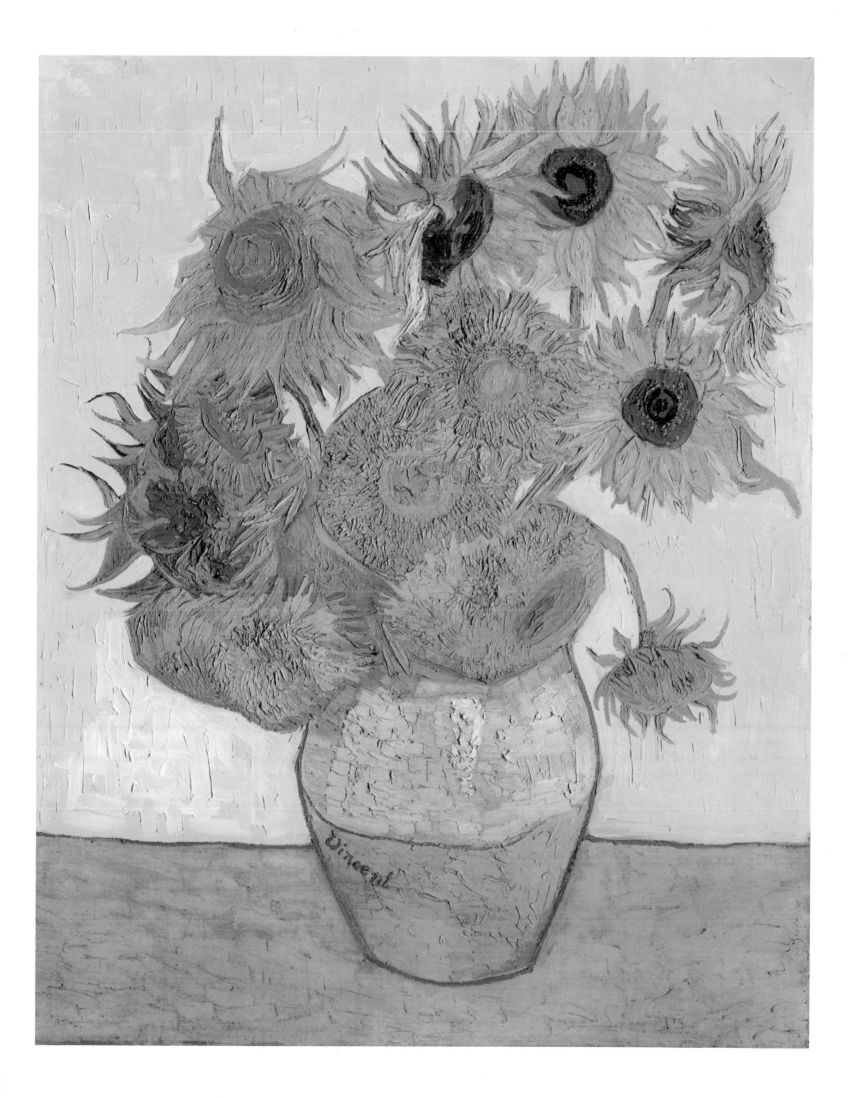

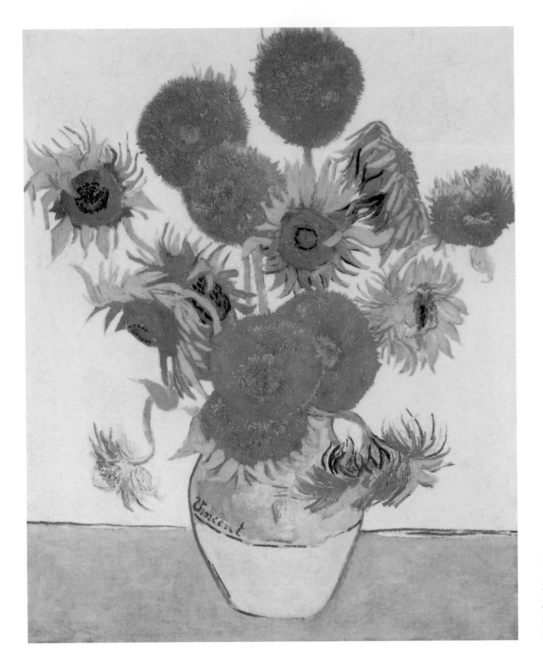

Still Life: Vase with Fourteen Sunflowers
Arles, August 1888
Oil on canvas, 93 x 73 cm
London, National Gallery

are mine." Gauguin was very well aware of what van Gogh was showing him: the only picture he managed to paint during his stay in the yellow house was *Vincent Painting Sunflowers* (Amsterdam, Rijksmuseum Vincent van Gogh). He, too, identified his friend with the flower.

The individual symbolism of the sunflowers was of secondary importance. Rather, they enabled van Gogh to display his working methods, how he approached his subjects, and what his particular concerns were in painting. The sunflowers he positioned in a vase early in the morning naturally called for urgency since they would wilt within hours. This provided van Gogh with the justification (as it were) for a devotion to speed which in fact he was only too glad to consider an end in itself. A painter unaccustomed to rapid work would never manage to seize the beauty that was wasting away minute by minute. It was the yellow of the sunflowers that was so magical, that colour of the south to which van Gogh had already paid homage in painting his house yellow. Placed in front of a dark background, the colour prompted associations of the typical contrast of the south, that contrast of blue and yellow which he had used in the painting of his house.

The Seated Zouave
Arles, June 1888
Oil on canvas, 81 x 65 cm
Argentina, Private collection

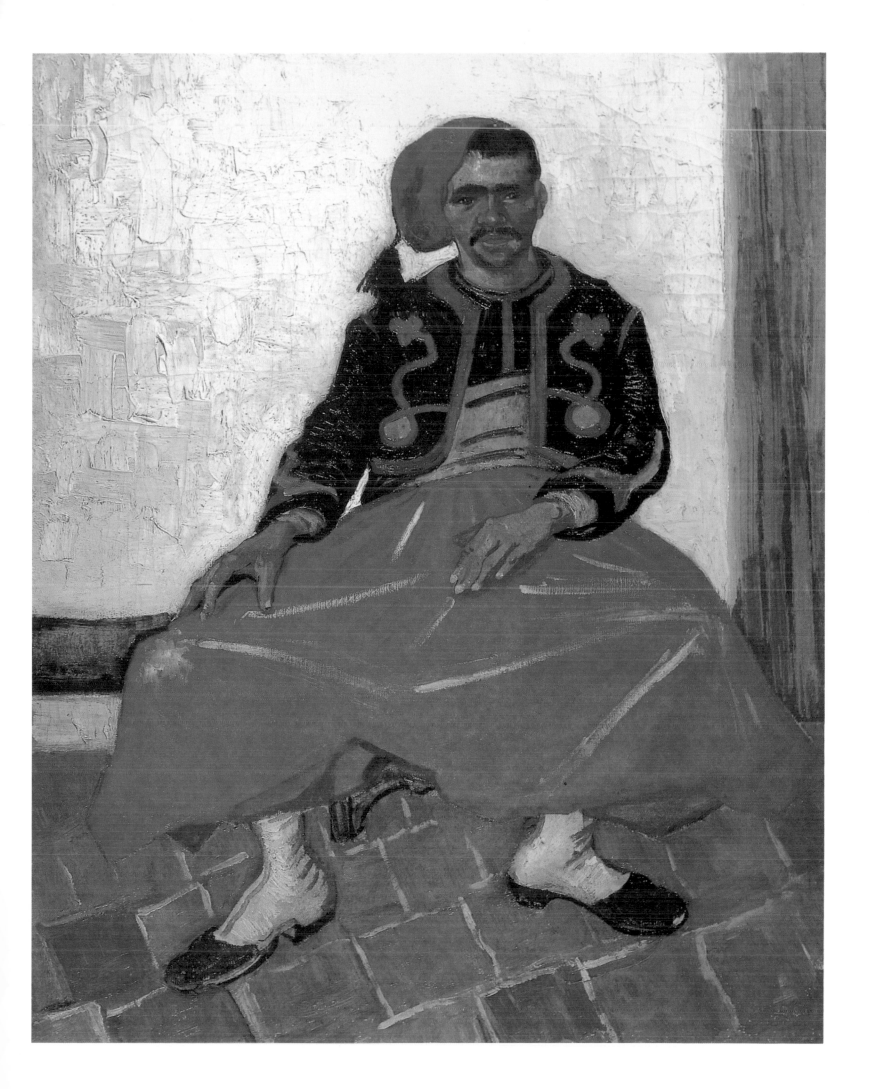

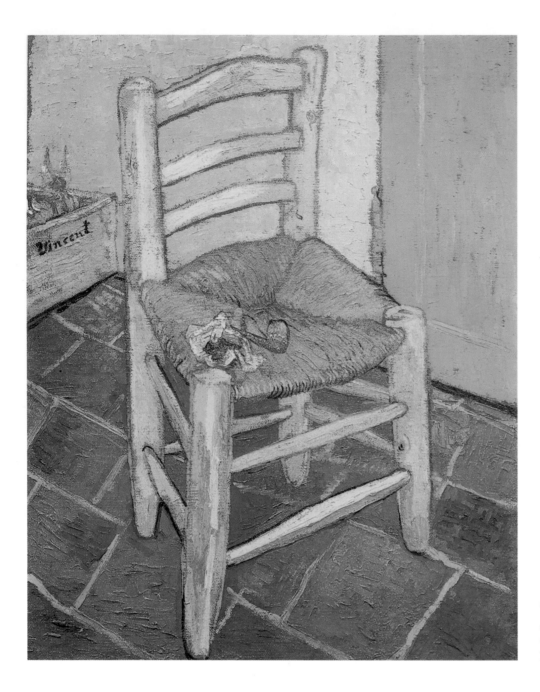

Vincent's Chair with His Pipe
Arles, December 1888
Oil on canvas, 93 x 73.5 cm
London, National Gallery

"I am going to cover the white walls of the room that you will sleep in, or Gauguin, when he comes, with nothing but paintings of large yellow sunflowers," Vincent promised Theo in Letter 534. "And then you will see these large pictures of bunches of twelve or fourteen sunflowers, filling the tiny room along with a pretty bed, everything else all very elegant." As he goes on he makes a vitally important statement: "There is no hurry at all, but I do have my own definite ideas. I want to make it into a real artist's house, nothing contrived, quite the opposite, nothing should be at all contrived, but everything – from the chairs to the pictures – should have character." The sunflower series and the poet's garden series are both parts of an overall decorative concept.

Van Gogh and Symbolism

The dream of the *Gesamtkunstwerk* ruled sovereign in a world whose highest principle was Beauty. *L'art pour l'art* was the slogan of the *belle époque*. The spectacle of artistic creation became an end in itself, whereas at one time it had

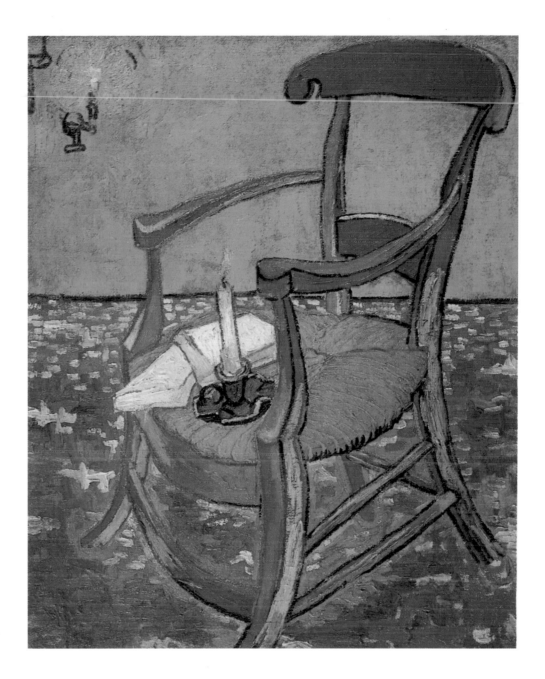

Paul Gauguin's Armchair
Arles, December 1888
Oil on canvas, 90.5 x 72.5 cm
Amsterdam, Rijksmuseum Vincent van Gogh,
Vincent van Gogh Foundation

merely provided the props and the set. In using all of their senses simultaneously, the artist and the well-disposed audience could share in the higher mysteries of synaesthesia. The uninitiated were excluded; the public was confined to the chosen few who debated the aesthetic issues of the age. Symbolism, a tremendously vague term, resembled the other isms in offering connoisseurs and artists who were brimful with aesthetic theories an arena for their debates, one which served the ideal of the *Gesamtkunstwerk*. Its trademark was an alertness to the possibilities implied in synaesthesia.

During his stay in Paris, van Gogh had been a debater in that arena for at least a year. So, was van Gogh a Symbolist? A painter to his fingertips, van Gogh never tried his hand at sculpture, limited his literary output to letter-writing, and never so much as mentioned the theatre or music. Is there any reason to suppose he shared in the dream of the *Gesamtkunstwerk*? Were his comments on the overall decorative system that governed his yellow house in fact more than simply words to clothe his naked misery? The fact is that van Gogh's relations with Symbolism are highly ambivalent. His personal appearance was quite enough to mark him out from the dandies and bohemians. His sympathies were too much on the side

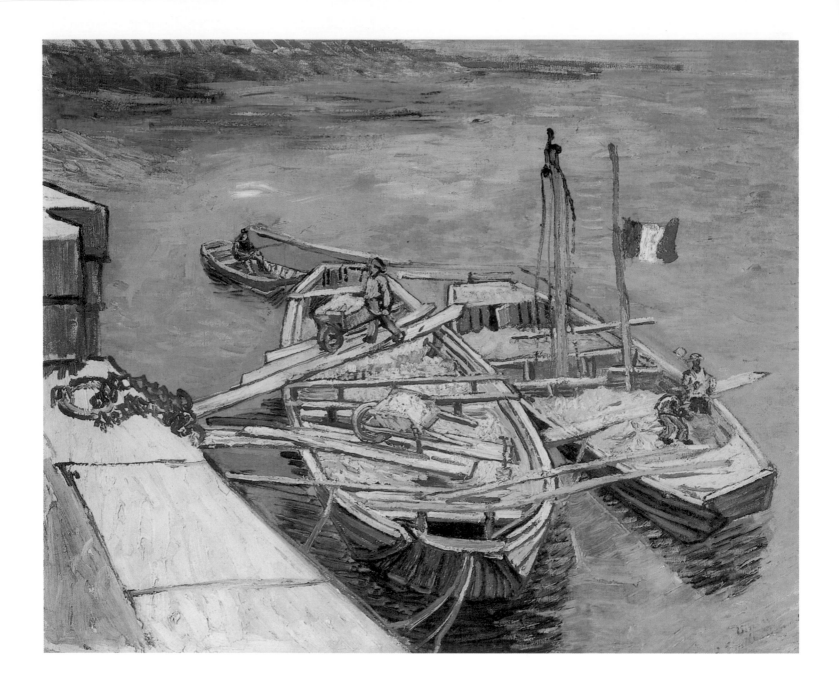

Quay with Men Unloading Sand Barges
Arles, August 1888
Oil on canvas, 55.1 x 66.2 cm
Essen, Museum Folkwang

of the common people, and the natural simplicity of their lives, for him to have much taste for the self-advertising and exhibitionism the Symbolists often went in for. Nevertheless, once he was far from the metropolis, from its aestheticism and world-views, van Gogh repeatedly called to mind things that indicate his affinity with the movement.

"It would be absurd not to concede the degree of decadence that we have reached," stated one of the Symbolist journals that had appeared around the year 1886. "Religion, morality and justice are in a state of decline. The sophistication of desires, feelings, taste, luxury, amusements – neurosis, hysteria, hypnotism, morphine addiction, scholarly charlatanism – they are all symptoms of a particular social evolution. The first signs appear in language. Changed requirements are met with new, infinitely subtle ideas of many and various kinds. This explains the need to coin new words in order to express the diversity of mental and physical sensations." This Décadence manifesto is of course too hymn-like in its praise of sophistication and the artificial to serve as a definition of van Gogh's art. A sense of degeneracy was in the air; people felt that genetic mismanagement had affected their very spirits; and the neurosis spread throughout their souls. It

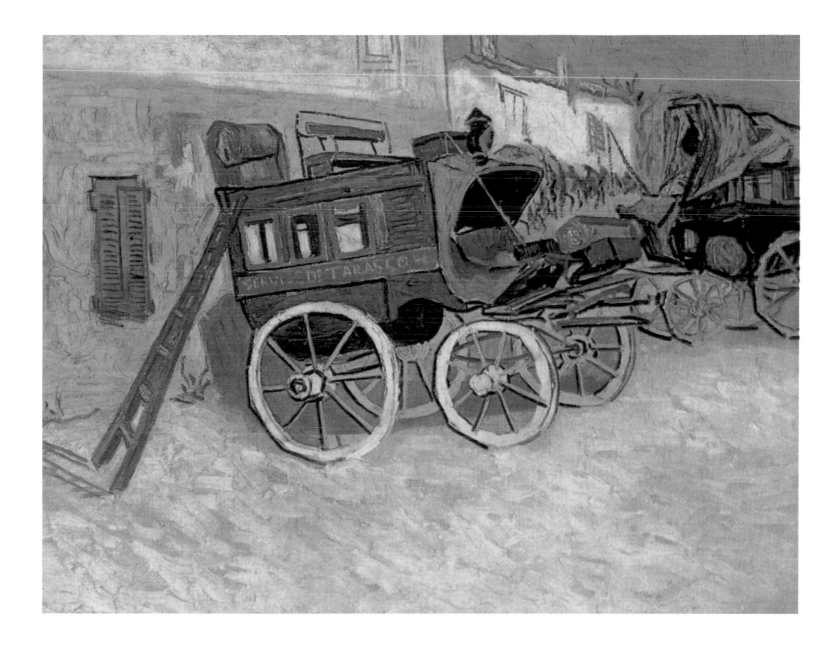

came to be the hallmark of the artist: there was agitation in his use of pen or brush, and his language had necessarily to be new because it arose from deep urges that would no longer be repressed.

And yet it was but a short step from the decadent to the primitive. The world evolves in mysterious, cyclical ways, and the modern age found itself once again at the starting point of all communication, having come full circle back to zero, to begin anew. Modernism began to take its bearings from the dignified, natural simplicity of peoples who had hitherto merely served as subjects of ethnological study. Modernism discovered itself by discovering primitivism – in other words, by making a new start. The simple prompted associations with the complex by introducing an extensive repertoire of cultural information. This is where van Gogh comes in: his art is an art of analogy – analogies of meaning and analogies of form.

Let us take another look at *The Café Terrace on the Place du Forum, Arles, at Night* (p. 127). In it, van Gogh presents a classic example of his use of analogous forms. Three parallel lines lead from the left-hand side to the centre of the composition: the lowest is the lintel of the window-frame at left, next comes the

Tarascon Diligence
Arles, October 1888
Oil on canvas, 72 x 92 cm
New York, The Henry and Rose Pearlman Foundation, Inc.

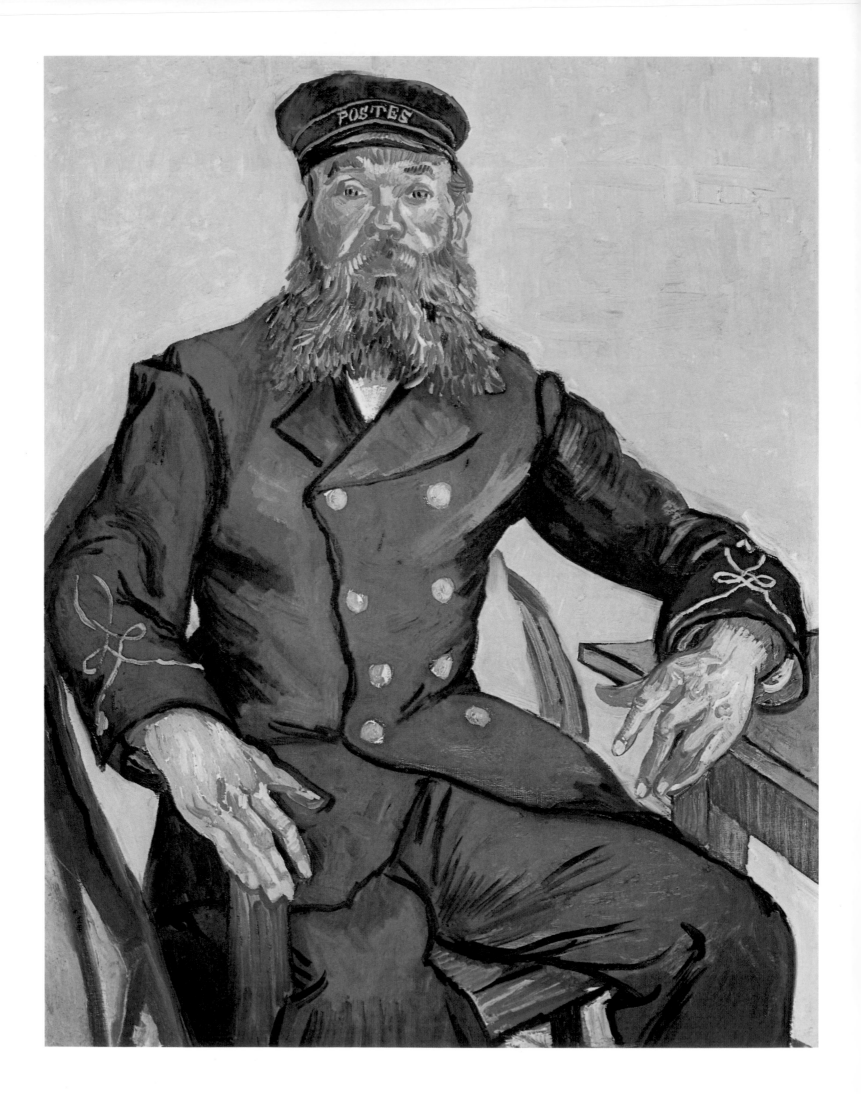

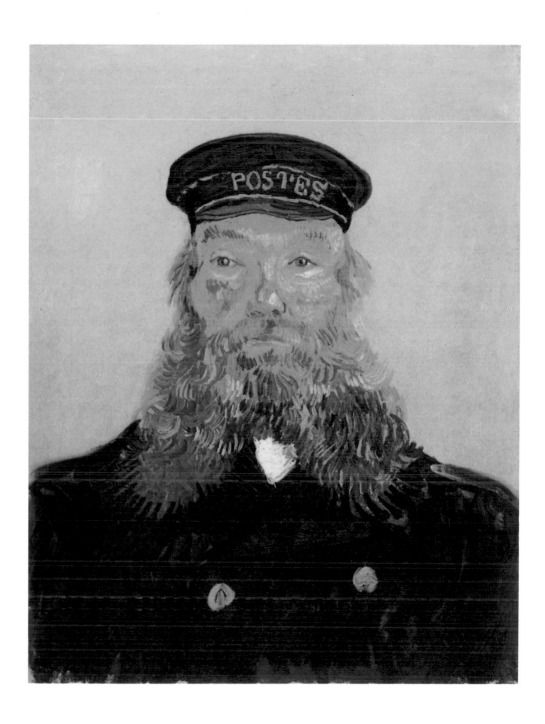

Portrait of the Postman Joseph Roulin
Arles, early August 1888
Oil on canvas, 64 x 48 cm
Detroit (MI), Collection Walter B. Ford II

Portrait of the Postman Joseph Roulin
Arles, early August 1888
Oil on canvas, 81.2 x 65.3 cm
Boston (MA), Museum of Fine Arts

reddish edge of the awning, and topmost is the gable of a house, pointing into the blue infinity of the heavens. The fact that these lines are parallel defies all the rules of perspective, according to which they ought all to be converging on a vanishing point. Van Gogh, however, quite deliberately sets out to flout the rules – only to establish new laws of his own within the picture. Lines (he seems to be saying) have other functions beyond the mere description of edges and frames and lintels. They also convey a message concerning themselves; they spin a self-referential graphic web over the canvas, attesting to the two-dimensionality of painting.

The fact that the use of lines freed from the confines of compositional laws was not merely dictated by chance is made apparent in *The Seated Zouave* (p. 139), which van Gogh painted in June 1888. The vast area of red alone is an acknowledgment of the autonomy of form. This autonomy is at odds with the principle of a descriptive account and can be seen as an intermediate step on the way to the actual goal: the use of formal analogy. The man's right shoulder, neck,

cap and tassel frame an area that resembles the shape of his foot. Again, the curvature of his boot-sole echoes the shape of the base of the stool (almost entirely concealed by the man's voluminous attire). The massive area of colour that represents the traditional skirt is crisscrossed by yellowish lines that echo the chequered tiling of the floor. Echoes: there are numerous examples of this use of formal analogy in the painting. Van Gogh was deploying the components of his composition in an abstract, geometrical fashion, on a level which suggested comparison with the impalpable, indefinable realm of music. His motifs were there as themselves; he was not using them to represent a given reality. Van Gogh was to continue his work on this problem during the period with Gauguin.

The literary quality of the Symbolist movement can be seen in the sheer mass of publications, periodicals, statements and creeds it generated. Time and again, the Symbolists used written forms – books, poems and so forth – to launch an "idea". This method was tacitly adopted by all, and it consorted well with van Gogh's artistic practice. He too was a conceptual artist. A thought or subject would have been in his mind a long time by the time he chose his motif. Van Gogh's paintings are veritably awash with meaning. He, too, followed the principle "never to state the idea directly". All his subjects – the sunflowers and sower, the diggers and boats alike – are more than mere objects or people; they come complete with literary associations.

This was indeed the occasion for a violent disagreement with Bernard at the end of 1889. Bernard had sent van Gogh a sketch for a painting of Christ on the Mount of Olives. For van Gogh, the Christian theme of the Mount of Olives was perfectly conceivable without the main character. The olive grove would convey as much meaning in itself as his fellow artist was so laboriously trying to pack into a historical scene. Van Gogh naturally took the Bible for granted; it was the foundation of his thinking, not a treasure-chest of motifs waiting for the artist to choose. Indeed, he never felt the need to state ideas drawn from Holy Scripture directly.

Gauguin in Arles

On 8 October, 1888, Gauguin wrote to his friend and supporter Emile Schuffenecker: "Theo van Gogh has sold some ceramics for me, for three hundred francs. So I shall be going to Arles at the end of the month and will probably remain there for a long time, since the point of the stay will be to work without financial worries until I am launched. In future he will be paying me a modest allowance every month."

But Gauguin was evidently uneasy about his agreement with Vincent's brother. He was financially dependent on the sums that Boussod & Valadon had offered him. This was the gallery for which Theo van Gogh organized exhibitions of young painters. The price Gauguin himself had to pay was to live with the other van Gogh, the oddball, in Arles. True, he valued his art highly; but he found the company of Vincent van Gogh rather beneath his dignity. It had in fact been only at Vincent's insistence that Theo had agreed to the arrangement. The artists' community would capture the south on canvas and then conquer the capital – that was Vincent's idea. Gauguin was wary from the start, feeling that his own future lay in the tropics. But he needed the money, and, once Theo had actually begun selling his work, things started moving.

Portrait of the Artist's Mother
Arles, October 1888
Oil on canvas, 40.5 x 32.5 cm
Pasadena (CA), Norton Simon Museum
of Art

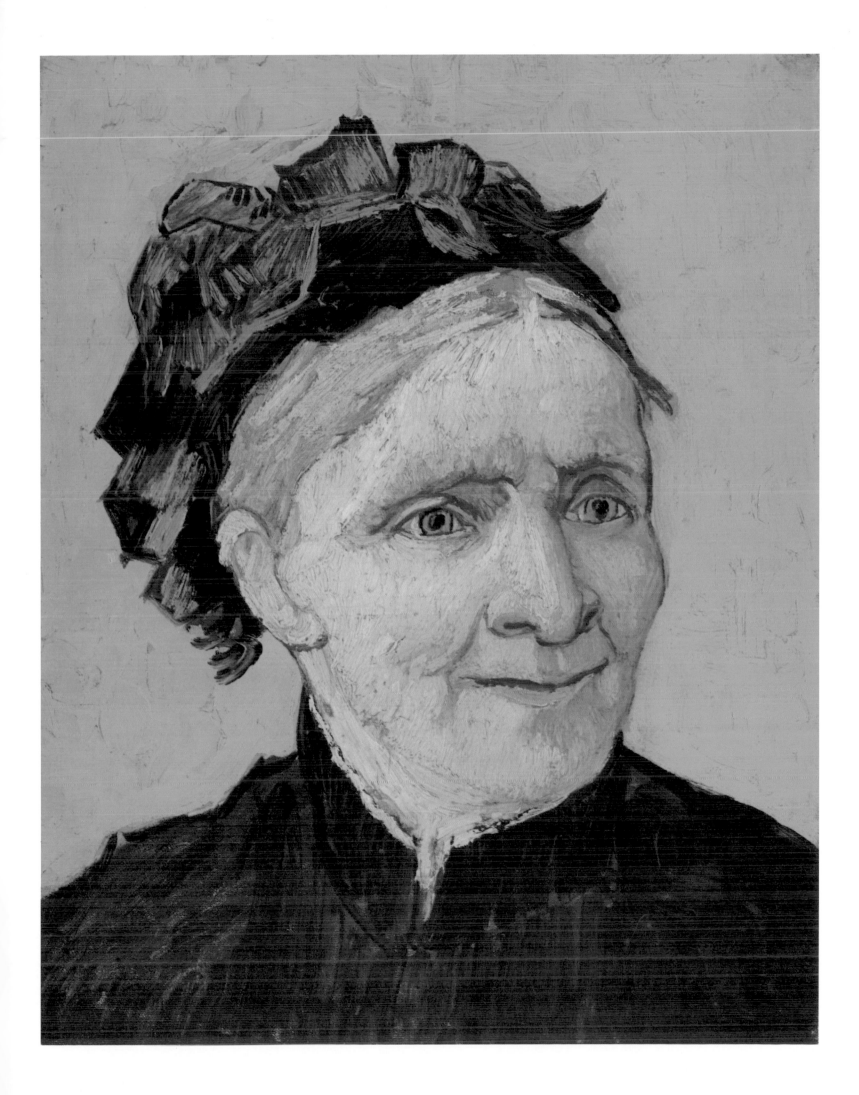

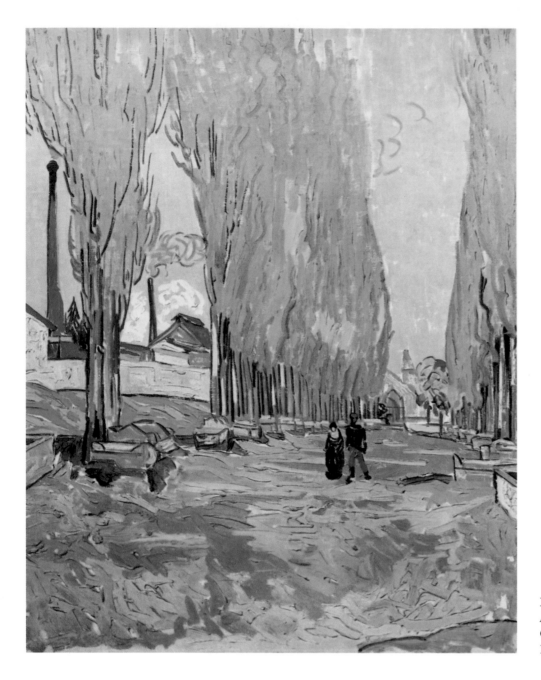

Les Alyscamps
Arles, late October 1888
Oil on canvas, 93 x 72 cm
Private collection

On 23 October Gauguin finally arrived in Arles. From the outset, he fell in with the role of abbot that he was expected to play in van Gogh's monastic yellow house. He ran the household and insisted on the same kind of orderliness in their life as we can see characterizes his work when we compare it with van Gogh's.

The very first paintings van Gogh did in this two-month period – the four views of Les Alyscamps (pp. 148–151) – reveal remarkable changes. The two earlier versions (pp. 148 and 149) are still in van Gogh's usual style. The artist allows himself to be captivated by his subject. He takes up his position in the middle of the lane, with its ancient sarcophagi, relics of a time when Les Alyscamps (to the south of the town) had been the burial ground. Two diagonals converge on a low horizon, bordered by poplars, which lend an air of solemnity. The sarcophagi are kept discreetly in the background. To suit his main subject (the trees), van Gogh has chosen a vertical format, which also enables him to paint a pastose, monochrome sky in contrasting colour. As usual, the canvas is covered with thick, writhing streaks of paint, proof that the picture was painted on the spot, in defiance of the elements.

Les Alyscamps
Arles, November 1888
Oil on canvas, 92 x 73.5 cm
Private collection

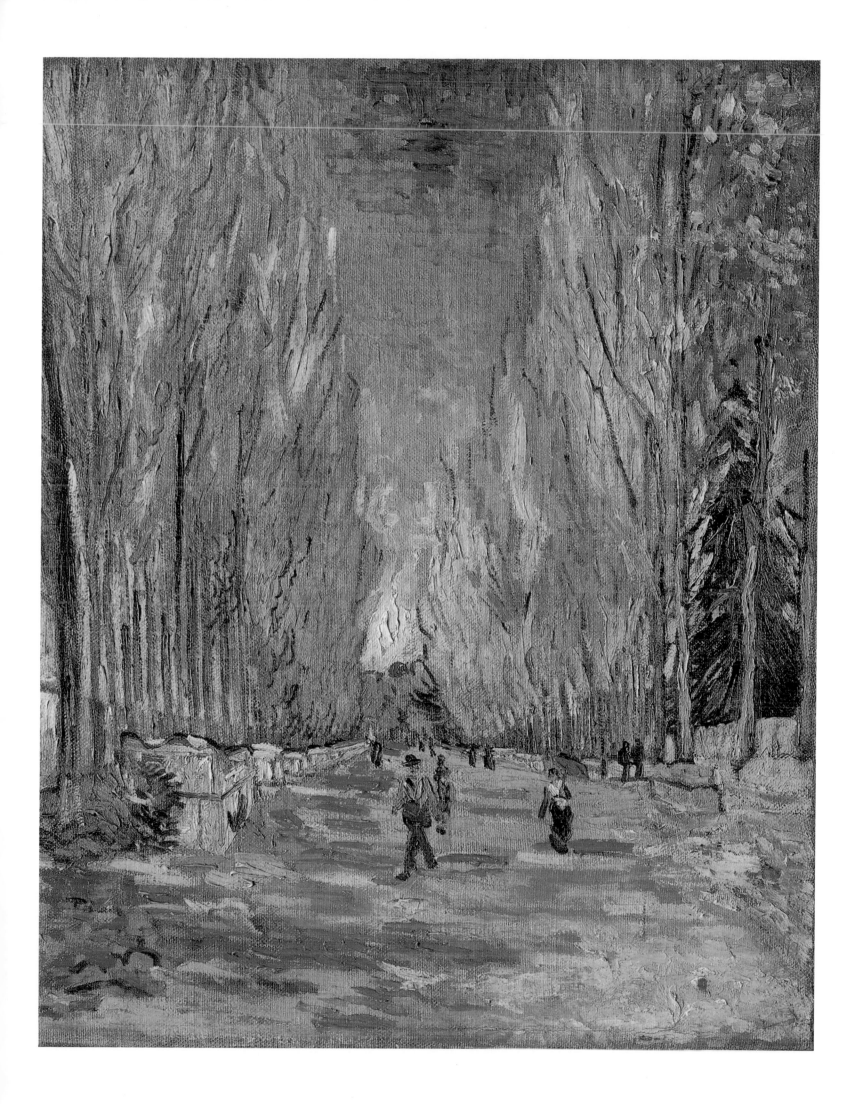

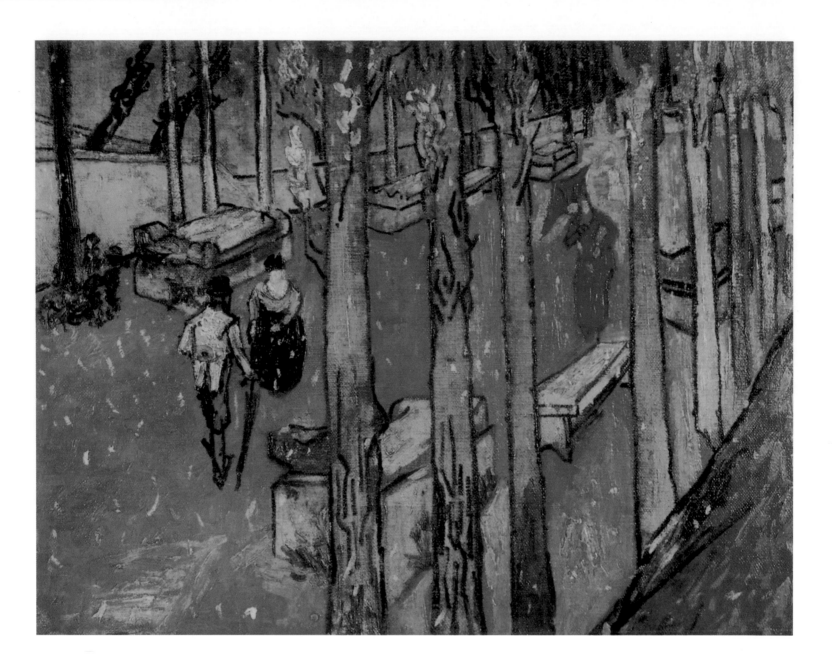

Les Alyscamps, Falling Autumn Leaves
Arles, November 1888
Oil on canvas, 73 x 92 cm
Otterlo, Rijksmuseum Kröller-Müller

The next two versions (pp. 150 and 151), in contrast, clearly betray the influence of Gauguin. Gauguin had procured several metres of coarse, rough canvas; and Vincent painted his two views on this, too, sacrificing the dense power of his style for a smooth-as-varnish finish. He also changed his position, moving from the centre to a point further off on the embankment, above the sarcophagi. In these later paintings, the trees have been rendered in fragmentary style, cut back in favour of an air of antiquity and of the burial ground (with the extra dimension of artifice that this implies). Now the horizon is almost at the top of the composition; and the spatial qualities of the scene are further obscured by the crisscrossing verticals of the tree trunks and diagonals of the lane. In short, van Gogh has opted for a sophisticated composition using an autonomous formal construct. If it were not for the familiar stock figures of a strolling couple or a lady with an umbrella, we would indeed have no proof that this was in fact the work of van Gogh himself. The pressure to conform must have been immense, particularly in the first few weeks. It appears that Gauguin wanted a pupil, perhaps indeed an imitator – and van Gogh's awe-struck respect for the Master knew no limits.

Apart from his own work, Gauguin also had an extremely important painting with him: Bernard's *Breton Women* (France, Private collection). Bernard had

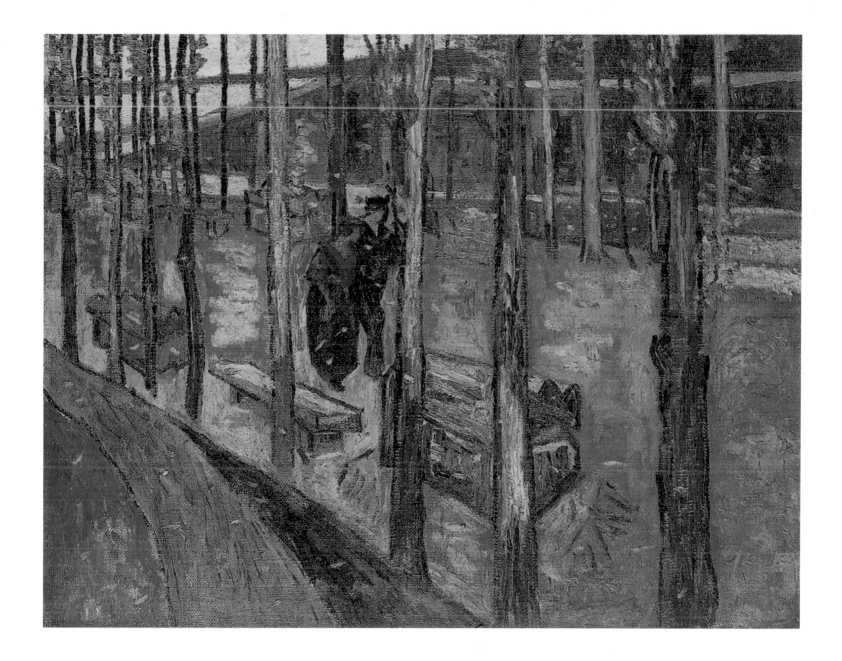

Les Alyscamps
Arles, November 1888
Oil on canvas, 72 x 91 cm
Collection Stavros S. Niarchos

painted it when the two artists were together at Pont-Aven in Brittany. That summer, Gauguin and Bernard had pitted their skill and wits against each other. At Pont-Aven they had spurred each other on in their daily labours, with the result that each artist produced a manifesto painting: Bernard's *Breton Women* and Gauguin's *The Vision after the Sermon* (Edinburgh, National Gallery of Scotland).

Van Gogh must have immediately recognised the originality of Bernard's masterpiece, for he included it among his personal repertoire of great works (by Millet, Delacroix, etc.) that he copied. His watercolour version (p. 152) is the sole surviving work on paper dating from the two Gauguin months. The gently undulating lines that snake across the picture disregard the outlines of the figures and, starting in the hems of the traditional skirts, intertwine. The women's headwear, widening into broad shawls, defines free-flowing forms that recur in similar style in a dog stretched out pleasurably on the ground. A figure in the background and the threesome in the upper right are included in the interplay of contours. Bernard's colours are unimaginative, and his sparingly used focal areas of unmixed paint do little to change this. Van Gogh, the colourist *par excellence*, retains these areas in a despairing manner in his own version; indeed,

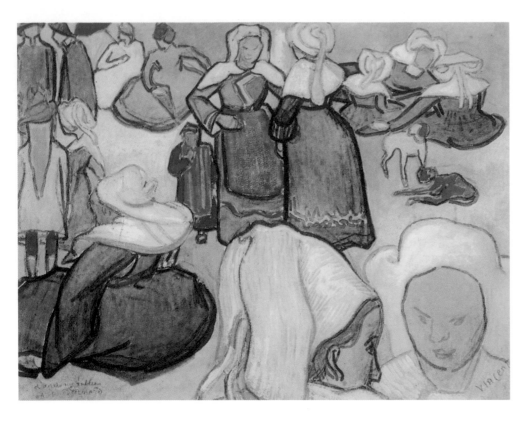

Breton Women (after Emile Bernard)
Arles, December 1888
Watercolour, 47.5 x 62 cm
Milan, Civica Galleria d'Arte Moderna

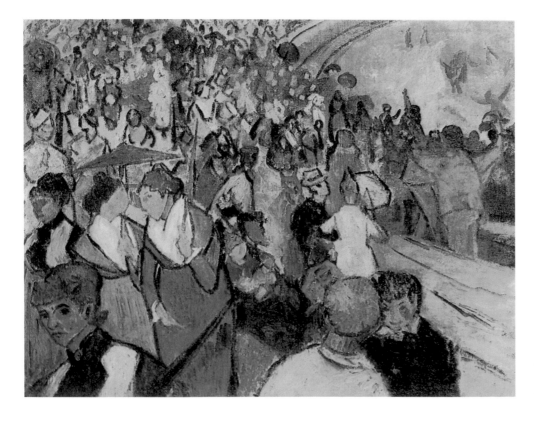

Spectators in the Arena at Arles
Arles, December 1888
Oil on canvas, 73 x 92 cm
St. Petersburg, Hermitage

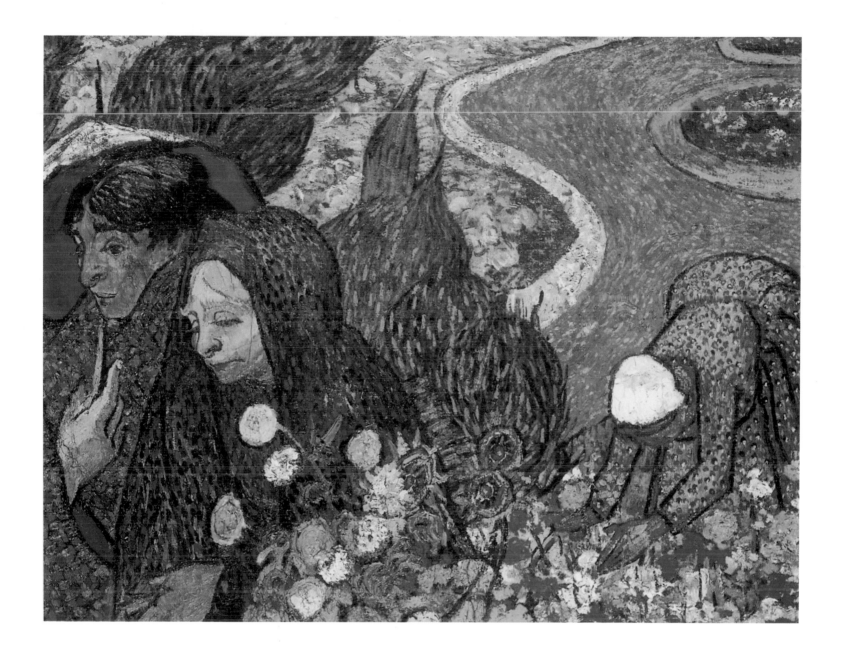

he follows the original very faithfully – even if his lines lack precision, the flow is at times interrupted, and the relations of the figures to each other are unclear. The almost total relinquishment of colour is in itself sufficient to prove van Gogh's emulation of Bernard's aesthetic principles.

In their idyllic summer retreat at Pont-Aven, Gauguin and Bernard, with Louis Anquetin and Charles Laval, had been working together on a project to establish a kind of art that was independent of nature and interested solely in delicacy of visual impact. They introduced the term Cloisonnism to painting; mediaeval goldsmiths had evolved the *cloisonné* technique in enamelware, and this new ism was concerned with the outlines that give objects in a picture – the motifs that are seen on the canvas – a solid presence, and thus independence and autonomy. If this approach seemed to rate lines above colour, it was because they stood for what is permanent and general, whereas colour (so the theory went) could only capture momentary sensations.

This represented a development that was not at all what van Gogh himself intended. Outlines merely helped van Gogh locate his motifs and transfer them to the canvas entire. Outlines also helped him regulate the flow of colour and kept it from becoming over-impetuous. In other words, outlines served to

Memory of the Garden at Etten
Arles, November 1888
Oil on canvas, 73.5 x 92.5 cm
St. Petersburg, Hermitage

underwrite the real: they checked his vehemence and provided a kind of pattern that could discreetly and efficiently mask his shortcomings as a draughtsman.

Meanwhile, van Gogh attempted to follow Gauguin's concept of art in paintings such as *Memory of the Garden at Etten* (p. 153). Everything is subordinated to a visionary mood, to the implication of an invisible world. There is no horizon to establish a verifiable spatial sense. Van Gogh's bold foreshortening is not so much a riposte to logic and sequence as a way of making the picture a graphic exercise in surface two-dimensionality; the notion of space seems to have become irrelevant. Everything in the picture has been framed in contour lines – even the dahlias growing from out of the foreground arrangement (so like a still life) are simply iridescent discs. The people passing are lost in thought and remote from us. No gesture or glance establishes any contact with the world outside the canvas – they remain quite emphatically in their two-dimensional counterworld, quoted almost verbatim from Gauguin's view of the park opposite, *Women in the Garden* (Chicago, The Art Institute of Chicago). All that recalls van Gogh's own aesthetic principles is his defiant use of dabs of paint; but they have an anachronistic flavour. They seem rather forced reminders of his discovery of colour, and appear somewhat out of place.

The Sower
Arles, November 1888
Oil on canvas, 32 x 40 cm
Amsterdam, Rijksmuseum Vincent van Gogh,
Vincent van Gogh Foundation

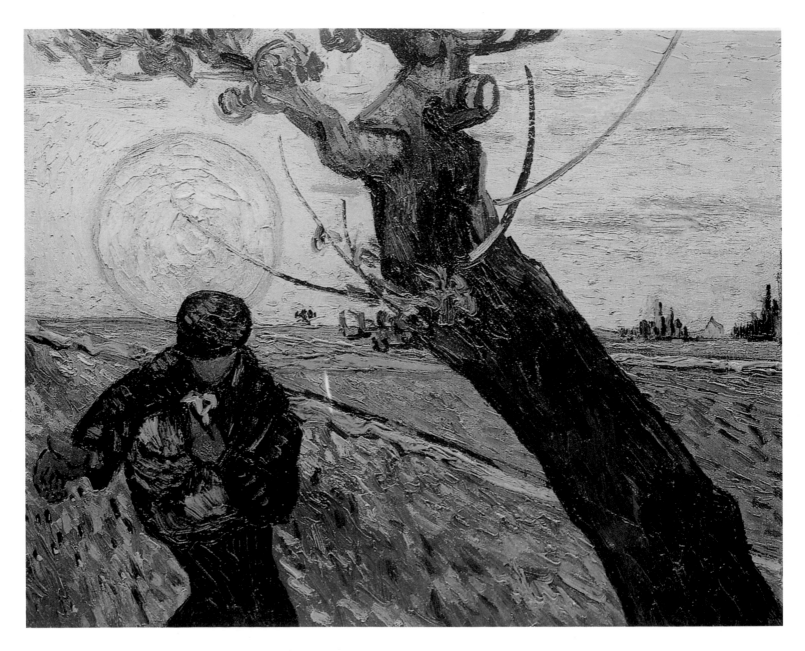

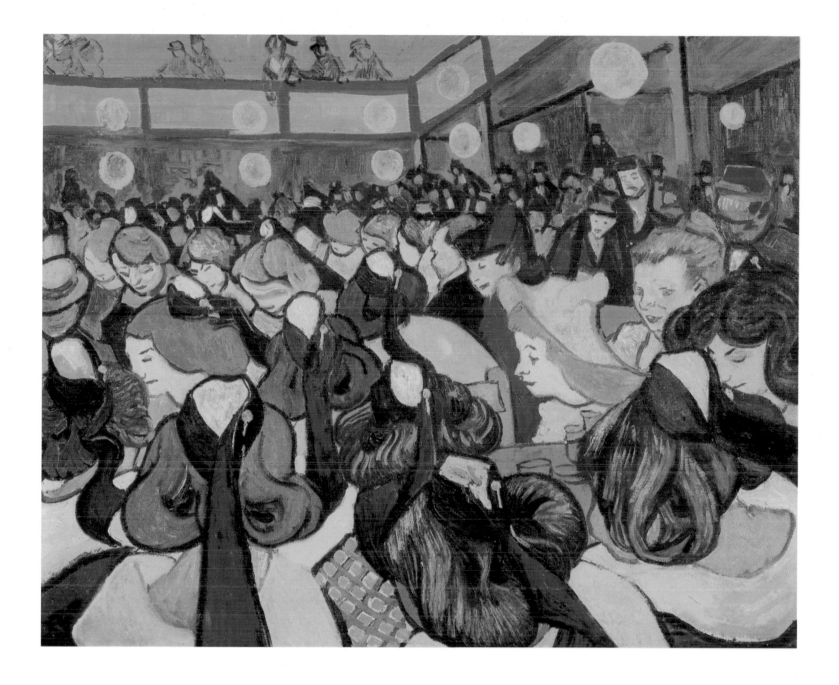

Van Gogh was concerned with the "bizarre, contrived" lines which removed his scene from everyday reality. There was a high price to be paid, because in painting like this he had to desert the original motifs and delve into his own imagination. To an extent, he was producing from deep within himself images which otherwise would have been supplied by the things of the world themselves. As the title points out, the picture is an exercise in memory, recalled from the past. This links it to other paintings done at the same time, such as *The Sower* (p. 154), *The Dance Hall in Arles* (p. 155) and *Spectators in the Arena at Arles* (p. 152). "Art is abstraction," was Paul Gauguin's definition, "you should derive the abstraction from Nature as you dream, and think more about your own creative work and what comes of it than about reality."

But there is another respect in which his *Memory of the Garden at Etten* is a key work of the period with Gauguin. It was the striking imitativeness of the painting, the derivative affinity to his revered Master's work, that made van Gogh realize the incompatibility of their aesthetic ideas. His memory, after all, was again trying to retrieve a quite specific fragment of the real. Van Gogh was remembering his own past and dreaming of his mother and sister taking a walk

The Dance Hall in Arles
Arles, December 1888
Oil on canvas, 65 x 81 cm
Paris, Musée d'Orsay

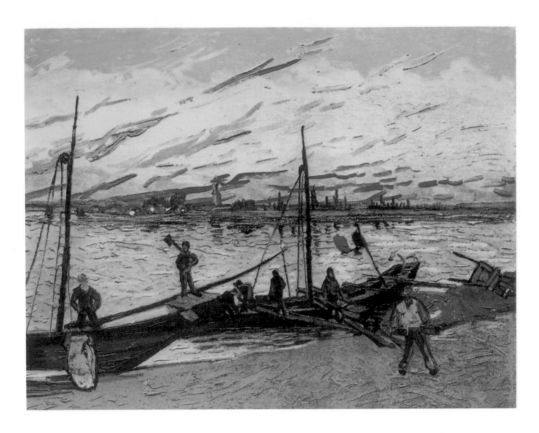

Coal Barges
Arles, August 1888
Oil on canvas, 71 x 95 cm
United States, Private collection

Coal Barges
Arles, August 1888
Oil on canvas, 53.5 x 64 cm
Madrid, Museo Thyssen-Bornemisza

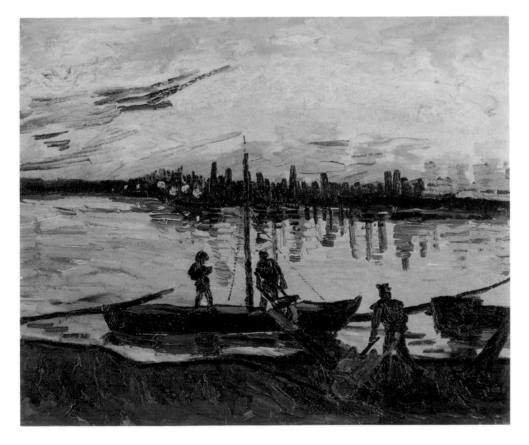

Page 157:
The "Roubine du Roi" Canal with Washerwomen
Arles, June 1888
Oil on canvas, 74 x 60 cm
New York, Private collection

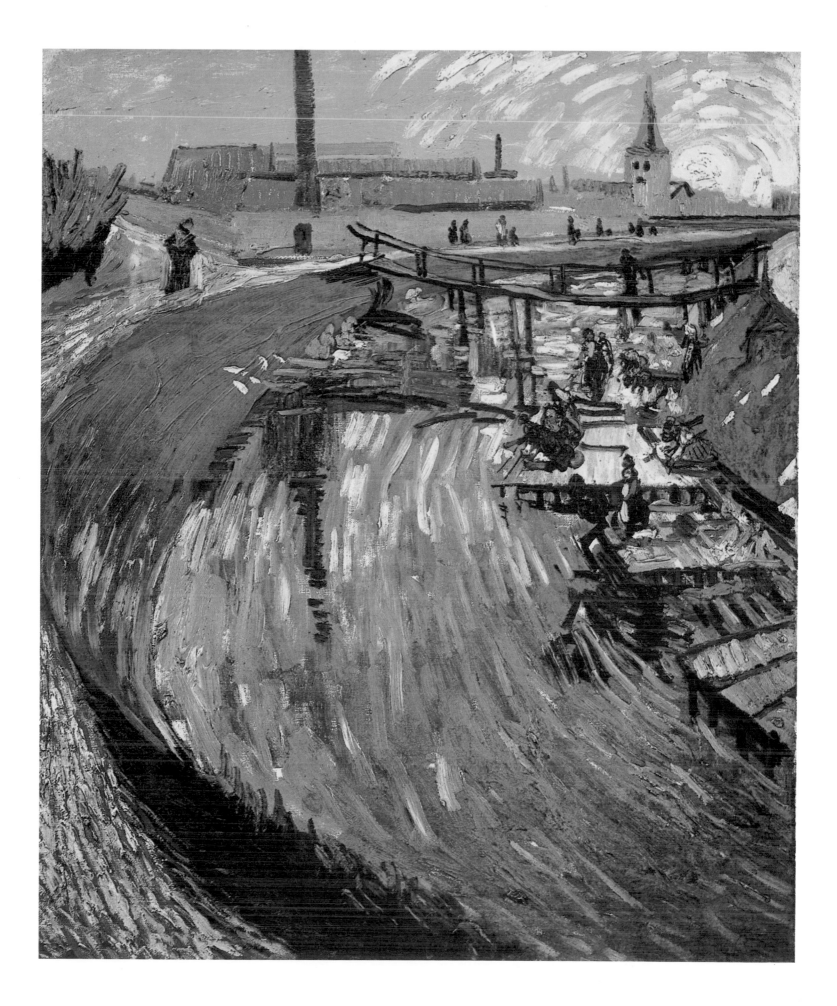

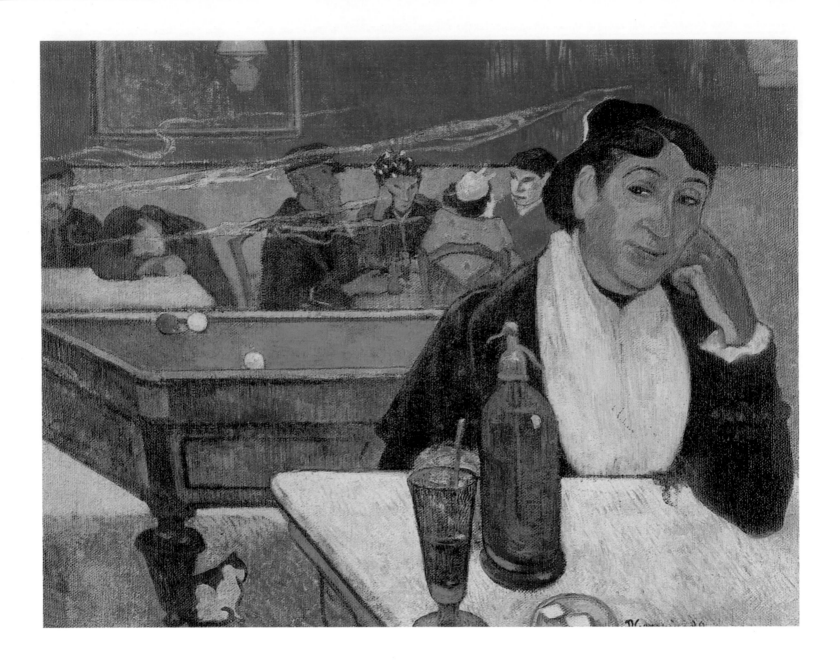

Paul Gauguin
Night Café in Arles (Madame Ginoux)
Arles, November 1888
Oil on canvas, 73 x 92 cm
Moscow, Pushkin Museum

Page 159:
L'Arlésienne: Madame Ginoux with Books
Arles, November 1888 (or May 1889?)
Oil on canvas, 91.4 x 73.7 cm
New York, The Metropolitan Museum of Art

in the vicarage garden he knew so well. His memory paintings were to signal an abrupt change in the way the two artists lived. Henceforth, they were rivals.

Since he arrived, Gauguin had taken his subjects from motifs that van Gogh had already worked on. Thus he produced alternative interpretations of van Gogh's harvest pictures, of *The 'Roubine du Roi' Canal with Washerwomen* (p.157), of the poet's garden, and of *The Red Vineyard* (p.162). In due course he tackled Vincent's pride and joy, the *Night Café*. Gauguin's version (p.158) dispenses entirely with the desolate mood of isolation which van Gogh recorded. The drinkers in the corners now fade in importance beside the foregrounded figure of Madame Ginoux, the proprietress. She is gazing out of the painting, which makes contact easier and releases the interior scene from that oppressive sense of isolation van Gogh had established. Van Gogh's was a nighttime scene if only because of the black despondency of its mood. Gauguin, by contrast, simply shows a café – we need to be told that it is a café that stays open at night. He did not paint the picture on the spot, but in his studio, and accordingly the painter's mood is not conveyed by the work. Gauguin worked in far too controlled and cerebral a way for his works to be mere descriptive accounts of situations. That said, though, his night café is not without that atmosphere of desolation which the place surely must

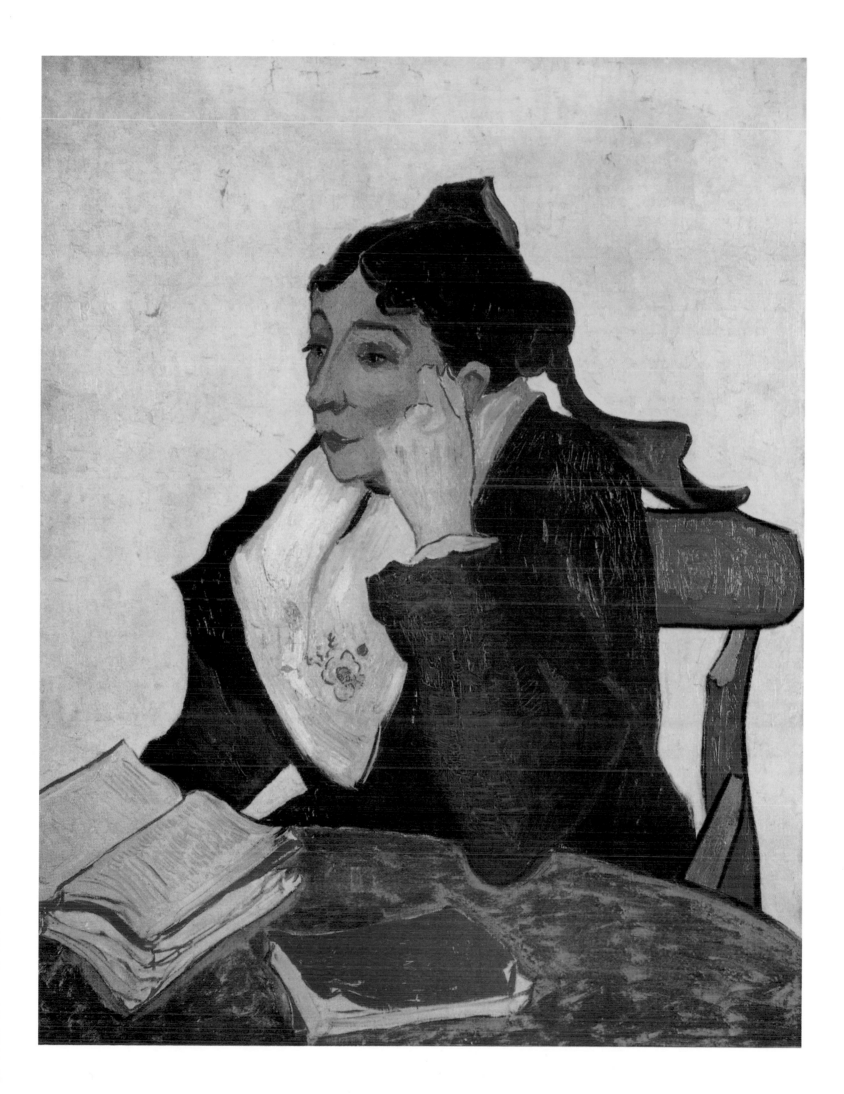

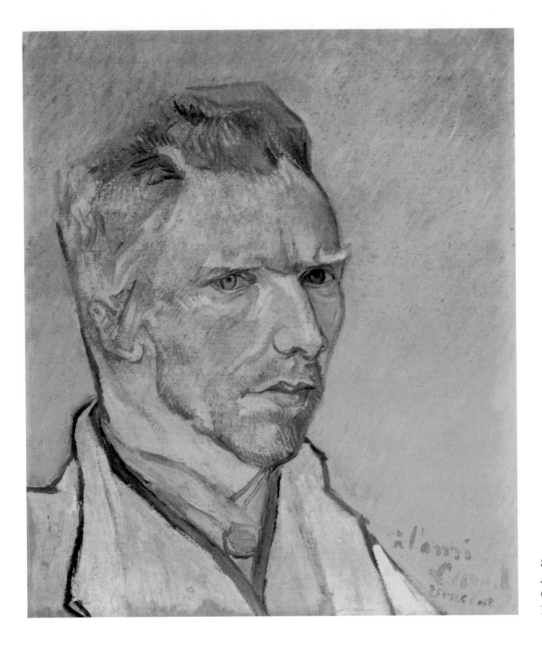

Self-Portrait
Arles, November–December 1888
Oil on canvas, 46 x 38 cm
New York, The Metropolitan Museum of Art

have had. For this reason, van Gogh loved the picture, while Gauguin despised it: "It's not my style", he wrote to Schuffenecker, "the local colours of some bar do not appeal to me." He would inevitably have had to abandon his own principles if he had followed van Gogh in his investigations of the seamier side of human life.

Gauguin's painting of the night café was two pictures in one: the café itself serves merely as a background for the portrait of the proprietress, and is a kind of attribute to indicate the status of the subject. Madame Ginoux had often sat for portraits in the yellow house; Gauguin was building up a stock of drawings (p. 165) that he intended to use for a painting. Van Gogh, on the other hand, would put up his easel, reach for his palette and brush, and have his painting finished (p. 159) in the time it took Gauguin to draw a sketch. Both artists have Madame Ginoux in the same pose, leaning on her left elbow, her head resting on her left hand. Gauguin painted her in frontal pose, something which pre-empted van Gogh, who had always valued eye contact with his models so highly; and van Gogh's readiness to be outmaned is a powerful reminder of the deep respect he had for his fellow artist. But he was his old self once he started painting: monumental monochrome areas of colour, arresting contrasts, and thick streaks of paint squeezed straight from the tube.

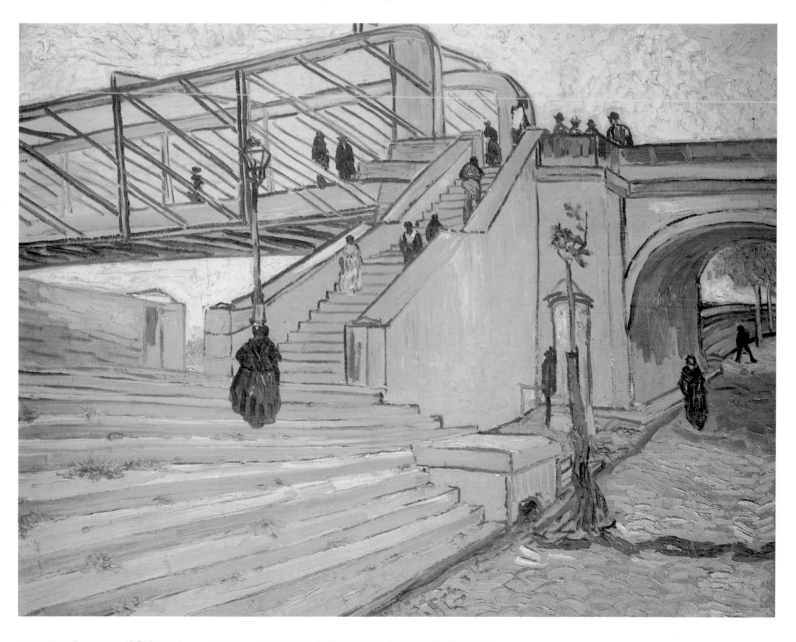

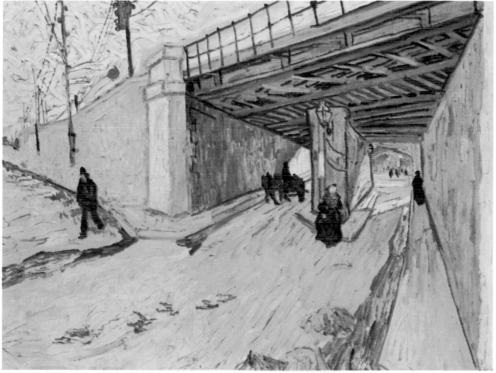

The Trinquetaille Bridge
Arles, October 1888
Oil on canvas, 73.5 x 92.5 cm
United States, Private collection

The Railway Bridge over Avenue Montmajour, Arles
Arles, October 1888
Oil on canvas, 71 x 92 cm
Zurich, Kunsthaus Zürich (on loan)

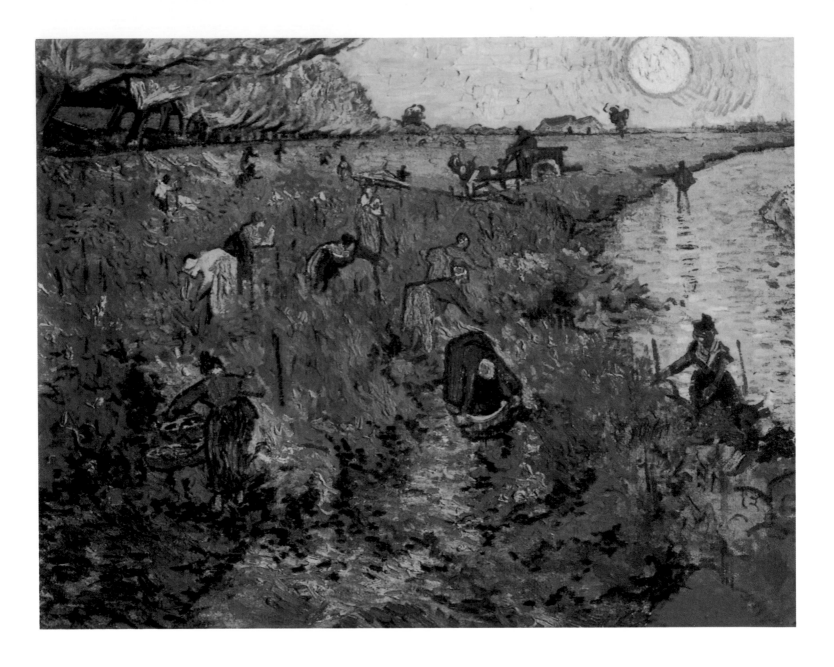

The Red Vineyard
Arles, November 1888
Oil on canvas, 75 x 93 cm
Moscow, Pushkin Museum

What was the two men's life in the yellow house really like? Why did van Gogh, who so relished the encounter of painter and sitter, not do a portrait of Gauguin? Why did Gauguin, by contrast, deign to paint a portrait of van Gogh, even though he did not especially value direct confrontation with a motif and indeed detested that quality of the palpably physical which linked the work to the subject? Why (by way of atonement) did van Gogh paint the two chairs, one of them a vacant throne – as if the old ban on images applied to Gauguin's person and he could only be portrayed symbolically?

The answer to all the questions may run something like this: Gauguin was tending to assume the lofty airs of an artistic genius, and was furthermore threatening to leave. Van Gogh became more and more unsure of himself, and felt obliged to question the value of his own work when faced with the increasingly apparent incompatibility of their approaches. Gauguin's predicament was no less serious than van Gogh's. He gave Schuffenecker a forceful account of their differences: "I feel a complete stranger in Arles. It is all so petty and wretched, the region and the people alike. Vincent and I rarely agree on much, least of all where painting is concerned. He admires Daudet, Daubigny, Ziem and the great Rousseau, all of them people I cannot stand. On the other hand,

he detests Ingres, Raphael and Degas, all of them people I admire. I say to him. 'You're right, boss', for the sake of a quiet life. He likes my paintings very much, but when I am at work on them he is forever saying that I am doing things wrong somewhere or other. He is a Romantic, whereas I have a taste for the primitive." Gauguin was facing up to the situation far more openly than van Gogh did. The latter's letters tended to gloss over the problems and repress his awareness that the project was failing. For Gauguin, the cost was not too great: he would simply have to leave, writing off two wasted months. But for van Gogh it meant the destruction of a world-view if the utopia all his toil was meant to establish finally proved unattainable. A large part of his own identity would be disappearing along with Gauguin.

Gauguin's later escape to the tropics was indicative of the impatience deep within him. Van Gogh, on the other hand, had broken off all his contacts, and

Willows at Sunset
Arles, autumn 1888
Oil on cardboard, 31.5 x 34.5 cm
Otterlo, Rijksmuseum Kröller-Müller

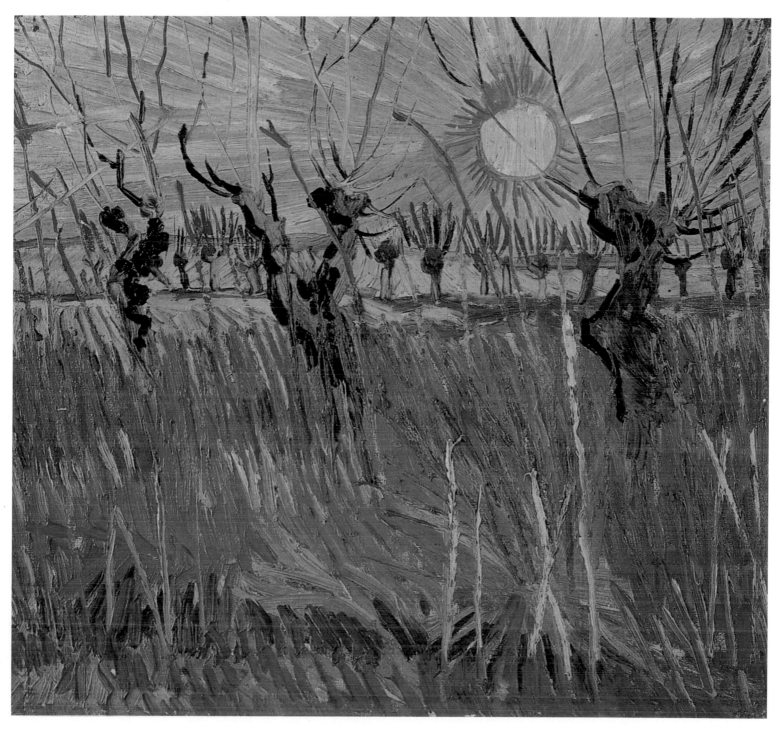

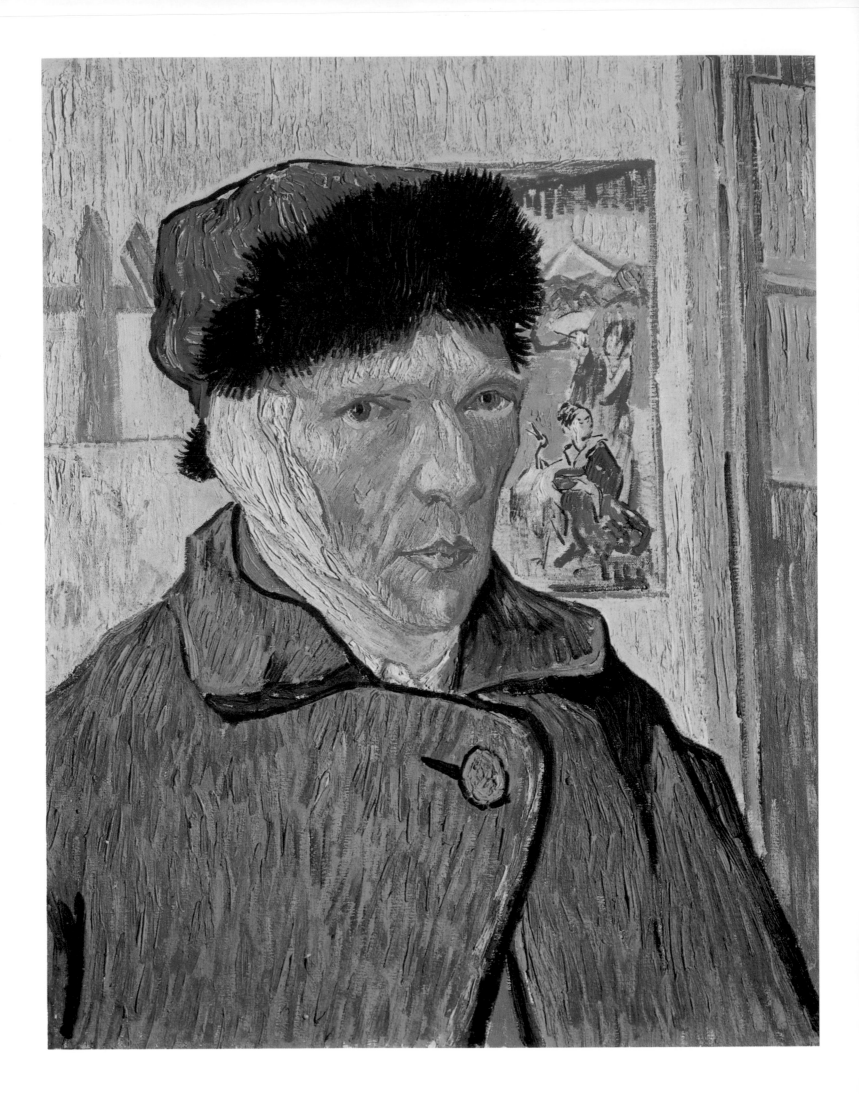

indeed had basically never entered into any commitments that might have brought the artificiality of his ideas and vague raptures home to him. Both of them wanted a return to the simplicity of a natural life, and both tried to present their ideals in their work; but van Gogh had fashioned a far more specific world of images, and supposed himself to be living in that world. Gauguin, by contrast, saw the evocative scenes of harmony he painted as being light years away from the bleakness of his life in Arles. For all his solidarity, he could not help thinking there was something crazy in van Gogh's ideas of life.

Van Gogh's subsequent periods of mental derangement did, in a sense, highlight the manic lack of realism in a concept of art that proposed to create a unity of reality and artwork, fact and fiction. But Gauguin must share the blame for the disastrous events that took place in Arles on the evening of 23 December – at Christmas, of all times. For some time, Gauguin had been threatening to turn his back on Arles, the artists' community, and his friend. On the evening of 23 December he left the house without saying where he intended to go. Vincent suspected that the hour of Gauguin's departure had come – and followed him. Gauguin, hearing a familiar footfall behind him, turned – and caught sight of a distraught van Gogh, doing an about-turn himself and hurrying back to the house. Gauguin now felt disturbed himself, and decided to spend the night in a guesthouse. Next morning, when he set off home, all of Arles was in a state of great excitement. It transpired that van Gogh had mutilated himself with a knife: he had cut off his earlobe, wrapped it in a handkerchief, and, in his injured state, gone to the brothel to give the lobe to a prostitute. Once he returned home he lost consciousness. And thus he was found by the police, who had been alerted by the recipient of the bizarre gift. Vincent was taken to the town hospital; and meanwhile Gauguin made himself scarce, without exchanging another word with van Gogh. The two artists were never to meet again.

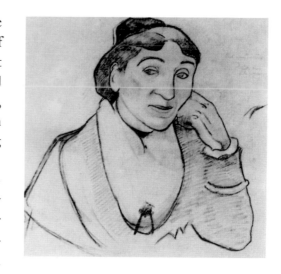

Paul Gauguin
L'Arlésienne (Madame Ginoux)
Arles, November 1888
Crayon and charcoal, 56.1 x 49.2 cm
San Francisco (CA), The Fine Arts Museum,
Aschenbach Foundation for Graphic Arts

Art and Madness

Plainly, Gauguin's sojourn in Arles was of central importance in van Gogh's breakdown. It was a model case of two strong personalities at war, as it were – fighting to the death. In *Avant et après*, the memoirs he published in 1903, Gauguin claimed to have seen a knife in van Gogh's hand when the other man followed him that night. In their life together, Gauguin expressed fundamental doubts concerning van Gogh's art, while Vincent, for his part, clung to his beliefs, defied the other's ideas – and knew there would be a price to pay for his insistence. He knew (and this was why he could not take evasive action as Gauguin could) that the day of reckoning was at hand, a day he had long seen coming. The concept of reckoning, of paying a price, is typical of the way the materialist 19th century thought. And Van Gogh felt that he was forever paying. In Letter 557 (written before Gauguin's arrival in Arles) we read: "I sense that I must go on creating till I am shattered in spirit and physically drained, precisely because I have no means of ever earning the amount we have spent." And shortly after his breakdown he once again observed (in Letter 571): "My pictures are of no value; though of course they cost me a very great deal, at times even my blood and my brain."

Van Gogh was prepared to make physical reimbursement of the costs he occasioned. Even before the Gauguin fiasco he had been well aware of the punishing

Self-Portrait with Bandaged Ear
Arles, January 1889
Oil on canvas, 60 x 49 cm
London, Courtauld Institute Galleries

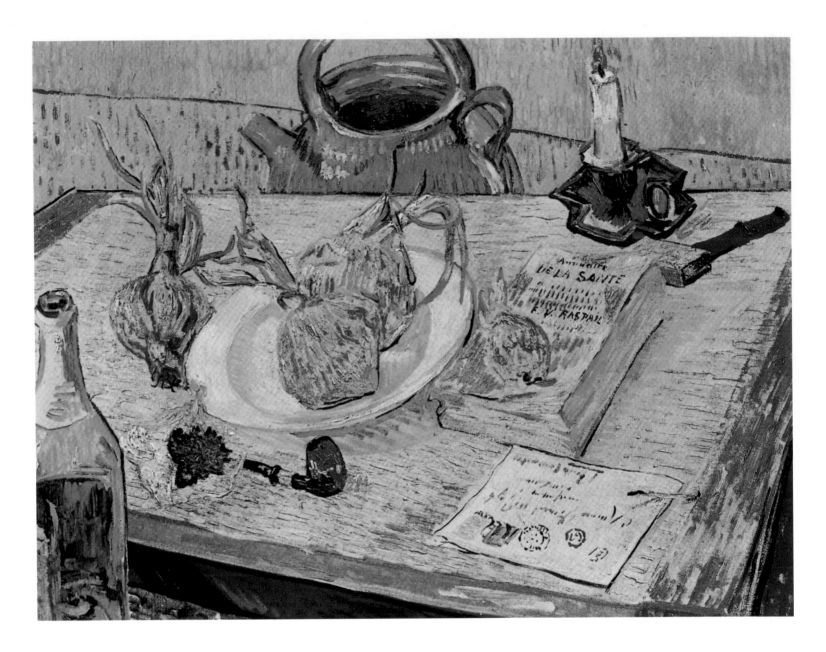

Still Life: Drawing Board, Pipe, Onions and Sealing-Wax
Arles, January 1889
Oil on canvas, 50 x 64 cm
Otterlo, Rijksmuseum Kröller-Müller

regimen he was submitting to in order to underwrite his artistic life. He was consuming large quantities of alcohol, coffee and nicotine: his drugs doubtless benefitted his paintings, but he also realised that he was paying the price of productivity in physical terms. "Instead of eating sufficiently and regularly I kept myself going (they said) with coffee and alcohol." Thus van Gogh described the conclusions of the clinic staff (in Letter 581). "I admit it; but in order to achieve that noble shade of yellow I achieved last summer I simply had to give myself quite a boost."

That December night he went an important step further, doing irreparable damage to his body. He was to remain mutilated till the day he died. Gauguin had called his artistry into question more than ever before; and van Gogh felt compelled to raise the stakes. The earlobe he cut off was the price he paid for his productivity – and he was resolved to keep up his output. He was subsequently to describe the hallucinations he experienced during his bouts of madness. He heard noises and saw visions: "It was hearing and seeing at once in my case," he wrote in Letter 592.

What complicated his novel action was the fact that he took the bloody earlobe to the brothel. Van Gogh seemed to be thinking that his deed would be met with understanding there and he would receive a sympathetic response. Nature has made the artist and the whore accomplices: "Our friend and sister is assuredly

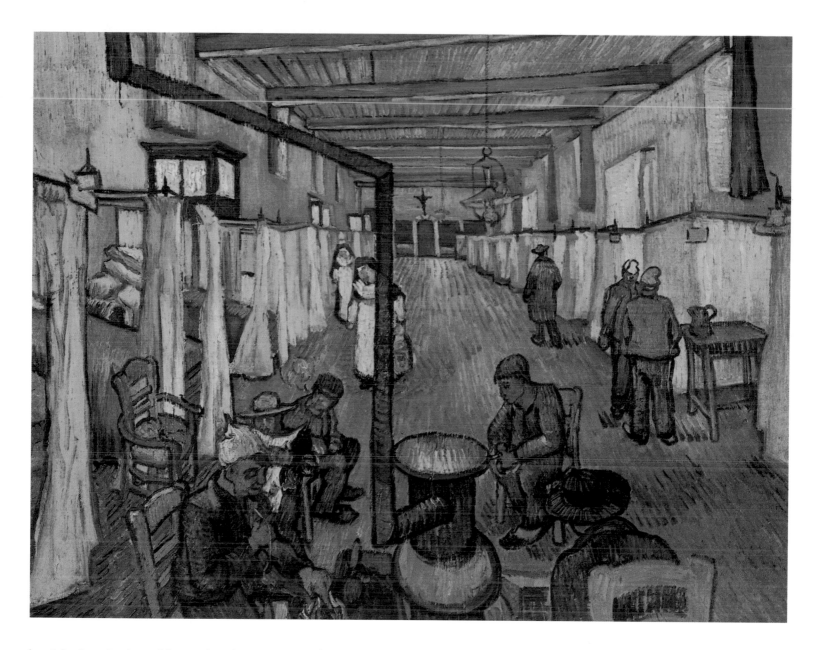

banished and rejected by society just as you and I are as artists," he told Bernard (Letter B14). Vincent wanted to be a monk "who visits a brothel once a fortnight". The artist's cell and the house of pleasure were the retreats to which the loner (though it was not what he would have chosen) could withdraw.

The ladies of the brothel had notified the police; and it was they who mobilized the crowd that gathered outside the yellow house the following morning. There was nothing else they could do, of course, and their action probably prevented Vincent from bleeding to death. Hitherto his crises as an artist had remained personal, or had been expressed in his countless letters and thoroughly individual paintings. They had been of no concern to the public whatsoever. But now events were being acted out on a public stage, and society dictated that he would play the part which, in a sense, he was made for. Van Gogh was now a lunatic.

Two weeks later, van Gogh was discharged from hospital. He had not been hospitalized on grounds of insanity but in order to stop the loss of blood caused by the wound. He returned to his house, resumed painting, and continued to see a small number of acquaintances in the neighbourhood. But a month later, at the beginning of February 1889, the case entered a new phase. Vincent suffered a bout of paranoia, was hospitalized once again, and remained in medical care for ten days. The good citizens of Arles had petitioned the authorities to

Ward in the Hospital in Arles
Arles, April 1889
Oil on canvas, 74 x 92 cm
Winterthur, Oskar Reinhart Collection

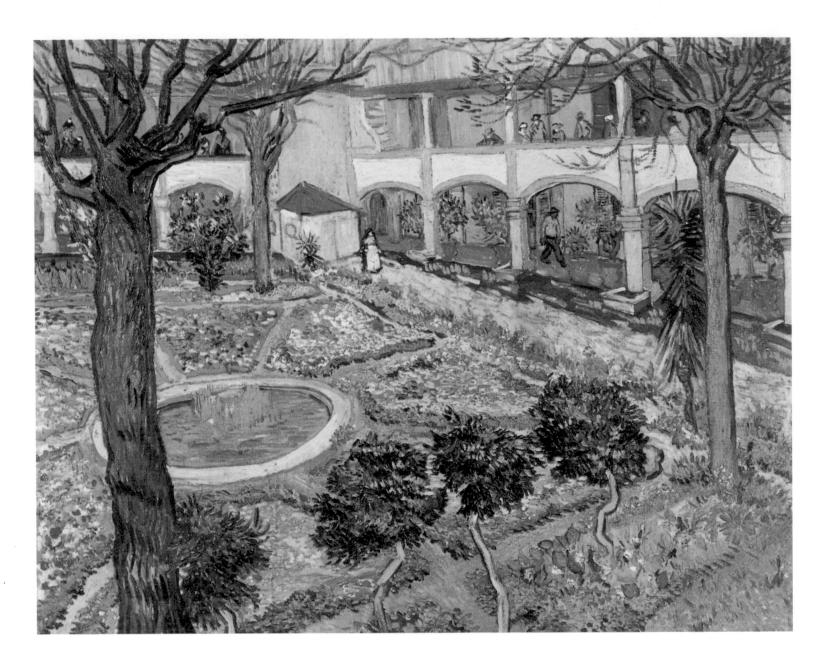

The Courtyard of the Hospital at Arles
Arles, April 1889
Oil on canvas, 73 x 92 cm
Winterthur, Oskar Reinhart Collection

lock up van Gogh on the grounds that he was a "public menace". In late February, he was hospitalized again. Of perfectly sound mind, he found himself under lock and key, with no books, nothing to paint with, not even his pipe. He was in a prison. But, since he had been labelled a lunatic, his solitary confinement was termed hospitalization.

If he was mad, no one would ask any more questions concerning the meaning of what he did – questions that had in any case long tormented him. Van Gogh made his peace with society – and voluntarily entered the asylum at Saint-Rémy, in a spirit of apparent selflessness. Van Gogh had officially been designated a *peintre maudit*, so to speak; and now non-conformity became a core feature of his role as madman. He saw clearly that the scandal he had occasioned would provide superb publicity for the cause of modern art, and it was fully apparent to him that he could serve to warn middle-class society of its own inherent dangers: "The terrible superstition certain people have concerning alcohol, people who pride themselves on never drinking or smoking – we are of course commanded not to lie or steal, etc., or to commit other greater or lesser crimes, and it is too hard to have nothing but virtues in a society we have our roots in, whether it is good or bad." (Letter 585).

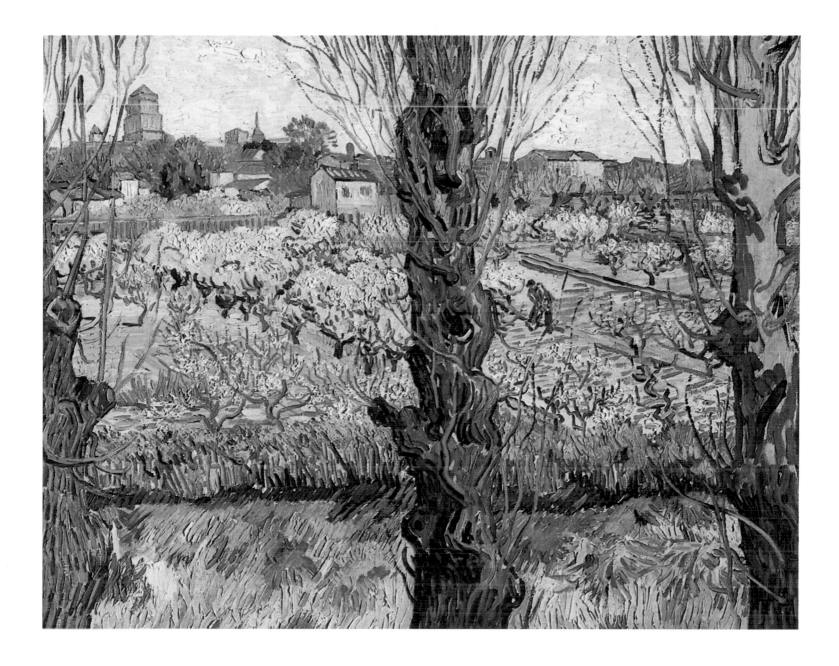

There is no doubt that van Gogh's suffered genuine fits of paranoia and impenetrable depression. His recurring bouts of madness were a way of evading the overpowering experience of solitude, a solitude born of his hypersensitive responses to the strangeness and contingency of Life. But Van Gogh's fits were also moments of convulsive inner unity that could scarcely be comprehended by outsiders. Van Gogh became his own legend. And this, of course, added a new slant to the unity of Art and Life, since both could be subsumed into previous experience in the history of mankind. It was only in madness that a true unity was established, beyond the petty battles of everyday life, in imitation of the great who had gone before. Imitation, too, of Monticelli the painter, who was said to have drunk himself mad. And of course van Gogh had his comrades in insanity: Friedrich Nietzsche, August Strindberg, Arthur Rimbaud.

"As far as I can judge," van Gogh wrote to his brother (Letter 580), attempting to reassure him, "I am not actually mentally ill. You will see that the pictures I painted in the period between my two attacks are calm and no worse than others I have done. Having no work to do is more serious than its tiring effects." Van Gogh tried to reassure Theo by claiming he was much as he had always been; and

Orchard in Blossom with View of Arles
Arles, April 1889
Oil on canvas, 72 x 92 cm
Munich, Bayerische Staatsgemälde-
sammlungen, Neue Pinakothek

it was true that the more striking changes in his nature were only to become apparent at Saint-Rémy, when van Gogh deliberately adopted his "lunatic" role. He took four subjects in his attempt to come to terms with his new situation. First, he quite specifically tackled the events of 23 December; second, he tried to express the sense of confinement and the resulting claustrophobia in his pictures; third, his need to establish trust and familiarity by means of his paintings acquired a new urgency; and, finally, van Gogh returned to some of the methods of his early days, especially his habit of copying, which now became of central importance.

The tranquillity, the consolation and the life expressed by everyday things became a particular concern, and van Gogh steadily aimed to translate the plurality of things into a coherent visual texture (cf. p. 186). In arranging the objects he selected as motifs, he bore in mind what was helpful and pertinent in his present condition. We see François Raspail's *Annuaire de la Santé*, a medical self-help annual; onions (which Raspail recommended for sleeplessness); his beloved pipe and tobacco pouch; a letter addressed to the artist, standing for the affection and support of his distant brother; a lighted candle, defiantly stating that the flame of life has not been extinguished yet; red sealing-wax beside it, attesting confidence that he will remain in touch with his

Two White Butterflies
Arles, Spring 1889
Oil on canvas, 55 x 45.5 cm
Amsterdam, Rijksmuseum Vincent van Gogh,
Vincent van Gogh Foundation

A Field of Yellow Flowers
Arles, April 1889
Oil on canvas on cardboard, 34.5 x 53 cm
Winterthur, Kunstmuseum Winterthur

Clumps of Grass
Arles, April 1889
Oil on canvas, 44.5 x 49 cm
Private collection

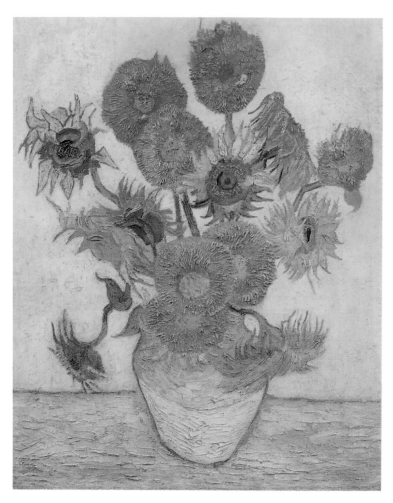

Left:
Still Life: Vase with Fourteen Sunflowers
Arles, January 1889
Oil on canvas, 100.5 x 76.5 cm
Tokyo, Yasuda Fire & Marine Insurance
Company

Right:
Still Life: Vase with Twelve Sunflowers
Arles, January 1889
Oil on canvas, 92 x 72.5 cm
Philadelphia, The Philadelphia Museum of Art

friends; and an empty wine bottle to suggest he has given up alcohol. In compositional terms, the principle of juxtaposition is none too successful. Van Gogh is simply recording in meticulous detail an emotional affection for the things that afforded him consolation, that gave promise of happiness and in-stilled new optimism.

Then there are three pictures that express the trials and sorrows of isolation: *Orchard in Blossom with View of Arles* (p. 169), *The Courtyard of the Hospital at Arles* (p. 168) and *Ward in the Hospital at Arles* (p. 167). Weeks of detention separate the reticently cheerful tone of the still life from the mild resignation of these works. Van Gogh's subject is his experience of confinement (though the style of the paintings remains unaffected at this point). *Orchard in Blossom with View of Arles* is a masterpiece of calm, sensitive examination of the artist's predic-ament. The attractive view of the town, and the blossoming fruit trees with their promise of a fine future, are seen beyond three gnarled poplar trunks. Unlike the tree trunks in the Alyscamps pictures (pp. 150–151), these verticals have no qualities of aesthetic subtlety: they are not so much a compositional device as barriers, marking the boundary beyond which the artist may not go. While placing bars across the line of vision was an approach he had learnt from Gau-guin, here it quite literally expresses the claustrophobia van Gogh inevitably experienced in solitary confinement. The utopian vision of a better life (which lies concealed in the garden and which van Gogh had been able to articulate only a year before) had now become inaccessible.

Ever since his first months in Paris, the digger working in the fields had disappeared from van Gogh's repertoire of figures and had been replaced by

others – a lady out for a stroll or a couple arm in arm. Now his emblematic figure of bygone days made a reappearance. The reappearance of the digger foregrounds toil and suffering once again. *Orchard in Blossom with View of Arles* is almost too explicit in the way it demolishes van Gogh's hopes: the traumatic intensity has even ousted Vincent's love of paradox.

In *Still Life: Drawing Board, Pipe, Onions and Sealing-Wax* (p. 166) van Gogh, needing consolation and new confidence, had ventured very close to his subjects. And in some of the nature studies he did that spring of 1889 he was practically producing close-ups of the green world: *Two White Butterflies* (p. 170), *Rosebush in Flower* (p. 174), *Clumps of Grass* (p. 171) and *A Field of Yellow Flowers* (p. 171). These are early examples of what was to be a major characteristic of his work at Saint-Rémy: an extremely close-up view coupled with his customary reverence for natural creation.

Clumps of Grass is like a jungle. It looks tentacular and threatening. It is turbulent and dizzying. The painting is a perfect example of van Gogh's method

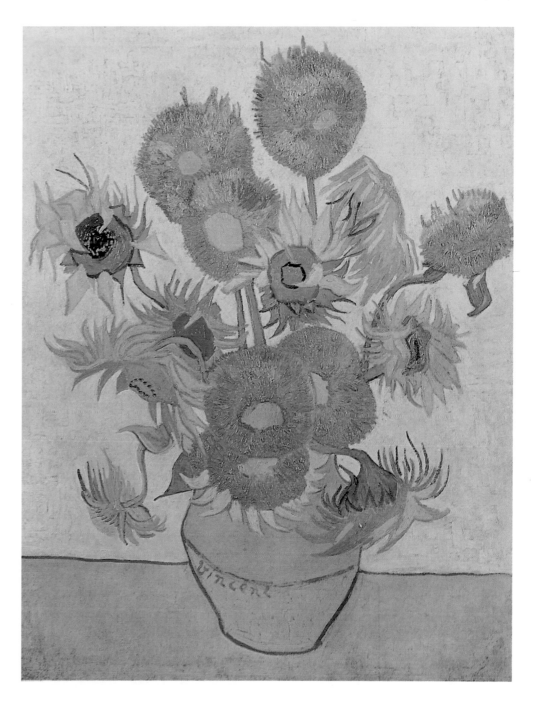

Still Life: Vase with Fourteen Sunflowers
Arles, January 1889
Oil on canvas, 95 x 73 cm
Amsterdam, Rijksmuseum Vincent van Gogh,
Vincent van Gogh Foundation

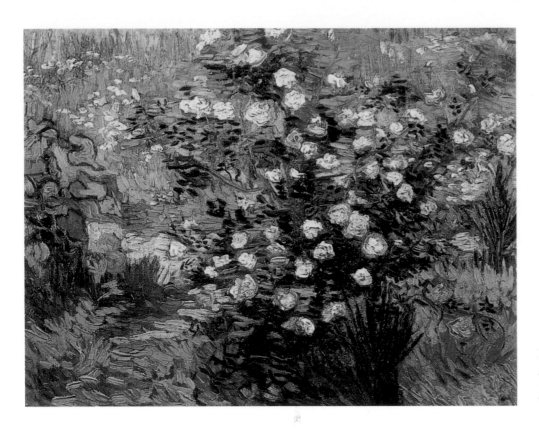

Rosebush in Blossom
Arles, April 1889
Oil on canvas, 33 x 42 cm
Tokyo, National Museum of Western Art

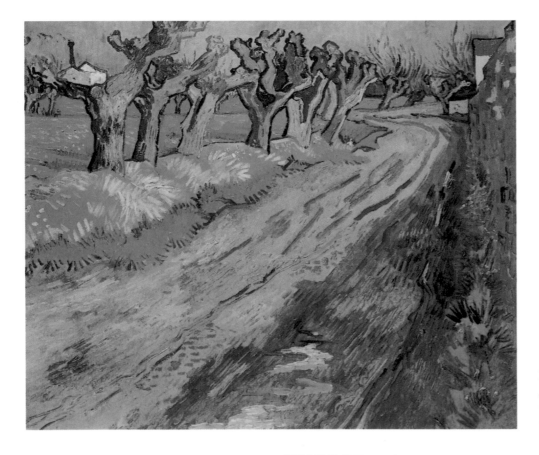

Pollard Willows
Arles, April 1889
Oil on canvas, 55 x 65 cm
Collection Stavros S. Niarchos

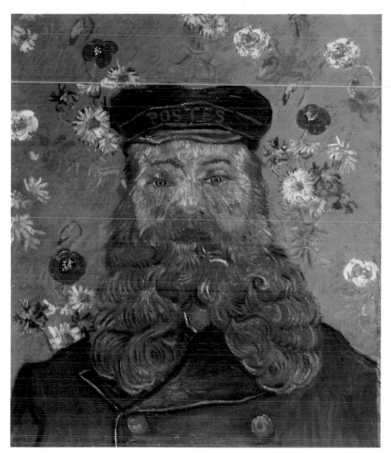

of articulating distress and manic compulsion. All he needs in order to convey an entire existential condition is a subject as simple and basic as clumps of grass. At this point it should be emphasized that this work has nothing whatsoever in common with the kind of artworks produced by the mentally ill. Van Gogh is using a sophisticated, stylized idiom to express the inexpressible.

Throughout those long weeks when he was kept in detention and under supervision, van Gogh was only allowed to paint within limits, and being deprived of his art was torture to him. Even when he was granted his palette and brush, there could be no question of roving the surrounding countryside in quest of a motif. The doctors had decided that he was not to be left unattended. So van Gogh had to turn to other subjects; and he began to paint copies of his own pictures. In doing so he selected two motifs. He painted three more versions of the sunflowers: two of them (pp. 172 and 173) were copies (with minor variations) of the original with fourteen flowers (p. 138), and a third (p. 172, right) was a copy of the original with twelve (p. 137). His use of colour still lends a sense of stunning immediacy to his subject. And, just as the originals were intended for the yellow house, so too the copies were meant for decorative use. Two of them were to serve as wing panels in a kind of triptych whose centre panel (also a copy) was to be the portrait of Madame Augustine Roulin, *La Berceuse*. Van Gogh painted no fewer than five versions of the portrait (pp. 176–177). The first of them had still been on his easel, unfinished, at the time of his breakdown. The woman, who appears to be enduring rather than enjoying sitting, is holding a cord in her hands. Madame Roulin had brought her baby with her and was rocking the cradle by pulling the cord while van Gogh painted. "Concerning this picture I told Gauguin," he recalled in Letter 574, "when we were talking about the men who fish the Icelandic waters, and their melancholy

Left:
Portrait of the Postman Joseph Roulin
Arles, April 1889
Oil on canvas, 64 x 54.5 cm
New York, The Museum of Modern Art

Right:
Portrait of the Postman Joseph Roulin
Arles, April 1889
Oil on canvas, 65 x 54 cm
Otterlo, Rijksmuseum Kröller-Müller

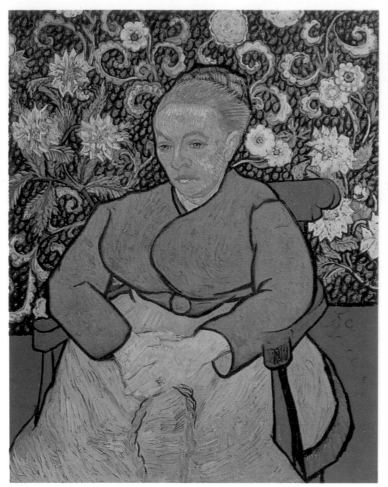

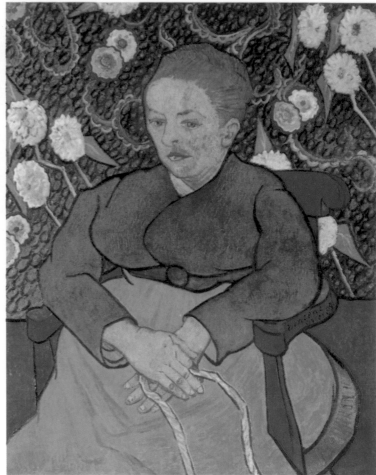

Left:
La Berceuse (Augustine Roulin)
Arles, December 1888
Oil on canvas, 92 x 73 cm
Otterlo, Rijksmuseum Kröller-Müller

Right:
La Berceuse (Augustine Roulin)
Arles, January 1889
Oil on canvas, 93 x 74 cm
Rancho Mirage (CA), Mr. and Mrs. Walter
H. Annenberg Collection

Page 177:
La Berceuse (Augustine Roulin)
Arles, January 1889
Oil on canvas, 93 x 73 cm
Chicago (IL), The Art Institute of Chicago

solitude exposed to the dangers of the desolate seas – I told Gauguin that in the course of one of these conversations I had the idea of painting a picture that would give seamen, who are both children and martyrs, the feeling of being rocked in a cradle if they saw it in the cabin of a fishing boat, as if a lullaby were being sung to them again." Arranged in a triptych with the sunflowers flanking it, the picture would also console poor van Gogh, the longing child and martyr.

Augustine was the wife of Joseph Roulin the postman, who was a neighbour and became Vincent's closest friend in Arles. Vincent saw the two of them as images of each other: Roulin was an alcoholic and a committed socialist, and not only shared certain of van Gogh's characteristics but also, as a family man with children, personified one of van Gogh's deepest wishes. The Roulins, and several of their children, sat for van Gogh time after time. It was no wonder, then, that he copied those pictures, trying to relive the sole fruits of his quest for affection. Van Gogh painted three copies (p. 175) of a shoulder-length portrait of Joseph Roulin that he had done back in summer 1888 (p. 145). As in the paintings of La Berceuse, what strikes us when we compare the copies with the original is the new, decorative background. As if to prolong his work on people he had developed a liking for, he painted countless tiny circles onto the background, meticulously added dots, and established a pattern of plants and flowers, arabesques of stems and blossoms forming abstract geometrical designs. Van Gogh was to pursue the use of vivid close-ups and copies in particular; both kinds of work held a promise of trust and intimacy, bridging the gap between the world outside (be it Nature or his fellow-beings) and the world within, which had become such an ordeal for him.

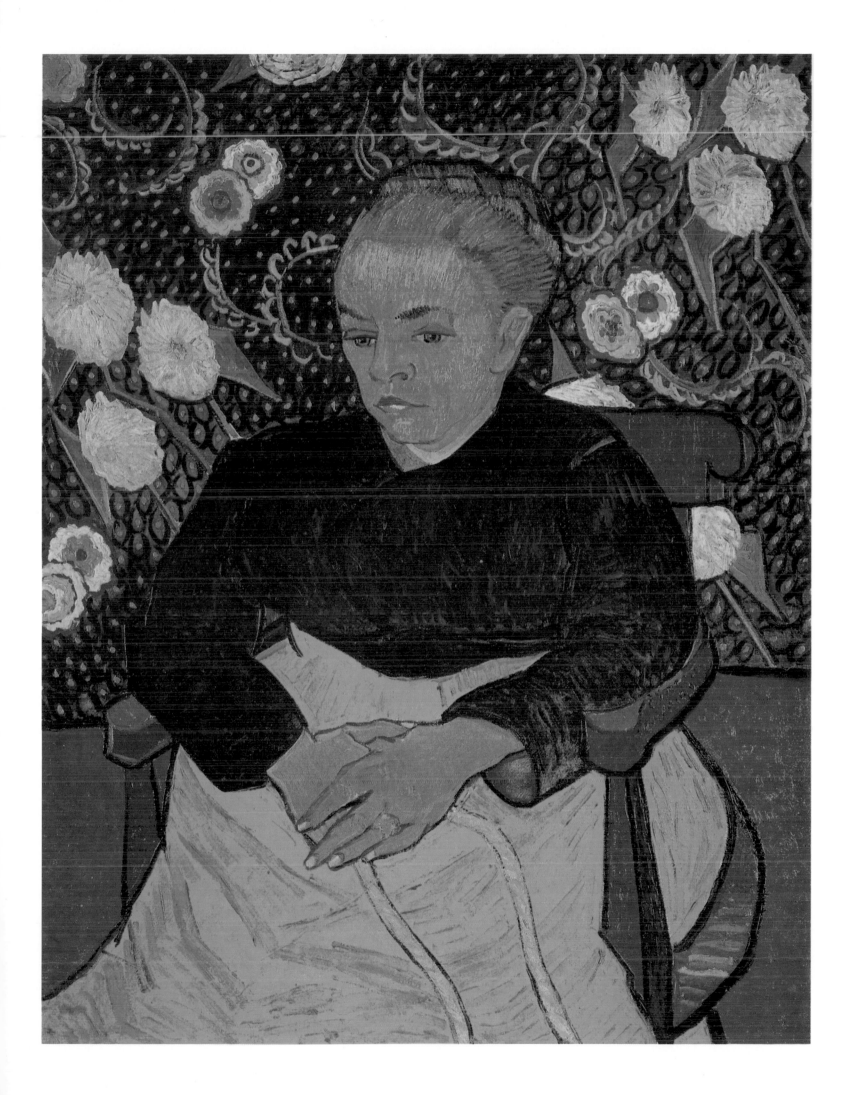

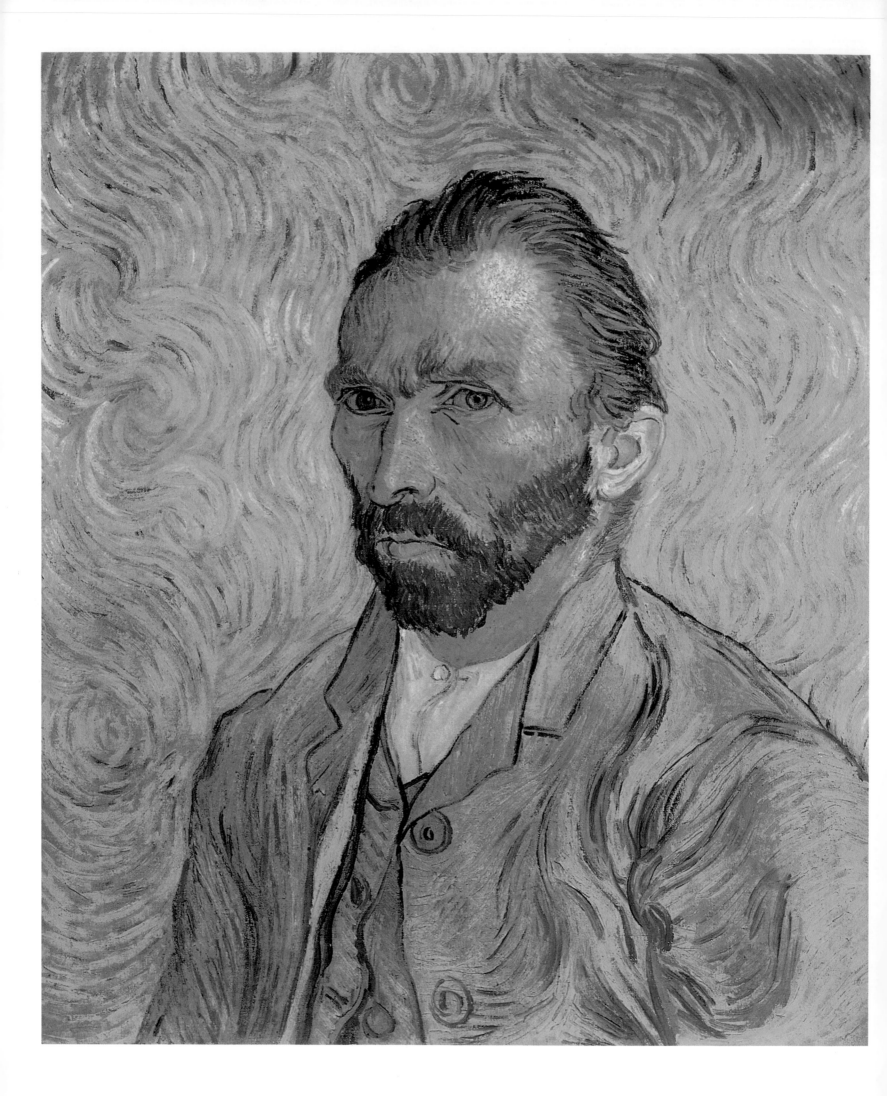

"Almost a Cry of Fear"
Saint-Rémy, May 1889 to May 1890

The Monastic Life

Shortly before Gauguin arrived in Arles, van Gogh wrote to his brother (Letter 556): "Once again I am close to [...] madness [...] If I did not have a kind of dual nature, a monk's and a painter's, I should long since have been quite totally in the aforesaid condition." Six months later he accepted his "dual nature", he preserved his artistic life intact and entered the monastery: Saint-Paul-de-Mausole, an asylum at Saint-Rémy, originally a 12th century Augustinian monastery, some twenty kilometres north of Arles.

Saint-Paul-de-Mausole was an asylum, monastery and studio all in one. Isolation was what van Gogh wanted; but he naturally had his doubts. "It is very likely that I have a good deal of suffering still ahead of me," he wrote to his sister (Letter W11) shortly before committing himself to the asylum. "This is not at all to my taste, to be honest, because I really do not want a martyr's life. I have always been after something other than heroism [...]; of course I admire it in others, but I repeat that I consider it neither my duty nor my ideal." This notwithstanding, van Gogh chose to lead the kind of life that Gauguin, for all his flirtations with images of crucifixion, would never have put up with. Van Gogh was revolted by his own martyrdom; but it was of his own making. The brooding melancholy of the monastic environment was just the thing to heighten van Gogh's mood and leave him more radical than before. Saint-Rémy was a vacuum. Sealed off from airy, colourful life, the artist could devote his whole attention to himself and the psychological forces that had him in their grip. He attempted to come to terms with them in his paintings, and was the better able to explore the depths of his life and art because he had no distractions, no contact with other people, and none of the drink or tobacco he had been addicted to.

Van Gogh realised immediately that the asylum was a place of punishment rather than pleasure, and recorded the realisation in three gouaches that are masterful in the simplicity with which they record his disillusionment and distress; two of them are reproduced in this book. *The Entrance Hall of Saint-Paul Hospital* (p. 180) shows the doors wide open, apparently inviting the patient to step out into the bright and cheerful garden, where a fountain is splashing merrily. Just a few paces will be enough, and he will be out in the peace and calm and light of Provence. But van Gogh cannot take those few paces. For him, springtime and the realm of hope beyond that threshold exist solely in picture form.

Self-Portrait
Saint-Rémy, September 1889
Oil on canvas, 65 x 54 cm
Paris, Musée d'Orsay

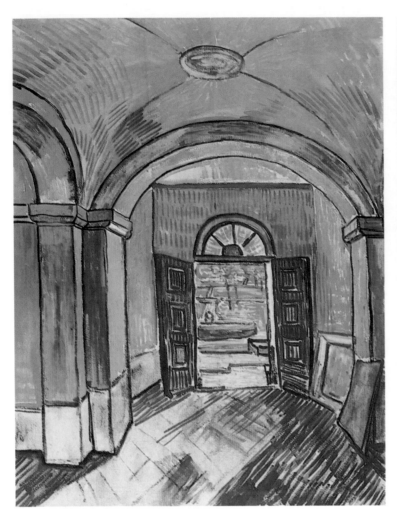

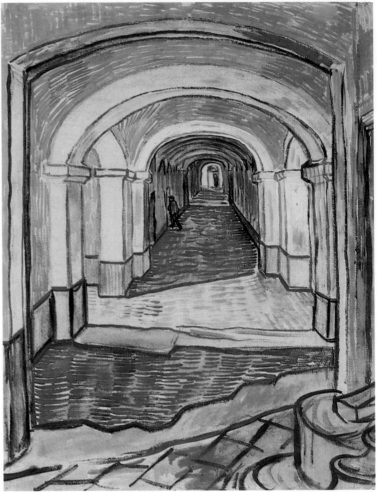

Corridor in Saint-Paul Hospital (p. 180) is even more depressing and hopeless. This is a world of endless labyrinthine passages, the architectural incarnation of monotonous and perpetual repetition. There is a figure in brown darting across the corridor, one of those restless characters that so often people van Gogh's scenes. Hitherto, these figures had never been attempting to go beyond the area defined in the visual space of the picture; but it is quite plain that this man is attempting to escape from this prison but will never succeed in doing so. The setting is not so much a building as a metaphor of his life.

Van Gogh used means of great simplicity; and we see once again how very alert his art was in spite of the turmoil in his spirit. On the edge of the abyss, he set himself a quota of work, new subjects and series to paint. Now, one picture staked a whole day's claim on the future, and a series represented belief in the continuation of life. Van Gogh's indefatigable determination to paint had never been greater than in the asylum at Saint-Rémy.

Theo recognised this immediately and expressed it in one of the forty letters or so that have survived from this closing period: "Your latest pictures have made me think a great deal about your state of mind at the time when you painted them. All of them exhibit a forcefulness in the use of colour that you never achieved before, which is curious in itself; but you have gone even further, and if there are painters who seek to establish their symbols by doing violence to form, then you are one of them in many of these paintings [...] But what work you must have been doing with your head, and how you ventured to the utmost limit, where one inevitably reels with giddiness." (Letter T10). For decades,

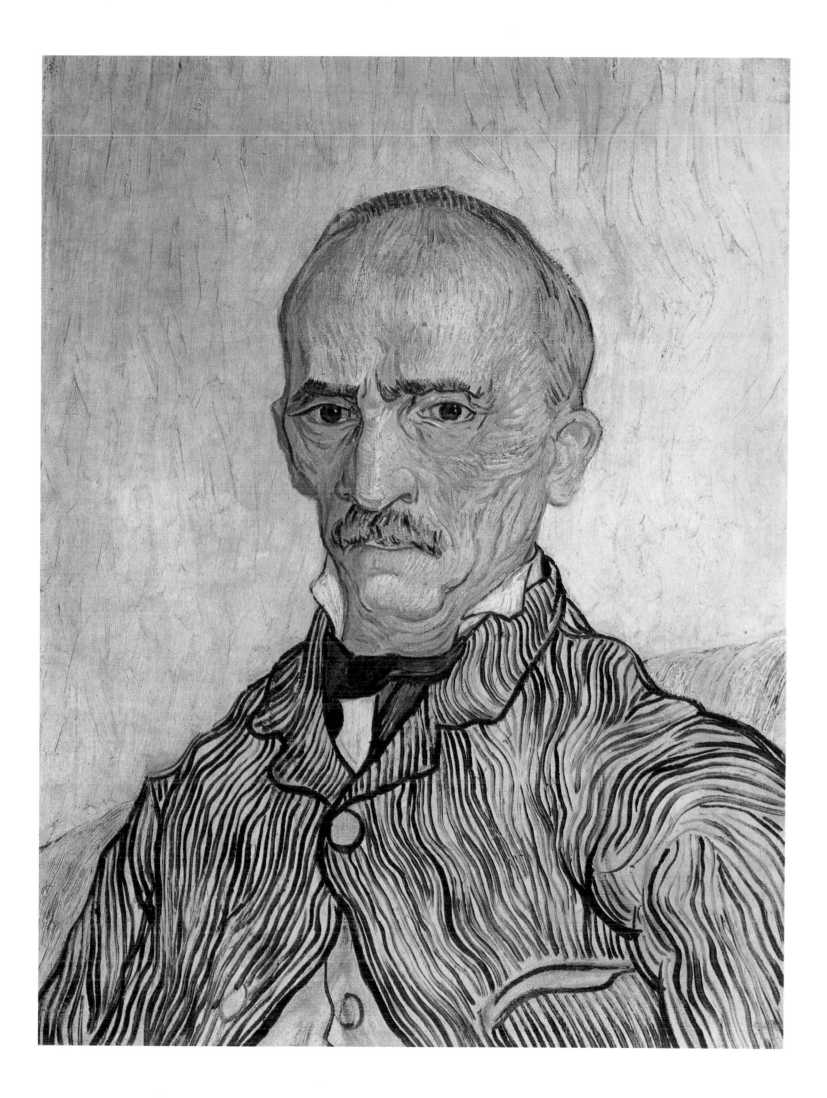

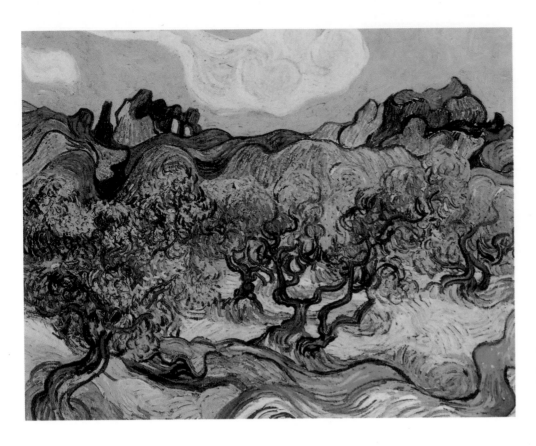

Olive Trees with the Alpilles in the Background
Saint-Rémy, June 1889
Oil on canvas, 72.5 x 92 cm
New York, Mrs. John Hay Whitney Collection

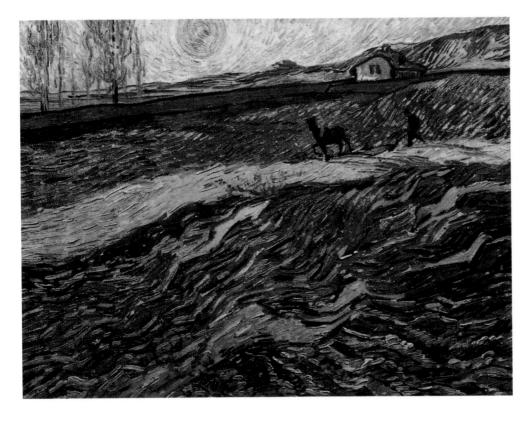

Enclosed Field with Ploughman
Saint-Rémy, late August 1889
Oil on canvas, 49 x 62 cm
United States, Private collection

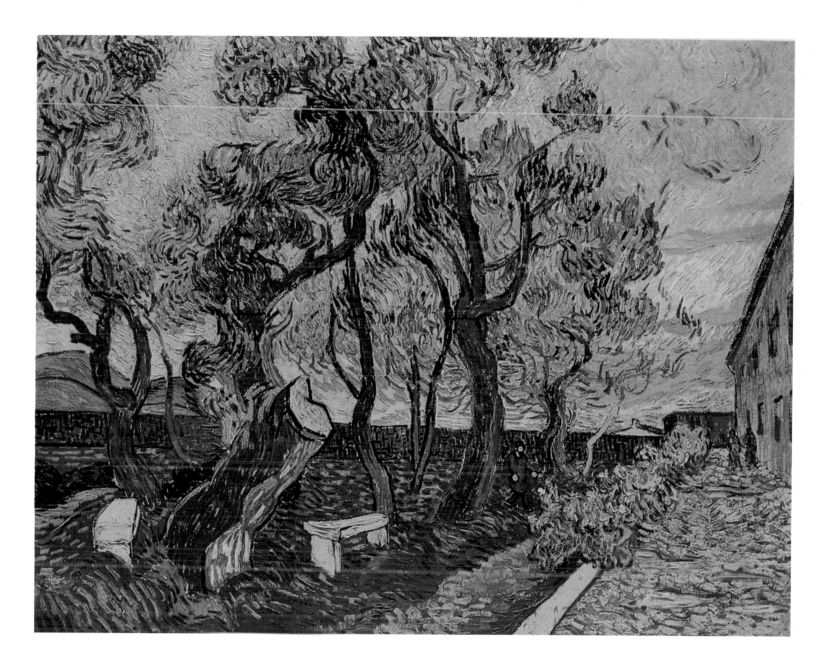

The Garden of Saint-Paul Hospital
Saint-Rémy, November 1889
Oil on canvas, 73.1 x 92.6 cm
Essen, Museum Folkwang

Theo had been extremely close to his brother, and was sensitive to his needs and approaches; and in this passage he perceptively expresses what lay at the heart of van Gogh's Saint-Rémy output. Van Gogh was trying to escape from lunacy into the conceptual world of complex art.

From Jacques-Louis David's *View of the Jardin du Luxembourg in Paris* (1794), van Gogh borrowed the prisoner's viewpoint in the numerous variations he painted on the motif of the walled field behind the asylum. In *Enclosed Field with Ploughman* (p. 182), for instance, van Gogh (like David) registers two areas separated by a wall or enclosure: the shut-in asylum with its modest piece of land, and beyond the wall the free world, the bright and sunny realm of liberty. The enclosure is broken only by the margin of the composition, and renders any exchange of the two realms, of within and beyond, impossible. It is not the enclosure, or the man at work, or the distant trees alone that express the experience of confinement and the unattainability of happiness. Van Gogh is putting his statement into his materials once again, and just as his colours and brushwork acted as utopian metaphors in Arles, so now they record the loss of hope and his fears for the future. Without van Gogh's transformational handling of paint, the motifs alone could not be so expressive.

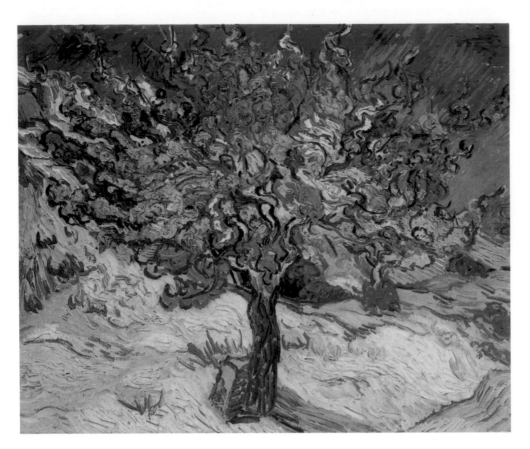

The Mulberry Tree
Saint-Rémy, October 1889
Oil on canvas, 54 x 65 cm
Pasadena (CA), Norton Simon Museum
of Art

Writing to Bernard, he described his painting *The Garden of Saint-Paul Hospital* (p. 183) in detail and then continued in these terms: "You will realize that this use of red ochre, green, darkened by grey, the black strokes that define the contours, all this tends to convey a sense of *angst*, of a kind many of my companions in wretchedness often suffer. And the motif of the big tree struck by lightning, and the sickly, pink-and-green smile of the last flower of the autumn, serves to heighten this impression." It was the task of colour to convey suffering through the motifs the artist painted. At Saint-Rémy, van Gogh's work acquired a new characteristic in the obsessive circular strokes and twisting, snaking lines. The possible variations on these stylistic devices are endless. When they are smooth and decorative, they lend some of his paintings a tapestry-like delicacy. One example is *Olive Trees with the Alpilles in the Background* (p. 182). Alternatively, they may be wild and inchoate, so that the painting becomes a relief of thick streaks, as in some of the pictures of cypresses (cf. p. 185).

Van Gogh signed only seven of some 140 paintings done in this monastic life at Saint-Rémy. Doubtless he was dissatisfied with what he had achieved. Long before Modernism programmatically adopted the strategy, van Gogh tried his hand at *art brut*, deliberately approximating to the visual world of the mentally sick. Equally certainly, though, van Gogh's refusal to sign most of these works bespeaks a wish for a quiet, humble, anonymous life.

Olives, Cypresses and Hills

Unlike his fellow inmates, van Gogh had not been committed to the asylum. He could leave the cloistered halls once the day's work was done and retire to his cell. The Saint-Paul-de-Mausole asylum was the centre of his life. Still, he de-

Cypresses
Saint-Rémy, June 1889
Oil on canvas, 93.3 x 74 cm
New York, The Metropolitan Museum of Art

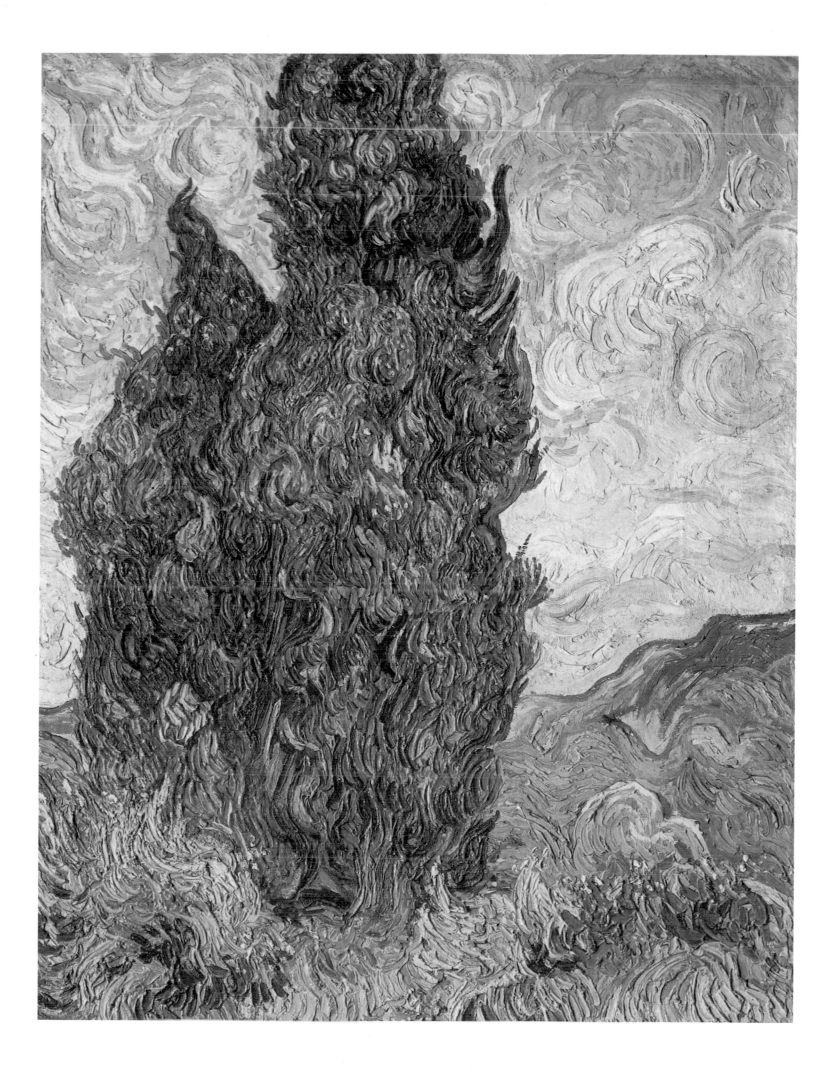

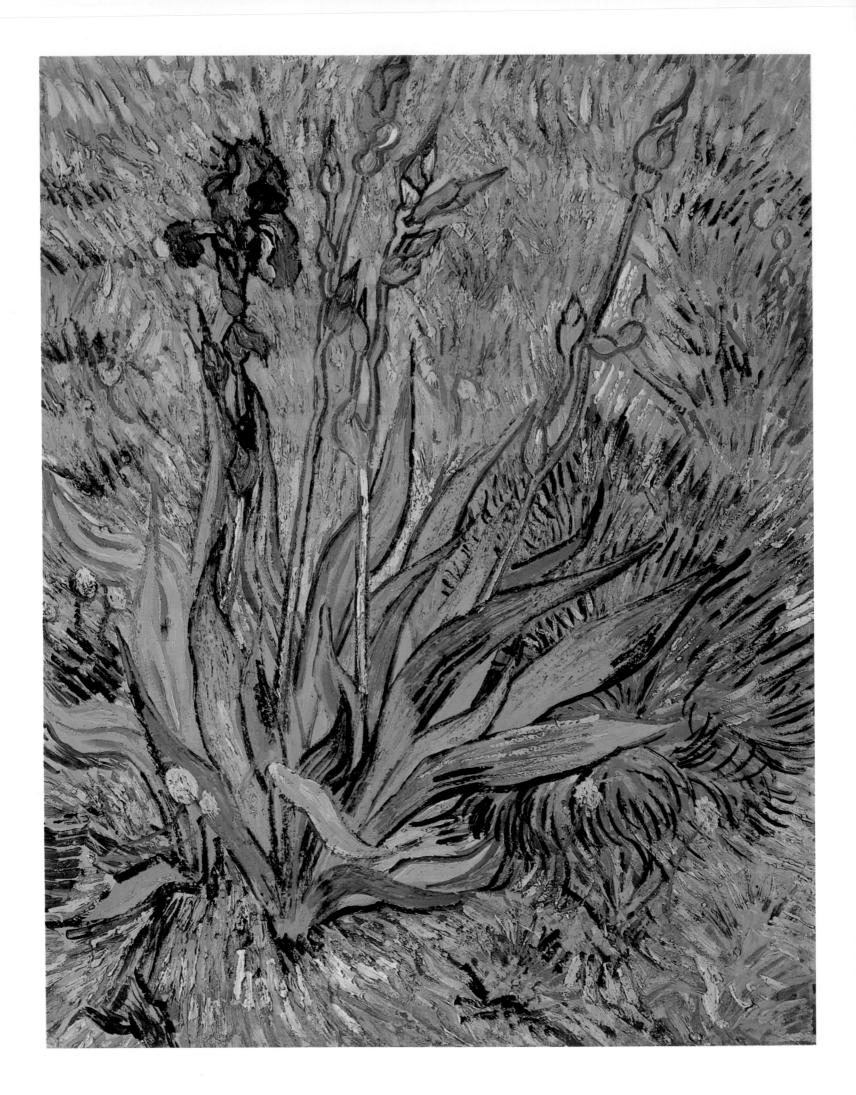

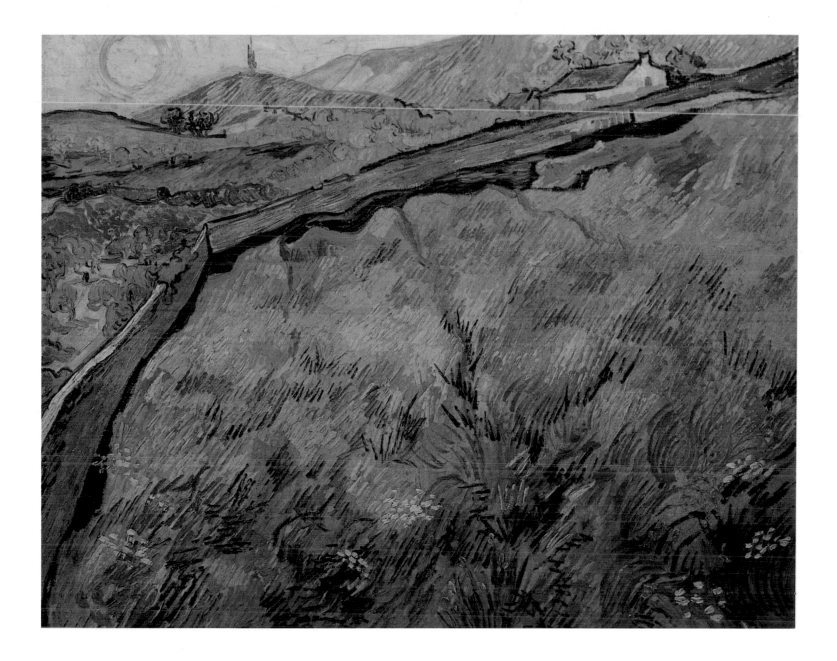

scribed ever-widening circles around it in those months; he needed subjects. The low wall that enclosed the asylum remained for weeks a mental borderline that he would not cross. Repeatedly he turned his attention to the no-man's-land between the wide and exciting world out there and his own smaller, confined world. He painted the field and the stone wall, his mental barrier. Beyond it, though, was an absorbing landscape whose distinctive features he was only now beginning to register. It was only now that he acquired his fondness for what was characteristically Mediterranean in the region: the cypress trees, the olive groves and the sparse vegetation on the hills. All he needed to do was look; the motifs already had that quality of bizarre originality, of darkness, of the demonic, which he increasingly sought in his art.

So when he looked across the wall (p. 187), he found a whole world of subjects awaiting him. There was a range of hills, the Alpilles, with countless olive trees at their feet and an occasional solitary cypress crowning them to counteract the gentle ups and downs of the hills with a bold vertical. His immense cypresses (p. 185) are seen so close that the top of one is cropped by the upper edge of the picture. Only the field remains to add an element of distance. Before van Gogh overcame that distance he first painted all his new discoveries in a single canvas,

Field of Spring Wheat at Sunrise
Saint-Rémy, May–June 1889
Oil on canvas, 72 x 92 cm
Otterlo, Rijksmuseum Kröller-Müller

Page 186:
The Iris
Saint-Rémy, May 1889
Oil on paper on canvas, 62.2 x 48.3 cm
Ottawa, National Gallery of Canada

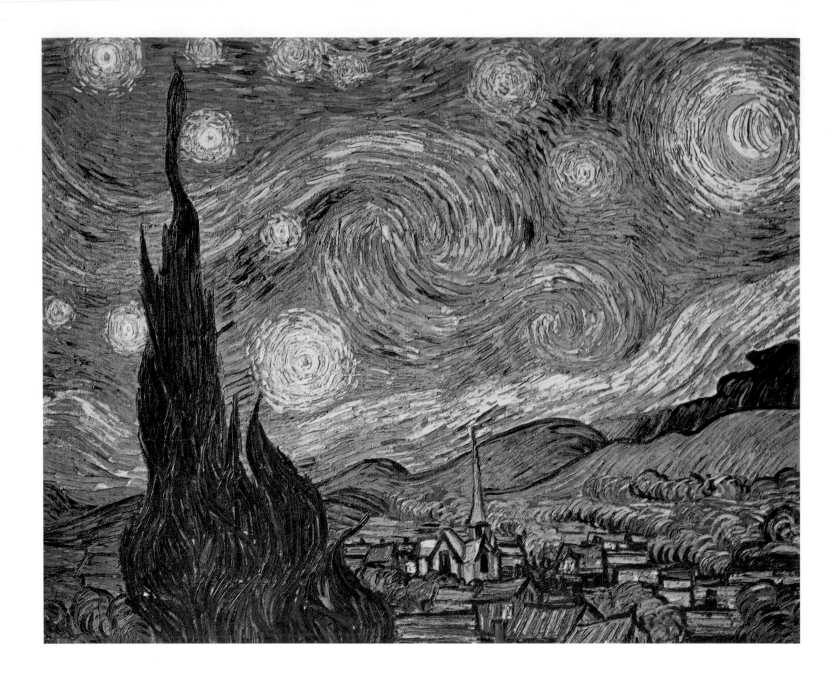

Starry Night
Saint-Rémy, June 1889
Oil on canvas, 73.7 x 92.1 cm
New York, The Museum of Modern Art

Page 186:
Self-Portrait
Saint-Rémy, late August 1889
Oil on canvas, 57 x 43.5 cm
New York, Private collection

and (characteristically, given his wariness of closer contact) he did it from memory and imagination. The painting was to become one of his most famous works: *Starry Night* (p. 188).

The artist is looking down on a village from an imaginary viewpoint. At left a cypress towers skywards, at right a group of olive trees cluster into a cloud, and against the horizon run the undulating waves of the Alpilles. Van Gogh's treatment of his motifs prompts associations with fire, mist and the sea; and the elemental power of the natural scene combines with the intangible cosmic drama of the stars. The eternal natural universe cradles the human settlement idyllically, yet also surrounds it menacingly. The church spire seems to be stretching up into the elements, at once an antenna and a lightning conductor. The nighttime scene offers the visual imagination its most distinctive, unique field of activity, since the lack of light requires the compensatory use of visual memory. Van Gogh's discovery of the luminous power of darkness was a personal aesthetic discovery.

There had been hills in Arles too, of course. But they entered his panoramic scenes as idyllic touches. His landscapes included the harvest, passing trains, isolated farmsteads and distant towns; and the hills were simply one more detail.

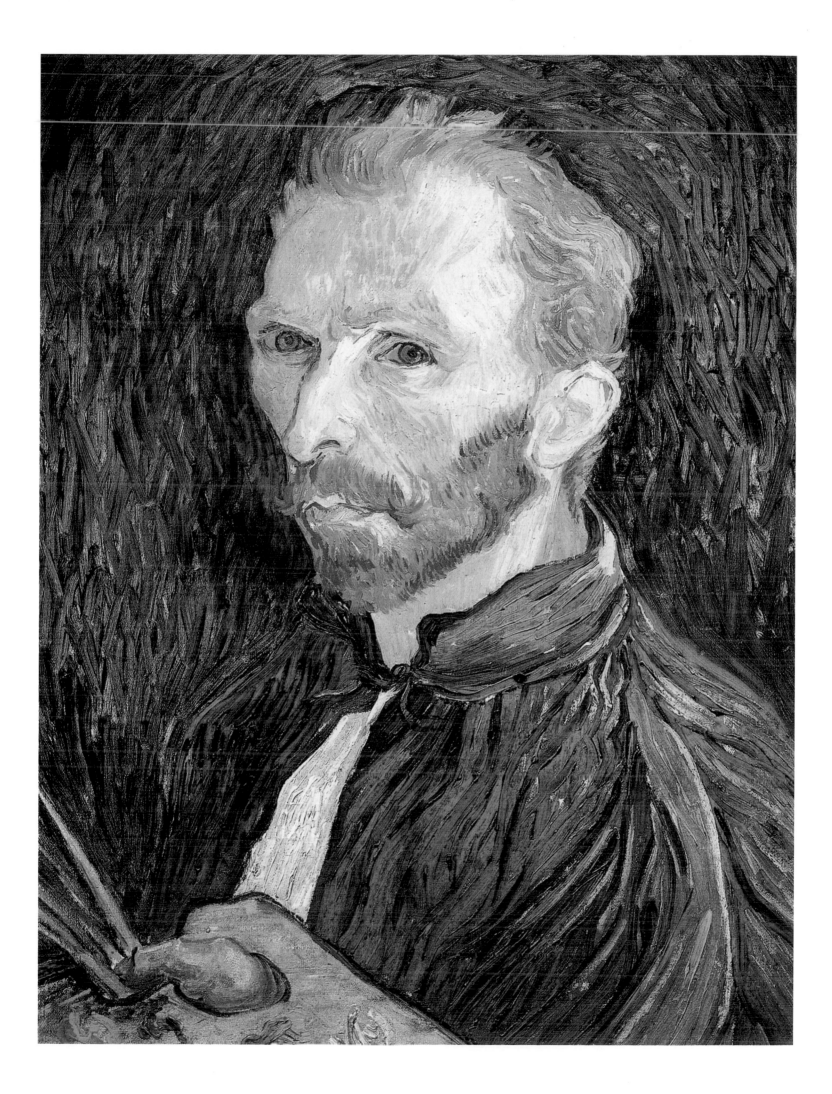

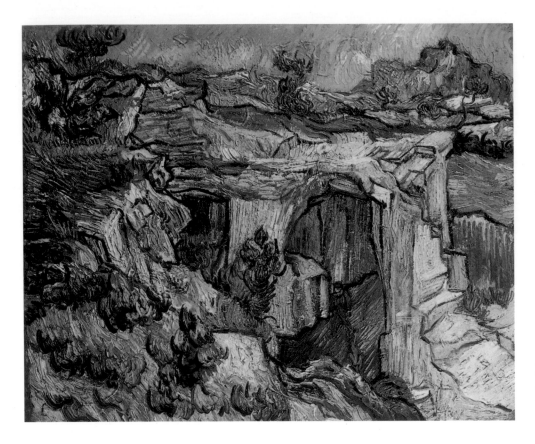

Entrance to a Quarry near Saint-Rémy
Saint-Rémy, October 1889
Oil on canvas, 52 x 64 cm
Private collection

Mountains at Saint-Rémy with Dark Cottage
Saint-Rémy, July 1889
Oil on canvas, 71.8 x 90.8 cm
New York, The Solomon R. Guggenheim
Museum, Justin K. Thannhauser Collection

In Arles, van Gogh's dream had been of the harmony of things and of the spatial dimensions in which that harmony could be felt. None of that remained. The hills rose up steep and abruptly now, menacing, threatening to drag the lonesome soul down into vertiginous depths. *Entrance to a Quarry near Saint-Rémy* (p. 190) irresistibly drags us down, and the greenery can afford no salvation. *Mountains at Saint-Rémy with Dark Cottage* (p. 190) impresses us with its tumultuous massifs, and has nothing of that picturesque, craggy mellowness that was in fact characteristic of the Alpilles.

Even when they are merely a background, the mountains can be menacing. *Enclosed Wheat Field with Peasant* (p. 191) shows the mountains so close that our fear of confinement is automatically redoubled. The stone wall and the rocky crags complement each other; the mountainside makes it impossible for us to see the blue sky and eliminates the sense of a horizon, so essential to our acquiescence in the harmony of a picture. Instead of that balance, we have instability. This instability can be traced to the motif of mountains, which is used less as a phenomenon with a symbolism of its own than as a focus of chaos in the overall compositional structure.

Enclosed Wheat Field with Peasant
Saint-Rémy, early October 1889
Oil on canvas, 73.5 x 92 cm
Indianapolis (IN), Indianapolis Museum
of Art

Olive Grove
Saint-Rémy, mid-June 1889
Oil on canvas, 72 x 92 cm
Otterlo, Rijksmuseum Kröller-Müller

The series of olive groves also harks back to Arles. At that time, van Gogh painted fruit trees in blossom, using nicely nuanced lighting and subtle colour combinations to approximate a Japanese ideal. The principle of light emanating from within survived into the fifteen Saint-Rémy paintings of olive trees. But now it had become of secondary importance. *Olive Grove* (p. 192), for instance, is altogether lacking in optimism. There is a quality of lament, almost of agony, in the twisted, knotted look of the olive trees. The agitated brushwork places the various components of the composition on a par, as it were, and conveys a vitality that depends heavily on the thickness and vigour of van Gogh's oils. The paint is a universal, used for the leafage, bark, ground and sky in the same way: this standard treatment has the drawback of robbing the different motifs of their individuality.

In *Olive Trees with Yellow Sky and Sun* (p. 193) the sun is merciless and the trees look as if they are trying to flee – but a dragging shadow is holding them back. This is an existence of slavery and mere endurance: there is not a trace of free, green burgeoning. Quite the contrary, the knotty trees look as if they are engaged in a wearisome struggle for a place in the sun.

Van Gogh had told his brother that Bernard and Gauguin were currently occupied with historical scenes on Biblical themes, first and foremost Christ on the Mount of Olives. Van Gogh himself had no need of this kind of anachronism in his art. In a letter to Bernard (Letter B21) he restated his view and offered a brief analysis of the aims of his olive grove series: "I am telling you about these pictures in order to remind you that the impression of fear can be produced without immediately having recourse to the Garden of Gethsemane; if one intends to offer tenderness and consolation, it is not necessary to present the main character in the Sermon on the Mount." Van Gogh was trying to articulate both fear and consolation in his series. For that reason he allowed people into the olive grove setting, a setting which so entirely lacks the comfort of a garden. These people are not out for a stroll or otherwise idling; they are hard at work (p. 194). Gethsemane is synonymous with the Passion of Christ and His followers' belief in redemption. In this series, van Gogh was aiming to appropriate the paradox for his own ends. The motif of the olive tree stood for his own capacity for suffering, and for his work, his art.

The cypress, with its tandem symbolism of life and death, sunlit cheer and

Olive Trees with Yellow Sky and Sun
Saint-Rémy, November 1889
Oil on canvas, 73.7 x 92.7 cm
Minneapolis (MN), The Minneapolis Institute of Arts

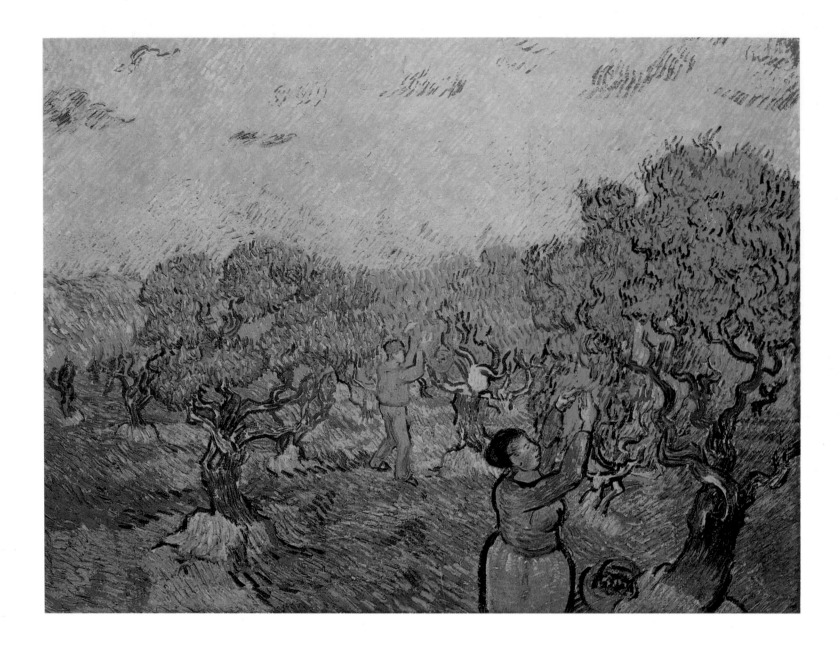

Olive Grove with Picking Figures
Saint-Rémy, December 1889
Oil on canvas, 73 x 92 cm
Otterlo, Rijksmuseum Kröller-Müller

black gloom, was obviously predestined for van Gogh's pictorial universe. There are only a few views of the tree alone, without the landscape it so strikingly tends to dominate. But those few are compacted, rich and pastose. The two trees in *Cypresses* (p. 185), for instance, are not so much two-dimensional features in a picture as reliefs modelled from countless streaks of green. The sky and greenery in the painting are arrestingly luminous, yet they still somehow lack the almost palpable physicality of the trees. It is as if van Gogh had needed to grasp his subject in a tactile way. It is by no means coincidental that he chose to return to the thick, streaky brushwork he had sometimes used in his early days.

The destabilizing effect of his mountains, the pathos and suffering he projected into his olive groves, and the torrents of colour that course through his cypresses, suggest that van Gogh's new motifs were serving a cause of reassurance. He had by now shed all trace of naivety – though he still had that characteristically vehement vigour in his treatment of subjects. Van Gogh in the asylum at Saint-Rémy saw cypresses and olive trees (these two trees alone) in the same way as the utopian enthusiast had seen sunflowers in Arles – as symbols of himself and of his art.

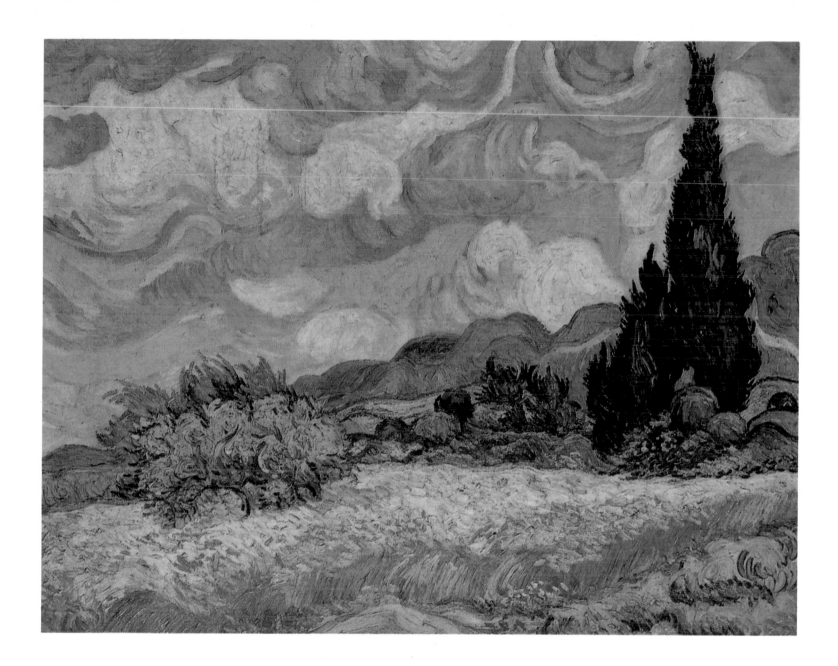

**Wheat Field with Cypresses at the Haute
Galline near Fygalières**
Saint-Rémy, late June 1889
Oil on canvas, 73 x 93.5 cm
Zurich, Private collection

The Portraits

"My work is a far better distraction than anything else at all, and if I were able
to plunge into it, with all my strength, it would probably be the best cure. The
impossibility of having models, and a number of other things, prevent me from
doing so." When van Gogh penned these words (Letter 602), he had just re-
covered from a bout of insanity, the first he had suffered at Saint-Rémy. Suddenly
paranoia had seized hold of him, just as he was standing at the easel and starting
work on Entrance to a Quarry. For five weeks that July and August, van Gogh
lay in mental darkness. He had tried to swallow the paint from his tubes. Need-
less to say, the governors of the asylum took his painting materials away from
him. Once he had regained his wits, van Gogh decided to make a fresh start.

Fearfully, he avoided all excitement. He was wary of leaving the asylum.
Restricted to motifs selected from within it, van Gogh began a series of portraits.
There were six of them in all, the only ones he did at Saint-Rémy; and they stand
out as isolated yet imposing achievements of the art of portrait painting. Van
Gogh sought the eyes of his subject, the mirror of the soul in which he would
find a reflection of himself. His subject's gaze came to have greater importance

than ever before. For three of the portraits, van Gogh took himself as the subject. In the self-portrait on page 189, van Gogh's bony head still bears evident signs of the recent struggles. It is not only the contrastive colours that make his face look paler than usual; the pale yellowish green apparently gave a faithful account of his condition at that time. Unusually for his self-portraits, van Gogh has equipped himself here with the attributes of the artist, partly by way of demonstrating his profession and partly for the concealment and support afforded by the painter's smock and palette. His gaze is wary and cautious, meeting ours reluctantly. The eyes are not focussed parallel, and this palpable divergence introduces an ambiguity into the object of their gaze. We have the impression that those eyes are not so much looking at any real thing as gazing inwardly upon imaginary worlds where literal vision is not required.

The painting on page 178 is both more confident and more aggressive. It is

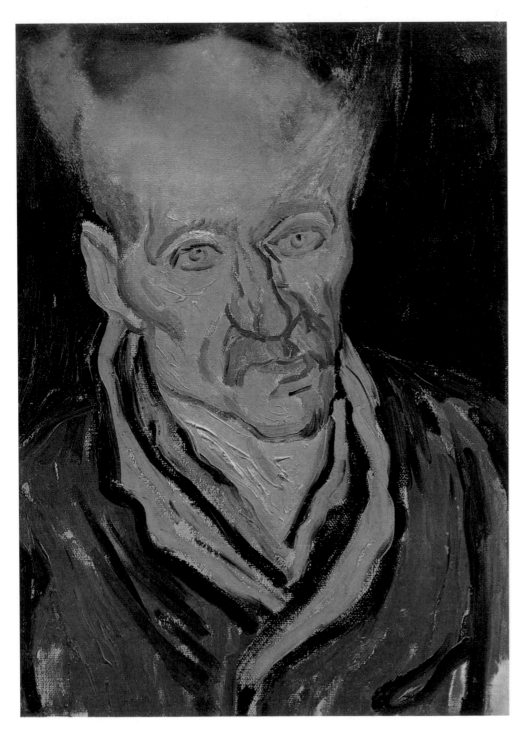

Portrait of a Patient in Saint-Paul Hospital
Saint-Rémy, October 1889
Oil on canvas, 32.5 x 23.5 cm
Amsterdam, Rijksmuseum Vincent van Gogh,
Vincent van Gogh Foundation

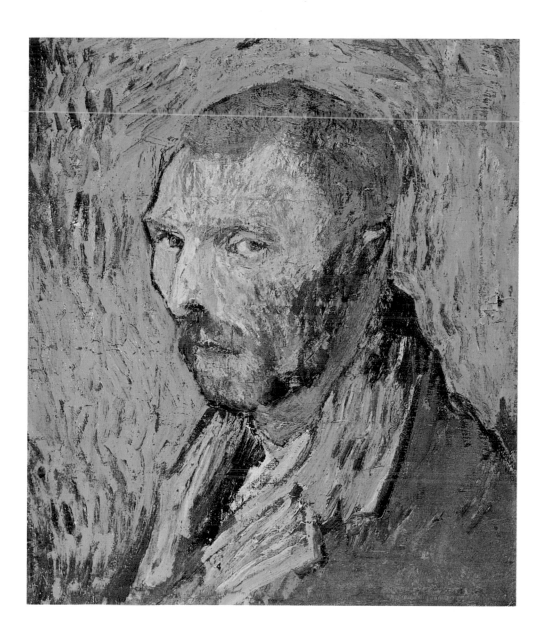

Self-Portrait
Saint Rémy, September 1889
Oil on canvas, 51 x 45 cm
Oslo, Nasjonalgalleriet

a surly, almost rude and choleric face – as if the sitter had had enough of examining his features for signs of madness. There are deep creases by the nose and cheekbones, the eyebrows are thick and prominent, the corners of the mouth have turned down. The snaking and swirling lines that denote the background are used for the person and clothing of the artist, too, and the restless rejection of harmony and tranquillity to which these lines attest sets the keynote of the subject's facial features: the need to deform and remake has created a new disorder in his physiognomy. The face is not so much meant to be coarse or angry as full of vitality, of the sense of the moment. The face van Gogh is here setting down on canvas is one that has seen too much jeopardy, too much turmoil, to be able to keep its agitation and trembling under control. This portrait articulates vitality. And the approach is plainly incapable of idealistic posing.

There is one more self-portrait, the most distorted, cruel and merciless of them all (p. 197), which he sent to his mother. This is a face like the potato faces of Dutch peasants, though one wholly lacking in rustic naivety. Van Gogh looks worn and emaciated, and marked by knowledge of profound things. And it is thus that van Gogh presents himself to his mother. In its use of thick streaks of muddy, earthy paint, the picture is visibly and palpably true to van Gogh's (artistic) origins. But if the post-Romantic avowal of the ugly which gave the

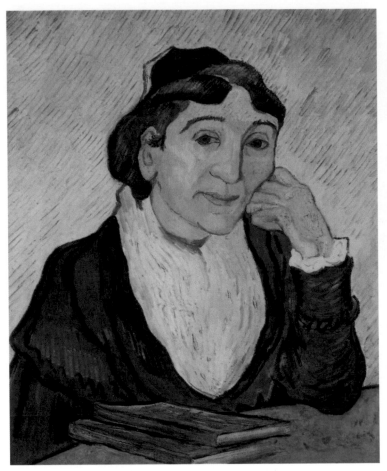

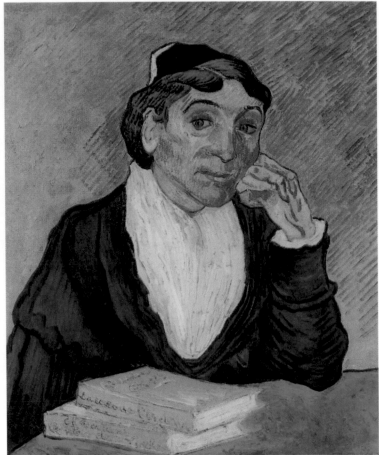

Nuenen pictures their emotional pathos had a quality of self-indulgence, that dimension has now been stripped away. The picture lacks bright colours, it lacks light, it shows a van Gogh with a mutilated ear and an underhand louring look on his face. This, his penultimate self-portrait, shows van Gogh finally rejecting himself as a suitable portrait subject.

Only once did van Gogh paint a fellow-patient, in *Portrait of a Patient in Saint-Paul Hospital* (p. 196). The man's blue eyes are fixed on an imaginary world. Once again the eyes are not focussed on the same place, though this time the discrepancy is on the horizontal axis, with one pupil somewhat above and the other somewhat below the mean. The man seems to be an intermediary between the earthbound realm and a higher spirituality; and the painting technique reproduces this quality nicely. His shirt and jacket are done in thick, furrowing brushstrokes, and his face is a knotty, craggy mass of palpable, earthy matter (comparable to the facial features of the self-portrait on page 197). At the upper margin, though, a glazed blur supersedes, and the top of the man's head seems to merge into the intangible vagueness of the background. This part of the painting makes an unfinished and fragmentary impression; and the incompleteness of the image matches that of the man's mind.

"A man who has seen a tremendous amount of dying and suffering" (Letter 604) was van Gogh's model for *Portrait of Trabuc, an Attendant at Saint-Paul Hospital* (p. 181). This picture, together with that of Trabuc's wife, makes up the total of van Gogh's Saint-Rémy portraits. The old man was chief attendant at the asylum. His stern but not hostile expression suggests a certain affection for the artist, and van Gogh in turn has tried to paint a fairly detailed, faithful portrait. Once again the lines marking the sitter's chin and eyes are picked up in the pattern

Left:
L'Arlésienne (Madame Ginoux)
Saint-Rémy, February 1890
Oil on canvas, 60 x 50 cm
Rome, Galleria Nazionale d'Arte Moderna

Right:
L'Arlésienne (Madame Ginoux)
Saint-Rémy, February 1890
Oil on canvas, 65 x 54 cm
São Paulo, Museu de Arte de São Paulo

Old Man in Sorrow (On the Threshold of Eternity)
Saint-Rémy, April–May 1890
Oil on canvas, 81 x 65 cm
Otterlo, Rijksmuseum Kröller-Müller

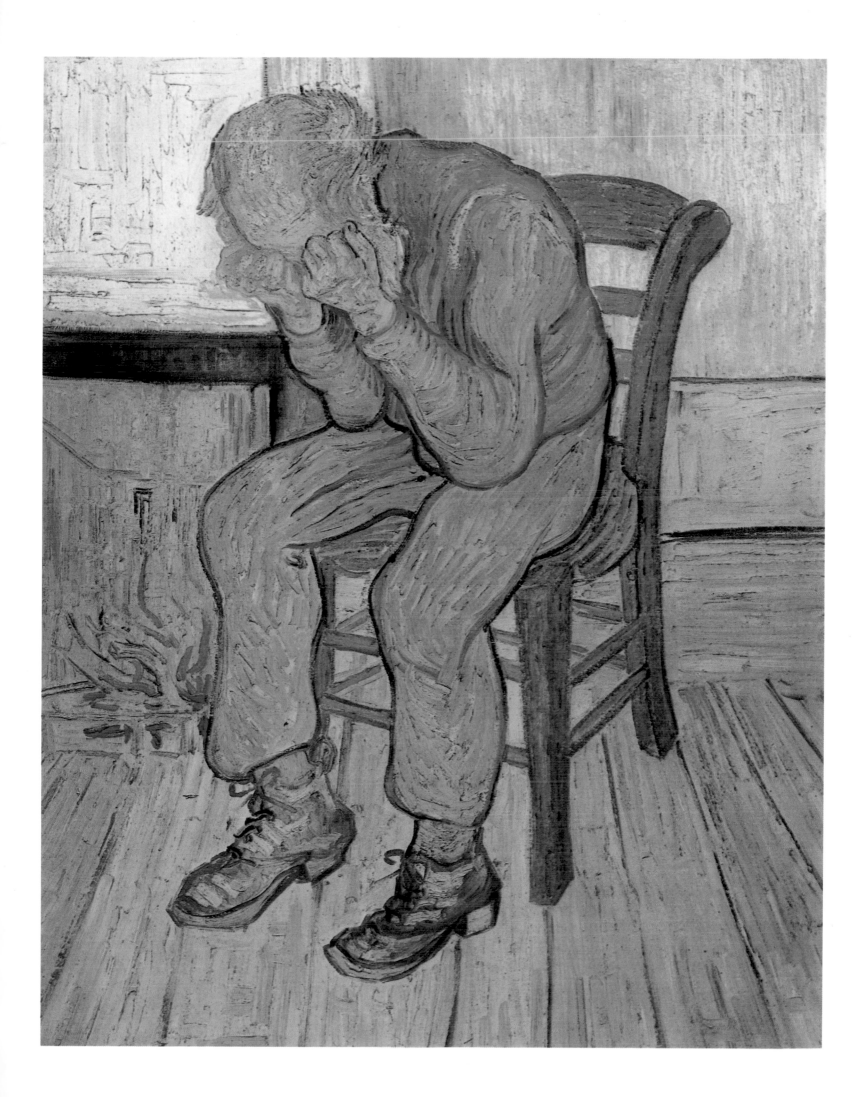

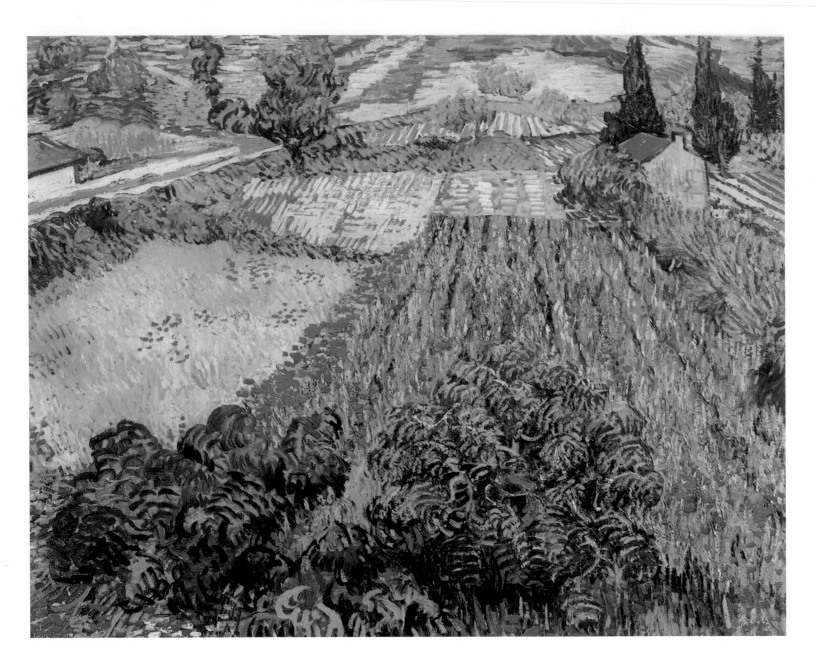

Field with Poppies
Saint-Rémy, early June 1889
Oil on canvas, 71 x 91 cm
Bremen, Kunsthalle Bremen

of the jacket, which is ornamental rather than functional in character. The contrast between the photographic realism of the head and the abstract patterning of the torso could scarcely be greater. Of course, Monsieur Trabuc's position in the asylum conferred a certain authority; and van Gogh may well have felt unable to indulge in that freedom of interpretation that he assumed he could take when painting his fellow patient. But this means that that measure of identification which made a pitiless revelation of the soul possible at all was absent in the painting of this picture. Van Gogh was not seeing himself in his model; rather, he was confronting the real state of affairs he currently found himself in. It is an unresolved painting, recording both distance and a willingness to communicate, and all his doubts are apparent in the antithesis of detail and sketchiness.

Space and Colour

In the asylum, what had survived of van Gogh's religious sense now served as an artist's means of translating visions into the power and glory of painting. His universal bearers of paradox (the figure in black, the people out walking, the

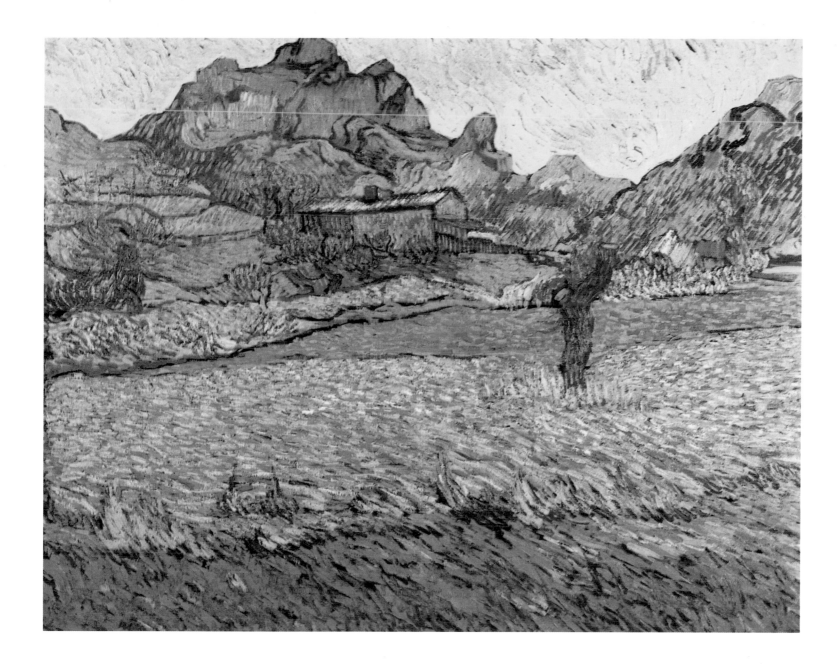

couple) were now intensified or indeed replaced by means of genuine visual energy. And space and colour (the constants of all painting everywhere) now heightened and concentrated the statements and meanings of van Gogh's art, which had hitherto been the task of iconographical elements.

Naturally, van Gogh remained true to the world of things, and the choice of motif continued to be decisive in capturing ambivalence and polarity. His was conceptual art, an art of content. Still, he had grown more careful in his choice of motifs. He added less and less in retrospect, in his studio. His attention was now commanded by immense subjects that filled his canvas in monumental manner – such as the cypress, surging skywards, the symbol of death so popular in graveyards, yet also a symbol reminiscent of the Egyptian obelisks and thus a sun symbol. A single motif could now include an entire world-view, all the sadness and joy in the universe.

Shortly after his arrival, van Gogh had already taken a corner of the Saint-Paul asylum garden as a subject (p. 202). The composition is dominated by a number of tree trunks seen in close-up, the verticals cropped by the upper edge of the canvas. Van Gogh was less interested in the cracked bark and knotty roots than in the ivy clinging to the trunks and wrapping the other vegetation in the picture.

A Meadow in the Mountains: Le Mas de Saint-Paul
Saint Rémy, December 1889
Oil on canvas, 73 x 91.5 cm
Otterlo, Rijksmuseum Kröller-Müller

Two Poplars on a Road through the Hills
Saint-Rémy, October 1889
Oil on canvas, 61 x 45.5 cm
Cleveland (OH), The Cleveland Museum
of Art

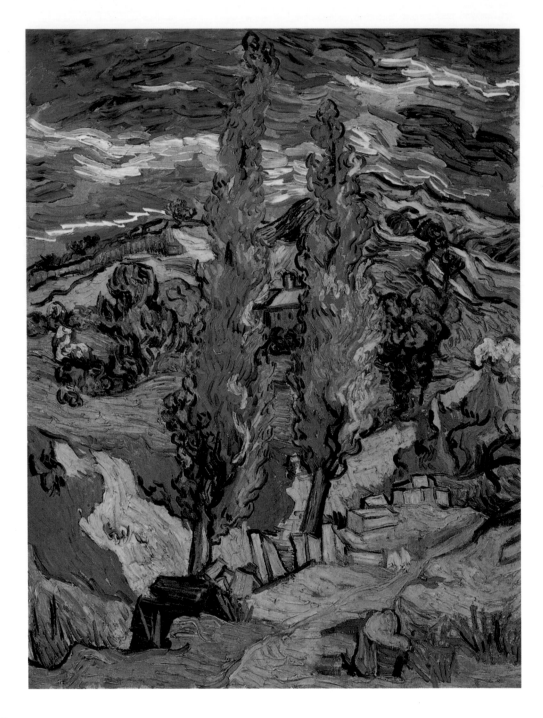

A Corner in the Garden of Saint-Paul Hospital
Saint-Rémy, May 1889
Oil on canvas, 92 x 72 cm
Whereabouts unknown

What was new here was the *mise-en-scène*: the ivy, for instance, is not tucked away in a corner, but foregrounded in a manner both cosy and threatening.

The most fundamental common denominator of Art and Nature is the role they both play in the mysteries of living and dying. Just as ivy, so gloriously alive, is in fact the bringer of death, so too painting, by capturing Life on a canvas, fixes it in a single moment of eternal death. If a thing cannot change, it is dead. Van Gogh wonderfully describes this in an account he gives (in Letter 592) of the painting of *Death's-Head Moth* (p. 203): "Yesterday I drew a very big and quite rare moth that is known as a death's-head, a moth of astonishing and very choice colouring. To paint it I should have had to kill it, which would have been a pity, as the creature was so beautiful." The symbolism seen by mankind in the living creature is transferred to the act of painting; and van Gogh would have had to kill the moth to produce a detailed version. Instead, he transferred the sketch to the canvas, added leaves and flowers, and so created a hymn to the vitality of Creation.

The conviction that informed the self-portrait on page 178 has a still greater

urgency here: painting translates time into space, and lacks a language in which to express the constant change and flux of phenomena. No matter how emphatic van Gogh's paeans to vitality (far beyond anything that had gone before), sooner or later he hit the limits set by the painting medium. At Saint-Rémy he struggled to establish the final implications of certain principles at work in his art. The struggle primarily affected his use of colour contrast and of a dual vanishing point in creating visual space.

At first glance, *Enclosed Field with Rising Sun* (p. 204) looks like another variation on van Gogh's theme of the enclosed area behind the asylum. But now the flatland has thematic competition. The canvas is full of bold strokes that link the foreground field to the hills and sky beyond; and if we look at the cornfield as van Gogh instructed us, we see that the field and the horizon have become a single unity. Two spatial principles are seen clashing here. One is the conventional central perspective that had been in use since the Renaissance and depended on a vanishing point located on the horizon. The other is a more suggestive funnel effect, drawing space down into unknown depths. The perspectival conflict is located in the bushes and the sun – the everyday, familiar face

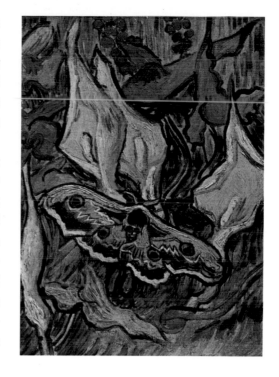

Death's-Head Moth
Saint Rémy, May 1889
Oil on canvas, 33.5 x 24.5 cm
Amsterdam, Rijksmuseum Vincent van Gogh,
Vincent van Gogh Foundation

Trees in the Garden of Saint-Paul Hospital
Saint-Rémy, October 1889
Oil on canvas, 73 x 60 cm
United States, Private collection

Enclosed Field with Rising Sun
Saint-Rémy, December 1889
Oil on canvas, 71 x 90.5 cm
Private collection

of the green world, and the glittering and mysterious aureole of the heavens. Van Gogh has been reviewing the symbolic functions of visual space. And he has decided to take both options. The decision as to the horizon beyond has been left open. Radiant infinity and everyday familiarity are seen here setting mutual limits.

In itself, a dual vanishing point was no innovation in van Gogh's œuvre. Back in The Hague he had done drawings in which lanes and roads on the heaths had gone in different perspectival directions (seen from the artist's point of view). And in Arles, for a short time, he had even adopted this approach as a method, in *The Trinquetaille Bridge* (p. 161) or *The Railway Bridge over Avenue Mont-majour, Arles* (p. 161), for instance. The constructions themselves meet the eye diagonally, leaving our gaze only one option: to follow the bridges to the end, hoping for wide open space. In The Hague and in Arles, van Gogh had experimented with his perspective frame, placing it before his eye so that its diagonals and those established by his own vision were counterpoised; and so those pictures were composed according to the laws of linear perspective.

In Saint-Rémy, though, the painter had abandoned his gadget. Presumably that was why he was now able to include mountains in his paintings, instead of forever following a sequence of horizontals, verticals and diagonals. Minus his perspective frame, van Gogh discovered the paradoxical power that the old sys-

tem of spatial construction had over its motifs. And now he countered this with the evocative power of the sun, with longing for infinite distance. Linear perspective attaches things to the foreground, as it were; whereas the whirlpool of concentric circles draws and drags them down to remote spatial depths. Thus, in *Wheat Field with Rising Sun* the protective and consoling aspect of the field is lost in unknown depths. Van Gogh had no need to be as radical in his colours to achieve as powerful an effect: the use of contrast was quite expressive enough. Even so, it is difficult not to conclude that the painter was only now becoming fully aware of the symbolic power hidden in the contrastive use of red and green, blue and orange, and violet and yellow. Again, a vehicle was needed, and this time van Gogh used his standard motif of the couple.

Ever since the days of Sien in The Hague (at the latest), van Gogh had had ambivalent feelings about women. He saw them as seductive sirens, and subscribed to the view of Woman as *femme fatale*, Medusa or enigmatic Sphinx that was common in the period. Yet in *Olive Grove with Picking Figures* (p. 194) we see a couple, representing the togetherness and contentment that were denied van Gogh in real life, busy picking olives. And in his bedroom (p. 206) he had

Noon: Rest from Work (after Millet)
Saint-Rémy, January 1890
Oil on canvas, 73 x 91 cm
Paris, Musée d'Orsay

apparently hung pictures of himself and a woman over the bed. In the better world he imaged forth in his pictures, happiness and good fortune were uncomplicated – even if van Gogh well knew that they were imaginary.

At the end of his Saint-Rémy period, van Gogh evolved what was in a sense the definitive solution of the problem in the painting *Landscape with Couple Walking and Crescent Moon* (p. 207). The couple are seen walking amidst cypresses and olives in a moonlit idyll, the hills behind them. In this landscape – surely the very epitome of Provence – van Gogh's vision appears in all its wistful harmony. The man and woman belong together. They are going the same way, talking, gesturing. And they belong together because the colour scheme links them, too. In the man we see the contrast of orange (his hair) and blue (his clothing), while the woman offers the contrast of yellow and violet. In addition, the two figures contrast with each other. It is no coincidence that the man resembles the figure of van Gogh in self-portraits, wearing blue overalls, his hair and beard ginger.

In van Gogh's handling of them, contrasting colours may be both mixed and juxtaposed at the same time, in a perpetual struggle for a happy mean that can

Vincent's Bedroom in Arles
Saint-Rémy, early September 1889
Oil on canvas, 73 x 92 cm
Chicago (IL), The Art Institute of Chicago

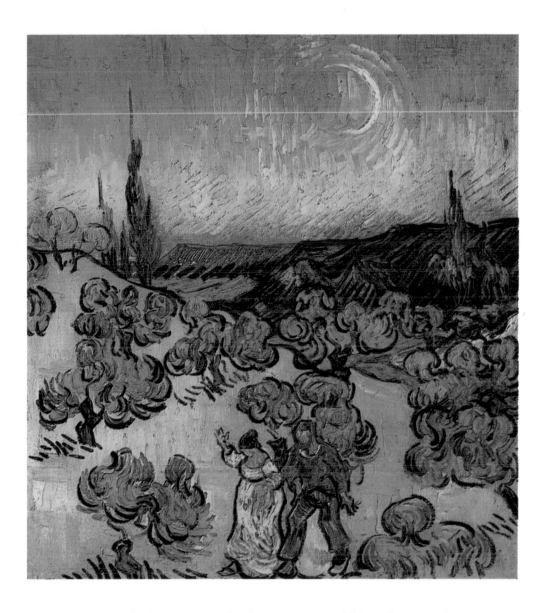

Landscape with Couple Walking and Crescent Moon
Saint-Rémy, May 1890
Oil on canvas, 49.5 x 45.5 cm
São Paulo, Museu de Arte de São Paulo

never be established or preserved. The contrast itself, in other words, expresses the paradoxical: it is a symbol of the irreconcilable ambivalences that are dominant in the real world. Van Gogh focusses this insight in his couples. But of course, once we have grasped this, we will need to view his entire œuvre in terms of paradox, of simultaneous direct simplicity and complexity of expression. From a vantage point informed by van Gogh's late work, we can look back with hindsight and understand the full symbolic power of his use of colour contrasts throughout.

Exhibitions and Criticism

For years the products of van Gogh's brush had been stockpiling. He had been sending regular consignments of his work to Paris, where Theo had been obliged to rent storage space. But the art treasures accumulating in Père Tanguy's back room could not go undiscovered for ever, and more and more interest was being shown. For his part, Theo (whom Vincent had often enough accused of doing nothing to help him) now went to work.

Apart from sneak previews at Père Tanguy's store and at the Restaurant Du Châlet, Paris had not yet had an opportunity to see Vincent's art. This state of affairs changed abruptly with the opening of the fifth Salon des Indépendants on 3 September, 1889. This alternative salon had been founded in 1884 by the

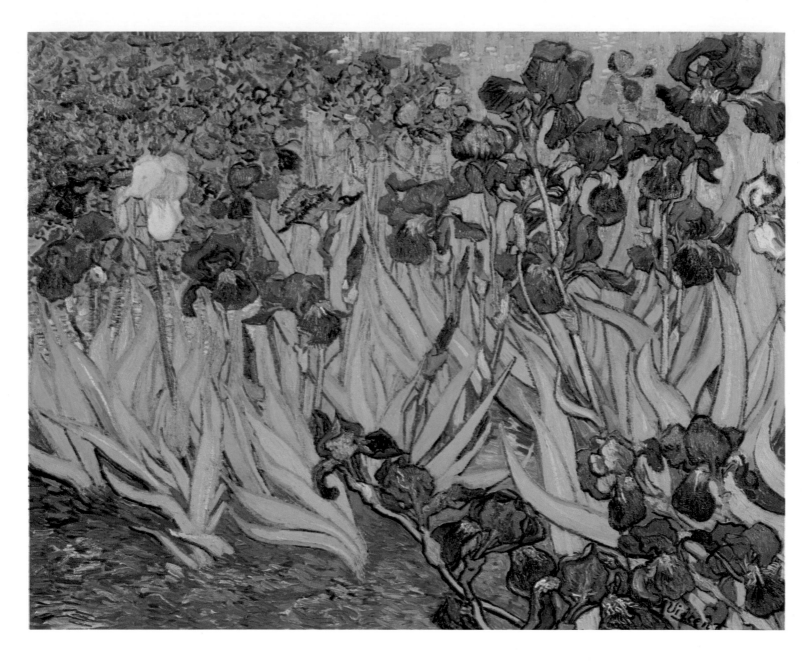

Irises
Saint-Rémy, May 1889
Oil on canvas, 71 x 93 cm
Malibu (CA), The J. Paul Getty Museum

Impressionists to offer exhibition space to those who were rejected by the Establishment. It took five years of encouragement from his brother before Vincent van Gogh submitted work. He exhibited two paintings: *Starry Night over the Rhône* (p. 131) and *Irises* (p. 208). The latter was painted in the first few days of his stay at Saint-Rémy. Naturally the whole of Paris could hardly be said to have registered these works; but artistic and open-minded people were impressed.

Van Gogh was given an interesting and surprising reception in Brussels. In January 1890, he had six pictures in the seventh exhibition of Les Vingt, the Belgian equivalent of the Indépendants. Any artist would have been glad to see opinion so divided. One Henry de Groux, a painter of conventional religious pictures, derided "the revolting pot of sunflowers by Monsieur Vincent," and withdrew his own work. He put in an appearance at the opening banquet nonetheless, indulged in new tirades, and provoked ripostes from Toulouse-Lautrec – who even challenged him to a duel. De Groux was debarred from membership in Les Vingt, and the painter, somewhat distraught, finally managed to bring himself to apologize. No report of this incident reached Saint-Rémy; but van Gogh did receive good news. He had sold his first painting in Brussels. *The Red*

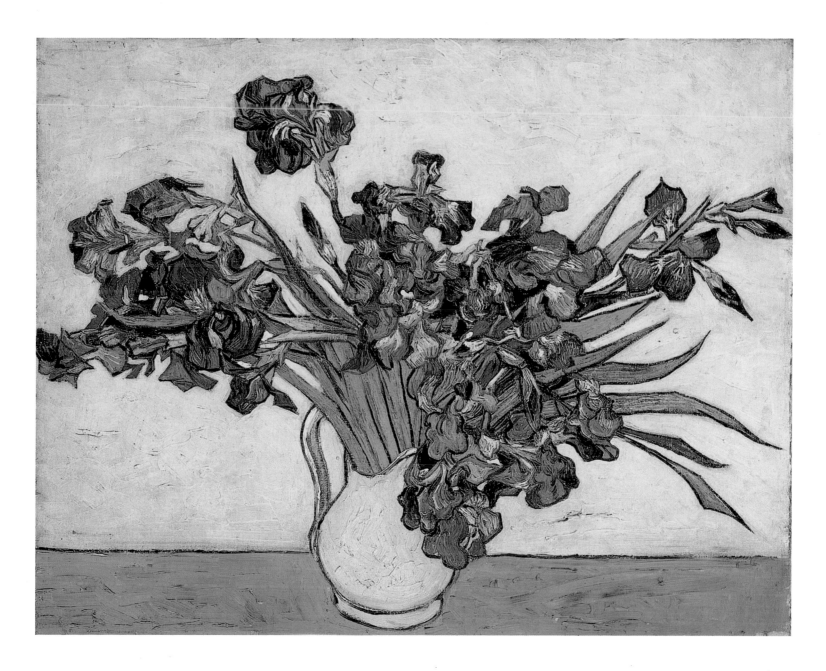

Vineyard (p. 162), done in Arles, went to Anna Boch (sister of his acquaintance Eugène) for 400 francs. It was to be his only sale during his lifetime.

Then, in January 1890, Albert Aurier's ambitious article on van Gogh appeared in the *Mercure de France*, the most important of the Symbolist publications. Bernard had drawn the Parisian critic's attention to his friend's work, and had shown him the paintings stored at Père Tanguy's shop. Theo was unaware of what was afoot. Aurier gushed about van Gogh's paintings, his genius, his madness, his solidarity with the common people, and the lack of understanding that the Dutchman's art met with.

At the sixth Salon des Indépendants in March 1890, van Gogh exhibited ten pictures. "Your paintings in the show are very successful," reported Theo (in Letter T32); "Monet said your pictures were the best in the whole exhibition. Many other artists have spoken to me about them." In just six months of busy public activity, Vincent van Gogh was now no longer a stranger to the art world, and his reputation was growing far beyond Paris coteries. He was seen as one of the promising new talents – and one who enjoyed the good fortune of having solid support on the gallery front. Theo had consolidated the reputation his business had as one of the leading modern art dealers. All the artists had hun-

Still Life: Vase with Irises
Saint-Rémy, May 1890
Oil on canvas, 73.7 x 92.1 cm
New York, The Metropolitan Museum of Art

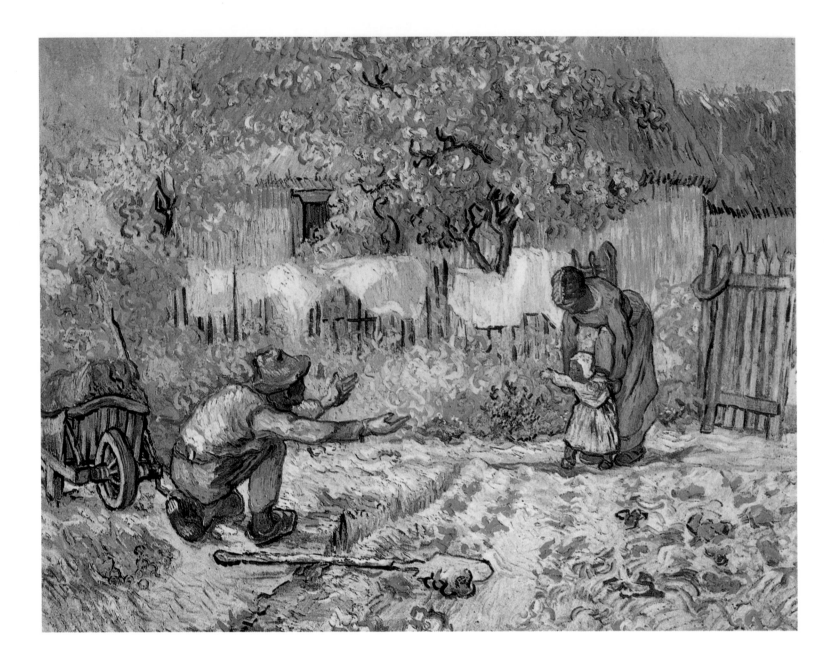

First Steps (after Millet)
Saint-Rémy, January 1890
Oil on canvas, 72.4 x 91.2 cm
New York, The Metropolitan Museum of Art

gered not only for fame, but even at times for their daily bread in youthful years, fired by the conviction that their dedicated labours would ultimately be worthwhile. The Impressionists were now reaping manifold dividends. Van Gogh, too, had a debit and credit sheet in his mind – though the way he saw it was different.

"When I heard that my work was something of a success, and read the article in question, I was instantly afraid that I would have to pay; in a painter's life it is generally the case that success is the worst thing of all." Thus Vincent to his mother, in Letter 629a. He had accepted solitude, sickness and the contemptuous neglect of the world as the price he inevitably had to pay for his art, indeed for his very life. If he was now to enjoy success, doubtless he would soon be called upon to pay more dearly than ever. Van Gogh was wary of even the smallest token of recognition, and his letter of thanks to Aurier was consistent in playing down his own claims and qualities: "You may possibly realise that your article would have been juster and to my way of thinking more persuasive if in your discussion of the future of painting and of colour you had dealt with Gauguin and Monticelli before referring to myself. For I assure you that the share I have or may have will remain negligible in future, too." (Letter 626a). His solid conviction that he would have to pay for success was to drive van Gogh to suicide.

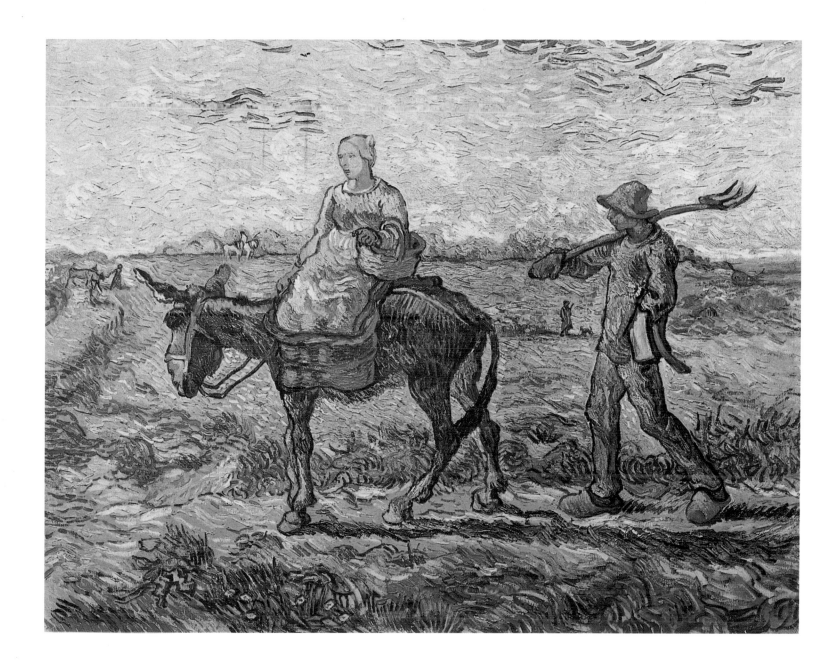

Homage to the Masters

The masters van Gogh followed at Saint-Rémy ranged from Delacroix via Rembrandt, the inevitable Millet, Honoré Daumier, and Gustave Doré, to Gauguin – and, modesty aside (for once), also included van Gogh himself. Generally he used prints from the collection he and his brother had made; Theo kept the collection in Paris, but Vincent had been involved in its creation throughout the years. Repeatedly, he had prints sent in order to copy them. In paraphrasing a number of works that had accompanied him throughout his career, providing points for him to take his bearings from, he was also paying homage – and in doing so, he revealed a great deal about the way he judged himself and his own ability.

At both the outset and the conclusion of this series of adaptations came very great artists indeed: Rembrandt and Delacroix. Other works in the series were of a lighter, genre nature; but Rembrandt and Delacroix gave weight and historical gravity. Apparently van Gogh only dared tackle Biblical subjects if he did it obliquely, via models. Thus, he painted his own versions of the *Pietà* (p. 212) by Delacroix, and of *The Raising of Lazarus* (p. 213) by Rembrandt.

Morning: Peasant Couple Going to Work
(after Millet)
Saint-Rémy, January 1890
Oil on canvas, 73 x 92 cm
St. Petersburg, Hermitage (formerly Krebs Collection, Holzdorf)

Van Gogh also did some two dozen versions of Millets, exercises in rustic social romanticism which are firmer and more arresting, if less ambitious, than the versions of Rembrandt and Delacroix. He gave his attention to individual figures. They were peasants binding sheaves, reaping, threshing or shearing sheep (p. 217). These subjects had always been favourites with van Gogh, and now served as reminiscences of his own artistic origins.

The pictures that served as his models were the equivalent of his musical scores. He then interpreted them, drawing both on the experience he had acquired and on his current state of mind. In his copies we see a principle at work that van Gogh obeyed in one way or another throughout his work – the principle of variation on a theme. The theme remained recognisable; but it could be treated in an infinite number of ways. Mountainous landscape, cypress trees and the enclosed field provided van Gogh with a repertoire of themes to improvise on; and every painting was a new performance.

Van Gogh's distinctive expressiveness consisted in freedom of interpretation, in improvisation and variation, in the rapid recording of an on-the-spot mood in order to set down a part of himself on the canvas. His jagged lines, orchestrated shapes and crude combinations of colours were not so much ends in themselves

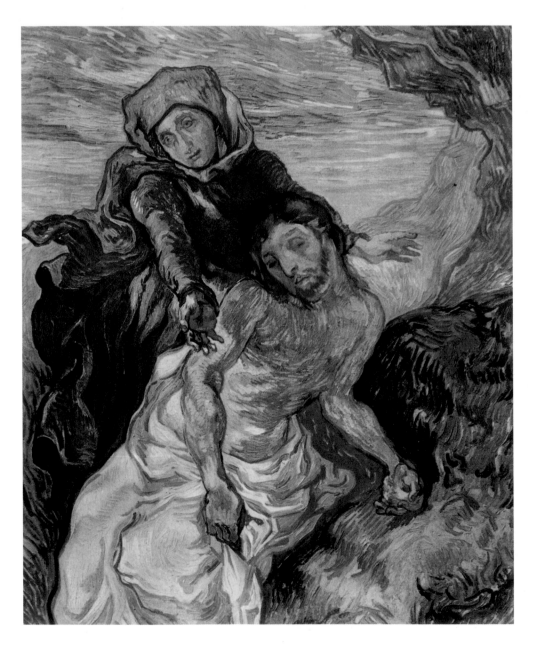

Pietà (after Delacroix)
Saint-Rémy, September 1889
Oil on canvas, 73 x 60.5 cm
Amsterdam, Rijksmuseum Vincent van Gogh,
Vincent van Gogh Foundation

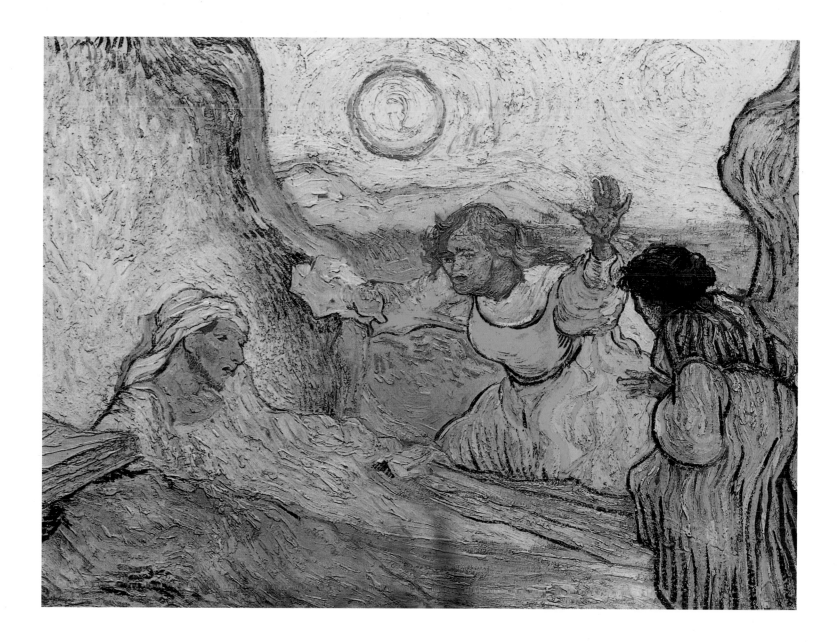

The **Raising of Lazarus** (after Rembrandt)
Saint-Rémy, May 1890
Oil on paper, 50 x 65 cm
Amsterdam, Rijksmuseum Vincent van Gogh,
Vincent van Gogh Foundation

as means of attesting the immediacy of the work. The brush and canvas were his instruments, and his virtuosity produced an overall harmony that drew upon years of experience and at the same time on the mood of the moment. This was why the time he took to produce a painting was of such importance. Van Gogh's chosen motif was the alien element, which could be used to convey meaning (feelings of loneliness, of homelessness, and so on); his work on the motif (in sketch form or in the paint) was the personal element, expressing his own personality. Essentially, van Gogh did not make any subjects his own. He merely borrowed them, as it were familiarizing himself with them for as long as they were his artistic subjects.

That is why the copies fit in so well with his œuvre as a whole. Van Gogh's revered masters served as models to identify with, and in this way made a contribution to his art. Daumier's *The Drinkers* simply reminded him of his own excesses in Paris and Arles; but once he painted a copy, the picture re-established its intrinsic power and meaning (p. 215). Doré's *Prisoners Exercising* doubtless underlined his own sense of confinement, but it was only when he added the brooding blue to the picture that he truly expressed his own situation (p. 214). The drawing of Madame Ginoux that served Gauguin as a preliminary study (p. 165) for his version of the *Night Café* was a reminder of the war the two friends

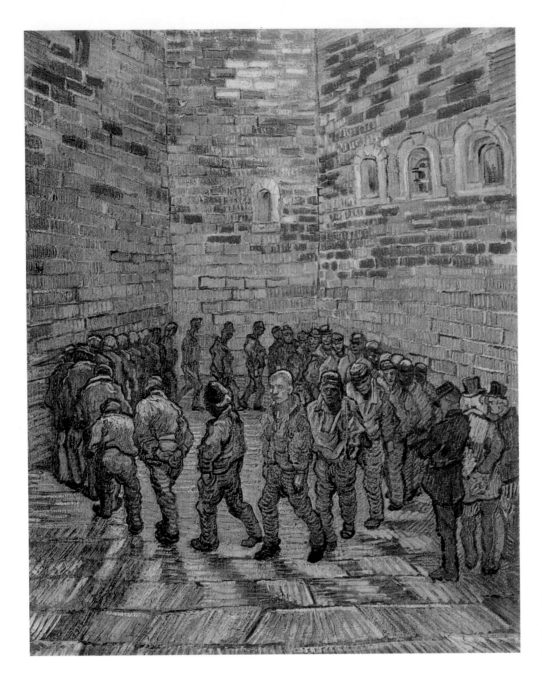

Prisoners Exercising (after Doré)
Saint-Rémy, February 1890
Oil on canvas, 80 x 64 cm
Moscow, Pushkin Museum

had fought in the yellow house; but only when he had painted his own versions of that study (p. 198) did van Gogh properly put that rivalry behind him. Van Gogh also linked up with his own younger days, reworking a piece he had done in The Hague and given a rather portentous title to *(On the Threshold of Eternity)*, remaking it as a simple, albeit monumental record of the passing moment (p. 199). In painting these pictures, van Gogh recorded part of himself and at the same time located a partner for the dialogue and communication he needed.

The Final Months in Saint-Rémy

The *Trees in the Garden of Saint-Paul Hospital* (p. 216) have an assured air. The atmosphere they establish is one of snug comfort beneath their inviting shade, an atmosphere that perhaps does not quite fit the place. The setting has something of a park about it, charming and carefree, and the gloomy monastic buildings of the asylum look as graceful as an orangerie or stately home. What pos-

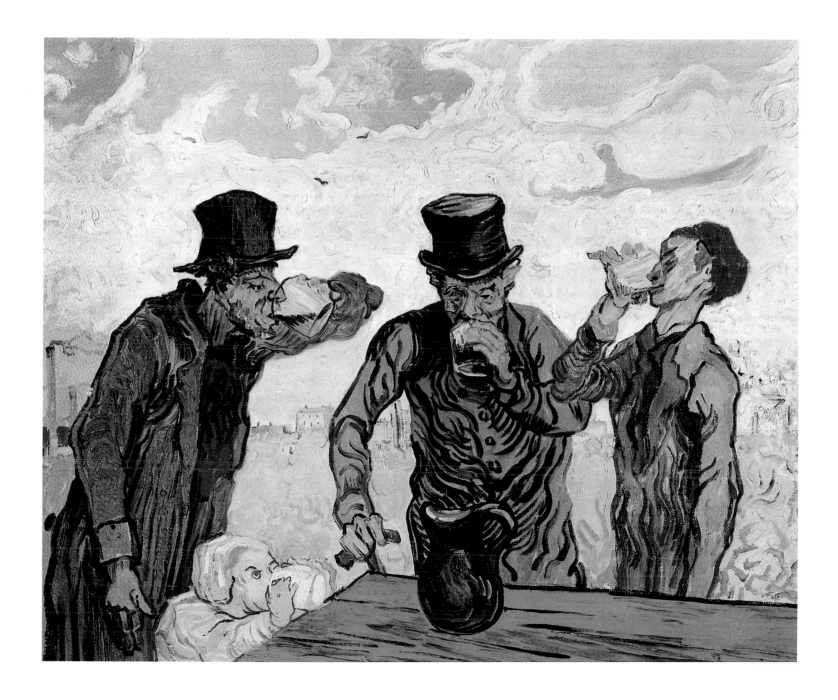

sessed van Gogh to transform the asylum by breathing the magic of the poet's garden at Arles upon it? Why are the male figures (who look more like chance passers-by than like careworn inmates of a lunatic asylum) accompanied by ladies (cf. the lady with the umbrella, and the couple in yellow), as if van Gogh were gazing at public gardens? And why is the painter himself (the man in the centre, in blue overalls and straw hat) in the picture? Had van Gogh's view of the asylum changed to one of cheerful optimism? Or was he merely indulging in wishful thinking, dreaming a new world free of doubt and suspicion?

Van Gogh had spent several weeks isolated in his room; now he was venturing into the open. With the memory of his first attack in Saint-Rémy still very strong in him, van Gogh was hesitantly reaching out again to the world and all it had to offer. His balance between good cheer and *Weltschmerz* had always been precarious, and now it had become more unstable than ever. With all the self-discipline in the world, van Gogh could not be sure of averting an escalation of his condition. That autumn of 1889, van Gogh confronted two facts. One was that his attacks would recur. The other was that, this being so, he might as well

The Drinkers (after Daumier)
Saint-Rémy, February 1890
Oil on canvas, 59.4 x 73.4 cm
Chicago (IL), The Art Institute of Chicago

Trees in the Garden of Saint-Paul Hospital
Saint-Rémy, October 1889
Oil on canvas, 90.2 x 73.3 cm
Los Angeles, The Armand Hammer
Museum of Art

follow the promptings of his heart and go back north, closer to his childhood home and the affection of his brother. This twin recognition explains why his existential *Angst* became all the more critical, while simultaneously his longing for the security and comfort of a familiar environment grew more and more acute. Van Gogh was to remain in the asylum for a further six months, in a stalemate of his own spirit's creation.

"It is now just a year since the attack back then," he wrote immediately before Christmas 1889 in a letter (W18) to his sister. He had scarcely written the words before the thing he had been fearing for weeks did indeed happen: again van Gogh succumbed to an attack. As in the year before, he plunged into a deep depression that lasted eight days. Again he tried to swallow his paint, and became incapable of contact with the outside world. That special affinity van Gogh had with Christmas, and his fixation on anniversaries, had joined forces against him.

It was a self-fulfilling prophecy; and the same thing was to happen on two further occasions. Twice van Gogh would go to Arles, to visit friends and collect pictures and furniture; and twice he would return in a helpless, deranged condi-

tion to the asylum. He was convinced that he was incapable of leading a normal life, and he saw to it that he got into situations that carried a high psychological charge whenever he had contact with the outside world. That was why he put up such resistance to the recognition his art was beginning to earn. There was a demonstrative, almost exhibitionist side to his attacks, as if he himself were consciously craving madness as a kind of proof of his artistic status.

Alongside flight from orderly everyday existence into the world of Art, there was a second kind of escape: the escape van Gogh longed to make back to the north, to his roots. The legacy of Arles was not madness alone. Van Gogh painted a final reminiscence of his utopian, optimistic days – a Japanese picture, *Blossoming Almond Tree* (p. 219). In painting it, he was not out to revive his own optimism, but to make an offering to his ever-caring brother. In spring 1889, Theo had married Jo Bonger, and in February 1890 she gave birth to their son, whom they named Vincent after the boy's godfather. The *Blossoming Almond Tree* was van Gogh's present to the infant that would perpetuate his name. Never before had he viewed the bright buds in such close-up; never before had he

Left:
The Spinner (after Millet)
Saint-Rémy, September 1889
Oil on canvas, 40 x 25.5 cm
Private collection

Right:
The Reaper (after Millet)
Saint-Rémy, September 1889
Oil on canvas, 43.5 x 25 cm
Rochester (NY), Memorial Art Gallery of
the University of Rochester

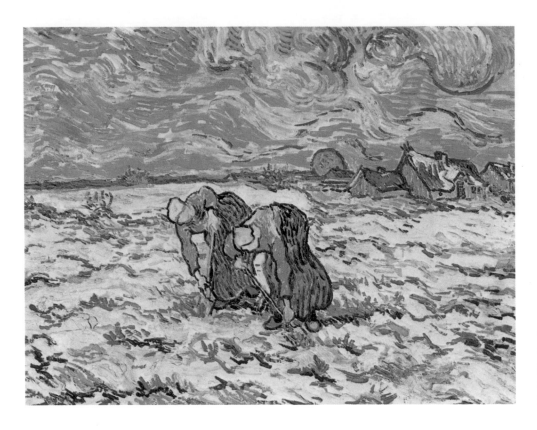

Two Peasant Women Digging in Field with Snow
Saint-Rémy, March–April 1890
Oil on canvas, 50 x 64 cm
Zurich, Stiftung Sammlung E. G. Bührle

Pine Trees and Dandelions in the Garden of Saint-Paul Hospital
Saint-Rémy, April–May 1890
Oil on canvas, 72 x 90 cm
Otterlo, Rijksmuseum Kröller-Müller

lavished such colour on the glorious blossoms. In the picture he tried to call forth for his godson what was denied to him: a carefree, happy future.

This work, done towards the end of his Saint-Rémy time, then, is a work of memory. And in Letter 601 he set himself a new goal: "to start all over again, with a palette, as I did in the north." The melancholy peasant scenes he had done in Drente and Nuenen underwent a revival. To his sister, he put it this way (Letter W20): "When I have such thoughts [...] I want to become a new, different person and be forgiven for painting pictures that are almost a cry of fear, even when the rural sunflower symbolizes gratitude. As you see, I can still put my thoughts together coherently – though it would be better if I knew how to work out what a pound of bread and a quarter pound of coffee cost, as the peasants do. Which brings us back to the old point. It was Millet who set the example: he lived in a cottage, amongst people unacquainted with our foolish arrogance and stupid high flown notions. Rather a little wisdom, then, than a great deal of energy and élan." Recent years, and involvement in the shifting fortunes of the isms, had cost him too much strength and kept him from his real task. He wanted to return to the unforced dignity of a simple way of life, close

Blossoming Almond Tree
Saint-Rémy, February 1890
Oil on canvas, 73.5 x 92 cm
Amsterdam, Rijksmuseum Vincent van Gogh,
Vincent van Gogh Foundation

to the land, in harmony with the seasons and the elements. Van Gogh had seen that the artificial tastes he had acquired in Paris and Arles led him nowhere.

His longing for northern simplicity was in the first place a matter of motifs. We see this in *Cottages and Cypresses: Reminiscence of the North* or in *Two Peasant Women Digging in Field with Snow* (p. 218), where the two women are seen planting potatoes in the vast plain. They were paintings done from memory; imagination no longer repelled him, as it had done in his days at the yellow house. The supposition that the choice and application of colours would now match his changed situation, and would be purified and smoothed out by a new inwardness, is exactly the notion we would expect of a realist like van Gogh. And sometimes he tried his hand at a dominant colour scheme; *Pine Trees and Dandelions in the Garden of Saint-Paul Hospital* (p. 218) is a good example. However, the brushwork has certainly not become more relaxed. There are still fat streaks all over the canvas, whirling and compacting as if van Gogh were out to create a relief. Of course his use of varnish was still perfect, serving to highlight the luminous power of the colours, as in *Still Life: Vase with Irises against a Yellow Background* (p. 221). Here, van Gogh has devoted his attention to the contours of the shapes that bear his colour contrast. The flower still life has a certain classical equilibrium, and could just as well have been painted in Arles – it takes obvious pleasure in colour and makes no attempt to distort or remake shapes. That said, though, the flowers are also a symbol of longing, recollecting those early days in Paris when van Gogh had devoted almost all his time to still-life painting.

"The patient, who was calm on the whole, suffered a number of violent attacks during his stay at the asylum, lasting from a week to a month. During these attacks he was overcome by terrible fears and anxieties, and repeatedly tried to poison himself, either by swallowing paint or by drinking kerosene stolen from the assistants when they were refilling the lamps. His last attack began on a trip to Arles and lasted for two months. Between attacks, the patient was absolutely quiet, and devoted himself entirely to his painting. Today he asked to be discharged, intending to live in the north of France in future, where he is convinced the climate will do him good." Thus Doctor Peyron, director of the asylum, in his final report on van Gogh's condition. In the space of a year, van Gogh had suffered four attacks in all; and all he had to show for that year was his paintings. Since he had entered the asylum of his own free will, there was nothing to prevent his request from being granted. And, as if he had never flinched from public life or from contact with the outside world, van Gogh set off alone on the long trip to Paris on 16 May, 1890.

Van Gogh's ways of escape – seeking oblivion through the act of remembering, a new start by staying put in the asylum – increasingly had a quality of panic. His art reflected this drifting state faithfully, with all his customary expressiveness and force. If van Gogh was changing to a new location again, it was not to expose his creative work to helpful influences, as it had been when he moved away from Nuenen or Paris. His departure was an existential act, intended to prevent the recurrence of his attacks.

Still Life: Vase with Irises against a Yellow Background
Saint-Rémy, May 1890
Oil on canvas, 92 x 73.5 cm
Amsterdam, Rijksmuseum Vincent van Gogh, Vincent van Gogh Foundation

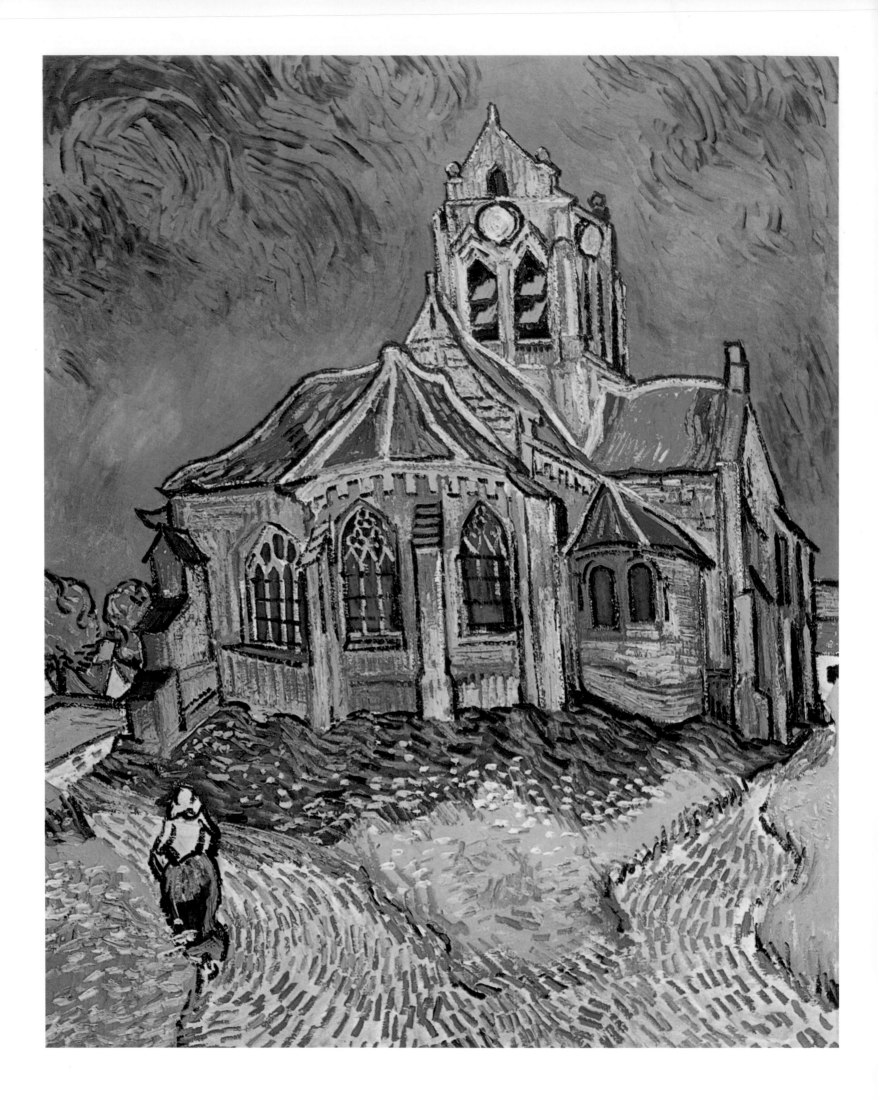

The End
Auvers-sur-Oise, May to July 1890

On Doctor Gachet's Territory

Van Gogh arrived in Paris looking fit and healthy. He seemed in excellent con-
dition, and certainly much better preserved than his bowed and feeble brother.
There followed three days in which he eagerly caught up on the metropolitan
art scene, for all the world as if he was resuming his old role as man-about-town
in the art capital of Europe. His friends came to call at Theo's home, and so did
a growing number of admirers. What doubtless benefitted him most of all,
though, was being able to see a large proportion of his œuvre together for the
first time; he could compare his earlier work with his later, and had before him
what had so far only existed in the nebulous realm of memory. For years van
Gogh had been working every day, interrupted only by his bouts of madness,
and now he paused for a while, inactive, his brush and pen untouched. But
inactivity was not for Vincent van Gogh. He could not remain idle for long, and
on 20 May, 1890 he crept off to Auvers-sur-Oise, which had been the focus of
his longing for the north for some weeks. The small town on the river Oise,
though scarcely beyond the outskirts of Paris, yet had that rural character he had
left behind in the south: and it had the advantage of being close to the capital
and his brother. For the time being, Auvers was the ideal refuge – as quiet a
country place as he could wish, but with as much access to the city as he needed.

The things he had toiled to retrieve from memory in his southern days were
before his very eyes in Auvers. Van Gogh promptly set about painting cottages,
and developed a manic obsession with the motif, discovering an apparently end-
less number of interesting angles to his humble subject. Often his perspective
was almost identical to that in imagined scenes he had painted in the asylum. It
is interesting, for example, to compare *Cottages: Reminiscence of the North*
(p. 224), painted at Saint-Rémy, with *Thatched Cottages* (p. 224), done on the
spot at Auvers. In both pictures the cottages are crowded up close, as if in need
of protection. The painter is keeping his distance, as if he did not wish to intrude
too much upon the idyll, and he merely records the essentials. That said, though,
we must note the great difference in van Gogh's technique in Auvers: the agita-
tion in his style has gone, the violence has vanished, and the rhetoric of the
treatment is as subdued and tranquil as the scene itself in contrast to earlier
work, in which the exuberance of van Gogh the draughtsman and colourist could
sometimes get rather out of hand. Van Gogh had anticipated that a return to the
north would produce a more subtle and objective style. In the very first works

The Church at Auvers
Auvers-sur-Oise, June 1890
Oil on canvas, 94 x 74 cm
Paris, Musée d'Orsay

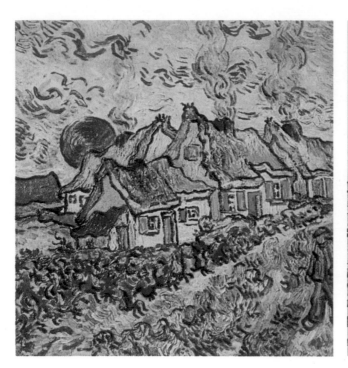

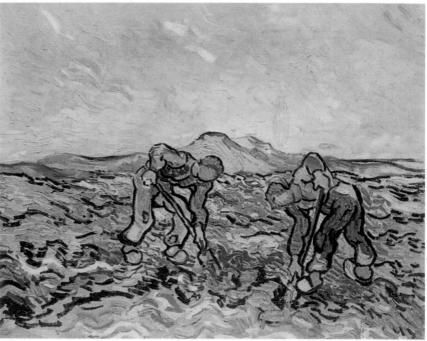

Cottages: Reminiscence of the North
Saint-Rémy, March–April 1890
Oil on canvas, 45.5 x 43 cm
Switzerland, Private collection

Right:

Peasants Lifting Potatoes
Saint-Rémy, March–April 1890
Oil on canvas, 32 x 40.5 cm
New York, The Solomon R. Guggenheim
Museum, Justin K. Thannhauser Collection

he painted there, he was out to prove his expectations right. His longing had been gratified: his mood was calmer. *The Church at Auvers* (p. 222) has a monumental quality, indeed the lofty majesty of a fortress, and seems to be affording protection to the town. This architectural portrait, reminiscent of the old tower at Nuenen, shows van Gogh evading the issue of his present situation and preferring to echo older times in his homeland.

His new-found friend Paul Gachet was the real reason why van Gogh moved to Auvers. Dr. Gachet was an ardent republican and socialist, and devoted to his artist friends, whose scorned and derided works he collected diligently. Soon he was inspired to paint too, and, using the pseudonym van Ryssel, he made some-

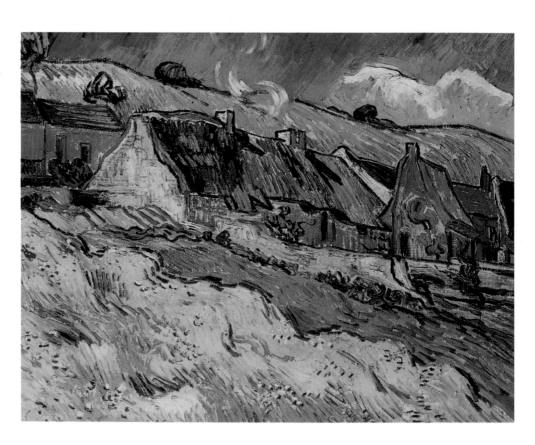

Thatched Cottages
Auvers-sur-Oise, May 1890
Oil on canvas, 60 x 73 cm
St. Petersburg, Hermitage

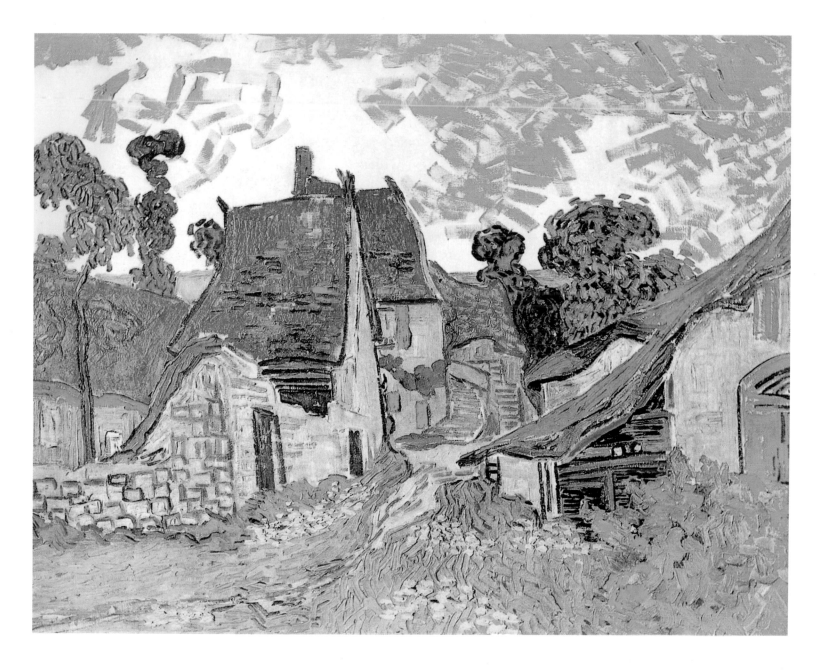

thing of a name for himself, mainly as a graphic artist. In 1873 Cézanne moved to Auvers on Gachet's account. Camille Pissarro was living not far away, at Pontoise. And it was Pissarro who told Theo van Gogh about the doctor, saying that his knowledge of the physiology of Man was accompanied by real insight into the soul. Vincent could hardly have found a better therapist. It was because of Dr. Gachet that van Gogh went to Auvers in the first place, and because of him that he stayed there.

In Gachet van Gogh found a friend, a sensitive, kindred spirit. Gachet was not as prompt to pronounce a diagnosis as those who later saw van Gogh as schizophrenic or epileptic; he was merely convinced that van Gogh's attacks would not recur, and in this he was to be proved correct – though at a price. As a token of friendship, van Gogh painted two portraits of the doctor (pp. 226 and 227). Both show him in the pose van Gogh considered typical of the man, in a contemplative and slightly melancholy mood. Gachet had written a doctoral thesis on melancholy. In terms of his temperament, melancholy was his middle name. It was no coincidence that his pose so closely resembled that of Madame Ginoux in the Saint-Rémy painting of *L'Arlésienne* (p. 198); van Gogh's earlier sitter, back in Arles, had had her own mental problems. Of course the head resting

Village Street in Auvers
Auvers-sur-Oise, May 1890
Oil on canvas, 73 x 92 cm
Helsinki, Atheneumin Taidemuseo

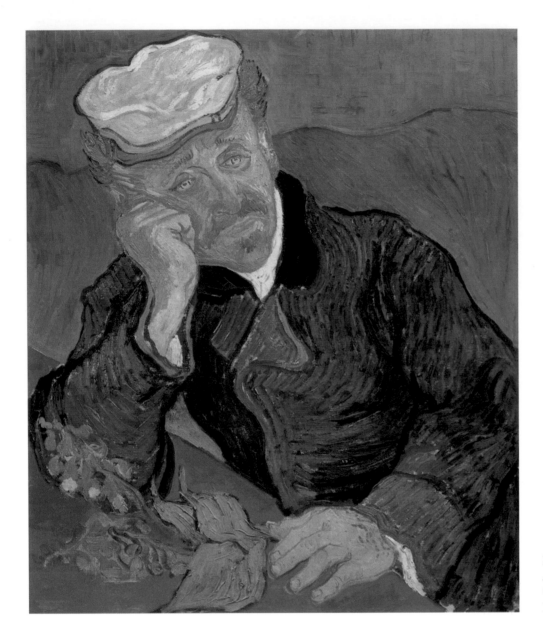

Portrait of Doctor Gachet
Auvers-sur-Oise, June 1890
Oil on canvas, 68 x 57 cm
Paris, Musée d'Orsay

heavily on the hand, the arm propped on the elbow, the drooping eyelids and glum mouth, had for centuries been the stereotype image of the melancholic and, by extension, of the suffering artist. Van Gogh was painting an *alter ego*. The portrait recorded a process of identification. The two books in one portrait (p. 227) are by the brothers Goncourt – *Germinie Lacerteux* and *Manette Salomon*. These attributes not only suggest a well-read man. They are also symbols of the modern spirit shared by the two men, emblematic of the optimistic yet despairing vision of the future they had embraced.

No one knew better than van Gogh that in the portraits of Dr. Gachet he was borrowing an ages-old traditional mould and filling it with his own individual details. In Letter W22 he wrote: "I should like to paint portraits that will strike people a hundred years from now like visionary apparitions. But I am not trying to achieve this by means of photographic similitude; rather, by means of passionate expression, using our modern knowledge of colour and our contemporary sense of colour as a means of expression and a way of heightening character." If the doctor's pose went back to ancient times, the treatment was extremely advanced; and it seems likely that Gachet himself was the catalyst of van Gogh's views at this point. Van Gogh was painting as he had always done, and the use of colour, and application of paint, were as vigorous and even violent as ever. But

Portrait of Doctor Gachet
Auvers-sur-Oise, June 1890
Oil on canvas, 67 x 56 cm
Tokyo, Ryoei Saito Collection

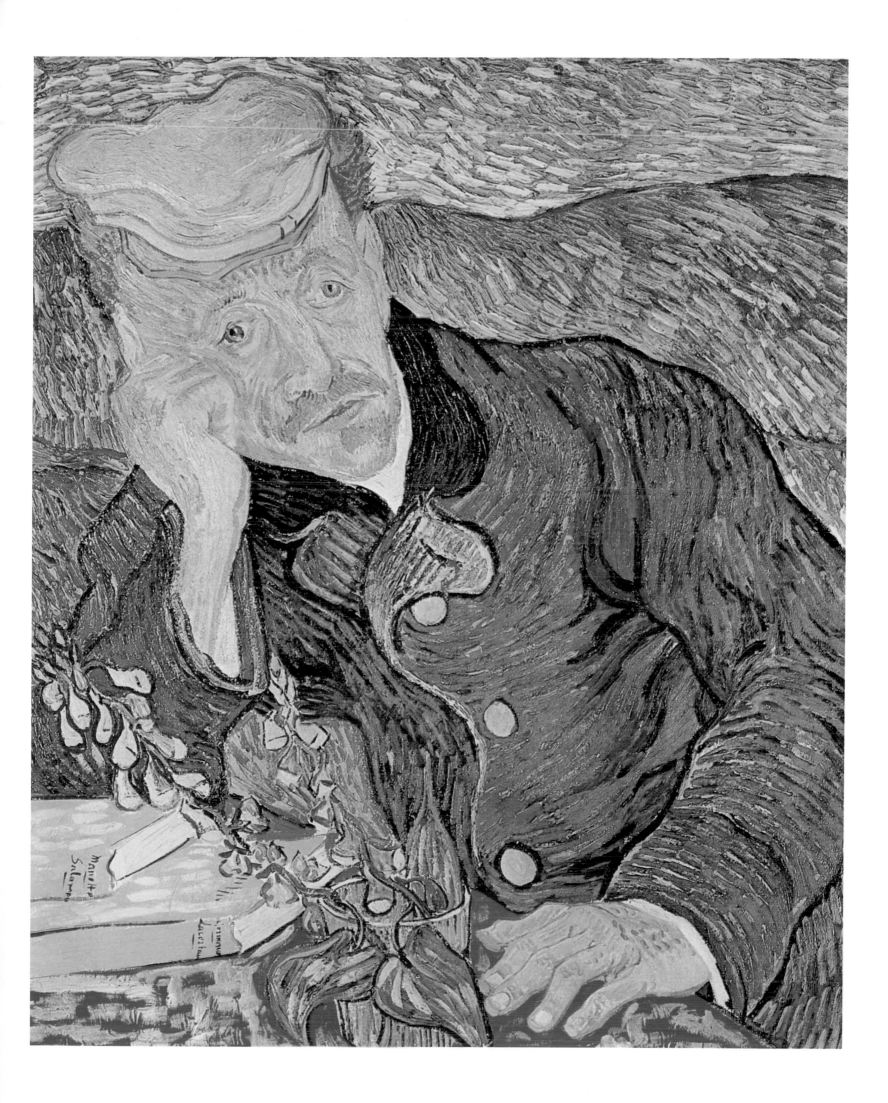

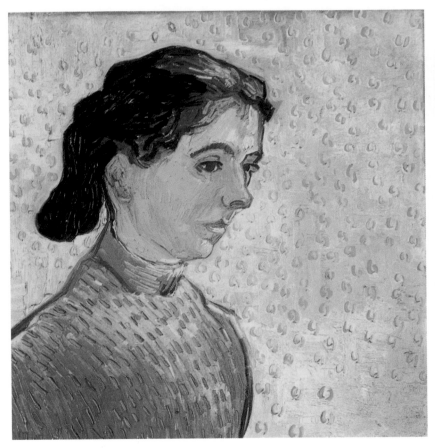

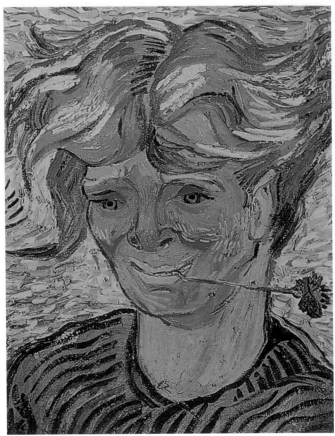

Left:
The Little Arlésienne
Auvers-sur-Oise, June 1890
Oil on canvas, 51 x 49 cm
Otterlo, Rijksmuseum Kröller-Müller

Right:
Young Man with Cornflower
Auvers-sur-Oise, June 1890
Oil on canvas, 39 x 30.5 cm
La Chaux-de-Fonds, Musée des Beaux-Arts

discussions with his new mentor may well have brought home to him for the first time the radically innovative quality of his own paintings. In his rural seclusion, van Gogh was thinking and working, indeed living, in a spirit of modernity almost in spite of himself. Now, after years of isolation, he fully perceived the nature of his own programme; Gachet reawakened the interest in staking out manifesto claims that van Gogh had lost in Saint-Rémy.

And van Gogh also had a new hero: Puvis de Chavannes. The rather dry and remote religious and mythic scenes of Puvis supplied a newly fashionable aesthetic demand for virginal grace and purity. In a sense, van Gogh's portraits of Dr. Gachet were recollections and even paraphrases of a work by Puvis. "For myself, the very ideal of figure painting has always been a portrait of a man by Puvis, showing an old man reading a yellow novel, with a rose beside him and a watercolour brush in a glass of water." (Letter 617). This portrait (which shows one Eugène Benon and is currently in a private collection at Neuilly) reappears in more contemporary style, the treatment more radical and the colour scheme more assured, in the portrait of Gachet on page 227. And it was not only in the painting that the influence of Puvis was of central importance: "It is a comfort," wrote van Gogh in Letter 617, referring to the picture by Puvis, "to see modern life as something serenely pleasant in spite of the inevitable sadness it brings."

The van Gogh who lived his last two months in Auvers was a more cheerful and confident artist, more cosmopolitan in temper. He painted some eighty works in that time – an average of more than one a day. They included thirteen portraits, painted in a very few weeks, a rate of production that he had scarcely achieved even in Nuenen. He was more interested than ever in youngsters and children, seeing them as symbols of carefree, optimistic life. There is no trace of despondency, depression, or premonitions of death in a painting such as *Young Man with Cornflower* (p. 228) – indeed, none of van Gogh's other portraits can

Daubigny's Garden
Auvers-sur-Oise, July 1890
Oil on canvas, 50 x 101.5 cm
Basle, Öffentliche Kunstsammlung Basel,
Kunstmuseum, on loan from the Rudolf
Staechelin'schen Familienstiftung

match the cheerful tone of this one. Of course, all van Gogh's paintings sought to respond to the world by expressing an optimism he could not necessarily find within himself. It is all too easy to project our hindsight knowledge of his suicide onto these late works. However, neither van Gogh's pictures nor the letters he wrote at the time demand interpretation as documents of a descent into the abyss – quite the contrary: van Gogh was taking considerable delight in his work. The

Wheat Field at Auvers with White House
Auvers-sur-Oise, June 1890
Oil on canvas, 48.6 x 63.2 cm
Washington, The Phillips Collection

Houses in Auvers
Auvers-sur-Oise, June 1890
Oil on canvas, 60.6 x 73 cm
Toledo (OH), The Toledo Museum of Art,
Gift of Edward Drummond Libbey

importance of Dr. Gachet's positive influence can hardly be exaggerated. It was Gachet who brought home to van Gogh the significance and value of his art, Gachet who used his natural authority to persuade van Gogh to do a new series of portraits, and a number of townspeople to sit for him.

The town of Auvers itself had the perfect atmosphere. Decades previously, Daubigny had bought a plot of land there and tempted Daumier and Corot to follow him. Three artists van Gogh valued highly had given the area their attention, recording it in paintings, transforming its moods in their use of colour and conferring the natural nobility of Art onto the townspeople. Van Gogh had always had a tendency to follow in someone or other's footsteps, and in Auvers it was an easy and natural thing to do. He painted three views of *Daubigny's Garden* (pp.229 and 231) on the spot, views relaxed and unstrained in mood. Undoubtedly, van Gogh's life at Auvers was far more pleasant than it had been at Saint-Rémy. Now van Gogh was seizing hold of the happiness Art and the pursuit of Art could afford him. If van Gogh's sense of being at odds with the world was

perhaps undiminished within, he yet encountered nothing in Auvers to make his condition worse. The reasons for his suicide must be sought elsewhere.

Van Gogh's Art Nouveau

Van Gogh rendered his new surroundings in a relaxed and calm style. In *Wheat Field at Auvers with White House* (p. 229), for instance, the house itself is positioned at a distance, allowing van Gogh a detached approach that dwells on an everyday scene caught at a given moment. The wheat is gradually ripening, and beyond the field we see a panoramic background where the motifs are packed

Daubigny's Garden
Auvers-sur-Oise, mid June 1890
Oil on canvas, 50.7 x 50.7 cm
Amsterdam, Rijksmuseum Vincent van Gogh,
Vincent van Gogh Foundation

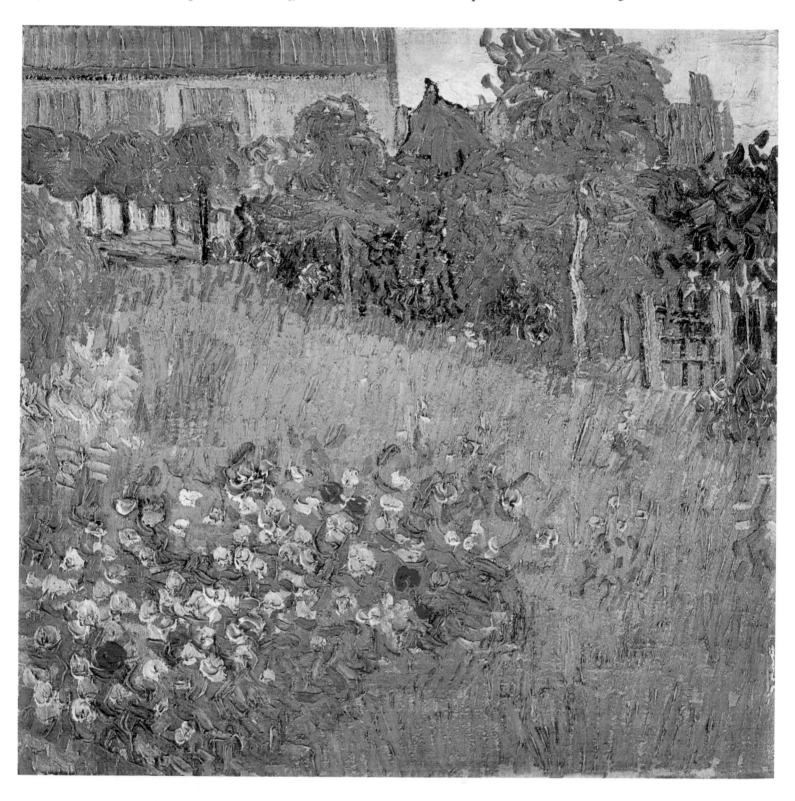

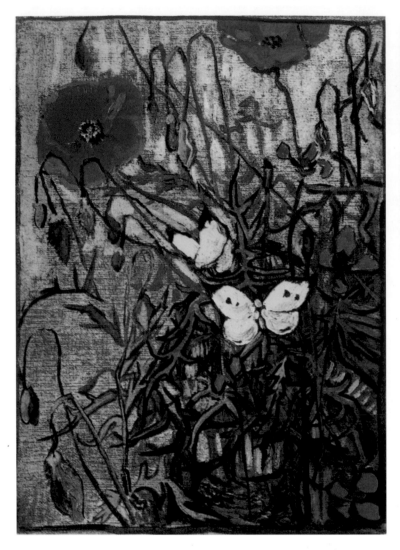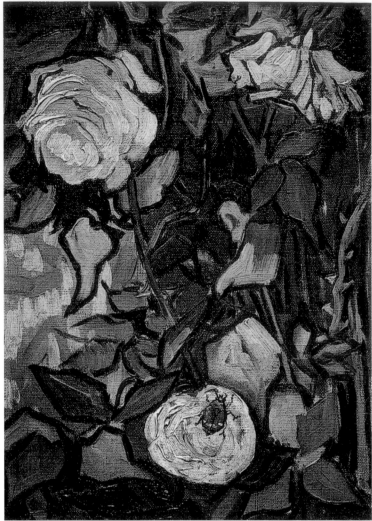

tight and the outlines begin to dissolve. Van Gogh has put his individual style at the service of the scene, and has returned to a task he had been neglecting for years, the task of simply showing things as they are. His brushwork introduces order into the sea of wheat, recording every single ear of corn with a bold stroke. His use of colour is modest, restricted to variations on green, now with a delicate yellow touch, now with a blue; the palette's sole contribution is white, non-colour white, inexpressive white, which has the sole function of signifying the whitewashed walls of the house. Harmony prevails. Van Gogh has carefully removed all trace of his own presence and has simply, selflessly recorded the look of the country. It is an idyll. But it is a sterile idyll.

In Auvers, van Gogh succeeded in combining two apparently irreconcilable methods, uniting the wild and the levelheaded, the violent and the controlled, the chaotic and the orderly. Generally speaking, his pictures became more decorative in character, approaching an ideal he had already toyed with in Arles. He adopted a new close-up view of Nature, giving his attention to the natural and thus beautiful appearance of things. The paintings of wild roses on pages 232 and 233 are good examples. The close-up treatment preserves a certain haphazard energy in the natural object without abandoning it to mere luxuriance and jungle chaos. Van Gogh's control of technique is stern; the beetle on one of the flowers (p.232) gives the impression of being the subject of a portrait. The artist who wanted to express the "remarkable relations" (van Gogh's phrase) of Nature was best advised to plunge into the heart of Nature, rather than stylizing them in his art.

Top:
Poppies and Butterflies
Saint-Rémy, April–May 1890
Oil on canvas, 34.5 x 25.5 cm
Amsterdam, Rijksmuseum Vincent van Gogh,
Vincent van Gogh Foundation

Roses and Beetle
Saint-Rémy, April–May 1890
Oil on canvas, 33.5 x 24.5 cm
Amsterdam, Rijksmuseum Vincent van Gogh,
Vincent van Gogh Foundation

Page 233:
Blossoming Chestnut Branches
Auvers-sur-Oise, May 1890
Oil on canvas, 72 x 91 cm
Zurich, Stiftung Sammlung E. G. Bührle

Still Life: Vase with Roses
Saint-Rémy, May 1890
Oil on canvas, 71 x 90 cm
New York, Private collection

Still Life: Pink Roses in a Vase
Saint-Rémy, May 1890
Oil on canvas, 92.6 x 73.7 cm
Rancho Mirage (CA), Mr. and Mrs. Walter
H. Annenberg Collection

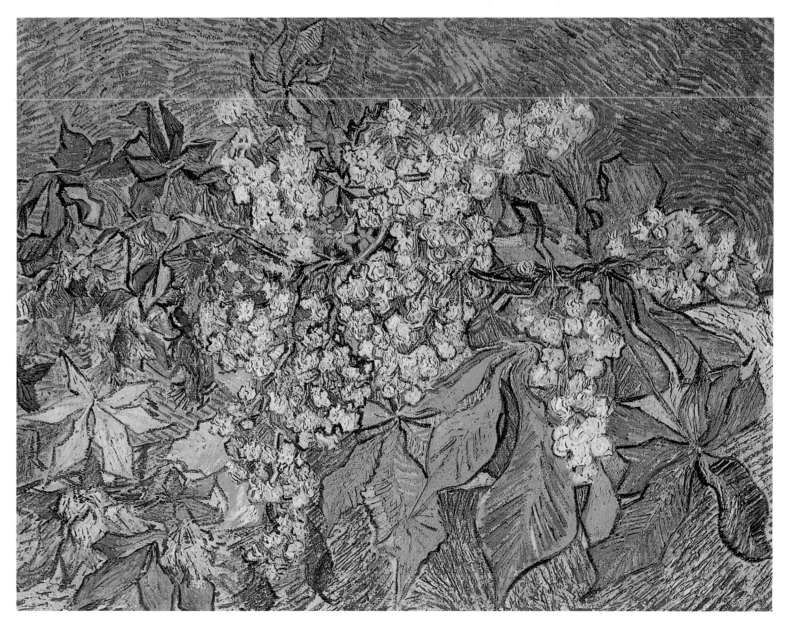

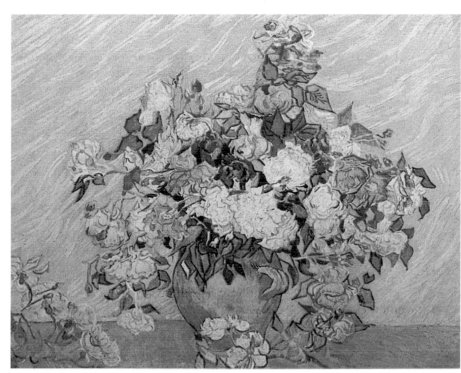

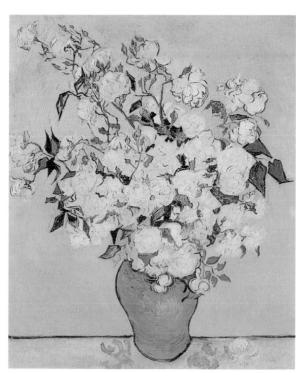

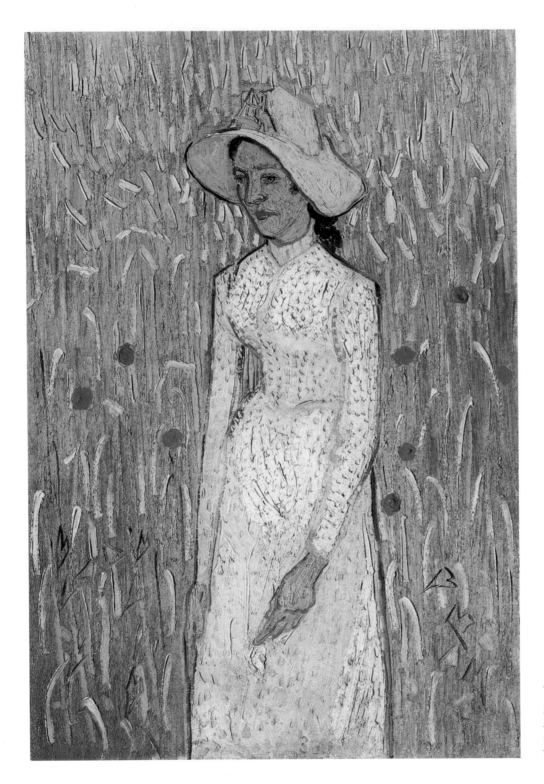

Young Girl Standing against a Background of Wheat
Auvers-sur-Oise, late June 1890
Oil on canvas, 66 x 45 cm
Washington, National Gallery of Art

The two pictures of young peasant women in wheatfields (pp. 234–235) illustrate this conviction well. The model is seen posing in surroundings that constitute her livelihood and *raison d'être*, in a field of ripening wheat. This setting functions both as attribute and as a traditional item in portrait iconography. On the other hand, though, the wheatfield itself (Nature under cultivation) hardly makes much of an impression. The stalks and flowers look like a wall because the painter's close-up is so extreme as to eliminate all trace of spatial depth, and because the local colours are so intense as to dispel atmosphere. The aesthetic unity of a subtly rendered human being and a delicately decorative background has a natural inevitability to it, whereas in portraits done towards the end of the Arles period, such as *La Berceuse*, the combination still had something brusquely forced about it.

Young Peasant Woman with Straw Hat Sitting in the Wheat
Auvers-sur-Oise, late June 1890
Oil on canvas, 92 x 73 cm
Berne, Collection H. R. Hahnloser

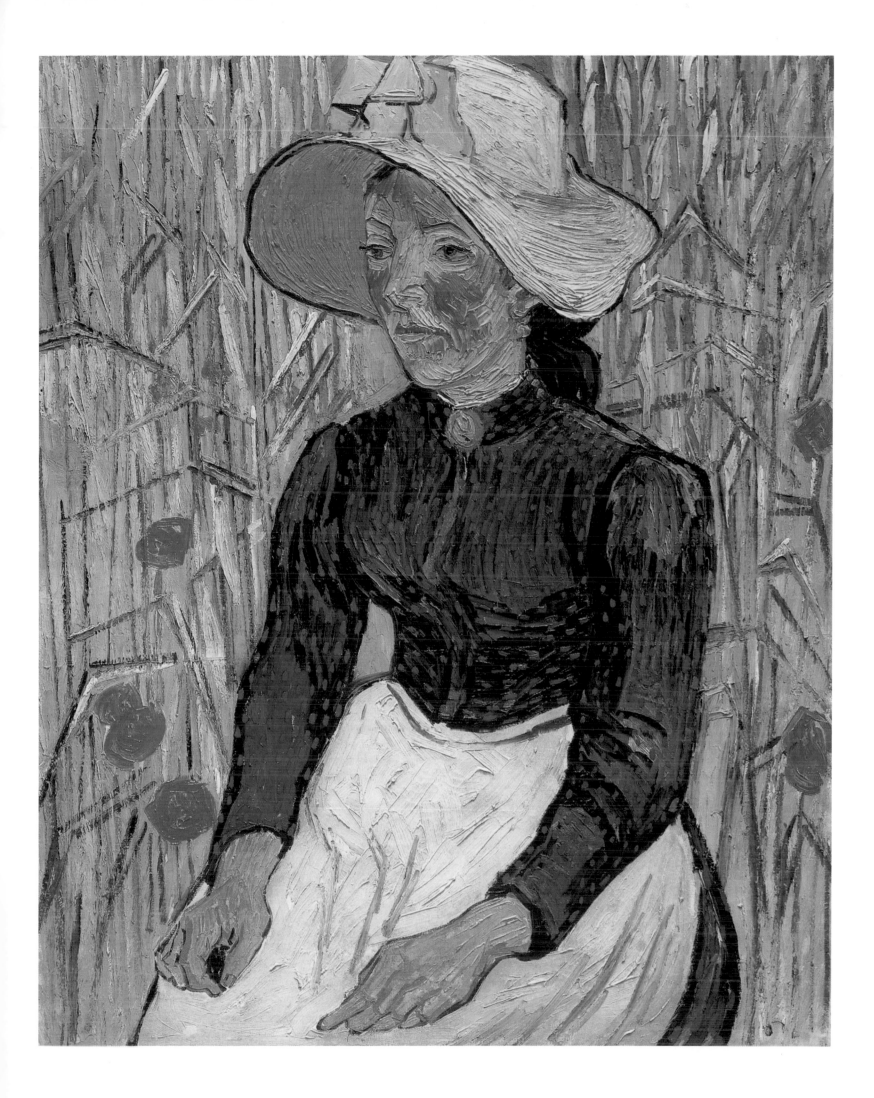

Nature was literal, immediate and real: it was also decorative, and played a significant part in making existence a more beautiful affair. Again van Gogh's instincts anticipated ideas that were only to become commonplace years later, with *Art Nouveau*. The wonders of Nature were appropriated by the crafts revival. Life would be better and more beautiful if lived in harmony with Nature. What was implicit in van Gogh became a slogan. Of course, in van Gogh this was all in an inchoate state, and proceeded from an aversion to pure aestheticism.

Impressed by Puvis de Chavannes' monumental painting *Inter artes et naturam*, which was meant to adorn the staircase of the Musée des Beaux-Arts in Rouen, van Gogh realised the possibilities of broad formats. Fourteen of the Auvers paintings are broad-format, and thirteen of them are almost exactly the same 50 x 100 cm format. Doubtless it was under Puvis's influence that van Gogh decided to measure out his canvas to a new norm, a norm which visually related his work to the frieze, a standard decorative medium in architecture. The first of van Gogh's broad-format paintings was even smaller: *Two Women Crossing the Fields* (p. 236). The colours have a pastel brightness: they are light and airy. The scene is set "between Art and Nature" – *Inter artes et naturam*. It is not a typical van Gogh. Indeed, it has a touch of plagiarism to it: the brushwork is economical, the colouring patchy. Van Gogh is aiming at a quality of "grace" that is normally alien to his approach. The painting is totally in the service of the decorative principle.

Puvis's serene account of an earthly paradise was really too big. To fit in with the architecture it was to adorn, the centre panel alone measured 170 x 65 cm. Van Gogh had no need to think in terms of wall space, and adopted his own proportion of precisely two to one. The series of thirteen paintings, uniform in format, was preceded by an unremarkable work done when van Gogh lacked canvas. The first version of *Daubigny's Garden* (p. 231) was painted on a napkin, a square piece of material the sides of which measured half a metre. Soon he was

Two Women Crossing the Fields
Auvers-sur-Oise, July 1890
Oil on paper on canvas, 30.3 x 59.7 cm
San Antonio (TX), Marion Koogler MacNay
Art Museum

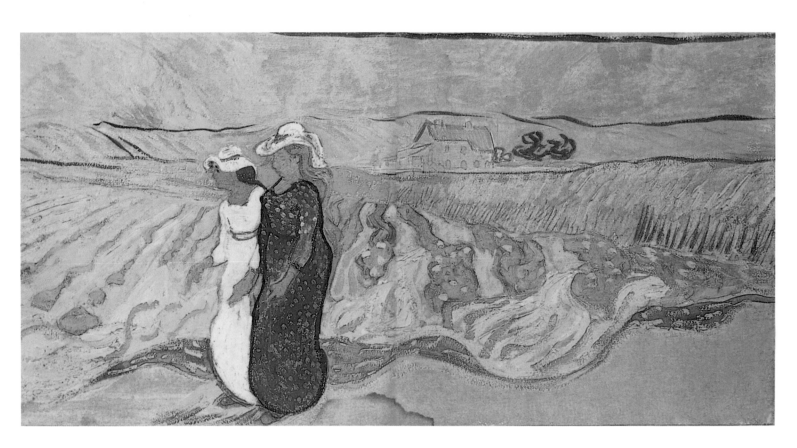

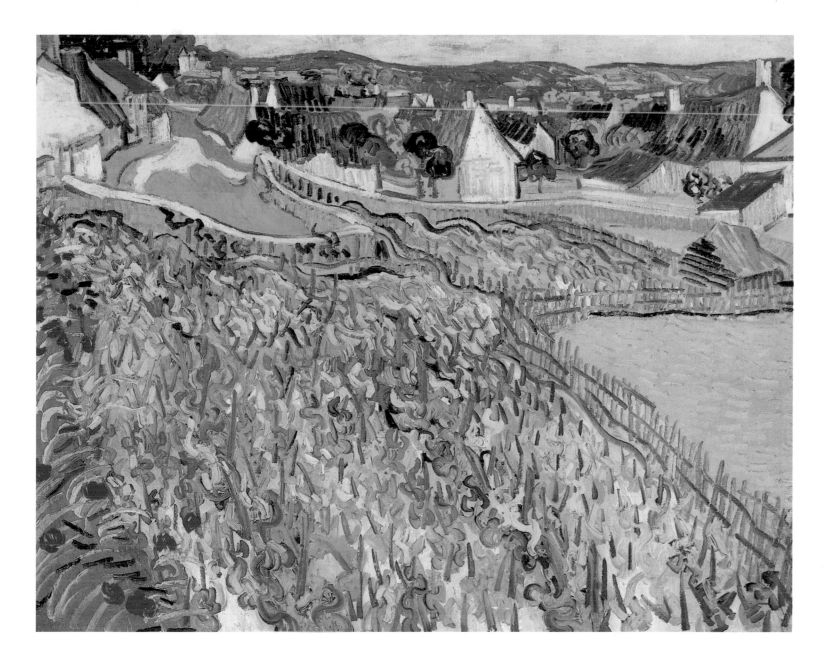

planning to paint a "more important picture" (Letter 642) of the subject, which he had grown fond of; and he did the two subsequent views of the garden by simply doubling the canvas area and thus establishing the frieze format (p. 229). It was the start of a new series.

This was to include the most decorative work of van Gogh's entire career. Let us take *Sheaves of Wheat* (p. 238) as an example. It uses the time-honoured contrast of yellow and violet. The sheaves are trim and neat. Van Gogh has sure-handedly opted for an additive principle for his composition: the verticals of the tower-like sheaves rise against a layered sequence of horizontals which themselves constitute a vertical scale. These horizontals vanish into a vague, distant depth which has more of the tapestry and wall about it than of fields and a plain. The sheaves are swaying, the lines have a tendency to run in circles: the painting has achieved an equilibrium of the natural and the ornamental (projected into the natural by a sensibility attuned to see it). In his realm between Art and Nature, van Gogh countered chaos with decorative order.

There were times, though, when his harmony failed, and the result could be far less delicate and ornate, though far fuller of energy and vitality. A perfect example is *Tree Roots and Trunks* (p. 239). Again using his frieze format, van

Vineyards with a View of Auvers
Auvers-sur-Oise, June 1890
Oil on canvas, 64.2 x 79.5 cm
Saint Louis (MO), The Saint Louis Art Museum

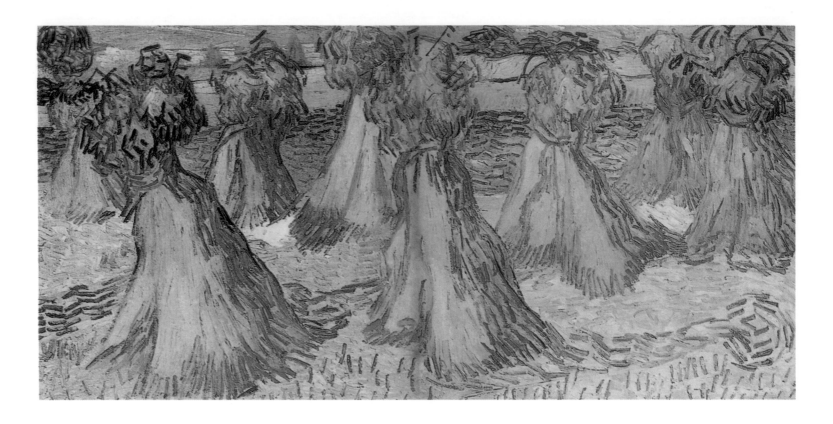

Sheaves of Wheat
Auvers-sur-Oise, July 1890
Oil on canvas, 50.5 x 101 cm
Dallas (TX), Dallas Museum of Fine Arts

Gogh compacts the full vigour of growth in an arresting close-up view. The knotted and gnarled roots and trunks produce vigorous exercises in pure painting – van Gogh is not out to portray this little green world, he is establishing radical equivalence between the organic and aesthetic realms, "between Art and Nature". That said, we must add that in the convoluted roots and trunks there is an obviously ornamental quality. It is as if the picture could not cope with the vitality of natural Creation and were withdrawing into two-dimensional remoteness from the real. The greater the abstraction, the greater the spatial flatness: but this old maxim of decorative art, though it applies to this painting, is by no means a damnation.

It can be argued that van Gogh had re-entered the conceptual world he inhabited at the time he decorated the "yellow house". Decorative considerations were again the cornerstone of his art. It was no coincidence that he was once more thinking of renting a house. But this time it was not to be the home of an artists' colony, but rather a place where he could spend weekends with Theo and his family. His purposes were now of a private nature – though the single-minded energy with which he pursued them remained unchanged. This is a major reason why he was influenced by Puvis de Chavannes. Every artist interested in the current revival of mural painting borrowed tips and inspiration from Puvis, and van Gogh, in his modest way, did so, too. Above all, he now discovered the decorative value of the frieze. True, he had no architectural space to adorn, nothing to add his art to in physical terms, but van Gogh had always been able to compromise. Just as he had tried to translate Wagner's *Gesamtkunstwerk* into his own visual idiom back in Arles, he now constructed a personal kind of memorial to Puvis. There is one further respect in which we may feel reminded of his time in Provence: van Gogh was again using the dots which are such a characteristic hallmark of Japanese art. In his portrait of *Marguerite Gachet at the Piano* (p. 241), a frieze-format painting on the vertical axis, the background is dotted with tiny dabs obviously of oriental origin.

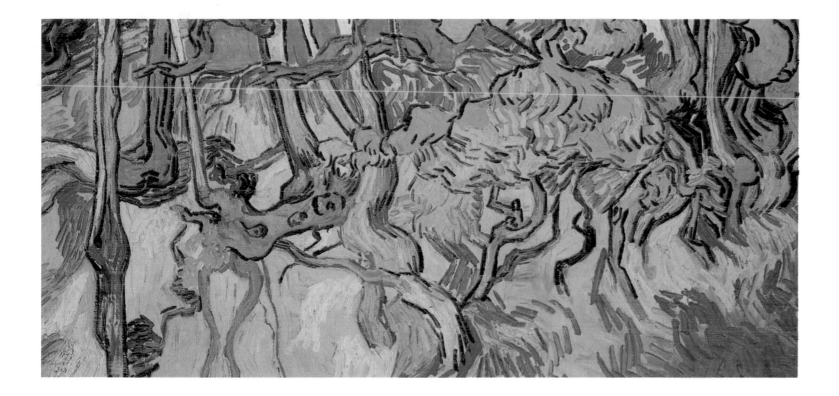

"I wish it were all over now": suicide

No one can say for sure where he got the revolver, nor where it was that he shot himself. But one thing is certain: on the evening of 27 July, 1890, seriously injured, he plodded heavily up the stairs at Ravoux's café to his room in the attic. Dr. Gachet was notified – who had just been praising the improvement in his friend's condition. It was not advisable to extract the bullet, so all he could do was hope for the best. Gachet wanted to notify Theo, but Vincent refused to involve the family and would not divulge Theo's private address. So Gachet contacted him at the gallery. When Theo arrived on the morning of 28 July he found van Gogh reclining peacefully in bed, puffing his pipe and with the air of a man content with a decision well taken. His last words are said to have been: "I wish it were all over now." Theo, writing to their mother, observed sadly: "He has found the peace he never found on earth", and he added: "He was such a brother to me." These simple words are all that need be said.

In Vincent's jacket pocket there was a letter he had meant to keep from his brother, perhaps because Theo had problems of his own at the time. Instead he wrote a second, that was more neutral and superficial in tone, and the earlier, unsent letter (652) remained as a kind of testament. It ended with the following passage, which for all its pessimism draws upon considerable feeling between the brothers: "But yet, my dear brother, there is this that I have always told you, and I repeat it once more with all the earnestness that can be expressed by the effort of a mind diligently fixed on trying to do as well as possible – I tell you again that I shall always consider you to be something more than a simple dealer in Corots, that through my mediation you have your part in the actual production of some canvases, which will retain their calm even in the catastrophe. For this is what we have come to, and this is all or at least the main thing that I can tell you at a moment of comparative crisis. At a moment when things are very strained between dealers in pictures by dead artists, and living artists. Well, my own work, I am risking my

Tree Roots and Trunks
Auvers-sur-Oise, July 1890
Oil on canvas, 50 x 100 cm
Amsterdam, Rijksmuseum Vincent van Gogh,
Vincent van Gogh Foundation

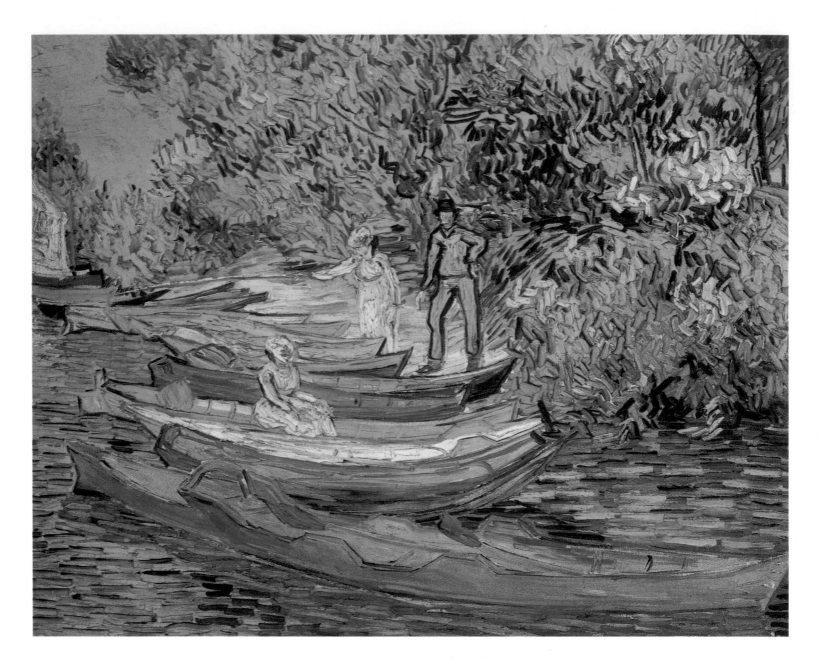

Bank of the Oise at Auvers
Auvers-sur-Oise, July 1890
Oil on canvas, 73.5 x 93.7 cm
Detroit (MI), The Detroit Institute of Arts

life for it and my reason has half foundered because of it – that's all right – but you are not among the dealers in men as far as I know, and you can still choose your side, I think, acting with humanity – but *que veux-tu?*" This letter bespeaks a deep affinity with the true *alter ego* in Vincent's life, his brother Theo. The "stranger on earth" had a twin brother. But it also reveals a quite concrete motive on van Gogh's part, so apparent that it has tended to be overlooked.

Van Gogh was not in the throes of a seizure when he killed himself. His suicide was a carefully considered act, and not undertaken at the promptings of some demon. True, he was afraid of a renewed bout of insanity; but that fear had now been with him for a year and a half. Like hundreds of others of his age (Gauguin among them) he saw himself following in the footsteps of Jesus Christ, taking the guilt of the entire world upon himself. Van Gogh, too, was one of those artists who acted out a Passion of their own. "They say it is all for the good that he is at rest," Theo wrote to his sister on 5 August, 1890, "but I hesitate to second it. Rather, I feel it is one of the greatest cruelties in life; he was one of the martyrs who die with a smile on their lips." It seems it was van Gogh's own brother (who knew and understood the artist better than anyone else) who started the martyrdom myth.

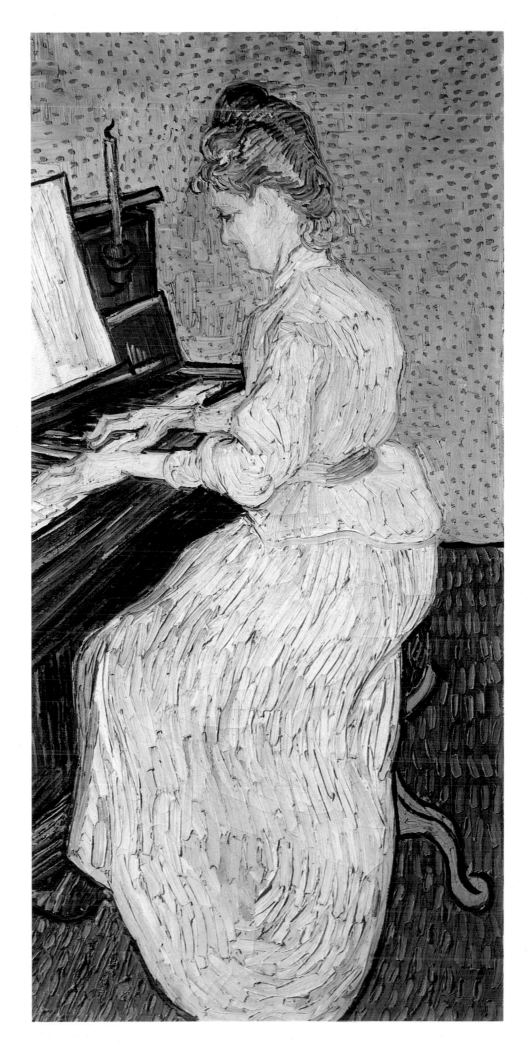

Marguerite Gachet at the Piano
Auvers-sur-Oise, June 1890
Oil on canvas, 102.6 x 50 cm
Basle, Öffentliche Kunstsammlung Basel,
Kunstmuseum

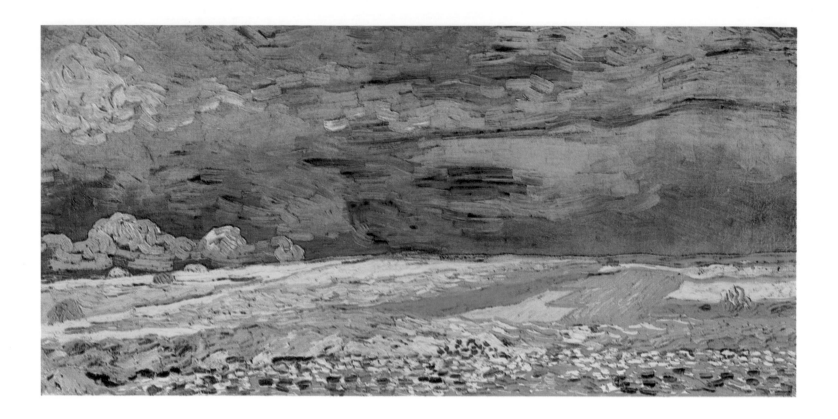

Wheat Field under Clouded Sky
Auvers-sur-Oise, July 1890
Oil on canvas, 50 x 100.5 cm
Amsterdam, Rijksmuseum Vincent van Gogh,
Vincent van Gogh Foundation

But why did van Gogh inflict the mortal injury on himself at a time when the worst of his tribulations were already over months ago? The only answer to the question is that provided by his paintings and letters. And the paintings and letters are revealing. In Auvers, van Gogh had been able to satisfy the longing for the north which he had been feeling all year. He had a deep need to return to the milieu of his youth, to come full circle to the origins of his art in Holland. And so he took to painting updated versions of farmers' crofts, of the church, or of peasant women. *Cows* (p. 245) harked back to work done in The Hague. In a sense it was a group portrait combining individual portraits done in his early days. The picture was done from an etching Dr. Gachet had, after the original by Jacob Jordaens in the Lille museum. Van Gogh makes a wary impression here, as if he were avoiding strong colour, as if he had learnt nothing at all in the years that had passed. Probably he was reflecting upon a phase in his own life as an artist when he was not yet so fully in command of the choices and decisions open to him – whether to go for detail or for the large, sketchy brushstrokes, and so forth. We certainly sense that van Gogh realised he had reached the end of some kind of evolutionary process. He wanted to go back, to return to the familiar environment he came from.

Wheat Field with Crows (p. 243) documents this need for return in a single motif. Here, van Gogh expressed his darkest premonitions – thus, at any rate, pronounces the conventional view. Critics tend fairly unanimously to detect a sense of menace in the dark birds flying from the horizon towards the fore-ground. They see the three paths as symbolic of van Gogh's feeling that he had nowhere to go, no way of escape. The whole mood of darkness, they claim, is reinforced by the stormy sky, which supplies so powerful a contrast to the yellow wheat. Van Gogh himself saw the picture as a paradoxical blend of sadness and consolation: "They are infinitely vast wheat fields beneath a dismal sky," he wrote in Letter 649, referring to this work and to *Wheat Field under Clouded Sky* (p. 242), "and I have not shied away from the attempt to express

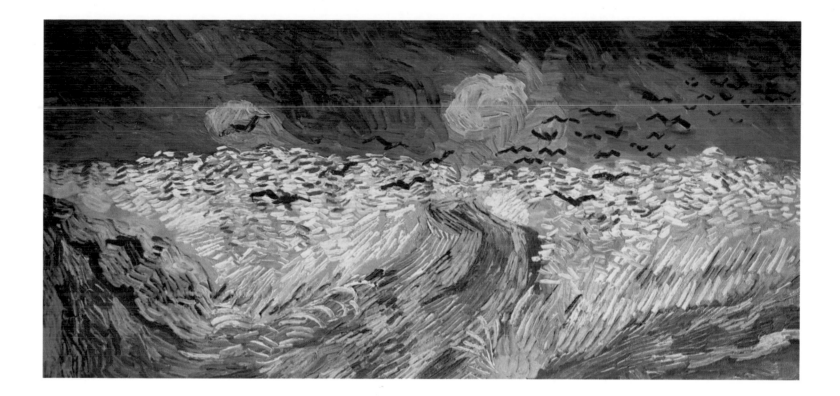

sadness and extreme loneliness [...] I almost believe that these pictures will communicate to you what I am unable to put into words: the health and vigour I see in country life."

Wheat Field with Crows is one of van Gogh's re-created memories of the north. In Letter 133, an important letter that broke several months of silence, he had compared himself to a bird in a cage, and commented: "But then the time comes when migratory birds fly away. A fit of melancholy – he's got everything he needs, say the children who look after him – but the sky is brooding and stormy, and deep within he is rebelling against his misfortune. 'I am in a cage, I am in a cage, and I've got everything I need, fools! I've got everything I could possibly want! Ah, dear God, freedom – to be a bird like the other birds!' A human idler of this variety is just like a bird that idles in the same way." The metaphor stayed with van Gogh even after he had given up his secure captivity and was living the hard life of the **artist**. One neighbour who had watched him in Etten recalled: "He was always drawing ravens struggling in a gale." What the painting articulates is a sense of the possible danger that freedom will turn to exposure and independence to isolation. It is the continuation of the thought in Letter 133: the bird that once longed to be released into the stormy skies is now having to struggle against the elements.

The road that took van Gogh to suicide began in his longing for the simplicity of his origins, and his awareness that it was impossible – he couldn't go back. Memories of the old days even prompted him to revive Pauline thoughts. In Letter 641a (to his mother), drawing upon an undiminished store of Biblical knowledge, van Gogh reflected upon St. Paul's First Epistle to the Corinthians, in which charity is identified as the greatest of the virtues: "Through a glass, darkly – it has remained thus: Life, and the wherefore of departure and death, and the permanence of disquiet, that is all one understands of it all. For myself, Life presumably must remain lonely. I have never seen those I had the most affection for other than through a glass, darkly." Now, adult and experienced,

Wheat Field with Crows
Auvers-sur-Oise, July 1890
Oil on canvas, 50.5 x 103 cm
Amsterdam, Rijksmuseum Vincent van Gogh,
Vincent van Gogh Foundation

Field with Poppies
Auvers-sur-Oise, June 1890
Oil on canvas, 73 x 91.5 cm
The Hague, Haags Gemeentemuseum
(on loan)

van Gogh's perceptions were reduced to paradox. Paul is confident of a happier existence in which knowledge is possible. But van Gogh can only see the confusions of the present.

Still, he had his art. "Painting is something in its own right," he continued in the same letter; "last year I read somewhere or other that writing a book or painting a picture is the same as having a child. I dare not assert that that is true in my own case – I have always felt that the last is the best and most natural thing [...] That is why I often make the utmost effort, even if that work is the least understood, and for me it is the sole link between the past and the present." Van Gogh was painfully aware of an existential lack: He had no children – and Art, however much the creative process might be identified with having children, was at best a poor substitute. His oppressive sense of having missed the true family meaning of Life, and his resultant governing passion for Art, are the consequences of van Gogh's soul-searching review of himself.

Van Gogh considered his own efforts unworthy: Art was great, his own creations paltry. In contemplating suicide, his fatal attraction was the keener because of his sense of the discrepancy between ideal greatness and his own tiny achievement. This, of course, was a typically Romantic tension; and van Gogh, in this respect a child of his materialist times, took to thinking in terms of payment. These terms were associated with a nagging self-reproach for having founded no family and fathered no children. The upshot was that van Gogh decided to kill himself in order to bequeath to Theo, and above all his godson, a treasure trove of paintings that could only increase in value after his death. If he himself was no longer alive, thought Vincent, he would at least live in his art.

During those few months, with his brother close to hand, taking an active interest in the affairs of the family, Theo van Gogh was in fact deep in a crisis of his own. The directors of Boussod & Valadon were good businessmen, but had little feel for the art their Dutch employee was accumulating. They considered

Theo a failure. Theo toyed with the idea of quitting and even emigrating to America. Vincent inevitably knew of these thoughts. And, knowing his brother as well as he did, he realised that if worse came to worse his own artistic career would still keep Theo from doing what was in his mind. He felt that his own share in the blame for Theo's mounting sorrows and doubts was a big one.

Exactly one year before, in July 1889, Millet's *Angelus* had been sold at auction – for over half a million francs. Millet was dead, of course. Van Gogh thought this state of affairs quite wretched: "And the high prices one hears of, that are paid for works of painters who are dead and who never received such payment in their lifetimes – it is like selling tulips, and is a disadvantage to living painters, not an advantage. And, like this business of selling tulips, it will pass." (Letter 612) In his own lifetime, at all events, van Gogh believed that he, too, would one day be fetching good prices, modest as he was about his own achievement. "And yet", he wrote in Letter 638, "and yet there are certain pictures I have painted that will be liked one day. But all the brouhaha about high prices paid recently for Millets etc. serves to make the situation worse, in my opinion." With such passages in mind, we may well find the close of his farewell letter less enigmatic. Those words were written "at a moment when things are very

Cows (after Jordaens)
Auvers-sur-Oise, July 1890
Oil on canvas, 55 x 65 cm
Lille, Musée de Beaux-Arts

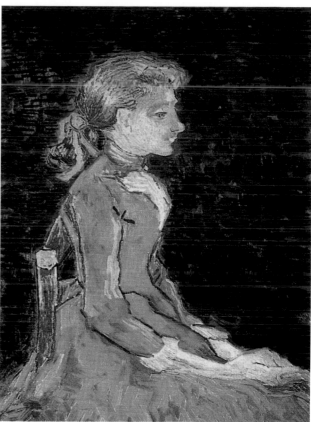

strained between dealers in pictures by dead artists and those who deal in living artists." Vincent's suicide would promote his brother Theo to the former category.

At this point the line of thought comes full circle. His suicide proved that the price of fame was death. But it was only physical death. And Theo, too, had his part in the production of some canvases (as Vincent had put it in Letter 652). In a sense, Vincent's suicide was one more way of expressing his longing to work together with his brother. His *alter ego*, who was capable of making a go of Art and family life at one and the same time, was to reap the profits of arduous years of sowing. To suppose that van Gogh had simply decided not to be a financial burden on his brother any more is surely inadequate. It *is* true, of course, that his decision could only have been taken at a critical financial moment, and only in close proximity to Theo and his family – which is why the decision was taken at Auvers, in July 1890. Some days before Vincent pulled the trigger, Theo had reached an agreement with his employers. Possibly Vincent learnt of this on his deathbed.

Vincent van Gogh died on 29 July and was buried the next day. Bernard was present at the funeral. "On Wednesday, 30 July, I arrived in Auvers around ten o'clock," he wrote to Aurier. "His brother was there with Dr. Gachet, and [Père] Tanguy, too. The coffin had already been closed. I was too late to set eyes once more on the man who took his leave of me so full of hope three years ago. All of his last paintings had been hung on the walls of the room where the coffin lay; they formed a kind of halo about him, and by virtue of the radiant genius they emanated, they made his death even more unbearable for us artists. A plain white cloth was draped on the coffin and there were a great many flowers – sunflowers, which he was so fond of. A great many people came, most of them artists. There were also neighbours who had seen him a time or two, briefly, but

Left:
Portrait of Adeline Ravoux
Auvers-sur-Oise, June 1890
Oil on canvas, 52 x 52 cm
Cleveland (OH), The Cleveland Museum of Art

Right:
Portrait of Adeline Ravoux
Auvers-sur-Oise, June 1890
Oil on canvas, 73.7 x 54.7 cm
Private collection

Page 246:
Portrait of Adeline Ravoux
Auvers-sur-Oise, June 1890
Oil on canvas, 67 x 55 cm
Switzerland, Private collection

Landscape at Auvers in the Rain
Auvers-sur-Oise, July 1890
Oil on canvas, 50 x 100 cm
Cardiff, National Museum of Wales

who loved him for his goodness and humanity. At three o'clock the coffin was borne to the hearse by his friends. Some of the people who were present wept. Theo van Gogh, who worshipped his brother and always supported him in his struggle for Art and the independence of Art, sobbed the whole time. Then he was lowered into the grave. He would not have wept at that moment. The day was too much his for us not to think how happy he might yet have been. Dr. Gachet tried to say a few words about Vincent's life, but he was weeping so hard that he could only stammer an indistinct farewell. He recalled Vincent's achievements, spoke of his lofty goals and of the great affection he had had for him although he had known him but a short time. 'He was an honest man and a great artist,' he said, 'and there were only two things for him: humanity and art. Art mattered more to him than anything else, and he will live on in it.' Then we returned home."

In the course of time, Vincent's plan to increase the value of his paintings by killing himself was to prove a success. However, his intended beneficiary was never to enjoy the fruits of this success. The two brothers were to prove inseparable even beyond this life, and a mere two months after Vincent's death Theo began to suffer delirium, and was never to recover. In fact Theo was to die a bare six months after Vincent, on 25 January, 1891. The van Gogh persona was truly dead: and only Theo's widow Jo remained behind to see that van Gogh's art was seen by the public. Her success, of course, is history now.

Revolution and Modernism

Auvers Town Hall on 14 July, 1890 (p. 251) shows the town's main square tricked out with countless tricolours. It was Bastille Day. In 1890, a hundred and one years had passed since the storming of the Bastille. And van Gogh – Dutchman, artist, social outsider – insisted on recording the festivities. It was a celebration

that touched him deeply: the French Revolution had demonstrated that the world can be remade, and that fact was analogous, after all, to the artist's immemorial task of conceiving alternative counterworlds. Van Gogh's art remains to this day the most radical testimony to the revolutionary spirit, not in his choice of subjects, but in the very look of his pictures, their coarseness and deliberately unfinished quality, the vigour with which they were painted.

"The great revolution: Art for the artists, my God, maybe it is utopian, and if so – all the worse," wrote an emphatic van Gogh from Arles (Letter 498). He had gone to Provence in quest of that better world he was so sure existed, or might exist. And there he came to see revolution as both event and historical condition – an ongoing process that would complete what the 18th century had begun. In the necessary struggle for the new era, Art was in the vanguard: it would indeed shortly take to using the term *avant-garde*. "When an Impressionist exhibition is on in Paris, I think a lot of people go home terribly disappointed or even indignant," he wrote at the same time (Letter W4), "just like in days when upright Dutch citizens would leave church and next moment hear a speech [...] by some socialist. And yet – as you know – in a period of ten or fifteen years the entire edifice of national religion has collapsed, whereas there are still socialists and will be for a long time to come, even if neither you nor I are particularly attached to either side. Art – official art – along with the training, administration and organization that go with it, are as feeble and rotten at present as religion, the decay of which we are witnessing."

It was only in Arles that van Gogh wrote with such commitment of working for change. Bernard saw this conviction as the source of Père Tanguy's friendship for van Gogh: "In my opinion, Julien Tanguy was not so much seduced by Vincent's paintings as by his socialism, though he valued the paintings as a kind of perceptible manifestation of the hopes they shared for the future." Van Gogh's peculiar contribution (arguably the most important in terms of its consequences) was to free that "perceptible manifestation" from concrete representation. Of

Thatched Cottages by a Hill
Auvers-sur-Oise, July 1890
Oil on canvas, 50 x 100 cm
London, Tate Gallery

Wheat Fields at Auvers under Clouded Sky
Auvers-sur-Oise, July 1890
Oil on canvas, 73 x 92 cm
Pittsburgh (PA), The Carnegie Museum
of Art

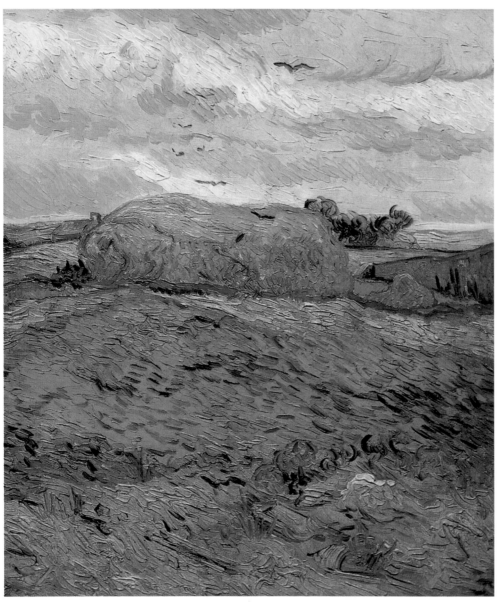

Haystacks under a Rainy Sky
Auvers-sur-Oise, July 1890
Oil on canvas, 64 x 52.5 cm
Otterlo, Rijksmuseum Kröller-Müller

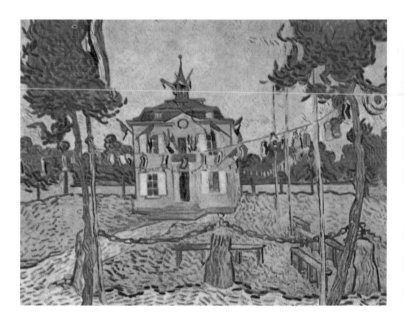

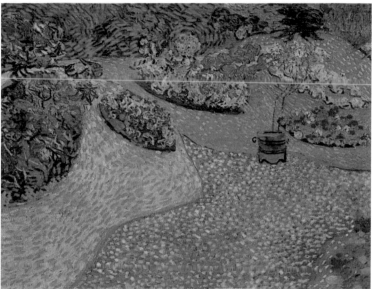

course he painted peasants, weavers, and a wide variety of everyday scenes – but what is more important is the staggering simplicity of his paintings. Of course he painted his subjects in a manner critical of society, showing them to be ugly and careworn – but what is more important is the artist's decision to side with lack of talent. Revolution was not a subject for van Gogh, it was a metaphor: the paintings themselves, rather than the subjects they depicted, articulated a concept of permanent change. His art was to be seen as a prototypical early stage in a process of evolution towards the better and nobler. Its unfinished and imperfect qualities, obvious in themselves, were apt to the age he lived in.

Viewed from the vantage point of Tradition, of what already exists, the whole of Modernist art is an articulation of barbarity. The scandals that attended Courbet's work, the contempt that was heaped upon the Impressionists, the scorn critics affected for Symbolism, were all prompted by what we might call Art's heretical standpoint towards the complacent pieties of the Establishment. In a sense, Modernism was one long series of fresh starts and prototypes. The countless isms which we think of collectively as Modernism were forever hailing the imminent triumph of a new style – a triumph that never quite happened. From time to time this took on a political slant, but there was never much of a social movement in early Modernism.

It was a dilemma that took intense form in van Gogh. He took compassion with the underprivileged for granted; from this there followed a religiously-motivated hope for a better age to come, when the battles would all have been fought and won. In addition, the uncompromising vehemence in van Gogh's own nature led him to identify more completely with other people's problems than was good for him. And, finally, he took pride in acquiring a virtuosity in his art that would enable him to determine the meaning of coarseness and bizarrerie, violence and the grotesque.

It is this that makes van Gogh the forerunner *par excellence* of Modernism, or at any rate of the Modernist avant-garde. Three painters in the final quarter of the 19th century – Cézanne, Gauguin and van Gogh – tend to be singled out as the great precursors of 20th century art. Of the three, only van Gogh possessed that quality of utopian excitement and upheaval which can truly point the way forward in Art.

Left:
Auvers Town Hall on 14 July 1890
Auvers-sur-Oise, July 1890
Oil on canvas, 72 x 93 cm
Private collection

Right:
Garden in Auvers
Auvers-sur-Oise, July 1890
Oil on canvas, 64 x 80 cm
Private collection

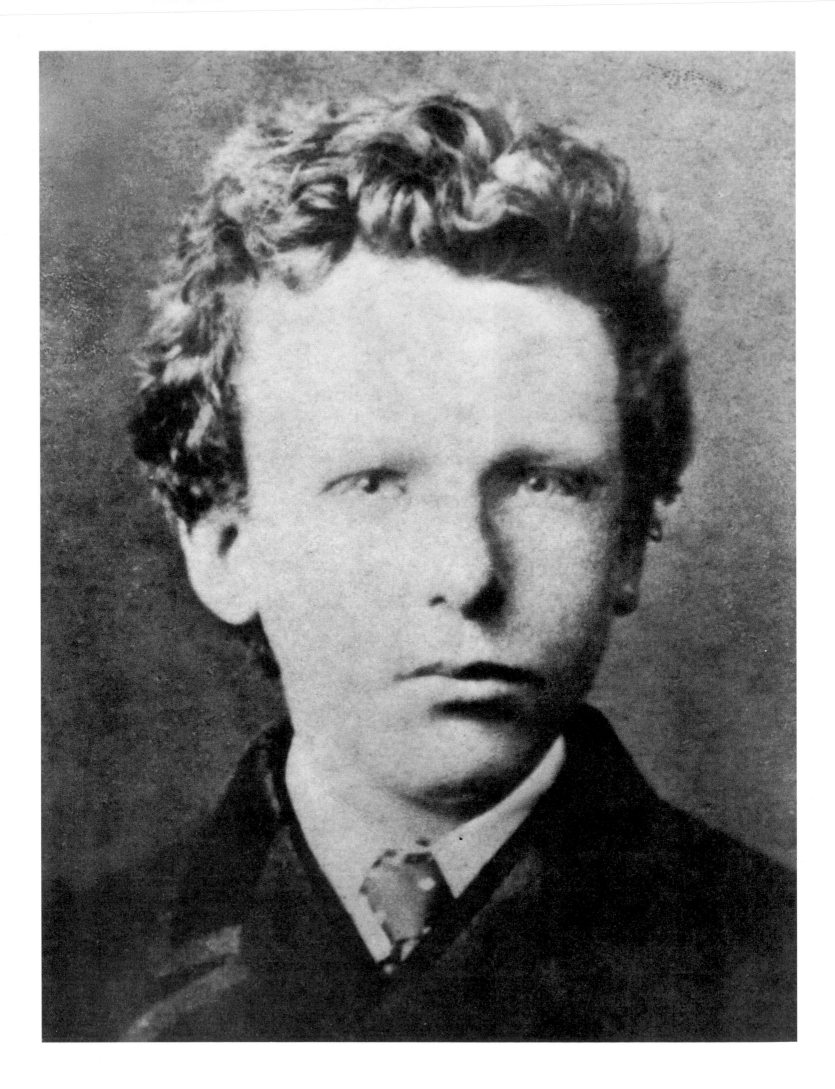

Vincent van Gogh 1853–1890
A Chronology

1853 Following the birth of a stillborn son of the same name, on the same day, the previous year, Vincent Willem van Gogh is born on March 30. He is the first of six children born to Theodorus van Gogh (1822–1885) and his wife Anna Cornelia née Carbentus (1819–1907). Theodorus, pastor in a Dutch Reformed community, and Cornelia, daughter of a court bookbinder in The Hague, married in 1851. Vincent is born at the vicarage in Groot-Zundert, Northern Brabant (Holland).

1857 Birth of Vincent's brother Theodorus (Theo).

1861–1864 Vincent goes to Zundert village school, and then to private boarding school at Zevenbergen, where he learns French, English and German and does his first drawings.

1866–1868 Vincent attends boarding-school at Tilburg, then returns to the family home in Groot-Zundert.

1869 Vincent is apprenticed to a branch of the Paris art dealers Goupil & Cie which his Uncle Vincent has established in The Hague.

1871 His father is transferred to a parish at Helvoirt in Brabant, where he moves with his family.

1872 Vincent spends his holiday with his parents and visits Theo in The Hague. Their life-long correspondence begins.

1873 *January:* Transferred to the Brussels branch of Goupil & Cie.
May: Transferred to Goupil & Cie's London branch. First he visits Paris and the Louvre.
June: A year at Goupil's in London begins. Makes drawings on walks but throws them away.
November: Theo is transferred to the branch of Goupil & Cie at The Hague.

The presbytery in Zundert where Vincent van Gogh was born. He first saw the light of day in the room from which the flag has been run out

1874 *Summer:* Vincent holidays for a few weeks with his parents at Helvoirt. In mid-July he returns to London with his sister Anna.
October–December: His uncle has Vincent transferred to the Paris headquarters of Goupil & Cie.

1875 *May:* Vincent is permanently transferred to Paris. He neglects his work and is unpopular with colleagues and customers alike. He visits museums and galleries.
October: Vincent's father is transferred to Etten near Breda.
December: Spends Christmas with his parents at Etten without permission from his employers.

1876 *April:* Vincent hands in his notice. Travels to Ramsgate in England, and works as an assistant teacher at Isleworth, a working-class suburb of London. Subsequently works as a teacher and curate with a Methodist minister. Delivers his first sermon in November, and proposes to devote his life to evangelical work with the poor. Vincent remains interested in art. He spends Christmas at Etten with his parents, who

are dismayed by his condition and persuade their son not to return to London.

1877 *January–April:* Recommended once again by his namesake uncle, Vincent is apprenticed at a bookshop in Dordrecht. He leads a lonely life.
May: Persuades his father that he has a religious vocation, and goes to Amsterdam to prepare for the theology faculty entrance examination. Studies Latin, Greek and maths, but finds the subjects difficult and abandons his studies.

1878 *July:* Returns to Etten, then to Brussels with his father to begin a three-month course for lay preachers.
August–October: Vincent takes the probationary course at the evangelical college at Laeken (near Brussels), but is found unsuited to the job of lay preacher, and returns to Etten.
December: Hoping to satisfy his sense of a religious calling, Vincent goes to the Borinage, a coal-mining district in Belgium, near the French border, where he lives in poverty.

1879 *January–July:* Assigned to Wasmes in the Borinage for six months as a lay preacher. Appalled at the frightful conditions the miners live in. His social commitment irritates his superiors, and they allow his commission to lapse on the grounds that he has no rhetorical talent.
August: Journeys to Brussels on foot, to ask the advice of Pastor Pietersen and show him his sketches of miners. Returns to Cuesmes in the mining district, and continues doing the same work, unpaid, till July 1880. Though he is living in poverty himself, he does all he can to help the needy. It is a critical period for Vincent, one that is to leave its mark on his subsequent life.

1880 *July:* Vincent writes to Theo, who is now working at the Paris office of Goupil and gives him financial support. Vincent describes his own agonizing uncertainty.
August–September: Devotes his time to drawing scenes of life in a mining community. Theo encourages him. Copies works by Millet.
October: Vincent goes to Brussels and studies anatomical and perspective drawing at the Academy. Admires the work of Millet and Daumier. Stays in Brussels until April 1881.

Vincent's brother Theodorus (Theo) Vincent (1857–1891), photographed about 1888–1890

1881 *Spring:* Vincent goes to Etten to see Theo, and they discuss his future as an artist. He stays in Etten, drawing landscapes.
Summer: Vincent falls in love with his recently widowed cousin 'Kee' Vos-Stricker, who is staying in Etten with her son. She returns to Amsterdam earlier than planned.
Autumn: Vincent goes to Amsterdam to propose to Kee, but she does not even allow him to call. Vincent holds a hand in a candleflame to prove to her parents how serious he is.
November–December: First oil and watercolour still lifes. Relations with his parents are strained because he is still obsessed with Kee and his religious views are extreme. At Christmas he has a violent quarrel with his father. He even rejects his father's gift of money and leaves Etten.

1882 *January:* Vincent moves to The Hague, living near Mauve, who gives him painting tuition and lends him money. Theo continues to send 100–200 guldens per month. Vincent's relations with Mauve cool off, partly because he refuses to work from plaster models. He meets Clasina Maria Hoornik (known as Sien), an alcoholic prostitute, who is pregnant. He looks after her, and she occasionally sits for him.
March: Though his admiration is undiminished, Vincent severs his links with Mauve. He does a good deal of drawing from Nature. Apart from Sien, most of his models come from poor districts. Uncle Cornelis orders twenty ink drawings of the city – Vincent's only commission.
June: Hospital, to be cured of gonorrhoea. His father visits him. Vincent wants to marry Sien, though his family and friends advise against it. He takes her to Leiden to give birth, and looks for a flat for a family of four.
Summer: Discovers the attraction of oils and begins to examine the problems of colour. Theo pays for his painting materials. Their father accepts a living at Nuenen and moves there with his family.

Autumn: For the rest of the year (and through to summer 1883) Vincent stays in The Hague, drawing and painting landscapes from Nature. During the winter he does sketches and portraits of ordinary people.

1883 *September–November:* Conversations and his correspondence with Theo lead Vincent to the painful decision to leave Sien, with whom he has been together for over a year. Lonely once more, he goes to Drente in northern Holland. He takes a barge to Nieuw Amsterdam and goes on long walks. The dark peaty landscape makes a strong impression on him. Vincent draws and paints the local peasants hard at work.
December: Moves to Nuenen, where his parents are now living, and stays till November 1885. During these two years he does almost two hundred paintings using dark, earthy colours. His parents try to help by overlooking his negligent dress style and unusual behaviour. He sets up a studio in a vicarage outbuilding.

1884 *January:* Vincent's mother breaks a leg and is confined to bed for a lengthy period. Vincent gives her loving care.
May: Vincent rents studio rooms in the Catholic sexton's house.
August: Brief relationship with Margot Begemann, a neighbour, but both sets of parents are strongly opposed. Margot attempts suicide.
August–September: Vincent designs six decorative pictures for the dining room of Charles Hermans, an Eindhoven goldsmith.
October–November: Vincent gives tuition to amateur painters from Eindhoven. They take long walks and go to museums together.
December: Hitherto, landscapes and pictures of peasants and weavers at work have predominated in Vincent's work. Now he tries his hand at portraits from models.

1885 Vincent's father dies of a stroke on March 26. Vincent is deeply affected. Following a quarrel with his sister Anna, he moves into his studio in the sexton's house.
April–May: Paints "The Potato Eaters" (p. 47), the major work of his Dutch period.
September: The Catholic priest in Nuenen forbids the villagers to go on sitting for Vincent. An attempt is made to blame him for the pregnancy of a young peasant girl he had recently

Vincent (with his back to the camera) with friend and fellow-painter Emile Bernard on the bank of the Seine at Asnières, 1886

54 Rue Lepic, where Vincent lived with Theo in Paris

drawn. Vincent takes to drawing mostly still lifes, showing potatoes, a copper kettle and birds' nests among other things (pp. 54–58).
October: Together with his friend Kerssemakers, Vincent goes to Amsterdam and visits the Rijksmuseum.
November: At the end of the month he moves to Antwerp and remains there till February 1886. He tries to make contact with other artists and sell his pictures. He finds some Japanese woodcuts and buys them.

1886 *January:* Vincent matriculates at the Ecole des Beaux-Arts and takes painting and drawing classes. However, he rejects the academic principles on which tuition is based and there are disagreements in consequence. Nevertheless he takes the admission exam for higher levels.
February: Overworked, poorly nourished and smoking too much, Vincent is ill for most of the month. At the end of February he decides to move to Paris to take classes with Cormon.
March: Arrives in Paris and arranges to meet Theo in the Louvre. Theo is managing a small gallery in the Boulevard Montmartre for Goupil, and gives Vincent a room in his own home. Meanwhile the Antwerp Academy rejects Vincent's work and puts him in the beginners' class.
April–May: Vincent studies at Cormon's atelier and meets fellow artists Russell, Toulouse-Lautrec and Bernard. Theo introduces him to the work of Monet, Renoir, Sisley, Pissarro, Degas, Signac and Seurat. Under their influence, Vincent uses brighter, livelier colours in his still lifes and pictures of flowers (pp. 70–73).
May: His mother leaves Nuenen. Paintings left behind by Vincent are bought by a junk dealer, who sells off some for ten centimes each and burns the rest.
June: Vincent and Theo move to 54 Rue Lepic in Montmartre, and Vincent sets up a studio there. He paints Paris scenes in a pointillist style.

Winter: Vincent and Gauguin become friends. Gauguin has arrived from Pont-Aven in Brittany. Vincent's complicated nature leads to tension between him and Theo, who has a nervous ailment.

1887 *Spring:* Portraits of Tanguy (pp. 90–91). Vincent works in the open on the banks of the Seine at Asnières with Bernard. In discussions with Bernard and Gauguin, Vincent refuses to see Impressionism as the culmination of the evolution of painting. He buys some Japanese coloured woodcuts at the Galerie Bing. He is a regular at the Café du Tambourin in the Boulevard de Clichy, and has a brief affair with the proprietress, Agostina Segatori (p. 85), who has modelled for Corot and Degas. He and Bernard, Gauguin and Toulouse-Lautrec exhibit at the Café, and Vincent decorates the walls with Japanese woodcuts.
Summer: Vincent paints a number of pictures in the pointillist style.

1888 *February:* Leaves Paris, where he has painted over two hundred pictures in two years, and moves to Arles, possibly at Toulouse-Lautrec's prompting. He finds the bright southern light and the warmth of the colours wonderful.
March: Vincent's dream is of an artists' colony that would put an end to financial worry. Paints numerous pictures of flowers and trees in blossom, which remind him of Japanese landscapes. Three of Vincent's paintings are exhibited at the Salon des Artistes Indépendants in Paris.
May: Vincent rents the right-hand side of the "yellow house" (pp. 132–133) in the Place Lamartine. It has four rooms and he is paying 15 francs a month. There he hopes to realise his dream of an artists' colony. Paints "The Langlois Bridge at Arles" (p. 111).
June: Visits Saintes-Maries-de-la-Mer and paints pictures of boats and the town (pp. 112–117). Meets Milliet, a Zouave second lieutenant (p. 139), who takes drawing lessons with him. Vincent does numerous landscapes and ink drawings on his trips to the Montmajour ruins (cf. p. 118).
August: Vincent makes the acquaintance of Joseph Roulin, a postman, and paints portraits of him (pp. 144–145). Sends 35 pictures to Theo. He now paints a sunflower series (pp. 136–138).
September: Vincent frequently paints out in the open by night, reportedly fixing candles on the easel and on the brim of his hat (pp. 127, 131).

Meets Eugène Boch, a Belgian painter and poet. Moves into the "yellow house".
October: Gauguin responds to Vincent's repeated requests and arrives in Arles on 23 October. Vincent and Gauguin live and work together.
December: With Gauguin, Vincent visits the Musée Fabre in Montpellier. The subsequent discussions are described by Vincent as "excessive tension". In the space of just two months these disagreements lead to a serious deterioration in their relations. According to Gauguin, on 23 December Vincent comes at him with a razor. Gauguin leaves the house in a hurry and spends the night in a hotel. During the night, Vincent cuts off his left earlobe in a temporary fit of insanity. He wraps it in newspaper and offers it as a gift to Rachel, a prostitute at a nearby brothel. Next morning the police find him in bed in his injured state and take him to hospital. Gauguin leaves Arles and informs Theo of his brother's condition. Theo immediately travels to Arles. Epilepsy, alcoholism and schizophrenia have all been proposed as the reason for Vincent's fit.

1889 *January:* Writing from hospital (p. 167), Vincent tells Theo he is better and sends warm greetings to Gauguin. On 7 January he returns to the "yellow house" and writes reassuring letters to his mother and his sister, though he is still suffering from insomnia. Paints self-portrait with a bandaged ear (p. 164).
February: Vincent is taken to hospital again, suffering from insomnia and hallucinations. He works intermittently in the "yellow house".
March: Townspeople of Arles petition the mayor to have Vincent hospitalized again.
April: The police close down his house with all the paintings. Signac visits him in hospital, and Vincent is allowed to go home in Signac's company. Theo marries Johanna Bonger. Vincent paints and sends Theo two crates of masterpieces.
May: Though he feels better, he voluntarily enters Saint Paul-de-Mausole mental asylum at Saint-Rémy-de-Provence. He has two rooms there, paid for by Theo; one, with a view of the garden, serves as a studio. He is able to paint outdoors, under the supervision of an orderly, Georges Poulet.
June: Paints cypresses (pp. 185, 188, 195).
July: After a visit to Arles he has another attack while painting out of doors, and is unconscious

for some time, with resultant damage to his memory.
August–November: Painting again. Copies pictures by Millet (p. 217) and Delacroix (p. 212). Writes to Theo of his wish to move back north. Exhibits six paintings with Les Vingt in Brussels.
December: Vincent sends Theo three packages of pictures. He has another attack and tries to poison himself by swallowing paint.

1890 *January:* Exhibits in Brussels. Toulouse-Lautrec challenges a painter who speaks dismissively of Vincent's work to a duel. An article on his work appears in the "Mercure de France". Writes to Theo that he has never felt more at peace.
February: Theo informs him that Anne Boch has bought "The Red Vineyard" (p. 162) in Brussels, for 400 francs. Soon after, Vincent suffers a further attack which lasts two months. Exhibits ten pictures in the Salon des Indépendants in Paris.
May: Visits Theo and his family in Paris. Moves to Auvers-sur-Oise. Theo has chosen Auvers for him because of Dr. Gachet (pp. 226–227), who paints himself and is friends with some of the Impressionists and will look after Vincent. In Auvers Vincent produces over eighty paintings.
June: Vincent and his brother's family spend a weekend with Gachet. Paints "The Church at Auvers" (p. 222).
July: Visits Theo in Paris, and sees Toulouse-Lautrec. Theo has professional worries, so Vincent returns to Auvers speedily. Paints large-format pictures, wheat fields beneath a stormy sky (pp. 242–243). On 23 July he writes his last letter. On 27 July he goes out for an evening walk, returns late, and retires to his room. M. and Mme. Ravoux realize that he is in pain. Vincent admits having fired a bullet into his chest. Gachet bandages him and notifies Theo. On 29 July Vincent sits propped up in bed all day, smoking his pipe. That night he dies, and is buried in Auvers cemetery the following day.

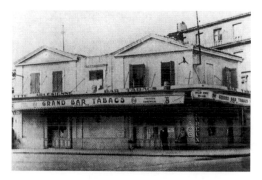

The "yellow house" in Arles. Vincent lived in the right half from 1888 till 1889. The building was destroyed in the Second World War

The room at Ravoux's café in Auvers where van Gogh died on 29 July 1890

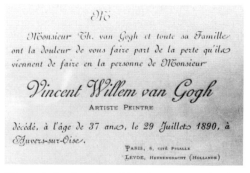

Vincent's death notice, which Theo sent to friends and relations. Below right are Theo's address in Paris and his mother's in Leiden

Acknowledgements

The authors and publishers wish to thank the museums, public and private collections, archives and photographers who provided material for reproduction in this volume. The owners of works are named in the credits except where they wish to remain anonymous or are not known. We have made every attempt to trace the holders of copyright in works reproduced in the book, but we should be very glad to have omissions or errors drawn to our attention. We also wish to thank the following archives: Colorphoto Hans Hinz, Allschwil; Ursula and André Held, Ecublens; Sotheby's of London and New York; Réunion des Musées Nationaux, Paris. Further illustrative material has been included from the archives of Benedikt Taschen Verlag and from the Ingo F. Walther Archive, Alling.

SELECT BIBLIOGRAPHY

Catalogues

Faille, Jacob-Baart de la: L'Œuvre de Vincent van Gogh. Catalogue Raisonné. 4 vols. Paris and Brussels, 1928

Faille, Jacob-Baart de la: The Works of Vincent van Gogh. His Paintings and Drawings. Amsterdam and New York, 1970

Lecaldano, Paolo: Tutta la pittura di Van Gogh. 2 vols. Milan, 1971

Hulsker, Jan: The Complete van Gogh: Paintings, Drawings, Sketches. Oxford and New York, 1980

Walther, Ingo F. and Rainer Metzger: Vincent van Gogh. The Complete Paintings. 2 vols. Cologne, 1990

Tesrori, Giovanni and Luisa Arrigoni: Van Gogh. Catalogo completo dei dipinti. Florence, 1990

Van Gogh's own Writings

Gogh, Vincent van: The Complete Letters of Vincent van Gogh. Introduction by Vincent Wilhelm van Gogh. Preface and Memoir by Johanna van Gogh-Bonger. 3 vols. London and New York, 1958

Documents, Memoirs

Gauguin, Paul: Avant et après. Paris, 1923 (Condensed English edition: The Intimate Journals of Paul Gauguin. New York, 1921)

Gauguin, Paul: Lettres de Paul Gauguin. Paris, 1946

Gachet, Paul: Souvenirs de Cézanne et de van Gogh à Auvers (1873–1890). Paris, 1953

Meier-Gräfe, Julius: Vincent. A Biographical Study. London and New York, 1922

Coquiot, Gustave: Vincent van Gogh, sa vie, son œuvre. Paris, 1923

Pach, Walter: Vincent van Gogh, 1853-1890. A Study of the Artist and His Work in Relation to His Time. New York, 1936

Uhde, Wilhelm: Vincent van Gogh. Vienna, 1937

Schapiro, Meyer: Vincent van Gogh. New York, 1950

Leymaire, Jean: Van Gogh. New York, 1951

Valsecchi, Marco: Van Gogh. Milan, 1952

Estienne, Charles: Vincent van Gogh. London, 1953

Cooper, Douglas (ed.): Vincent van Gogh. Drawings and Watercolours. New York, 1955

Perruchot, Henri: La Vie de Van Gogh, Paris, 1955

Rewald, John: Post-Impressionism. From Van Gogh to Gauguin. New York, 1956 (3rd revised edition: New York and London, 1978)

Elgar, Frank: Vincent van Gogh. Life and Work. New York, 1958

Cabanne, Pierre: Van Gogh, l'homme et son œuvre. Paris, 1961

Longstreet, S.: The Drawings of Van Gogh. Los Angeles, 1963

Erpel, Fritz: The Self-Portraits by Vincent van Gogh. Oxford, 1964

Hammacher, Abraham Marie: Genius and Disaster: The Ten Creative Years of Vincent van Gogh. New York, 1969 (New edition: New York, 1985)

Keller, Horst: Vincent van Gogh. The Final Years. New York, 1969

Tralbaut, Marc Edo: Van Gogh, le mal aimé. Lausanne, 1969 (English edition: Vincent van Gogh. London, 1974)

Wadley, N.: The Drawings of Van Gogh. London and New York, 1969

Wallace, Robert: The World of Van Gogh. New York, 1970

Cabanne, Pierre: Van Gogh. Paris, 1973

Hulsker, Jan: Van Gogh door van Gogh. De brieven als commentaar op zijn werk. Amsterdam, 1973

Descargues, Pierre: Van Gogh. New York, 1975

Leymarie, Jean: Van Gogh. Geneva, 1977

Uitert, Evert van (ed.): Vincent van Gogh. Zeichnungen. Cologne, 1977

Pollock, Griselda and Fred Orton: Vincent van Gogh: Artist of His Time. Oxford and New York, 1978

Hammacher, Abraham Marie and Renilde: Van Gogh. A Documentary Biography. London, 1982

Hulsker, Jan: Lotgenoten. Het leven van Vincent en Theo van Gogh. Weesp, 1985

Zurcher, Bernhard: Van Gogh, vie et œuvre. Fribourg, 1985

Stein, Susan Alyson (ed.): Van Gogh. A Retrospective. New York, 1986

Wolk, Johannes van der (ed.): De Schetsboeken van Vincent van Gogh. Amsterdam, 1986 (English edition: The Seven Sketchbooks of Vincent van Gogh. New York, 1987)

Bernard, Bruce (ed.): Vincent van Gogh. London, 1988

Uitert, Everet et al (ed.): Vincent van Gogh. Paintings. Rijksmuseum Vincent van Gogh, Amsterdam (exhibition catalogue). Milan 1990

Wolk Johannes van der et al (ed.) Vincent van Gogh. Drawings. Rijksmuseum Kröller-Müller, Otterlo (exhibition catalogue). Milan 1990